Painted

Delight

THIS EXHIBITION AND CATALOGUE

IN CELEBRATION OF THE FESTIVAL OF INDIA

ARE SUPPORTED BY

THE PEW MEMORIAL TRUST AND THE BOHEN FOUNDATION

PHILADELPHIA MUSEUM OF ART

JANUARY 26 TO APRIL 20, 1986

Painted

Delight

INDIAN PAINTINGS FROM PHILADELPHIA COLLECTIONS

Stella Kramrisch

PHILADELPHIA MUSEUM OF ART

Cover: *God Indra Visits the Imprisoned Sītā
in Rāvaṇa's Palace Garden While the
Guardian Demonesses Sleep* (detail of no. 120)

EDITOR: George H. Marcus
COPY EDITOR: Judith Ebbert Boust
PHOTOGRAPHY: Joan Broderick and Eric Mitchell
DESIGNER: Joseph B. Del Valle
COMPOSITION: John C. Meyer, Philadelphia
PRINTING: Lebanon Valley Offset, Annville, Pa.

ISBN 0-87633-064-2

Library of Congress Cataloging-in-Publication Data

Kramrisch, Stella
 Painted delight.

 Bibliography: p.
 1. Illumination of books and manuscripts, Indic—
Collectors and collecting Pennsylvania—Philadelphia—
Exhibitions. 2. Miniature painting, Indic—Collectors
and collecting—Pennsylvania—Philadelphia—Exhibitions.
I. Philadelphia Museum of Art. II. Title.
ND3247.7.K67 1986 745.6'7'0954074014811 85-31013
ISBN 0-87633-064-2
ISBN 0-8122-7954-9 (Univ. of Pa. Pr.)

CONTENTS

PREFACE

*I*NTEREST in the arts of India has flourished in Philadelphia since the early years of this century, most strikingly revealed in the gift to this Museum in 1919, by members of the Gibson family, of carved stone sections of a sixteenth-century temple hall from Madura. The acquisition of this impressive architectural interior boded well for the Museum's Indian collection, which received its first paintings in 1925 as a gift from Lydia Thompson Morris. Persian and Indian miniature paintings were included in the Sesqui-Centennial Exposition of 1926, and an important group of Indian paintings collected by the president of the Pennsylvania Academy of the Fine Arts, John Frederick Lewis, was given to the Free Library of Philadelphia in 1933.

To celebrate the Festival of India, organized by the governments of India and the United States for 1985–86, it seemed appropriate that this Museum select for exhibition and publication, in many cases for the first time, from the rich variety of Indian paintings owned in the Philadelphia area. We are enormously grateful to the individual lenders, Dr. Alvin O. Bellak, Mr. and Mrs. William P. Wood, Mrs. Harvey Z. Yellin, and several anonymous collectors, as well as to the Free Library, for sharing the works in their possession. We would also like to express warm thanks to the donors who have given paintings or funds for their purchase to this Museum over the years. The combined generosity of The Pew Memorial Trust and The Bohen Foundation has made it possible to mount the exhibition and publish this catalogue.

For Dr. Stella Kramrisch, who has selected the paintings and written the text that accompanies them, *Painted Delight* is the most recent in a remarkable sequence of projects devoted to the art of India, a subject she has done much to illuminate for Western scholars and viewers. The title she has chosen for the exhibition succinctly expresses what she has always sought to reveal in works of art: the delight of the artist, whether court painter or rural craftsman, in his creation. In bringing this project to fruition, Dr. Kramrisch has been ably assisted by Elizabeth Johnson, Nancy Baxter, and Bernice Connolly, as well as by the staff of the Registrar's office and the departments of Publications and Special Exhibitions. Denise Thomas and Faith Zieske, Associate and Assistant Conservators of works on paper, have worked long and thoughtfully to enable many of the fragile objects in the exhibition to be presented to the public. The Division of Education has planned a lively program of music, dance, film, and lectures that remind us that for centuries in India the visual arts have been intimately associated with the performing arts.

Anne d'Harnoncourt
The George D. Widener Director

ACKNOWLEDGMENTS

I WISH to acknowledge the courtesy of scholars whose council and confirmation helped in the making of this catalogue: Milo Cleveland Beach, Peter Gaeffke, Catherine Glynn, Brijinder N. Goswamy, Barbara Stoler Miller, and Mark Zebrowski. I am also grateful to Terence McInerney for providing information, to Richard Cohen for help in translating the inscriptions in Sanskrit and Sanskrit-derived languages, to Ellen Smart for translating the Persian inscriptions, and to Sheila Canby for her work when this project was in a preliminary stage and Darielle Mason for help with bibliographical verification.

My special thanks are due to the Museum's Director, Anne d'Harnoncourt, for suggesting an exhibition of Indian paintings from Philadelphia collections and for her unflagging interest in its implementation; to George Marcus for his judiciousness in editing the text and his cooperation in planning the appearance of the catalogue; to Joseph B. Del Valle for his imaginative design of the catalogue; and to the staff of every department of the Museum, especially my own, and, in particular, my former departmental secretary, Elizabeth Johnson. Without their cooperation this exhibition could not have come about.

S.K.

PRONUNCIATION OF SANSKRIT

Vowels should be pronounced as in Italian; a lengthening sign as in ā indicates a long vowel; e and o are always long; ṛ in Sanskrit is a vowel and should be pronounced like the ri in ring; c should be pronounced as in church; j as in joy; ś and ṣ like the sh in ship; h after a consonant should be pronounced distinctly as the th in hothouse.

DIMENSIONS

The dimensions given are those of the entire sheet including mounts, height preceding width, although plates do not always reproduce the entire object.

INTRODUCTION

PAINTINGS, at all times in India, have had their place in homes, public buildings, and temples. When Indian painting reached its moment of perfection on the walls of the cave sanctuaries of Ajanta in the middle of the first millennium of this era, it was expected that a cultured citizen would practice painting and keep at hand, ready for use, an assortment of brushes and paints. Moments of creativity and aesthetic delight were to be anticipated and experienced. A connoisseur contemplating a painting could lose himself in it; he could transcend his personal concerns and experience a delight—if for moments only—not of this world (*alaukika*) but akin in its intensity to the yogic state of *samādhi* (self-transcendency).

The paintings shown here, from the fifteenth to the nineteenth century, owe their existence to different kinds of patronage. Those of western India and in the service of the Jain religion are a well-defined group (nos. 1–3); wealthy citizens, bankers, and merchants were its supporters. The same holds true for the illustrations of the *Bhāgavata Purāṇa* of 1525–50 (nos. 4–5), which were painted for Hindu devotees and had citizens of the merchant class as their patrons. Patronage of the arts was not only the privilege of royalty and the aristocracy; it was given, however, on an unprecedented and incomparable scale by Emperor Akbar (1556–1605), and the kingdoms of India, at their courts, followed the Imperial example. This was the beginning of Rajput painting, with its many schools in northern, western, and central India.

PRE-MUGHAL PAINTING

The work of the studio that Akbar set up in the mid-sixteenth century, which introduced the Imperial, or Mughal, school, represents both a revolution and a renaissance in Indian painting, a revolution in respect to the then current practice of painting in northern India and a renaissance of Indian painting of a thousand years earlier.

In the middle of the first millennium of the present era, Indian painting on the walls of the cave sanctuaries of Ajanta conjured a world full of life, meditation, and action in which figures of gods, men, and animals commingled with plants and buildings in dense propinquity in a space created, as well as filled, by the volumes of their bodies. Modeled in no other light than that of inner vision, volumetric objects and figures rich in the flexions and foreshortenings of their rounded limbs appear emerging from a ground that they fully cover in staggered contiguity.[1] The depth of the painting reaches only as far as the figures that fill it; there is no background and rarely the suggestion of space or extension behind or above them. Architectural units—a house, rampart, gateway, scaffold of a swing—define the space according to their respective positions and the foreshortening demanded in each context.

Multiple perspective embodied in stereotypes, such as rocks represented as cubes and prisms shown simultaneously from more than one side, upholds the configuration of groups and the movements of the figures in only as much space as is filled by their bodies and required by their

movements. When intervals do occur, the interiors of buildings supported by slender pillars, for example, or open areas, they are dotted with flowers and represent either the floor within or the ground outside on which the figures stand. These do not recede in depth but appear sloping forward like that of a box without a front, tilted and open toward the spectator. Ramparts and fences—parallel to the spectator's eye or bent at sharp, obtuse angles—contain the throng of figures, preventing them from spilling over. Scene emerges from scene, story from story, as they cover the walls of the rock-cut sanctuaries of Ajanta. No flexion of limbs or body is left out of the assemblages of figures. Their infinitely varied groups obey the rhythm in which plants grow next to them or umbrellas sway above their heads. Faces are large-featured, the eyes in particular—at times, they exceed the outline of a head in three-quarter view.

An ancient text demands that the painter show a living body as if breathing;[2] the swell of its outlines visually obeys this demand. Increasing or decreasing in thickness, the outlines model the figures. Similarly, the painting of flowers renders their dew-fresh petals as if unfolding under the spectator's eyes. Naturalism in these paintings captures the breathing, living presence of its figures; nothing could be further from the conception of *nature morte,* or still life. Along with the specific activity or movement of each figure, be it man, animal, or plant, the inner pulsation of its life is shown.

The earliest Ajanta paintings (from about the first century B.C.) prefigure—across a gap of about six centuries whose achievements have been destroyed—the height of the tradition of the paintings at Bagh and Ajanta. The Ajanta tradition extended to Badami in the southern Deccan and to the far south, to Malabar.[3] It continued in Ellora, close to Ajanta, into the ninth century. The South Indian wall paintings in Sittanavasal, from the ninth century, are based on this tradition, as are those of the Chola dynasty in the Bṛhadīśvara temple in Tanjore from the early eleventh century. The figures in miniature paintings on palm leaves of this period in eastern India are rendered according to the Ajanta tradition. The Ajanta tradition was active also north of India. The wall paintings of the eleventh century in the monasteries of Alchi in western Tibet[4] are indebted to the Ajanta tradition channeled through the style of painting in Kashmir, of which, however, nothing has been preserved except the corresponding style of Kashmir metal images.

In western India, while the rich context of the paintings such as that of Bagh and Ajanta began to subside after the eleventh century, the sense of volume and modeling persisted in the rendering of the human figure. The process of reduction may be seen in a painting on a wooden book cover from western India of the twelfth century.[5] A vestigial modeling outline circumscribes Picassoesque distortions of the figures: overlarge heads in three-quarter profile that carry wide-open eyes, the farther eye floating unforeshortened across the outline of the face onto monochrome ground. This mannerism was to become a hallmark of the Western school of Indian painting.[6]

By the twelfth century Islam had entered India. As Muslim rule spread, temples were destroyed and images defaced. Their exposure on public monuments endangered them, and hardly anything but literary descriptions of wall paintings survived in northern India. When images were painted in books illustrating sacred texts, however, they were safe. Sheltered in libraries, they were preserved for centuries. In the seclusion of monastic and private libraries they could be meditated upon without fear. Because the pages of the earliest books were made of palm leaves, the illustrations had to be small. With the introduction of paper in the fourteenth century, the size of the illuminated page increased. It was in Gujarat, in western India, that the large and wealthy community of the Jains subsidized and preserved their illustrated books. The illustrations, which flourished there into the sixteenth century, have a style of their own essentially different from that of Ajanta (nos. 1–3).

By the fourteenth century a new figure had entered the miniatures of the Western, or Gujarat, school, that of the Sahi chief with his Mongolian physiognomy and richly ornamented costume—a sumptuously patterned caftan—covering his body. Whereas the Indian figures are modeled in flowing lines suggesting the volume and flexibility of their bodies and clad in supple, transparent garments, the Sahi type is painted two-dimensionally as a color patch filled with a large, con-

tinuous pattern. This contrast stimulated the painters; they painted textile patterns covering the entourage of the figures, filling their miniatures with a splendor that spread over the surface of the paintings. The Western school created a linear style, an antithesis to the tradition of Ajanta; however, it has a density of its own, a compulsive linear logic inventive of new formal elements.

The art of book illustration was practiced in several centers in northern and central India in the early sixteenth century. Although aware of the Western school, they did not succumb to its spell. In these parts of India, which were under, or close to, Muslim rule, Islamic book illustrations were known and assimilated in some cases but in other instances had little effect on local practice. At the Muslim court of Mandu in central India, a merging of Indian and Persian form in the first decade of the sixteenth century achieved a new style of two-dimensional consistency. Elsewhere, as in the paintings of the *Bhāgavata Purāṇa* of 1525–50 (nos. 4–5), a dynamic, purely Indian, endlessly resourceful two-dimensional style could afford to incorporate one or the other Persian motif in its own integrity. The home of this style is still unknown, but it could be the region of Delhi-Agra or Mewar. Although the illustrations of this *Bhāgavata Purāṇa* (The Ancient Story of Lord Kṛṣṇa, composed in the ninth to tenth century) and also subsequent illustrations of another *Bhāgavata Purāṇa* manuscript (no. 6) are contemporary with Mughal rule, their style is pre-Mughal.

MUGHAL PAINTING

From these several Indian schools all over northern India, Emperor Akbar brought artists to his Imperial studio. Under the supervision of two Persian masters, Mir Sayyid Ali and Abd as-Samad, as if by a miracle, the emperor achieved the completion of the 1,400 illustrations of the *Hamza-nāma* between the years 1562 and 1577. Their large scale (about 32 by 25 inches) exceeds that of any book ever made in India. Its twelve volumes of illustrations represent the renaissance of Indian painting (nos. 7–8).

It was Akbar who brought about the *Hamza-nāma* illustrations. More than just an Imperial patron of these large-scale paintings, Akbar was their creative mind. This extraordinary ruler was born in 1542 in the desert of Sind, after his father, Emperor Humayun, had been defeated in battle and was fleeing India. Humayun took refuge with Shah Tahmasp, whose court in Tabriz had gathered great Persian painters. Muslim rulers were patrons of learning and the arts, and workshops were attached to their libraries. When Humayun was able to return to India, he invited the two masters of painting to work at his court in Delhi.

Humayun died soon after his return to India, and Akbar was but fourteen years old when he succeeded to the throne. Son of Humayun and grandson of Bābur, Akbar was the third Timurid, emperor of India. In his veins flowed the blood of Timur and Genghis Khan, who had established vast empires in Central Asia. Akbar's aim was the conquest and unification of Hindustan, and within a few years he consolidated his power and conquered almost the whole of India as far south as the Godavari River. He united the country, surrounded himself with Hindus, married Rajput princesses, and called to his court the country's leading thinkers, poets, and artists. His deeply probing mind searched for the truth in many religions: Muslim, Hindu, Jain, Zoroastrian, Christian. Himself a Muslim, he was a Sufi, a mystic, and therefore was disliked by the Muslim orthodoxy. To open the minds of those of his entourage whose language was Persian, he had the great Sanskrit epics, the *Mahābhārata* and *Rāmāyaṇa*, translated into Persian and illustrated by the artists trained in his Imperial studio. Weekly, at times daily, the emperor had his painters lay out their work before him; he followed it with an intensity that also made him listen to the books that were read to him. Although Akbar had great Persian painters as his teachers, he was—so it is said—illiterate. He absorbed all knowledge by hearing and seeing; his mind ranged over fields vaster than his empire, and his library of twenty-four thousand volumes encompassed subjects from astrology to zoology.

Akbar had been enthralled by the wild and fantastic adventures of the *Hamza-nāma,* the "Romance of Amir Hamza," an uncle of the Prophet Muhammad. Now Akbar had his two master painters and their coworkers in the Imperial studio—about one hundred—illustrate the text. It was a grandiose undertaking. During the fifteen years it was in progress, Akbar conquered India. The operations on the battlefields were under his personal direction. He planned and took part in the siege of Chitor (1567–68) and took this fortress from his most powerful opponent, the rana of Mewar, shooting Jaimall, its Rajput commander, through his head.

Akbar was a realist. He made real his vision of a united India. In his studio he created a new form of reality in the world of painting. He had been trained in the Persian school of painting. To begin with, the leading artists of his studio were Safavid masters, while the contingent of painters was Indian. The paintings of the *Hamza-nāma,* however, are neither like Persian paintings nor like northern Indian paintings of any sixteenth-century school. The paintings of all these northern schools are two-dimensional, the figures painted on a monochrome ground. The figures in Safavid paintings, however, exist on the plane of the painting, where they float or are suspended according to a mode of visualization, a conceptual perspective, that combines a bird's-eye view with multiple perspective. The painting is organized in juxtaposed color fields: Adjacent fields differing in color meet at right or obtuse angles, implying the space of three-dimensional extensiveness together with its objects in nature. Weightless, impalpable planes are the fields of display for the figures. In utter fineness of line and color, Safavid paintings are laid out as a multicolored surface, a world to which the eye is led but which it is not to enter.

The paintings of the *Hamza-nāma,* on the contrary, show almost palpable figures, modeled and occupying a space that contains them. They are its volumetric contents. They are modeled by line and shading in a way that rounded the limbs of the Ajanta figures and, vestigially, also of those that came later down to the sixteenth century in the South Indian wall paintings of Lepakshi in the Hindu kingdom of Vijayanagar. However, whereas the figures of Ajanta move in the compact space that they bring about by their three-dimensional presence, the figures of the *Hamza-nāma* exist in space-filled settings. These are provided by the schemata of Safavid paintings.

Persian paintings are organized according to a conceptual perspective. It comprises the so-called bird's-eye view—an archaic convention that places one above the other figures or scenes meant to be understood as located behind one another, thus avoiding overlapping—and multiple viewpoints by turning into the plane of the painting the nearly unforeshortened extent of surfaces that cannot be seen simultaneously. Thus the floor of a room and its back wall are painted as adjacent areas distinct by their color and their position. The rectangle of the wall is above the area allotted to the ground. Similarly, the top surface of a box is painted as if it were a lifted lid, a four-sided area above the rectangle of its front view. The interior of a canopy, not normally visible from outside, will be turned into the picture plane and float on its differently colored ground. Side views of objects similarly will be laid out in the plane at an angle to the front surface of that object.

Persian painting makes the most clear-cut and logical use of conceptual perspective; it is essentially a painter's perspective. While it depicts it also defines objects and their position, translating them in terms of the surface onto which they are transferred. The figures placed into this conceptual framework share its elegance in clear-cut, flowing silhouettes at their appointed places. Single or shuffled in groups, they are accents, weightless presences, placed according to the story they illustrate. Their groups, their spacing, the inclination of a head, the raising of a finger—all show the story in its visualized form. Conceptual perspective formed by color fields and bounding lines has its perfected form in Persian painting of the fifteenth and sixteenth centuries.

Indian painting of the Ajanta school also rendered objects in accordance with conceptual perspective, stressing, however, the volumetric aspect of each figure or object. Rocks, for example, are painted as conglomerations of cubes, each of them depicted simultaneously from the front and one or more sides. Conceptual perspective was used to render the compact solidity of each shape, be it a rock cube or the rounded limb of a human figure; the compactness of the figures and their contiguity fill the respective structural unit, the interior of a building or a scene out-of-

doors. In either setting the human figures show forth from their ground full of their own expansiveness, three-dimensionally, breath inflated.

The conceptual perspective of Safavid paintings remained the framework of the *Hamza-nāma* illustrations. It became filled with figures and shapes modeled from within and volumetric and, in this respect, akin to those of Ajanta. However, in the *Hamza-nāma* illustrations the modeled shapes of the human figures are not receptacles and conduits of the rhythm of the ongoing process of life. They are charged with concentrated, explosive energy, thrusting forth in movements, sallying forth in foaming waves of rivers, and twisting in inflated masses of rocks, in gnarled trunks of trees, erect in pillars swelled with massive gravity, luxuriant in masses of foliage, condensed and articulated in patterns.

Akbar inspired the painters who gave form to his vision. His genius worked through their sensitivity and craftsmanship. It activated propensities that had had little scope for centuries, and had lingered in vestigial remnants or had gathered momentum in their restricted planar field, in the illustrations of the *Bhāgavata Purāṇa* of 1525–50 (nos. 4–5). Akbar's dynamism was given form by his painters in figures whose palpable shapes are modeled by means applied in the paintings of Ajanta. There they were sustained by the breath of life, by the inner experience that life has of itself. In the *Hamza-nāma* paintings these shapes are charged with energy, taut with concentrated vigor. In their palpability and resilience they look back to Ajanta; their drive, however, was not part of the classical Indian tradition of Ajanta. It was Akbar who instilled it into the three-dimensional figures and shapes of the *Hamza-nāma* illustrations.

Charging vitality, conveying inner tension, had been given form in a planar context in the illustrations of the *Bhāgavata Purāṇa* of 1525–50. Artists trained in this tradition and called to Akbar's Imperial workshop were ready to infuse the palpable shapes of the *Hamza-nāma* with its vitality. The two Indian traditions, that of the plastically modeled form found in classical Indian painting of Ajanta and that of the linear dynamism of the *Bhāgavata Purāṇa* illustrations, merged completely into components of the style of the *Hamza-nāma*. Over and above this, they were pictorially structured according to the conceptual framework of the composition of Safavid painting. In it the Indian figures found their place, within ramparts, under canopies, within and outside buildings, in any spatial context set up by the conceptual perspective.

In the *Hamza-nāma* illustrations the scale of the figures in relation to their space is larger than that of Safavid figures. The shapes of the latter remain sparse and are delicately inserted into their conceptual framework. The *Hamza-nāma* illustrations give to the conceptual framework a robust substantiality. The figures fill, act, and gesticulate within the space in front of a wall or parapet, and simultaneously also in the space within it; walls are not ethereal planes or extensions between calibrated columns, but on the contrary represent solidly built structures, detailed in every part.

If the figures of the *Hamza-nāma* illustrations are of combined Indian lineage, the structure of the paintings is essentially Safavid, its elegance clad in a new ponderousness that is Indian, of the classical tradition. The *Hamza-nāma* illustrations inspired by Emperor Akbar in his search for reality succeeded in fusing palpable shapes modeled by painterly means, replete with life and energy, with a conceptual framework that retained the integrity of a painted world of self-supporting illusion.

Historically, the *Hamza-nāma* illustrations represent a renaissance of classical Indian painting and a revolution in the art of its day, which was planar. As in every revolution, the forces that led to it remained active in the new framework of which they became part. The driving force had found a form of its own in the planar style of the illustrations of the *Bhāgavata Purāṇa* of 1525–50. Its impulsive vigor became part of the style of the *Hamza-nāma* illustrations.

The other contributing factor was the classical and diminished tradition, reduced to only the modeling line as in the western and other Indian schools of the sixteenth century. It was reborn in the *Hamza-nāma* illustrations in modeling capacity, which held a new vitality. The Indian components of the *Hamza-nāma* style were ordered in a conceptual perspective that had found its ultimate perfection in Safavid painting—which was the background of Akbar's artistic inheritance.

Akbar had at his command his own inner resources. He also commanded the vast resources of his empire for the equipment and productivity of the Imperial workshop. The maintenance and enlargement of his vast library were also his concern. The illustrated manuscripts of the library undoubtedly were admired by the emperor and made available to his artists. In these manuscripts the artists found confirmation and stimulation in their quest for giving form to the sights of nature. The gnarled trunks of ancient trees on whose bark the life force had left its signature held their particular interest, as did the shapes lifeless in themselves but replete with movement, such as a drapery tossed by the wind or folds of dress gathered by the movement of the wearer. These caught their eyes in nature—and in paintings in the illustrated Persian manuscripts of the Imperial library. They were to become recurrent motifs in the *Hamza-nāma*.

It is likely that works such as the *Jami al-Tawarikh* illustrated in Tabriz in 1314, and the *Shah-nāma* of Firdausi of 1330–36, also from Tabriz, were in the Imperial library. There, the artists could have seen, among other things, dress folds derived from illustrated manuscripts of the Eastern Christian churches.[7] Similarly, and also in the selfsame *Jami al-Tawarikh,* the corrugated design of the bark of the Sacred Tree of Buddha could be associated with the rendering of Eastern Christian formalism, but it also could be a Chinese borrowing.[8] The variously gnarled, mighty tree trunks are among the most expressive motifs of the *Hamza-nāma* illustrations. The phantasmagoric rocks piled in diverse formations in variously stylized varieties, which occupy so large a place in the *Hamza-nāma* and subsequent Mughal illustrations, were seen by Akbar's artists in nature and prefigured in Persian paintings. Whatever the shape, either seen in nature or chosen from within an artistic tradition, it was infused with life and given new form in the *Hamza-nāma*.

By the time of the *Hamza-nāma* paintings, the Portuguese had settled in southwestern India (Goa). It is possible that over the decades of their presence in India, some works of European art reached India and became known to Indian artists. It was, however, only in the 1580s, at the invitation of Emperor Akbar that Jesuit missions brought presents to his court in the shape of European paintings and engravings; thereby European Renaissance perspective was introduced and became an essential ingredient of the Mughal school. Among the presents brought to Akbar by the Jesuit missions were not only Renaissance paintings but also the polyglot Bible printed by Plantin in Antwerp between 1568 and 1573 and illustrated with engravings. The new vistas laid open by these works had their immediate—and abiding—effect on Mughal painting. The "realism" that had pervaded the *Hamza-nāma* illustrations was ready to integrate or give way to a new "perspective"—widening the scope of Mughal painting.

Following the work of the *Hamza-nāma,* countless illustrations came to embellish books of history, biography, and poetry. By a special technique, the miniature paintings were burnished; their rich palette of newly imported colors, in addition to those already known, together with a most detailed execution gave them a jewel-like quality.

Akbar encouraged his entourage to commission paintings and to set up studios. The greatest work of Indian epic poetry, the *Mahābhārata,* was translated into Persian under the name *Razm-nāma* (Book of Wars) and illustrated more than once (nos. 13–17). These illustrations were the work of artists employed in the Imperial studio as well as in lesser ones. In this way a sub-Imperial Mughal style developed. It promulgated the Imperial style while diluting it; new values and new forms emerged from it, and local schools came into existence.

In his later years, Akbar's ongoing search for reality led him to an exploration of the human personality and he particularly encouraged the art of portraiture. Mughal portraits show the disposition and destiny of the individual in physiognomies that come to life each time they are contemplated. Individual portraits became one of the subjects of album pages. They found favor with Akbar's son and successor, Jahangir (1605–27), and during his reign, portraiture became an official subject serving state occasions and politics. In the early part of the seventeenth century, the range of loosely bound album pages included paintings of lyrical themes and also the most keenly observed "portraits" of animals and flowers. Under the patronage and connoisseurship of Emperor Jahangir, Mughal miniature painting had become a court art of utmost refinement.

PAINTING IN THE DECCAN

Contemporary with painting of the Imperial Mughal school, painting at the courts of independent Muslim kingdoms in the Deccan, the plateau region south of the Vindhya Mountains, reached a perfection of its own. Three independent kingdoms, Ahmadnagar, Bijapur, and Golconda, left paintings of great mastery and unmistakable Deccani identity. In the northern Deccan, too, outside these kingdoms, at the end of the sixteenth century *rāgamālā* paintings of subtle intimacy vibrate with colors unknown in their combinations beyond this region. Even in the eighteenth century, when Deccani painting had long passed its zenith, the works have a subtle richness, a lingering warmth, and a reverberating depth unknown to Mughal or other Indian schools of painting.

Painting in the Deccan reached the height of its artistic achievement during the rule of Sultan Ibrahim Adil Shah II of Bijapur (1579–1627), who, like Akbar, created through his artists surpassing masterworks, although different in kind. In the portrait painting of this ruler (about 1595) regality and spontaneity blend, sumptuousness and intimacy are at one. Of Turkish Ottoman descent but not a conqueror like Akbar, Ibrahim Adil Shah II equaled the Mughal emperor in the intensity of his love of painting and in the quality of paintings begotten by that love. Like Akbar, too, he was a painter and mystic; he was a disciple of Akbar in his newly founded faith, the Din-i-ilahi. He effected his own synthesis of Hinduism and Islam. He introduced his own book, the *Kitab-i-Nauras,* with an invocation to Sarasvatī, the Hindu goddess of learning. Like Akbar, a Muslim of non-Indian descent, he infused with his own vision the work of Indian painters, mostly Hindus, whom he called to his court. The masters whom he inspired, like those who were called to Akbar's Imperial studio, responded, each in his own manner, to create a style as essentially Deccani as that of Akbar's studio was Mughal. Although the background of both schools was Safavid Persian, each created a new world of art: dynamic, tangible, realistic, a world teeming with action in conquered space, in the Mughal studio; a kingdom of sated nostalgia, abandoned to scents and dreams, lingering in flowers, glowing in colors, calm and deep, in the Deccan. In this world of enchantment, modeled bodies, voluminous garments, and inserts of European distant views occupy or float in a picture space of deep tenderness.

RAJPUT PAINTING IN THE PLAINS

Mughal painting had its beginning in the vision and workshop of Emperor Akbar, the *Hamza-nāma* paintings being his most outstanding and most personal creation. Under Emperor Jahangir the Imperial workshop catered not only to that emperor's exquisite taste in art and nature but also to his sense of ostentation. Increasingly Mughal art became a court art. In the last two decades of the sixteenth century it had taken into itself the achievements of the art of European Renaissance painting. Akbar, in his passion for painting and his desire to acquaint the courtiers and nobles of the realm with the mind of Hindu India, encouraged the translation of Indian texts and their illustration by artists both within the Imperial workshop and outside it. This led not only to works of sub-Imperial standard but also to the assertion of artistic values contributed regionally. Artists trained in the sub-Imperial workshops found their places at one or the other of the Rajput courts that had become part of the Mughal empire.

The ancestors of the Rajputs had entered India from Iran and Central Asia between the fourth and seventh centuries of this era. The conquerors founded kingdoms in northern and western India. As "sons of kings"—this is the meaning of the designation "Rajput"—they became part of the Kṣatriyas, the second, or warrior, caste of Hinduism. Their fighting spirit established them as rulers of kingdoms, but it also led them to fight among themselves and to lose their sovereignty to the Mughals. Although they became politically and economically dependent on the Mughal empire and adapted its fashions and style to their own, they were Hindus spiritually; the art they

patronized did not seek to represent the reality of the world of action but sought to conjure, by visual means, the rhythms by which the intangible world of devotion and emotion, filtered through sound and music, assumed color and acquired visibility.

Rāga paintings are uniquely Indian creations. The word *rāga*—derived from *rañj,* to color— denotes a musical mode that has "the effect of colouring the hearts of men."[9] This definition, formulated in about the fifth century, was given visual form about a thousand years later in the shape of pictures of human/divine figures that personified the respective melodic patterns[10] and could be meditated upon. In the sixteenth century the religious emotion released by the melodic patterns became centered on Kṛṣṇa and Rādhā, and identified with love, the soul's love of God. Literature defined the types of hero and heroine and paintings showed the state and attitude of the heroine in typical situations.

Rāga paintings are an epitome of the uniquely Indian interconnectedness of music and visual form on the one hand and of erotic and religious experience on the other. The formulas or metaphors that convey the respective mood, though abstracted from visual reality, are not abstract; they render and evoke emotion, capture in line, color, and spacing a mood experienced and projected into figures that carry poignantly the expressive ingredients for visualizing the mood they are intended to convey. It is laid out in the way the figures move and are spaced and the manner in which they are associated with the objects depicted, buildings and elements of nature. Their symbolic suggestiveness is a quality super-added to their expressiveness. Two birds, for instance, may suggest their coupling; a woman embracing a tree may hint at a similar connotation.

Like the performance of Indian music, which demands variations and improvisation of a melodic pattern, the basic scenario established for each of the six *rāgas* and their thirty-six consorts, or *rāginīs,* allows for variations and elaborations. Each school of Rajput painting and each period put its mark on the style of their presentation.

Its elements are formulas coined in pre-Mughal and early Mughal paintings. The linear abstractions of the one and the spatial conventions of the other are employed side by side, as if magnetically attracted to the flat ground of the painting. On it "three-dimensional" motifs such as a building are laid out, each complete, containing as much space as its original conception knew how to incorporate in its limits. A repertory of set motifs, such as that of a building together with the space it was meant to contain (no. 46), or flatly drawn trees, are juxtaposed, allowing the monochrome ground on which they are projected to be seen in its relevance as rhythmical counterpart to the figures. Single elements, such as trees, may be shuffled, their flat expanses where they overlap creating a pictorial density of interlocked color planes.

Rhythmical disposition of color planes, each charged with an intensity that fills the bounding lines, be they taut and wiry or sinuous and modeling, was the main concern of the artist. However, with the admission in the late sixteenth century of the physical perspective of Western Renaissance paintings into the context of Mughal painting, this trait also, in a modified and diminished way, became part of Rajput painting.

Illustrations of *rāgamālās* (complete sets of the six *rāgas* and their thirty-six *rāginīs*); related texts on the heroes and heroines of human/divine love, such as the *Rasikapriyā* of Keśavadās, and especially the texts celebrating Kṛṣṇa, the *Bhāgavata Purāṇa* and the *Gītagovinda;* as well as myths and legends of the great epics, the *Mahābhārata* and the *Rāmāyaṇa,* were favorite subjects of Rajput painting. Furthermore, the pleasures of life—festivals, hunts, and portraits—were frequent themes found therein. The mode in which the latter were presented did not differ from that of sacred subjects of myth and legend, *rāgas* and *rāginīs,* heroes and heroines. In Rajput paintings the world is laid out as a theophany. Each figure on its ground transmits the wonder of its being. The hero is the lover, is the gallant, and is the god.

The continuity of pre-Mughal tradition in Rajput painting on the one hand, the transition from Mughal and sub-Imperial Mughal to Rajput painting on the other, can be followed most clearly in the schools of Bundi and Mewar. In both, *rāgamālā* paintings are pregnant with the seeds of the past. Their germination was rapid and determined the flowering of each school.

The almost miraculous coming into existence of the Bundi style is documented by an inscription on a folio of the Chunar *rāgamālā* dated February 25, 1591.[11] The artists were pupils of the two Persian masters at Akbar's Imperial studio, Mir Sayyid Ali and Abd as-Samad. Their illustrations in the Chunar *rāgamālā* employ the three-dimensional formulas evolved in Akbar's studio. As if taken out of the larger compositions of the *Hamza-nāma* they now accommodate the iconographic requirements of the respective *rāgas*. Where a *rāga* or *rāginī* is surrounded by nature, trees, and flowering shrubs these are given a density steeped in luxuriant warmth. Emotional warmth also emanates, for example, from a figure of Bhairava Rāga and fills the interior where the god, seated on a lotus flower and wearing a garland of severed human heads, strums his lute (*vīṇā*).[12]

No *rāgas* are known to have been painted in Mughal art. The painters of the Chunar *rāgamālā*—so the inscription tells—were Muslims, sons of Shaykh Phūl Chishtī, a saint. The illustrations, moreover, were painted not in Bundi itself but in Chunar, close to Benares. They set the tone for the work of the Bundi school. The sons of the Muslim saint were trained by Persian masters in the Imperial studio, where an emotion-charged warmth of mood had no place. In its subsequent phases, the Bundi school remained distinct from other Rajput schools by qualities that distinguish the illustrations of the Chunar *rāgamālā*.

The other Rajput school, distinct from the day of its inception, is that of Mewar. There, a *rāgamālā* illustrated at Chawand (1605)[13] shows some continuation of the pre-Mughal style of the *Bhāgavata Purāṇa* of 1525–50, its vigor tamed, the figures controlled in rectangular color fields of clear proportions and bland hues. Mughal motifs are sporadic and slight. None of the volumetric projections of architectural themes of Mughal origin organizing the painted field is known to the placid symmetries of this earliest work of Rajput painting in Mewar.

A new zest was infused into the work of the Mewar school in the paintings by Sāhibdīn of about 1629 (see no. 60). Harsh in line and loud in color, the areas are coordinated in such a way that the figures stationed at their junctures appear as if weighed on a scale that registers the intensity of adjoining color fields, their spatial disposition and extent. Beyond the planning of his sober forms, Sāhibdīn eventually achieved a "style of highly controlled lyricism."[14]

The names of the artists who at the beginning left their mark on painting at Bundi and Mewar respectively are known. It is their vision that each of these schools remains indebted to: the works of Bundi in their vibrant tenderness of mood and landscape, the paintings of Mewar in their clear-cut sobriety of burning colors. While the Mewar school retained its individuality with, at times, shrill assertiveness, by the mid-eighteenth century it allowed Mughal and European perspectives to enter its tradition with startling effectiveness. The Bundi school, on the other hand, passed on its richer and more subtle heritage to masters of the nearby Kotah school. In Kotah a great master whose name is not known created, in the mid-eighteenth century, images of Durgā unrivaled in Indian painting (nos. 50–51). In the last quarter of the century in pictures of the hunt the very air of Kotah passes through the excitement of the scene.

The schools of Rajput painting in Rajasthan, thirteen of which are represented here, flourished not only at the courts of the larger kingdoms but also in small principalities and fiefs. Their departure from the Mughal style, beginning about the year 1600, did not exclude contacts with the Imperial center during the following century. The work of the school of Kishangarh, known from the later part of the seventeenth century, was remarkable for its elegance. It attained its peak in the paintings of Nihal Chand under the rule of Raja Sawant Singh (1699–1764), himself a painter and poet of deeply religious inspiration, known as Nāgari Dās. This inspiration pervades those of the paintings assigned to Nihal Chand that have Rādhā and Kṛṣṇa for their subject. An unearthly elegance emanates from these figures, seductive in their nobility (no. 75).

Few of the artists who either founded a school or made it rise to its height are known by name. A network of mutual influences brought about by contacts of courts and the migration of artists not only connected the many Rajput centers of painting but also extended to the schools of the Deccan. In more than one instance, particularly in the schools of the Panjab Hills, a master of

one regional school went to another and modified or even completely altered the style of that school.

In the late eighteenth, and in some cases into the mid-nineteenth, century the schools of Rajput painting, although aware of late Mughal and European trends, retained their identities. Works of great originality, such as *The Meeting* by an unknown artist in Jaipur (no. 78) and *The Birth of Kārttikeya* (no. 58) here assigned to the artist Chokha of Devgarh in the early nineteenth century, were created in more than one center.

South of Rajasthan, in Gujarat, in the first half of the seventeenth century, the illustrations of a *Bhāgavata Purāṇa* (nos. 39–42) present atavistically and on a level near to that of folk art the figurative elements of contemporary and earlier Rajasthani paintings. Whereas Rajasthan was the home of most Rajput schools, several developed in central India. The region of Malwa touches Mewar in Rajasthan in the northwest; its southernmost part extends to the river Narmada. In this region the paintings of the caves of Bagh of about the fifth century rivaled those of nearby Ajanta. In the early sixteenth century the *Nimat-nāma* painted at Mandu, the capital of Malwa, excelled in miniature paintings of a pure blend of planar contemporary Indian and Persian styles. It left no trace in the Malwa school of painting, which is known from the second quarter of the seventeenth century. At this phase, the Malwa school of painting looks back to the style of the *Bhāgavata Purāṇa* of the second quarter of the sixteenth century (nos. 4–5). Although it is limited in the range of its compositions, the disciplined boldness of its colors and design give to the Malwa school a unique primitive charm. Its strength was diminished after the middle of the seventeenth century with the introduction of Mughal elements.

RAJPUT PAINTING IN THE PANJAB HILLS

Painting at the Rajput courts in the Himalayan valleys, preeminently in Basohli, Kulu, and Mankot, unlike that of the Rajput courts in the Indian plains, did not begin as an offshoot of Mughal painting or as a sub-Imperial Mughal graft on an earlier, local tradition. Motifs, however, of Mughal architecture were taken for granted. They were transformed in the paintings of the "hill" schools and fashioned as frame and setting for the figures.

The hill schools, at the courts of Basohli, Kulu, and Mankot, are peaks of artistic achievement rising from the same mountain range yet clearly differentiated one from the other. The school of Basohli, a small principality fifteen by twenty miles in extent founded in 1598, emerged in about 1660 with paintings whose figures, fiercely noble and indomitably elegant, are bounded by trenchant yet subtly modeling lines. The tension of contraries is so great in this style that it includes occasional distortions, such as a face in front view rendered as a tilted platter on which are served eyes, more than human and staring. The faces of Basohli figures, however, are generally in profile; eyes bulge, large and steady, hypnotized by the direction into which the profile of the face is turned. Their sharp, angled, Grecian noses jut above minute mouths that have nothing to say because everything is communicated by gestures that cut across the distance between the figures. Trunks of trees, tender as asparaguses and sharp as needles, carry rich foliage of species freshly invented for the purpose of each painting, and steeped in heavy, earthy, yet glowing colors that set them off against an equally color-charged contrasting ground.

For about a quarter of a century painting at Basohli maintained the high tensions of its aristocratic form until a painter called Devīdāsa (possibly from Nurpur) in 1695 placed his heavy hand on the Basohli style. Subsequently, the painter Manaku from Guler, between 1730 and 1735, introduced a calm wide-spaced style in which hardly anything except the large, slightly bulging eyes remembers its past in the Basohli style of 1660 to 1690. In each of these two instances the work of a single artist from outside Basohli changed an established style. The origin of this power-charged style, hitherto unaccounted, is to be found in one great artist from Basohli whose name is not known.[15]

Close to Basohli in style, but far less complex and more diversified, the paintings from Kulu stem in part from an indigenous folk art, while the school of Mankot excels in animated reticence, emotional subtlety, and purity of line. These main Himalayan schools, by the middle of the eighteenth century, could not resist the impact of Mughal naturalism that reached them—already transformed—through the hill school of Guler. The artists of this school, though indebted to Mughal painting, looked with open eyes at nature that surrounded them. The landscapes of Guler paintings and those of Kangra, with their verdant hills, are the most lyrical companions of gods and men, with whom they share a style of tender expressiveness. Here the world seen as theophany includes gently sloping hills, calm lakes, and a clear sky.

The sky had hardly a place in early Rajput paintings with their planar, color-saturated, opaque ground. A cloud-streaked strip at the upper margin or a mere color-bound patch in one of the upper corners indicated the sky, whereas, at the end of the sixteenth century, Mughal painting adapted its naturalistic depiction from European Renaissance paintings to a high horizon. Transformed, the sky expands in luminous clarity over the mythical scenes playing in the landscape of Guler and Kangra. The figures of the Kangra school are attuned to sharper linear cadences than those of Guler. They were appreciated by Raja Sansār Chand (1775–1823) of Kangra, the great patron of this style. Kangra paintings particularly excel in the rendering of architectural themes; their spatial constructs draw the final consequences of Mughal space formulations of the *Hamza-nāma*. The colors of both the hill schools, however, are delicate in their nuances, totally unrelated to the boldness and inventiveness of the palette of those indigenous schools, of which Basohli is the foremost.

One of the most interesting hill schools is that of Mandi. Indebted to Mughal painting, it comprised, at its height between about 1720 and 1740, vestigial Mughal traces, a sturdy naturalism of its own, an equally sturdy primitive hill-school factor, and a creativity in which all these components fused in visionary paintings of tantric divinities.

The freshness and immediacy emanating from Rajput paintings belie the complexity of their stylistic history. To this day many thousands of paintings preserved in museums and other collections are cared-for sources of delight ready for further study.

FOLK PAINTING

Folk paintings have no specific patron. They are in demand by villagers particularly at weddings and at definite seasons when they are part of annually recurrent celebrations and performances. The picture showmen (*citrakathis*) who exhibit the paintings are at the same time the bards who tell the story they have illustrated. Folk paintings lack the finish of art produced under patronage. The illustrations are on cheap paper; its plain off-white color is the ground, used without any preparation. They have their own style coined by hereditary training and repetition. Folk paintings do not seek effects but are effective; they tell their stories and show their figures unmistakably. Myths and legends are their themes. Association with a sacred spot on the religious map of India has invigorated their fluency.

The painter-performers use two different techniques. The Paithan paintings of the Deccan regions of Maharashtra and Karnataka are shown leaf by leaf. Each leaf has a painting on the front and back, two sheets of paper having been glued together. The two sides are shown in succession and then the next leaf is similarly shown until the recitation ends. None of the Paithan paintings antedates the last century, and the itinerant painter-bards did not renew their stock of paintings after the end of the nineteenth century.

The paintings of these *citrakathis* of the Deccan are conceived in a heroic dimension that all the figures have in common. Their heavy build is augmented by costumes based on fashions of their day or yesteryear. The archaic formula of showing head and legs in profile, the body in front view, serves here to increase the tension of the gestures of the figures. Flamboyant yet taut, they

communicate and also charge the figured or vacant areas. Each figure or ensemble exists in its own ambience, generally a rectangular area, and frequently the painting is divided in two main fields. Animals and vegetation have the same heroic grandeur as the figures of the heroes; they carry it off in ornamental patterns or color fields that cover their amplitude. With very few exceptions all the figures have one groundline in common, from which they extend to the top of the painting. Vegetation motifs similarly based, and extending from the bottom to the top of the painting, fill the intervals, if any, between the figures. The color compositions are mellow in tone and varied. While employing formulas, they are used creatively from one painting to the other. Each painting adds some visual surprise to the ongoing recitation of deeds of valor and fantasy.

In Bengal another type of picture showman uses the painted scroll as the visual form of narrative art, unrolling the scroll on a bamboo scaffold while the narrator points to the respective scene that illustrates the theme in demand—by the villager who passed by and is in need to hear and see a special story—that may sustain his heart and mind. Myths, divine images, and scenes from the other world—that of death—are shown and told to him according to his wish. Picture showmen of this kind are of ancient lineage. They practiced their art from before the time of the Buddha. They were still active in eastern India through the nineteenth century and in a debased way into the twentieth.

Places of pilgrimage and temples to this day are centers for the dissemination of religious knowledge and their own significance within it by means of booklets, images, and paintings available at little cost and easy to carry. Some of the scroll painters of Bengal might have settled at the temple of the dreaded goddess Kālī in Kalighat near Calcutta. There, instead of showing their customer the particular scene or image he was in need of, they painted on single sheets of paper the image of Kālī as well as other gods and goddesses—and also figures, objects, and scenes associated with the temple and life around it. These were rapidly painted, in great numbers and with quick brushstrokes (see nos. 137–38).

1. See A. Ghosh, ed., *Ajanta Murals* (New Delhi, 1967).
2. *Viṣṇudharmottara Purāṇa,* pt. 3, ed. P. Shah (Baroda, 1958), p. 156 (43.29).
3. See Stella Kramrisch, *Drāviḍa and Kerala in the Art of Travancore* (Ascona, 1953), pl. 39 (wall painting in a cave, Tirunandikkara, eighth–ninth century).
4. Pal, 1982, pl. s66.
5. Khandalavala and Chandra, 1969, fig. 1.
6. It occurs sporadically at Alchi; see Pal, 1982, pl. LS13.
7. See Gray, 1961, pp. 25–26, 32.
8. Ibid., p. 24.
9. O. C. Gangoly, *Rāgas & Rāgiṇīs* (Bombay, 1948), vol. 1, p. 2.

10. Dahmen-Dallapiccola, 1975, p. 2.
11. See Skelton, 1981, p. 124; and Beach, 1974, p. 9.
12. Welch, 1985, pp. 342–44, no. 228; see also Welch, 1973, pp. 40–41, no. 17; and Beach, 1974, figs. 1–2.
13. Topsfield, 1981, pp. 232–33, pl. 8, fig. 502.
14. Ibid., p. 235.
15. The name of the two artists from Nurpur and Guler are recorded because they were outsiders, whereas local artists were so well known at each court that they did not require identification; see Goswamy, 1968, pp. 18–20; and Brijinder N. Goswamy, "Of Patronage and Pahari Painting," in Pratapaditya Pal, ed., *Aspects of Indian Art* (Leiden, 1972), pp. 130–38.

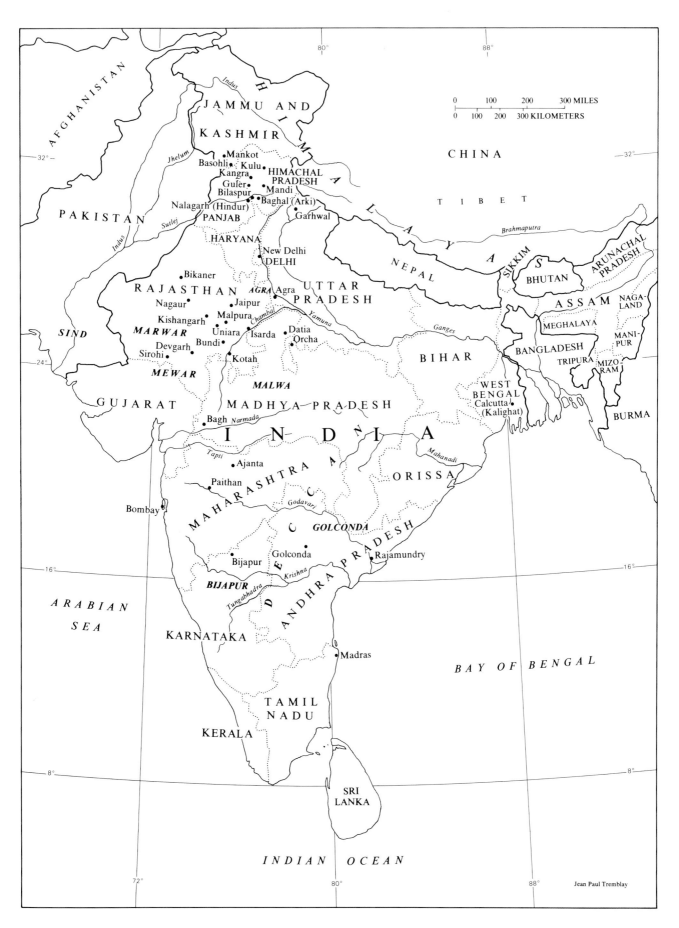

AFGHANISTAN

JAMMU AND

KASHMIR

HIMALAYA

CHINA

PAKISTAN

• Mankot
Basohli • Kulu
Kangra •
Guler • HIMACHAL
Bilaspur PRADESH
• Mandi
Nalagarh (Hindur) • Baghal (Arki)
PANJAB • Garhwal

TIBET

Indus
Jhelum
Sutlej
Brahmaputra

HARYANA

New Delhi
DELHI

• Bikaner

RAJASTHAN AGRA • Agra UTTAR
PRADESH

NEPAL SIKKIM S ARUNACHAL
BHUTAN PRADESH

Nagaur • • Jaipur

Kishangarh • Malpura • MARWAR Uniara • Isarda • Datia
Devgarh • Bundi • • Orcha
Sirohi • • Kotah

ASSAM NAGA-
LAND

MEGHALAYA MANI-
PUR

Ganges

BIHAR

BANGLADESH TRIPURA MIZO-
RAM

MEWAR

MALWA

GUJARAT MADHYA PRADESH

WEST
BENGAL
Calcutta •
(Kalighat)

BURMA

Bagh • Narmada

INDIA

Tapti
• Ajanta

Paithan • MAHARASHTRA

Bombay •

Godavari

Mahanadi

ORISSA

GOLCONDA

Bijapur • • Golconda • Rajamundry

BIJAPUR Krishna

D E C C A N

ANDHRA PRADESH

Tungabhadra

ARABIAN
SEA

KARNATAKA

• Madras

BAY OF BENGAL

TAMIL
NADU

KERALA

SRI
LANKA

INDIAN OCEAN

0 100 200 300 MILES
0 100 200 300 KILOMETERS

32° 32°

24°

16° 16°

8° 8°

72° 80° 88°

Jean Paul Tremblay

PRE-MUGHAL

PAINTING

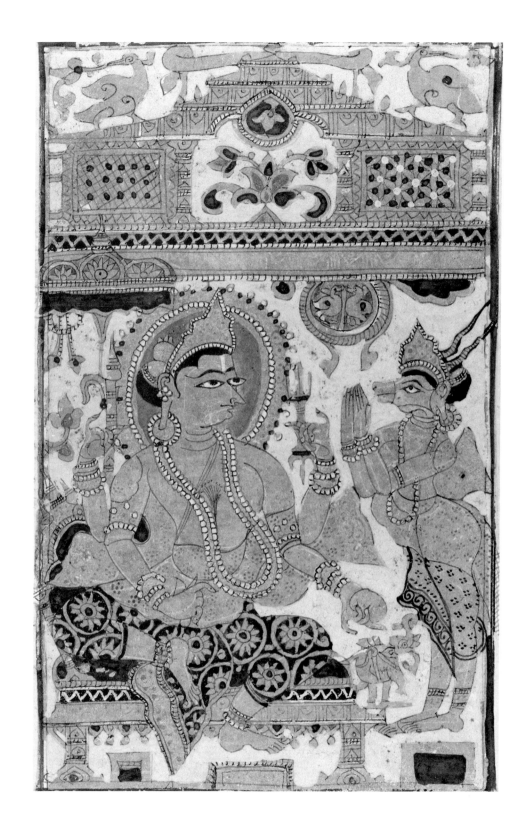

1 *God Indra Instructs Hariṇaigameṣin to Transfer Mahāvīra's Embryo
from the Brāhmaṇī Devānandā to Queen Triśalā*

WESTERN SCHOOL, NORTH GUJARAT, 1432
ILLUSTRATION FROM THE *Kalpasūtra*
OPAQUE WATERCOLOR WITH GOLD ON PAPER, 5⅛ x 13″ (13 x 33 cm)
PHILADELPHIA MUSEUM OF ART. ANONYMOUS GIFT. 67-226-1(7)

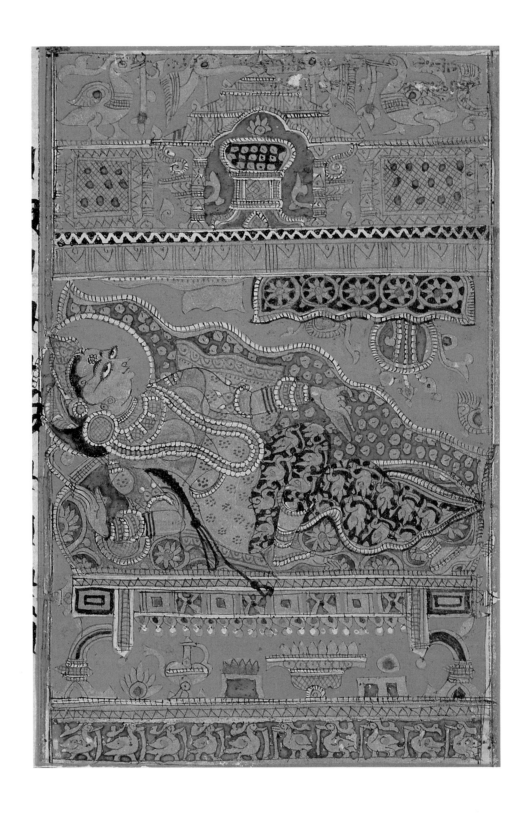

2 *Queen Triśalā on Her Couch*

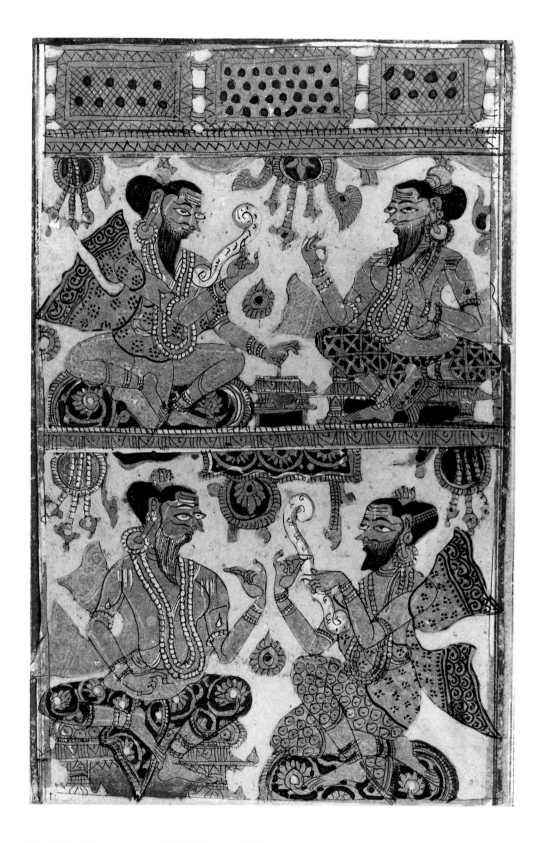

3 *The Interpreters of the Fourteen Dreams*
WESTERN SCHOOL, NORTH GUJARAT, 1432
ILLUSTRATION FROM THE *Kalpasūtra*
OPAQUE WATERCOLOR WITH GOLD ON PAPER, 5⅛ x 13″ (13 x 33 cm)
PHILADELPHIA MUSEUM OF ART. ANONYMOUS GIFT. 67-226-1(20)

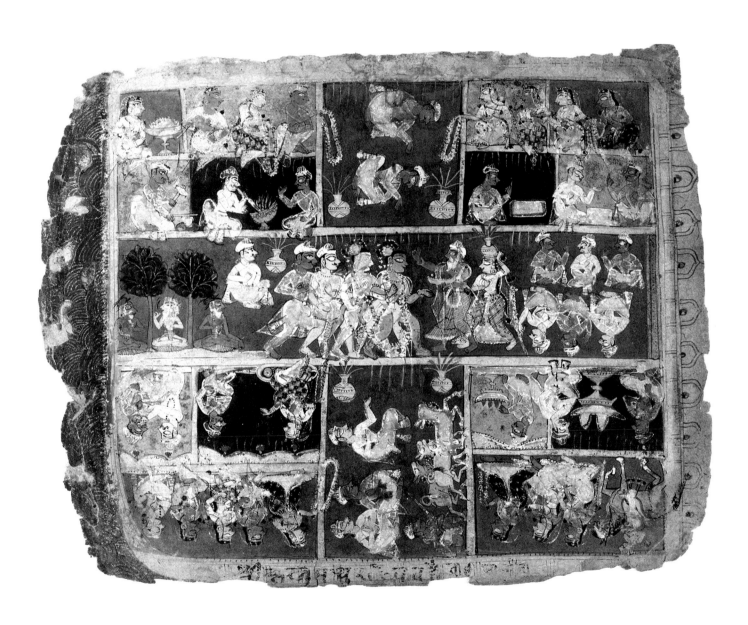

4 *Kṛṣṇa and Balarāma, Arriving in Mathurā, Plan to Confront Kaṁsa*

DELHI-AGRA AREA, 1525–50
ILLUSTRATION FROM THE *Bhāgavata Purāṇa*
OPAQUE WATERCOLOR ON PAPER, 7 x 9″ (17.8 x 22.9 cm)
PRIVATE COLLECTION

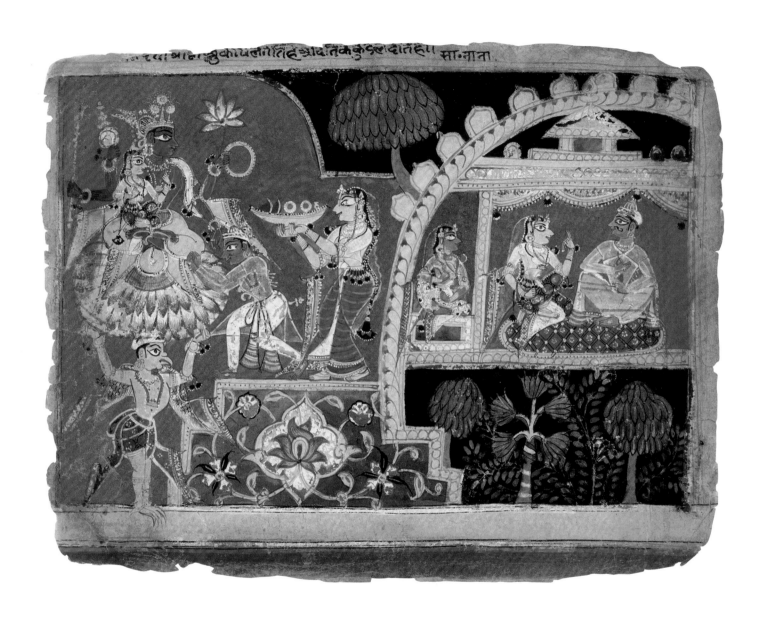

5 *The Victory of Pragjyotiṣa*

DELHI-AGRA AREA, 1525–50
ILLUSTRATION FROM THE *Bhāgavata Purāṇa*
OPAQUE WATERCOLOR ON PAPER, 6⅞ x 9″ (17.5 x 22.9 cm)
COLLECTION OF DR. ALVIN O. BELLAK

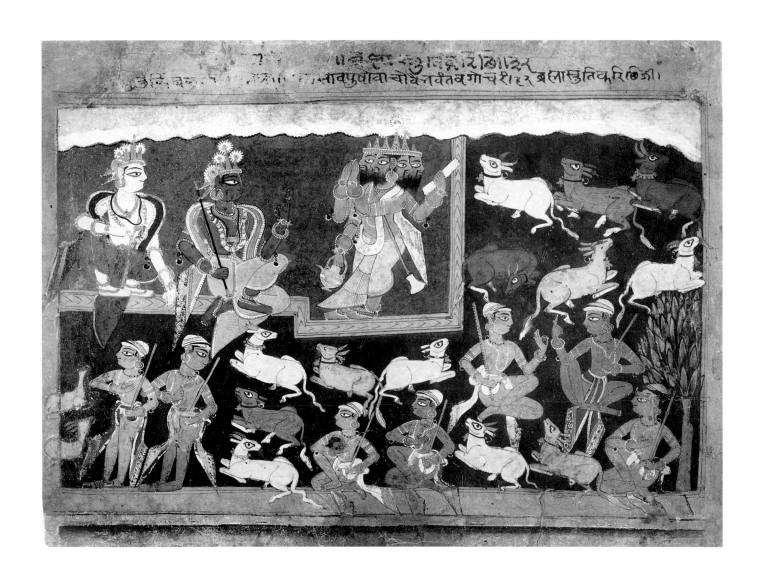

6 *Brahmā Offers Homage to Kṛṣṇa*

RAJASTHAN(?), C. 1570
ILLUSTRATION FROM THE *Bhāgavata Purāṇa*
OPAQUE WATERCOLOR ON PAPER, 7¼ x 10⅛″ (18.4 x 25.7 cm)
COLLECTION OF DR. ALVIN O. BELLAK

MUGHAL

PAINTING

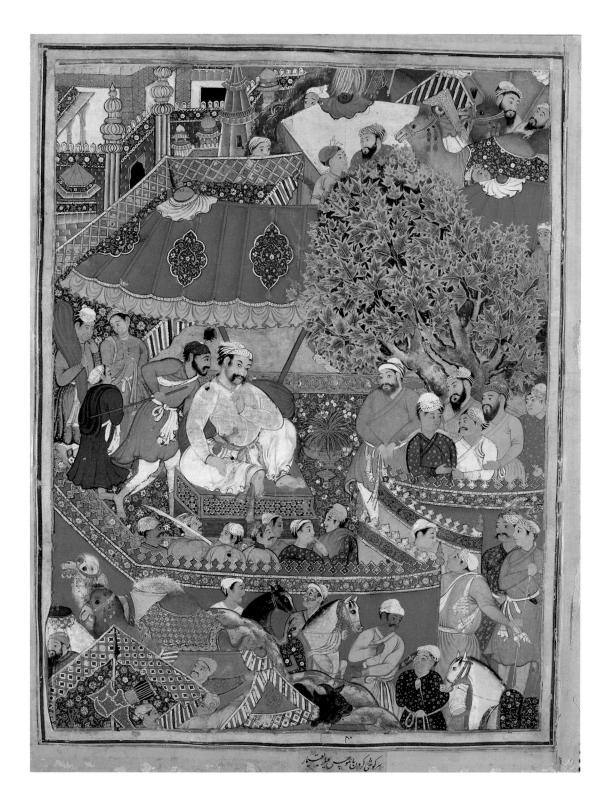

7 *King Tisūn Receives the Good News That Mahābat, Son of*
King Sharīf, Will Be His Ally
MUGHAL SCHOOL, 1562–77
ILLUSTRATION FROM THE *Hamza-nāma*
OPAQUE WATERCOLOR WITH GOLD ON CLOTH, 31⅛ x 24⅞″ (79 x 63.2 cm)
FREE LIBRARY OF PHILADELPHIA. RARE BOOK DEPARTMENT,
JOHN FREDERICK LEWIS COLLECTION

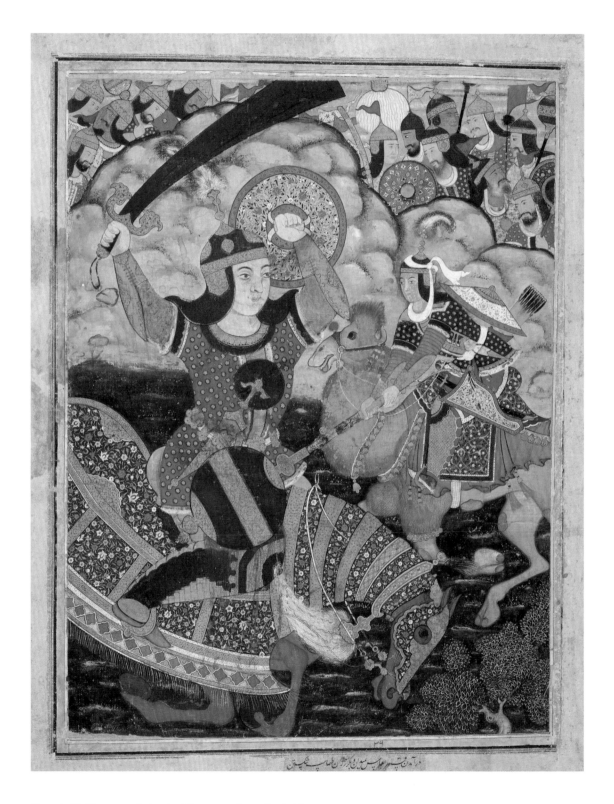

ارا آمدن بیشهر عباس سیان از کبرگران طامپا شکربین

8 *A Follower of Amir Hamza Attacks Tahmasp*
MUGHAL SCHOOL, 1562–77
ILLUSTRATION FROM THE *Hamza-nāma*
OPAQUE WATERCOLOR WITH GOLD AND SILVER OR TIN ON CLOTH
31 x 25½″ (78.7 x 64.8 cm)
PHILADELPHIA MUSEUM OF ART. GIFT BY EXCHANGE WITH THE BROOKLYN
MUSEUM. 37-4-1

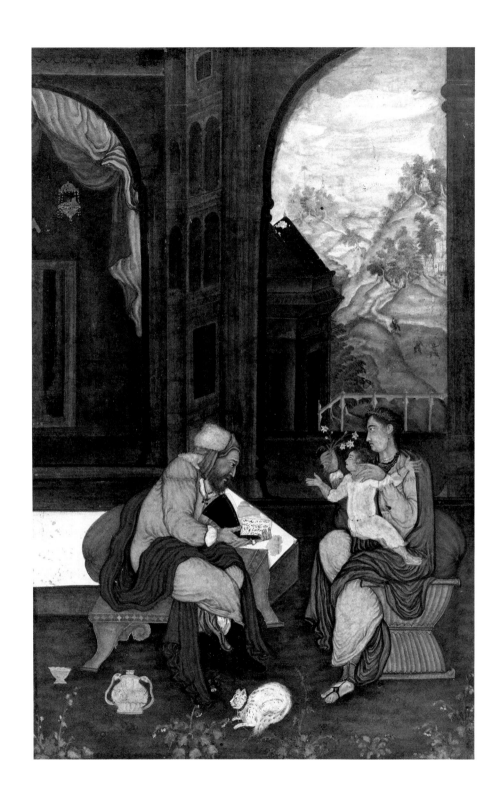

9 *The Holy Family*
MUGHAL SCHOOL, 1585–90
OPAQUE WATERCOLOR WITH GOLD ON PAPER
18¹⁄₁₆ x 11″ (45.9 x 27.9 cm)
FREE LIBRARY OF PHILADELPHIA. RARE BOOK DEPARTMENT,
JOHN FREDERICK LEWIS COLLECTION

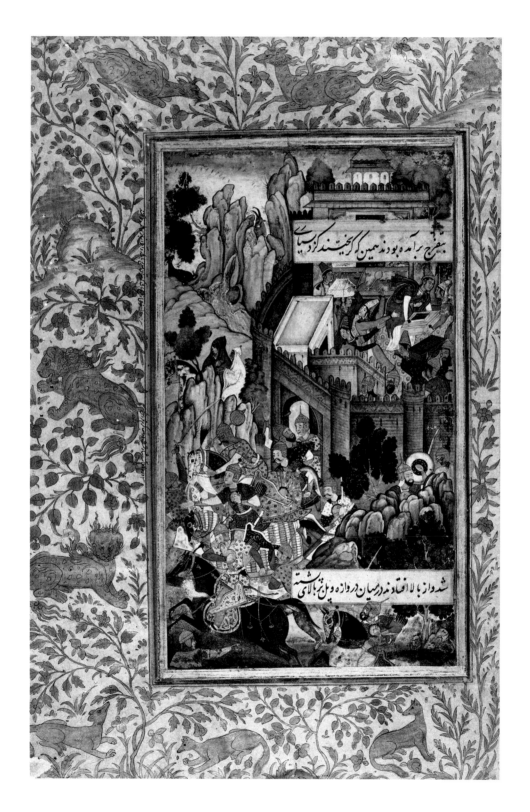

10 *Evacuation of the Royal Castle at the Battle of Asfara in May* 1494
MUGHAL SCHOOL, 1589
ILLUSTRATION FROM THE *Bābur-nāma*
OPAQUE WATERCOLOR WITH GOLD AND SILVER OR TIN ON PAPER
13½ x 8⅞″ (34.3 x 22.5 cm)
FREE LIBRARY OF PHILADELPHIA. RARE BOOK DEPARTMENT,
JOHN FREDERICK LEWIS COLLECTION

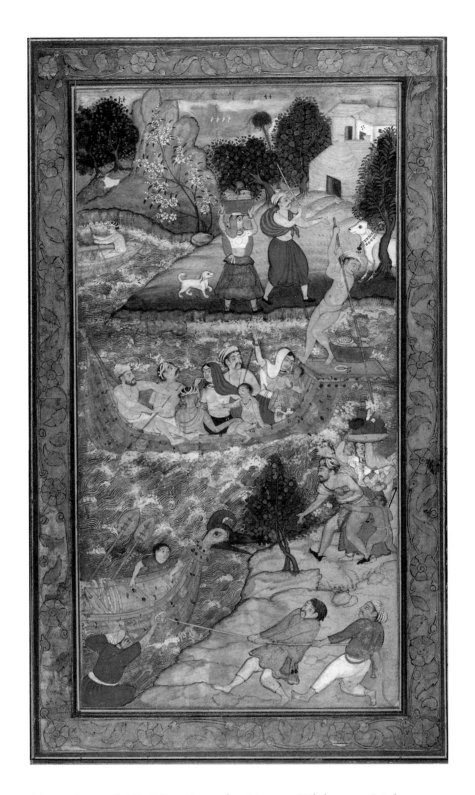

11　*Bābur and His Men Cross the River at Bilah, near Multan*

MUGHAL SCHOOL, 1589
ILLUSTRATION FROM THE *Bābur-nāma*
OPAQUE WATERCOLOR WITH GOLD LEAF ON PAPER
11¼ x 7⁵⁄₁₆″ (28.6 x 18.6 cm)
PHILADELPHIA MUSEUM OF ART. GIFT OF MR. AND MRS.
WILLIAM P. WOOD IN HONOR OF DR. STELLA KRAMRISCH

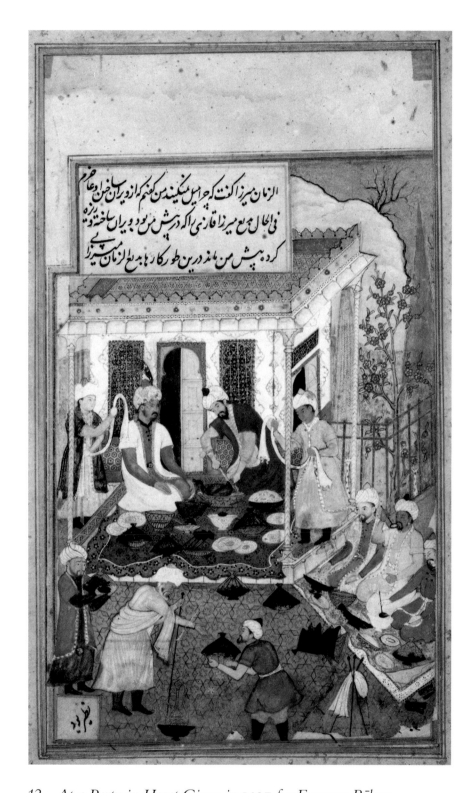

*12 At a Party in Herat Given in 1507 for Emperor Bābur,
a Roast Duck Is Carved for Him by His Cousin*

MUGHAL SCHOOL, 1589
ILLUSTRATION FROM THE *Bābur-nāma*
OPAQUE WATERCOLOR WITH GOLD ON PAPER
13⅞ x 9¹⁄₁₆″ (35.2 x 23 cm)
PHILADELPHIA MUSEUM OF ART. THE SAMUEL S. WHITE, 3RD,
AND VERA WHITE COLLECTION. 67-30-305

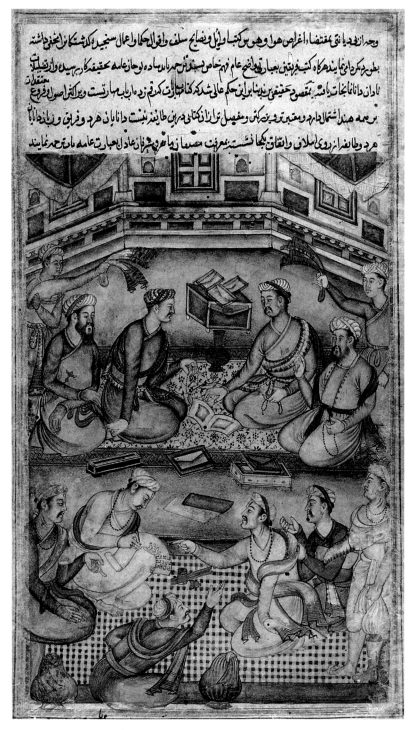

13 *Abu'l Fazl Discusses the Translation of the Mahābhārata into Persian with Muslim and Hindu Scholars*

SUB-IMPERIAL MUGHAL SCHOOL, 1598
DHANU
ILLUSTRATION FROM THE *Razm-nāma*
TRANSPARENT WATERCOLOR WITH GOLD ON PAPER
11⁹⁄₁₆ x 6⁵⁄₁₆″ (29.4 x 16 cm)
FREE LIBRARY OF PHILADELPHIA. RARE BOOK DEPARTMENT,
JOHN FREDERICK LEWIS COLLECTION

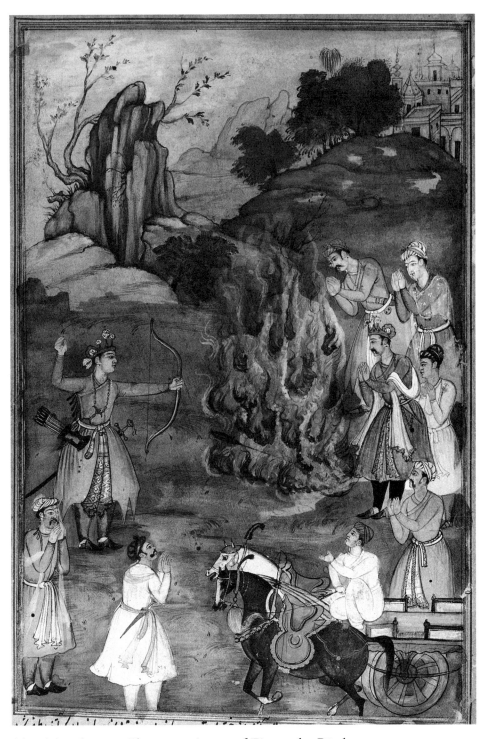

14 *Aśvatthāman Shoots an Arrow of Fire at the Pāṇḍavas*
SUB-IMPERIAL MUGHAL SCHOOL, 1598
ASI
ILLUSTRATION FROM THE *Razm-nāma*
OPAQUE AND TRANSPARENT WATERCOLOR WITH GOLD ON PAPER
12 x 6⅞″ (30.5 x 17.5 cm)
FREE LIBRARY OF PHILADELPHIA. RARE BOOK DEPARTMENT,
JOHN FREDERICK LEWIS COLLECTION

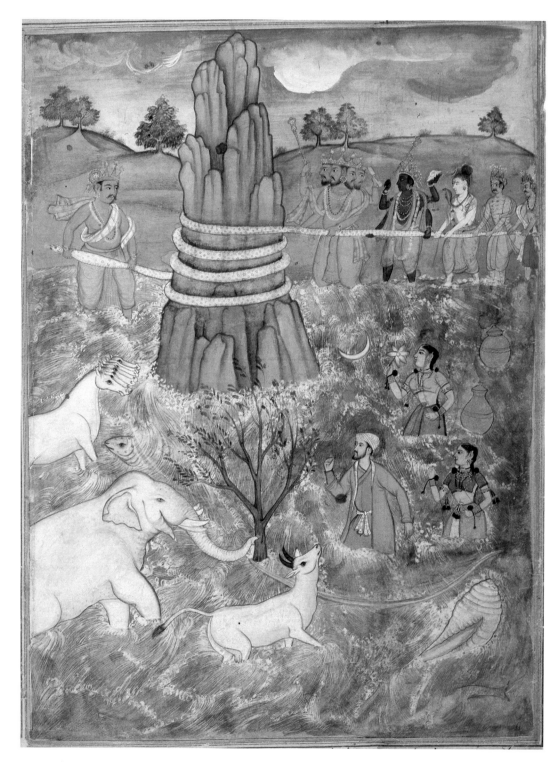

15 The Churning of the Ocean

SUB-IMPERIAL MUGHAL SCHOOL, 1598
FATU
ILLUSTRATION FROM THE *Razm-nāma*
OPAQUE AND TRANSPARENT WATERCOLOR WITH GOLD ON PAPER
11⅝ x 6½″ (29.5 x 16.5 cm)
FREE LIBRARY OF PHILADELPHIA. RARE BOOK DEPARTMENT,
JOHN FREDERICK LEWIS COLLECTION

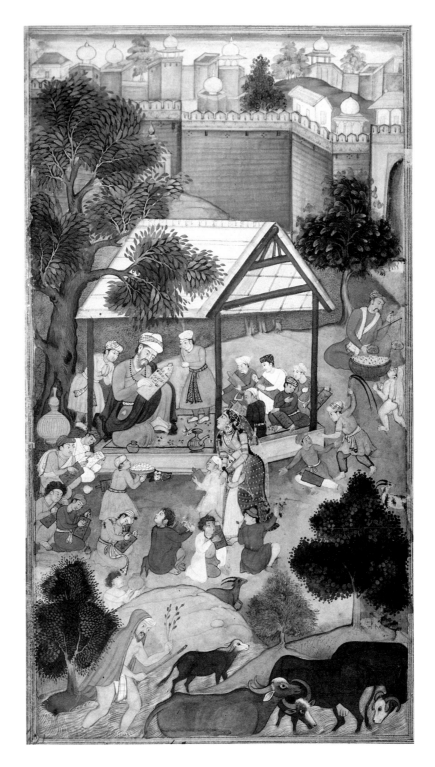

16　*The Teaching of the Schoolmaster and the Explanation by the*
Teacher of the Necessity of Wise Tradition

SUB-IMPERIAL MUGHAL SCHOOL, 1598
ASI THE YOUNGER
ILLUSTRATION FROM THE *Razm-nāma*
OPAQUE AND TRANSPARENT WATERCOLOR ON PAPER
11⅝ x 6¾″ (29.5 x 17.1 cm)
FREE LIBRARY OF PHILADELPHIA. RARE BOOK DEPARTMENT,
JOHN FREDERICK LEWIS COLLECTION

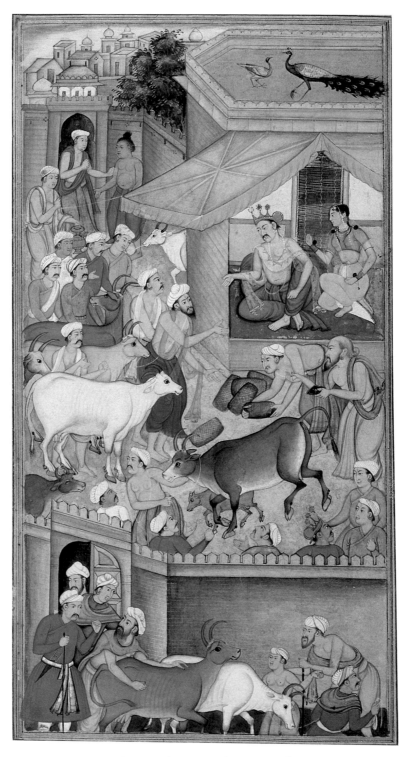

17 *King Yudhiṣṭhira and His Wife Draupadī*
Give Their Possessions to the Brahmans
SUB-IMPERIAL MUGHAL SCHOOL, 1598
SARUN (SARVAN)
ILLUSTRATION FROM THE *Razm-nāma*
OPAQUE AND TRANSPARENT WATERCOLOR ON PAPER
11⅞ x 6⅝" (30.2 x 16.8 cm)
FREE LIBRARY OF PHILADELPHIA. RARE BOOK DEPARTMENT,
JOHN FREDERICK LEWIS COLLECTION

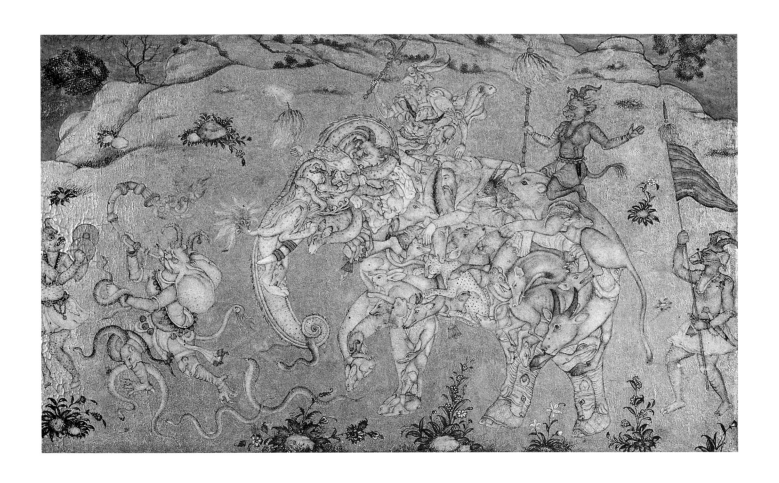

18 A Composite Elephant Is Led by Demons

MUGHAL SCHOOL, 1575–1600
OPAQUE WATERCOLOR WITH GOLD ON PAPER, 15⅞ x 23⁷⁄₁₆″ (40.3 x 59.5 cm)
FREE LIBRARY OF PHILADELPHIA. RARE BOOK DEPARTMENT,
JOHN FREDERICK LEWIS COLLECTION

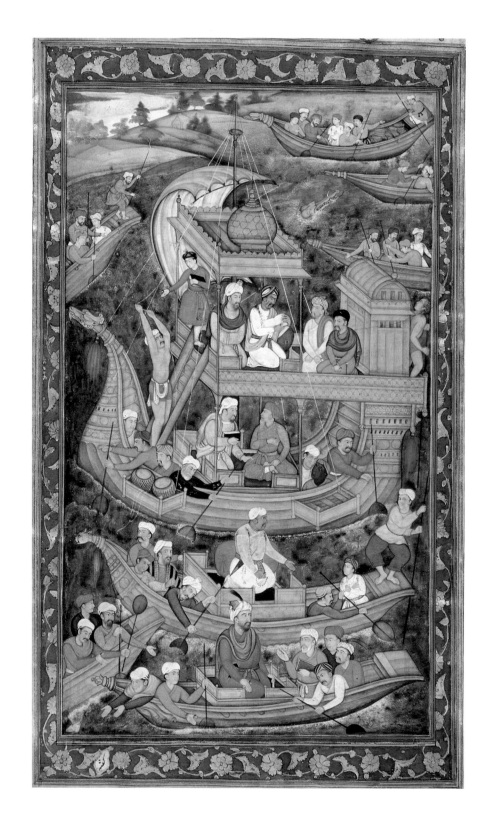

19 *Akbar's Expedition by Boat to the Eastern Provinces*

MUGHAL SCHOOL, 1602–4
ILLUSTRATION FROM THE *Akbar-nāma*
OPAQUE WATERCOLOR WITH GOLD ON PAPER, 13½ x 9⅛″ (34.3 x 23.2 cm)
PHILADELPHIA MUSEUM OF ART. THE SAMUEL S. WHITE, 3RD,
AND VERA WHITE COLLECTION. 67-30-389

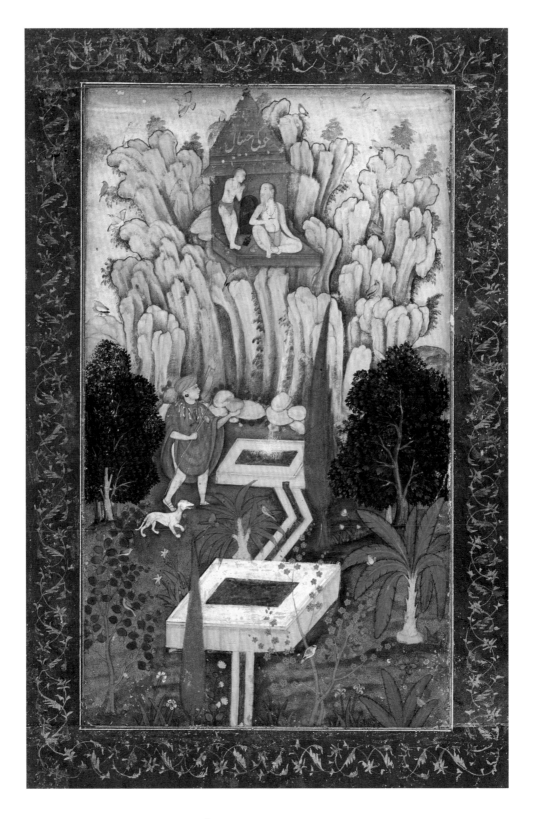

20 *Yogi of the Mountains*
MUGHAL SCHOOL, 1600–1610
OPAQUE WATERCOLOR WITH GOLD ON PAPER, 10¼ x 7″ (26 x 17.8 cm)
PRIVATE COLLECTION

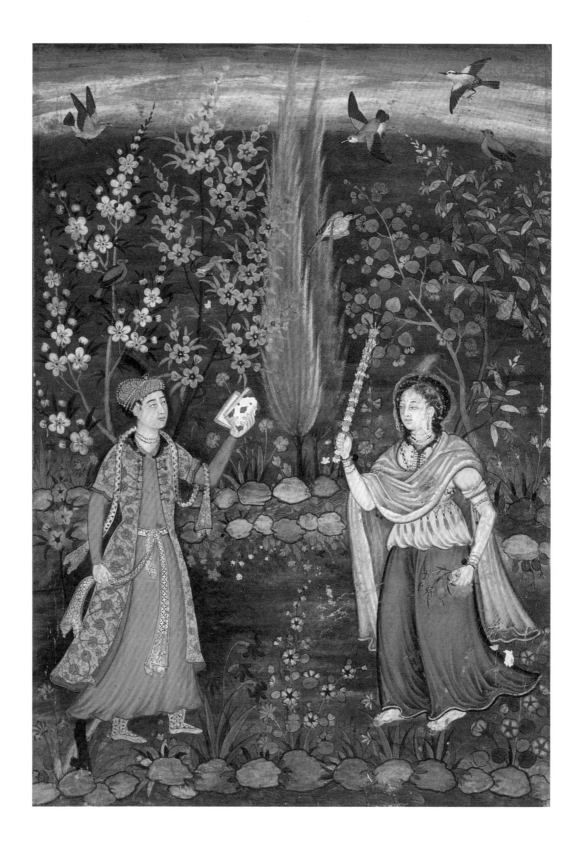

21 *Meeting in a Garden*
MUGHAL SCHOOL, C. 1610
OPAQUE WATERCOLOR WITH GOLD ON PAPER, 18⁹/₁₆ x 12³/₈″ (47.1 x 31.4 cm)
FREE LIBRARY OF PHILADELPHIA. RARE BOOK DEPARTMENT,
JOHN FREDERICK LEWIS COLLECTION

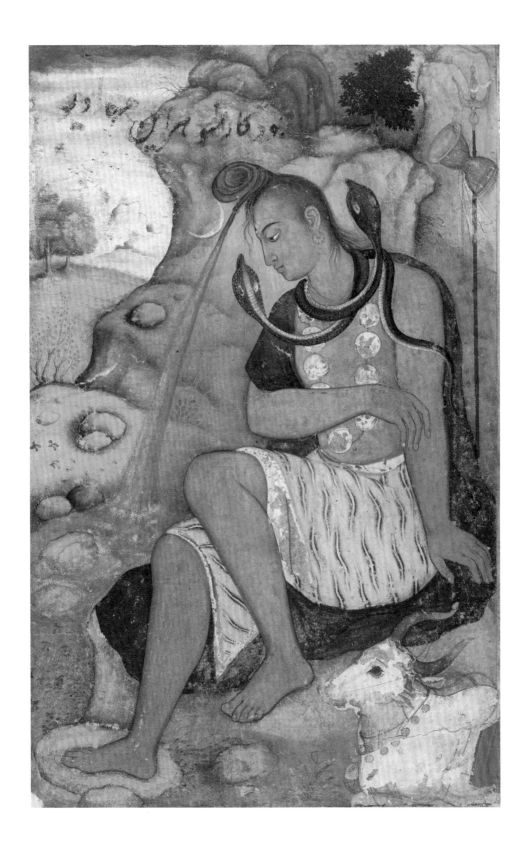

22 *The Descent of the Ganges*
MUGHAL SCHOOL, 1605–10
OPAQUE WATERCOLOR WITH GOLD ON PAPER, 6 x 3⅞″ (15.2 x 9.8 cm)
PRIVATE COLLECTION

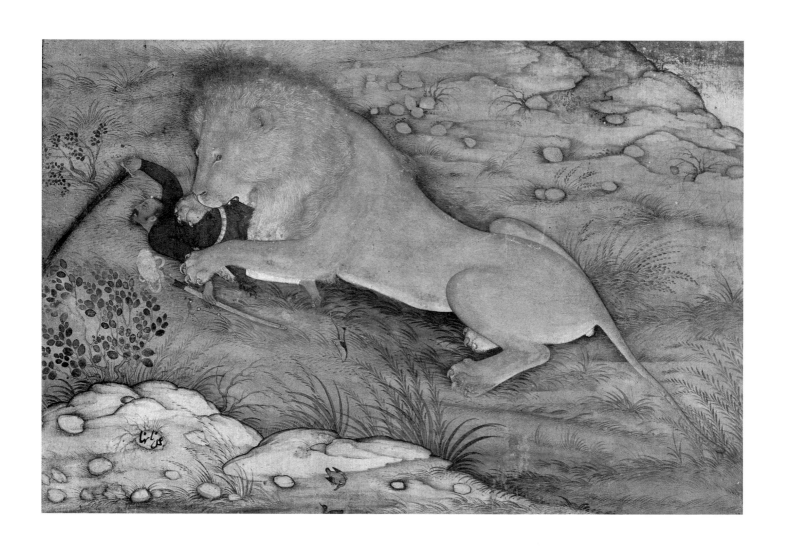

23 *Lion Attacking a Man*

MUGHAL SCHOOL, C. 1613

NĀNHĀ

OPAQUE WATERCOLOR WITH GOLD AND SILVER OR TIN ON SILK

9¾ x 14⅝″ (24.8 x 37.1 cm)

FREE LIBRARY OF PHILADELPHIA. RARE BOOK DEPARTMENT,

JOHN FREDERICK LEWIS COLLECTION

24 *Kalij Pheasant*
MUGHAL SCHOOL, C. 1620
TRANSPARENT AND OPAQUE WATERCOLOR AND MARBLED PAPER WITH
GOLD ON PAPER
$12\frac{7}{8}$ x $8\frac{1}{8}''$ (32.7 x 20.6 cm)
FREE LIBRARY OF PHILADELPHIA. RARE BOOK DEPARTMENT,
JOHN FREDERICK LEWIS COLLECTION

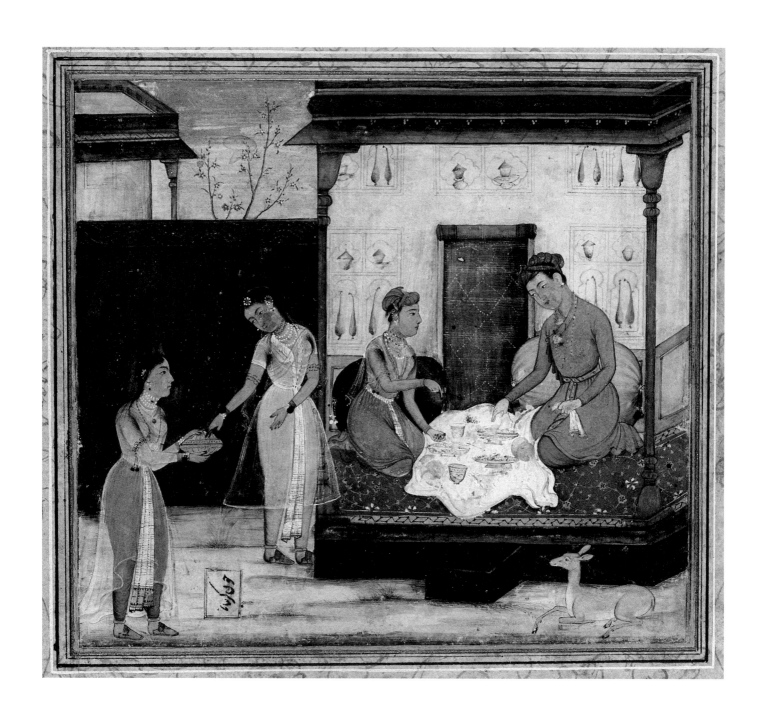

25 *The Repast*
SUB-IMPERIAL MUGHAL SCHOOL, C. 1620
OPAQUE WATERCOLOR WITH GOLD ON PAPER, 7¹⁵⁄₁₆ x 12⁷⁄₁₆″ (20.2 x 31.6 cm)
CITY OF PHILADELPHIA. ON PERMANENT LOAN TO
THE PHILADELPHIA MUSEUM OF ART

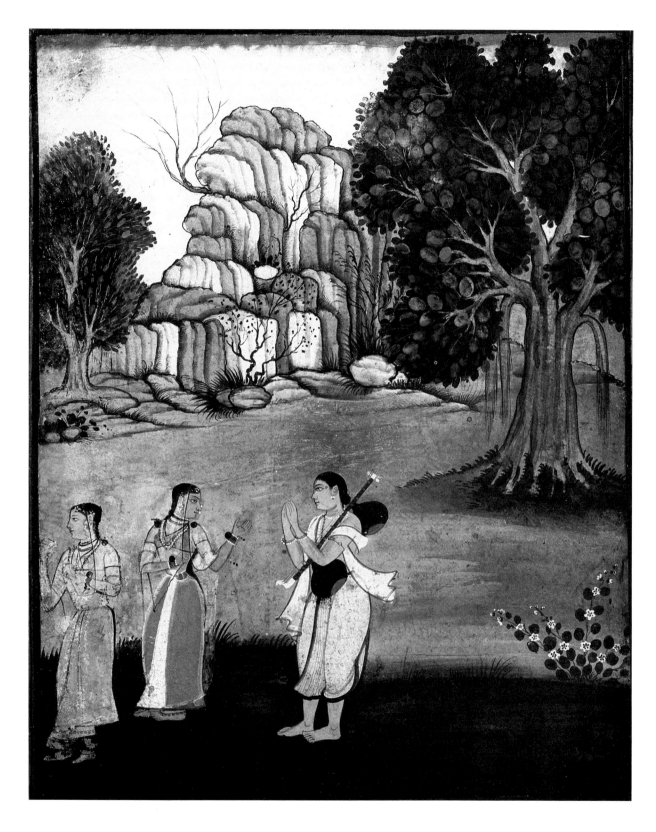

26 *Mādhava Bids Farewell to Kāmakandalā*

SUB-IMPERIAL MUGHAL SCHOOL, c. 1620
OPAQUE WATERCOLOR ON PAPER, 9¾ x 7⅝″ (24.8 x 19.4 cm)
COLLECTION OF DR. ALVIN O. BELLAK

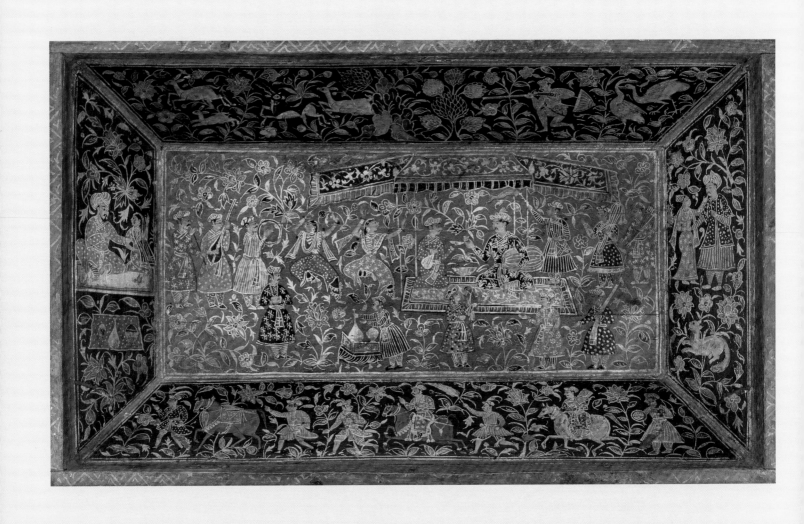

INSIDE OF CASKET LID: SCENES OF FEASTING, DANCING,
MUSIC MAKING, HUNTING, AND OTHER TRADITIONAL THEMES

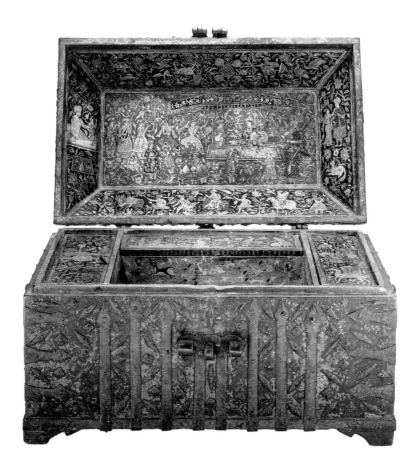

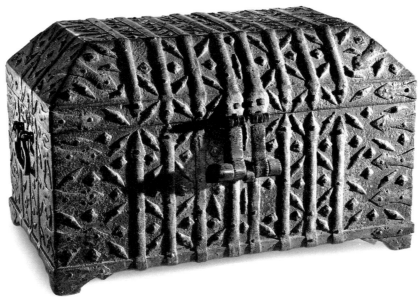

27 Casket

MUGHAL SCHOOL, SIND, 1600–1650
WOOD AND METAL; INTERIOR DECORATED WITH PAINT AND GOLD LEAF
OR FOIL, POSSIBLY OVER GESSO, 10¾ x 18½ x 11¼″ (27.3 x 47 x 28.6 cm)
COLLECTION OF MRS. HARVEY Z. YELLIN, FROM THE SAMUEL YELLIN
COLLECTION

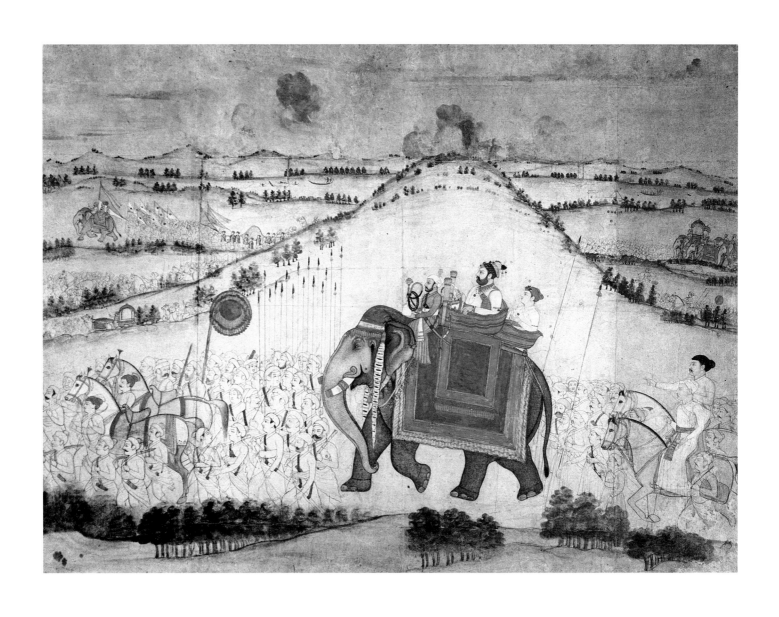

28 *Emperor Muhammad Shah, Mounted on an Elephant, Rides to Battle*
MUGHAL SCHOOL, c. 1740
OPAQUE WATERCOLOR WITH GOLD ON PAPER, 13 x 18⅛″ (33 x 46 cm)
PRIVATE COLLECTION

PAINTING

IN THE

DECCAN

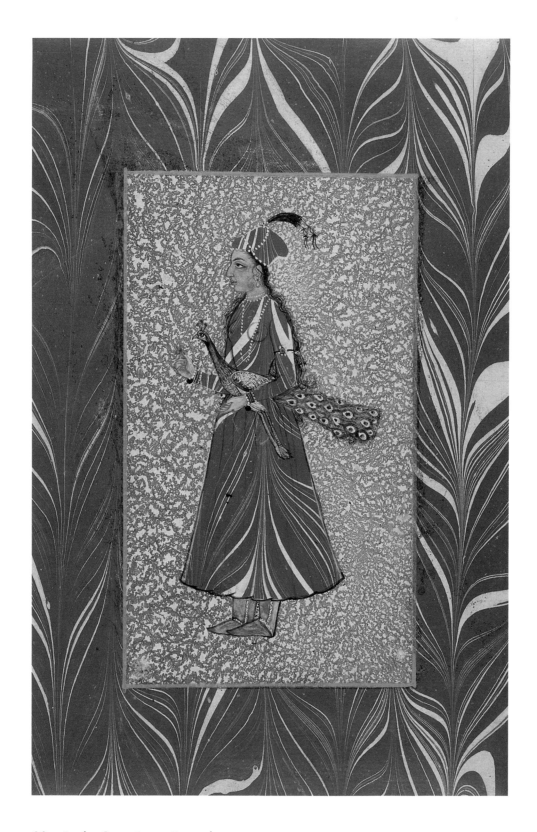

29 *Lady Carrying a Peacock*
BIJAPUR SCHOOL, C. 1660
OPAQUE WATERCOLOR AND MARBLED PAPER ON PAPER
8 x 5¼" (20.3 x 13.3 cm)
FREE LIBRARY OF PHILADELPHIA. RARE BOOK DEPARTMENT,
JOHN FREDERICK LEWIS COLLECTION

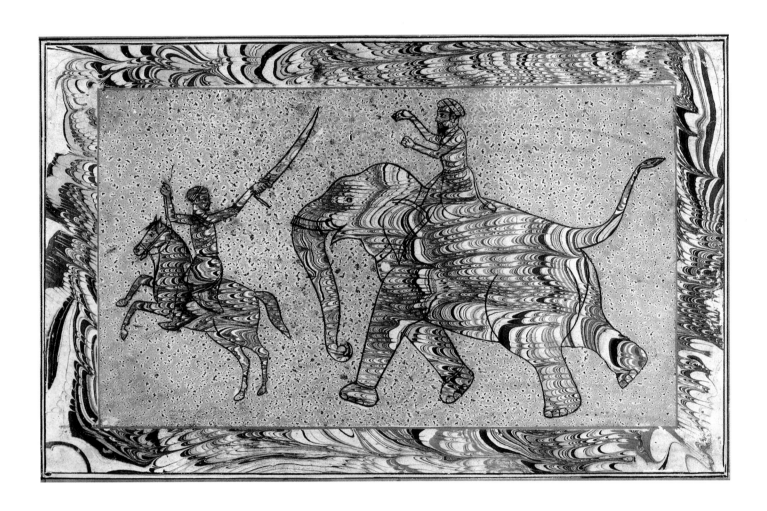

30 Elephant Rider and Horseman
BIJAPUR SCHOOL, 1650–1700
OPAQUE WATERCOLOR AND MARBLED PAPER ON PAPER, 7⅛ x 10¹⁵⁄₁₆″ (18.1 x 27.8 cm)
FREE LIBRARY OF PHILADELPHIA. RARE BOOK DEPARTMENT,
JOHN FREDERICK LEWIS COLLECTION

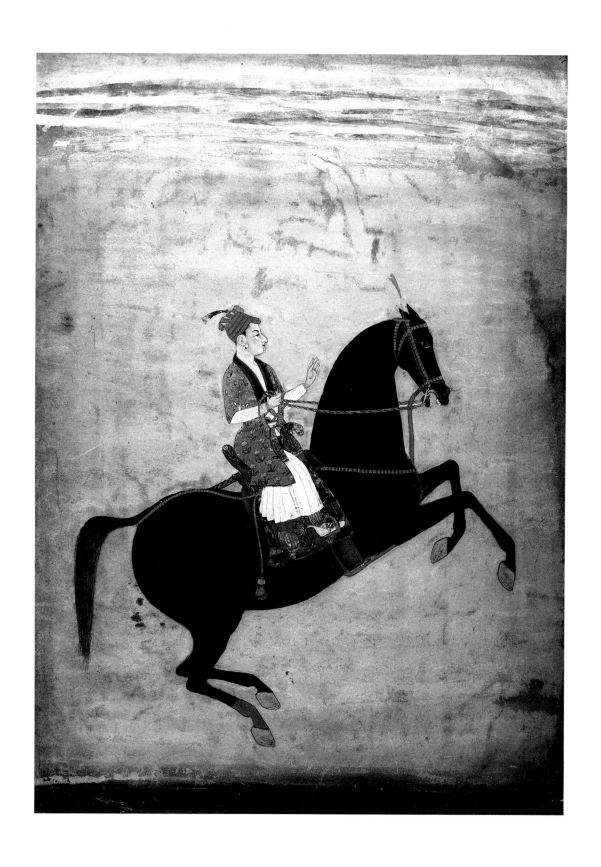

31　Equestrian Portrait of a Young Prince

DECCAN SCHOOL, 1675–1700
OPAQUE WATERCOLOR ON PAPER, 11 X 7¾″ (27.9 X 19.7 cm)
COLLECTION OF DR. ALVIN O. BELLAK

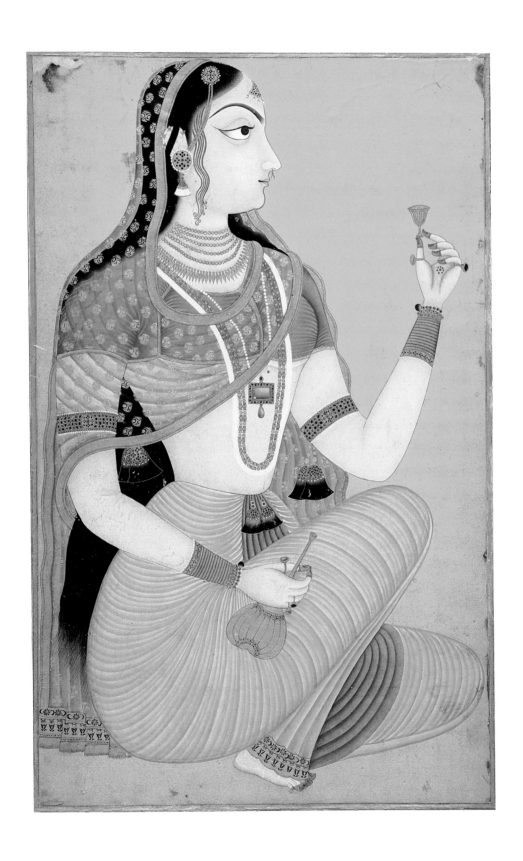

32 A Lady of the Court

GOLCONDA SCHOOL, c. 1700
OPAQUE WATERCOLOR WITH GOLD ON PAPER, 15⅛ x 9¾″ (38.4 x 24.8 cm)
COLLECTION OF DR. ALVIN O. BELLAK

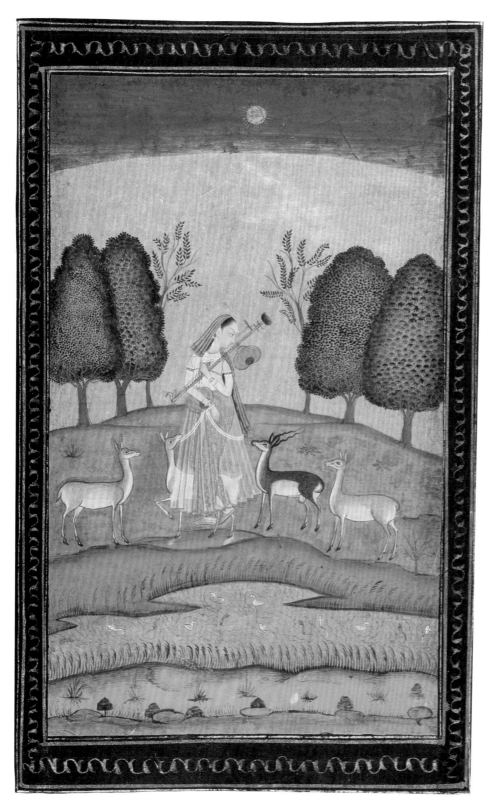

33 Toḍī Rāgiṇī

DECCAN SCHOOL, 1700–1750
OPAQUE WATERCOLOR WITH GOLD AND SILVER OR TIN ON PAPER
17 x 9⁹/₁₆″ (43.2 x 24.3 cm)
PHILADELPHIA MUSEUM OF ART. PURCHASED:
KATHARINE LEVIN FARRELL FUND. 1977-12-1

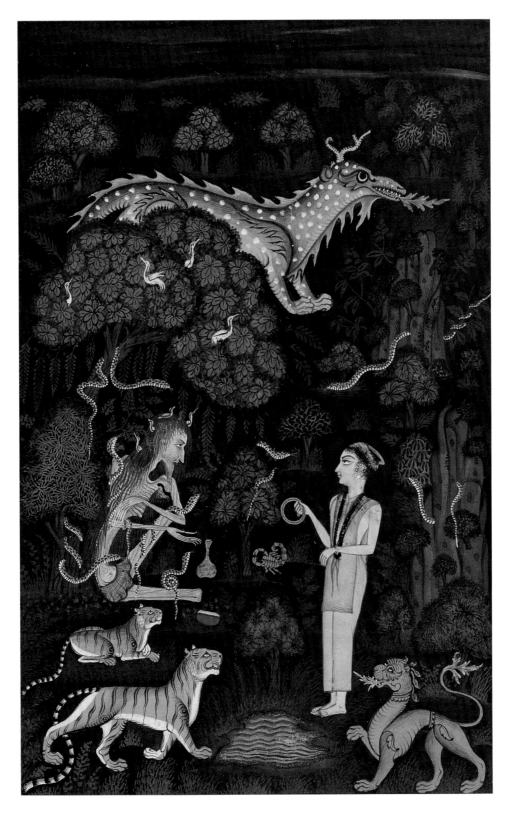

34 Prince Manohar Receives a Magic Ring from a Wizard

DECCAN SCHOOL, 1743
ILLUSTRATION FROM THE *Gulshan-i-Ishq*
OPAQUE WATERCOLOR WITH GOLD ON PAPER, 14 x 10″ (35.6 x 25.4 cm)
PHILADELPHIA MUSEUM OF ART. GIFT OF MRS. PHILIP S. COLLINS IN
MEMORY OF HER HUSBAND. 45-65-22

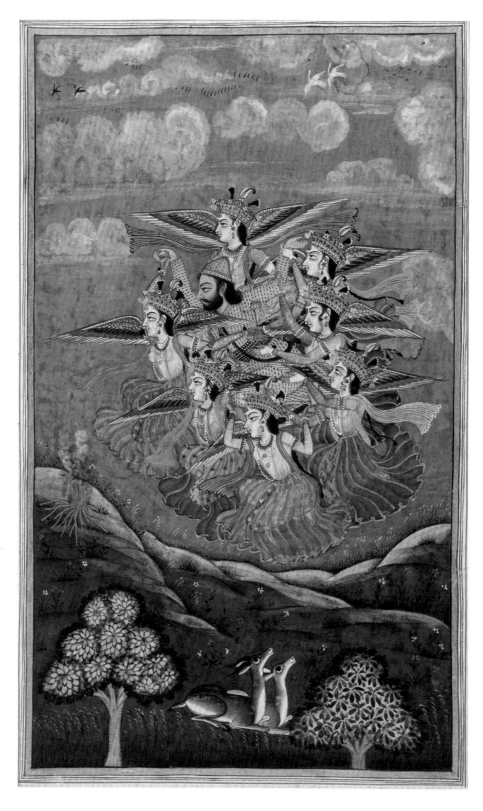

35 *Flying Fairies Carry Raja Bikram toward Kanakgir*
DECCAN SCHOOL, 1743
ILLUSTRATION FROM THE *Gulshan-i-Ishq*
OPAQUE WATERCOLOR WITH GOLD ON PAPER, 14 x 10″ (35.6 x 25.4 cm)
PHILADELPHIA MUSEUM OF ART. GIFT OF MRS. PHILIP S. COLLINS IN
MEMORY OF HER HUSBAND. 45-65-22

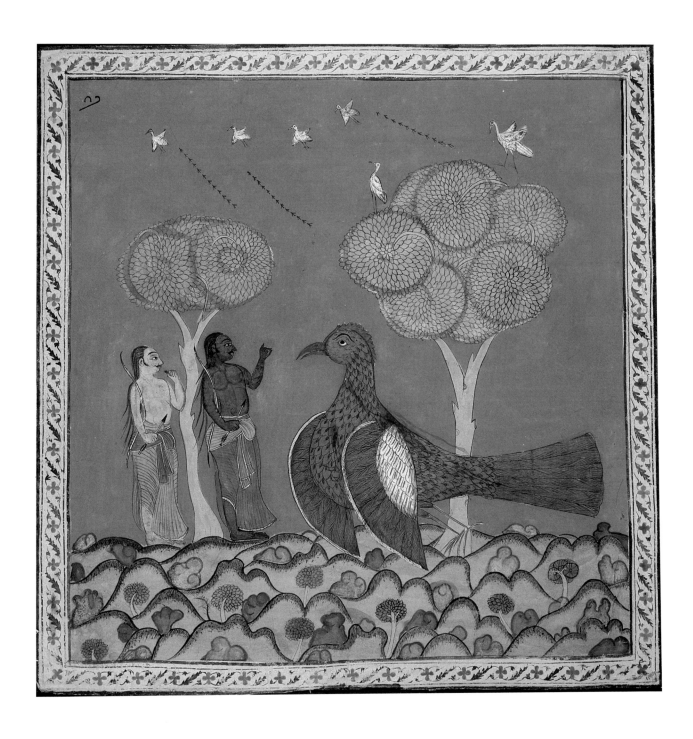

36 *Dying Jaṭāyus Tells Rāma and Lakṣmaṇa about Sītā*

RAJAMUNDRY SCHOOL, C. 1750
OPAQUE WATERCOLOR ON PAPER
13¾ x 13⅞" (34.9 x 35.2 cm)
PHILADELPHIA MUSEUM OF ART. PURCHASED:
KATHARINE LEVIN FARRELL FUND. 75-149-1

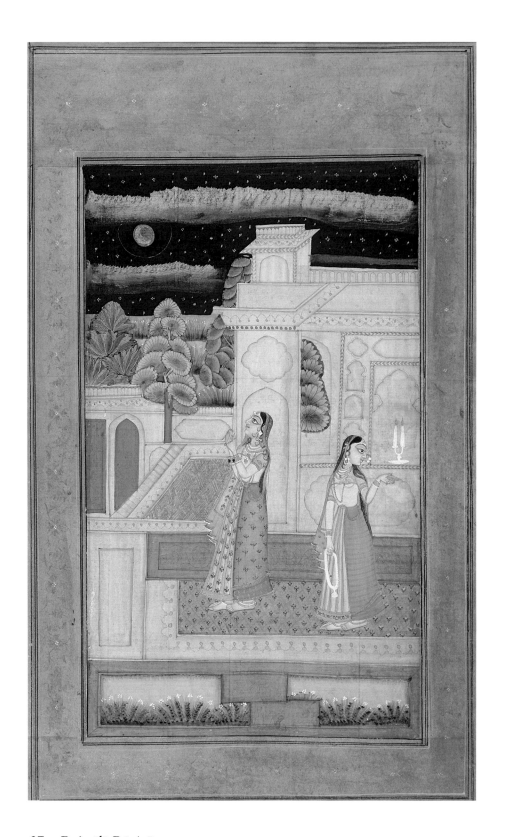

37 *Baṅgālī Rāgiṇī*
DECCAN SCHOOL, 1740–60
OPAQUE WATERCOLOR WITH GOLD AND SILVER OR TIN ON PAPER
11⅞ x 7³⁄₁₆″ (30.2 x 18.2 cm)
PRIVATE COLLECTION

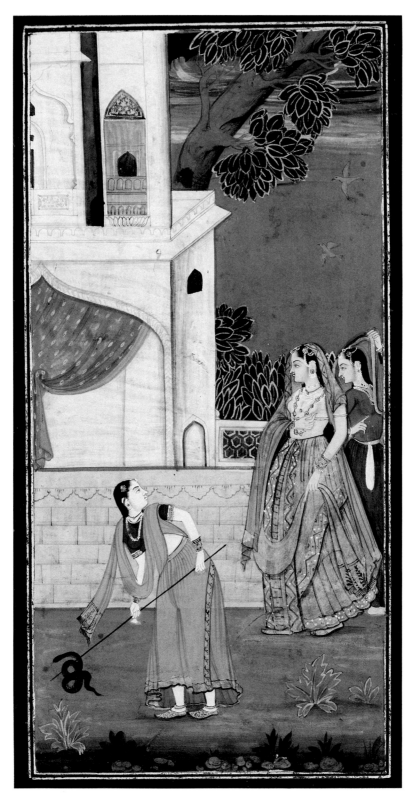

38 *Lady Watching Her Maid Kill a Snake*
BIJAPUR SCHOOL, 1775–1800
OPAQUE WATERCOLOR WITH GOLD ON PAPER
12 x 6¹³⁄₁₆″ (30.5 x 17.3 cm)
PHILADELPHIA MUSEUM OF ART. PURCHASED:
KATHARINE LEVIN FARRELL FUND. 72-160-2

RAJPUT PAINTING

IN THE PLAINS

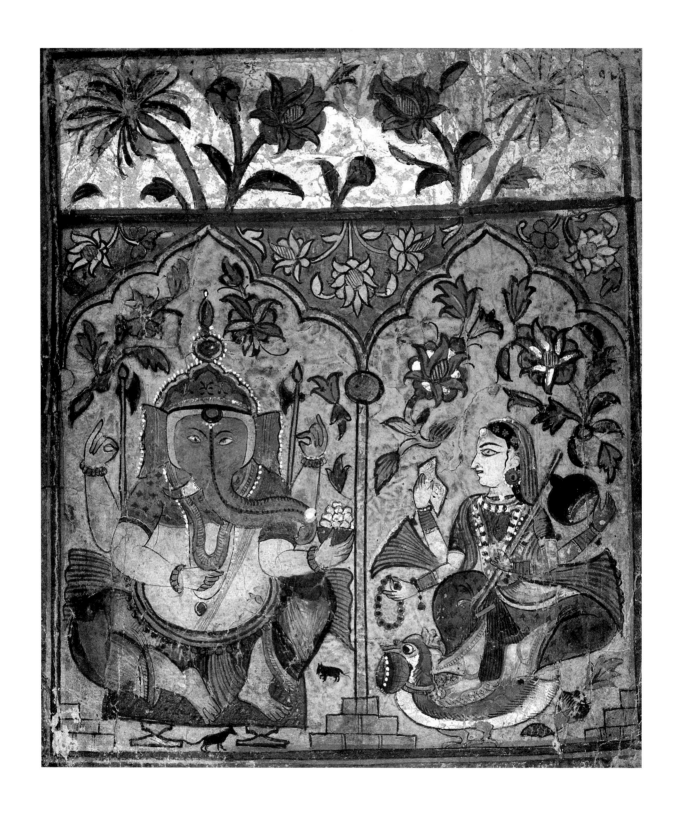

39 Gaṇeśa and Sarasvatī

GUJARAT SCHOOL, 1625–50
ILLUSTRATION FROM THE *Bhāgavata Purāṇa*
OPAQUE WATERCOLOR WITH GOLD AND SILVER ON PAPER, 10³⁄₁₆ x 8³⁄₄″ (25.9 x 22.2 cm)
PRIVATE COLLECTION

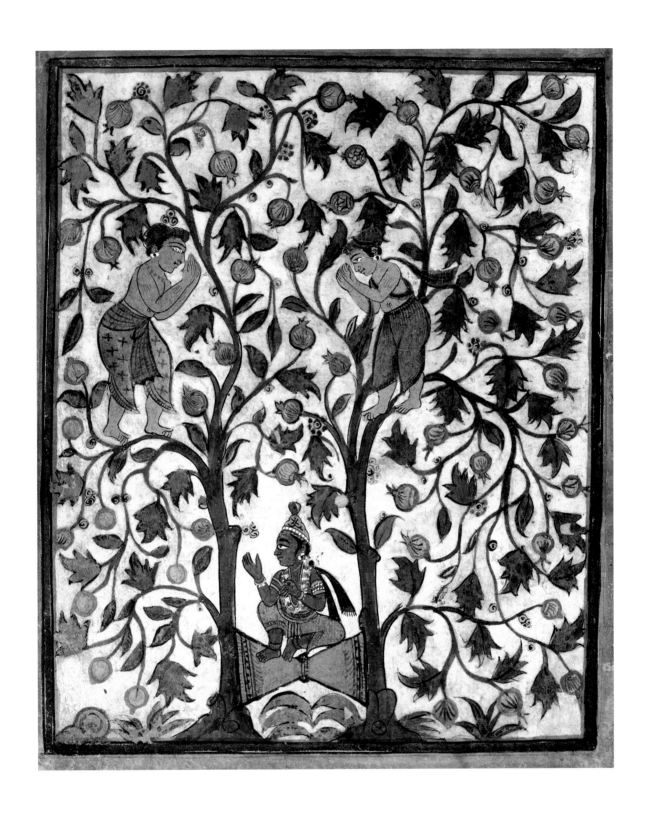

40 *Kṛṣṇa Splitting the Yamalārjuna Tree*

GUJARAT SCHOOL, 1625–50
ILLUSTRATION FROM THE *Bhāgavata Purāṇa*
OPAQUE WATERCOLOR WITH GOLD ON PAPER, 10¼ x 9″ (26 x 22.9 cm)
PRIVATE COLLECTION

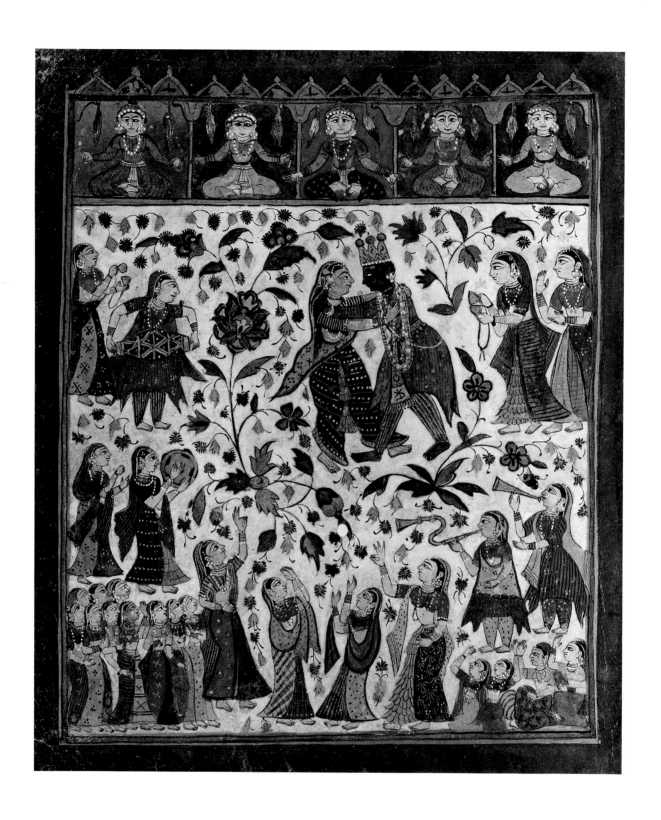

41 *Kṛṣṇa Dancing with a Single Cowherdess*
GUJARAT SCHOOL, 1625–50
ILLUSTRATION FROM THE *Bhāgavata Purāṇa*
OPAQUE WATERCOLOR WITH GOLD AND SILVER ON PAPER, 10⅜ x 8¹⁵⁄₁₆" (26.4 x 22.7 cm)
PHILADELPHIA MUSEUM OF ART. GIFT OF MR. AND MRS. LESSING J. ROSENWALD
59-93-61

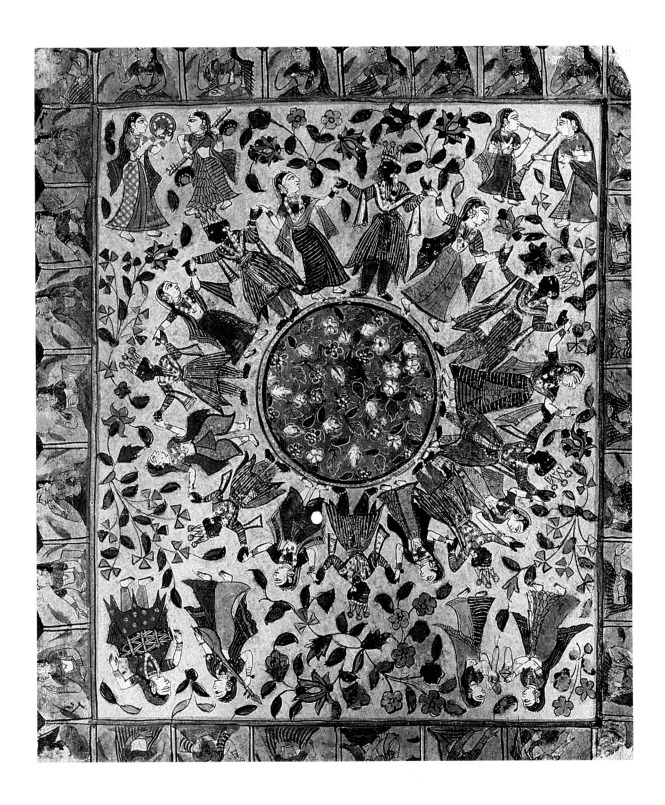

42 *Kṛṣṇa Dances with the Cowherdesses (Rāsamaṇḍala)*

GUJARAT SCHOOL, 1625–50
ILLUSTRATION FROM THE *Bhāgavata Purāṇa*
OPAQUE WATERCOLOR WITH GOLD ON PAPER, 10⅜ x 9″ (26.4 x 22.9 cm)
PHILADELPHIA MUSEUM OF ART. GIFT OF MR. AND MRS. LESSING J. ROSENWALD
59-93-60

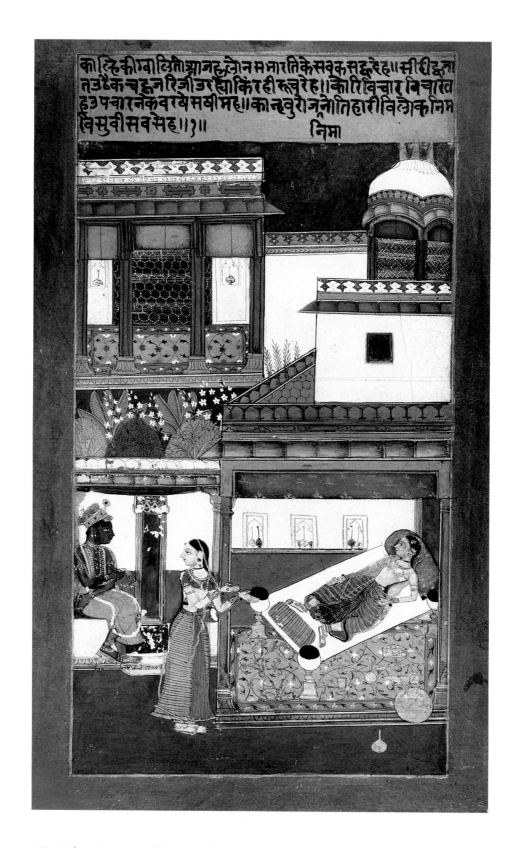

43 *The Account of the Confidante*

BUNDI SCHOOL, RAJASTHAN, c. 1660
ILLUSTRATION FROM THE *Rasikapriyā*
OPAQUE WATERCOLOR WITH GOLD ON PAPER, 11¾ x 7¾" (29.8 x 19.7 cm)
PRIVATE COLLECTION

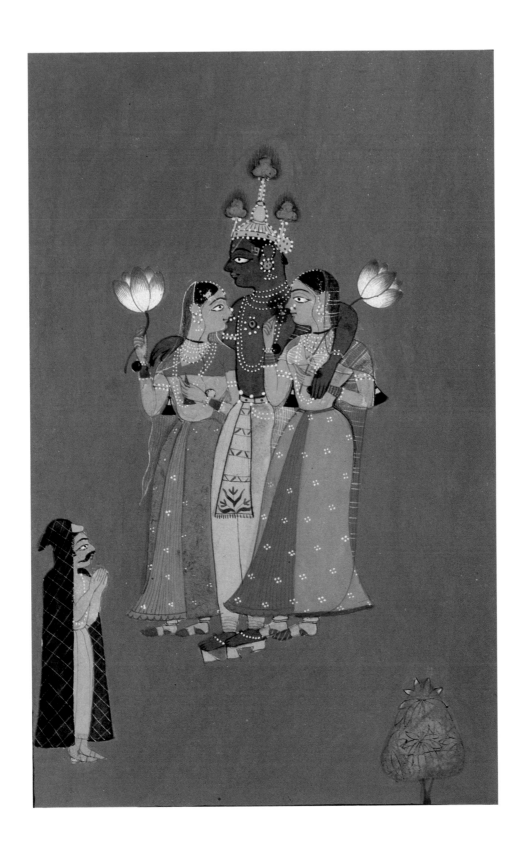

44 *Kṛṣṇa and Two Cowherdesses Beheld by a Herdsman*
BUNDI SCHOOL, RAJASTHAN, C. 1675
OPAQUE WATERCOLOR ON PAPER, 7 x 4⅝″ (17.8 x 11.7 cm)
PRIVATE COLLECTION

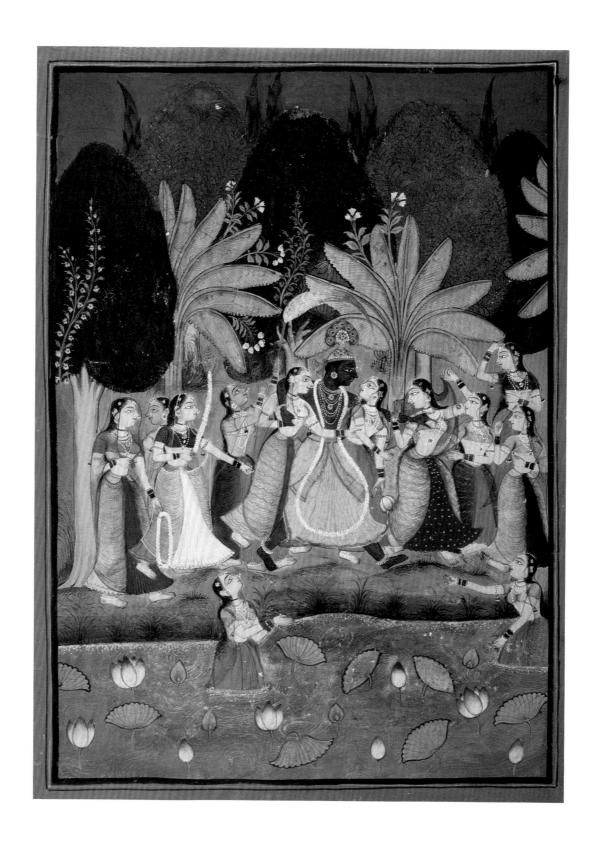

45 *Kṛṣṇa Sports with the Cowherdesses*
BUNDI SCHOOL, RAJASTHAN, C. 1680
OPAQUE WATERCOLOR WITH GOLD ON PAPER, 12⅜ x 9⁹⁄₁₆″ (31.4 x 23 cm)
PHILADELPHIA MUSEUM OF ART. PURCHASED: KATHARINE LEVIN FARRELL FUND
AND MARGARETTA S. HINCHMAN FUND. 1981-92-1

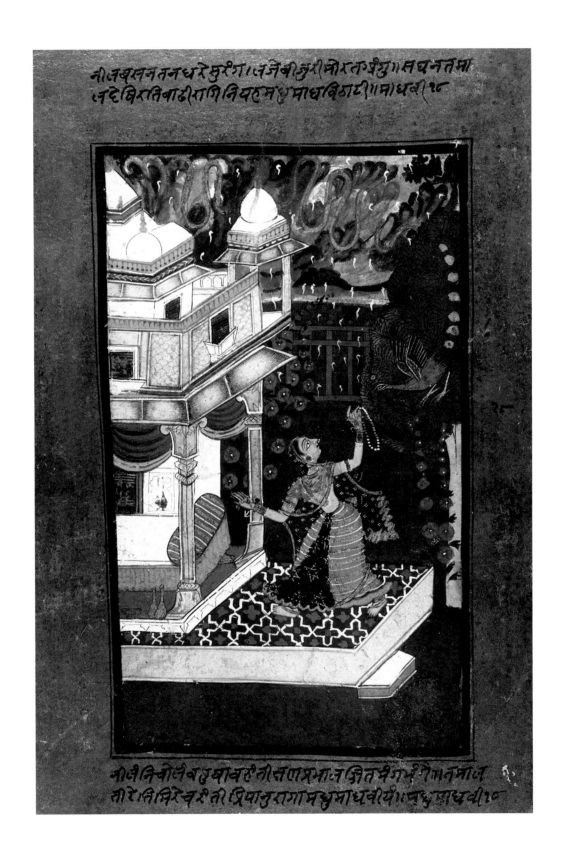

46　*Madhumādhavī Rāgiṇī*
BUNDI SCHOOL, RAJASTHAN, 1660–80
OPAQUE WATERCOLOR WITH GOLD ON PAPER, 11⅛ x 7⅞″ (28.3 x 20 cm)
COLLECTION OF DR. ALVIN O. BELLAK

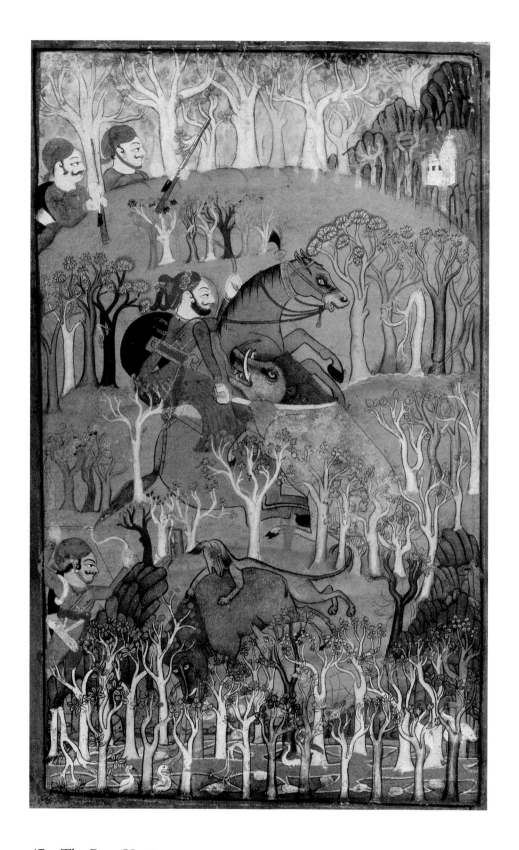

47 *The Boar Hunt*

BUNDI SCHOOL, RAJASTHAN, 1785–1800
OPAQUE WATERCOLOR WITH GOLD ON PAPER, 14 x 9½″ (35.6 x 24.1 cm)
PHILADELPHIA MUSEUM OF ART. PURCHASED: GEORGE W. B. TAYLOR FUND
1977-10-1

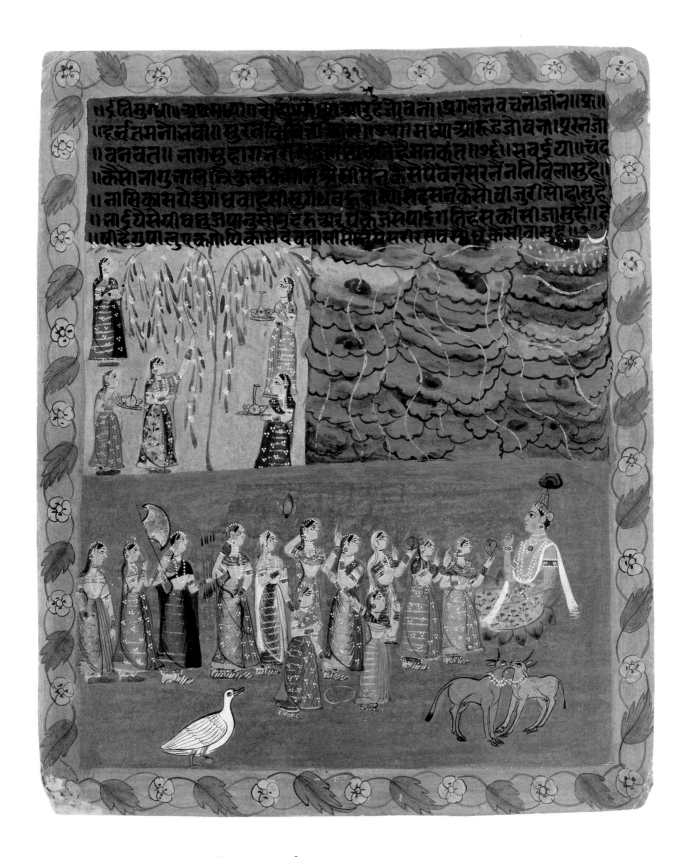

48　*Kṛṣṇa Surveys the Madhyā Types of Heroines*
UNIARA SCHOOL, RAJASTHAN, C. 1760
ILLUSTRATION FROM THE *Rasikapriyā*
OPAQUE WATERCOLOR WITH GOLD ON PAPER
11 x 8¹⁵⁄₁₆″ (27.9 x 22.7 cm)
PHILADELPHIA MUSEUM OF ART. PURCHASED: JOHN T. MORRIS FUND. 69-262-3

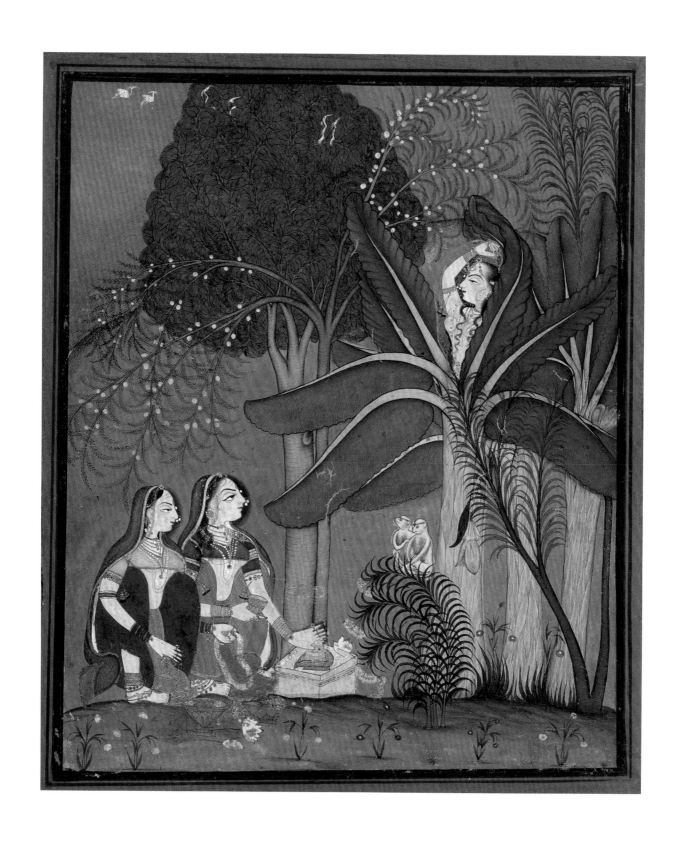

49 *Apparition of a Wish-Granting Tree Spirit during Worship of the Liṅga*
KOTAH SCHOOL, RAJASTHAN, C. 1700
OPAQUE WATERCOLOR ON PAPER, 10½ x 8⅝" (26.7 x 21.9 cm)
PRIVATE COLLECTION

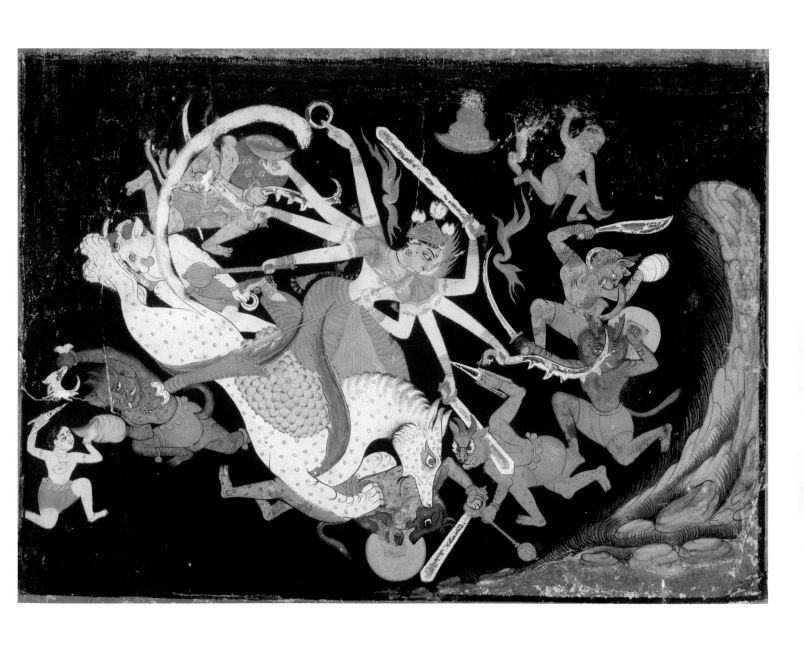

50 *The Great Goddess Durgā Slaying Demons*
KOTAH SCHOOL, RAJASTHAN, c. 1740
OPAQUE WATERCOLOR WITH GOLD ON PAPER, 12⅜ x 17¼″ (31.4 x 43.8 cm)
PRIVATE COLLECTION

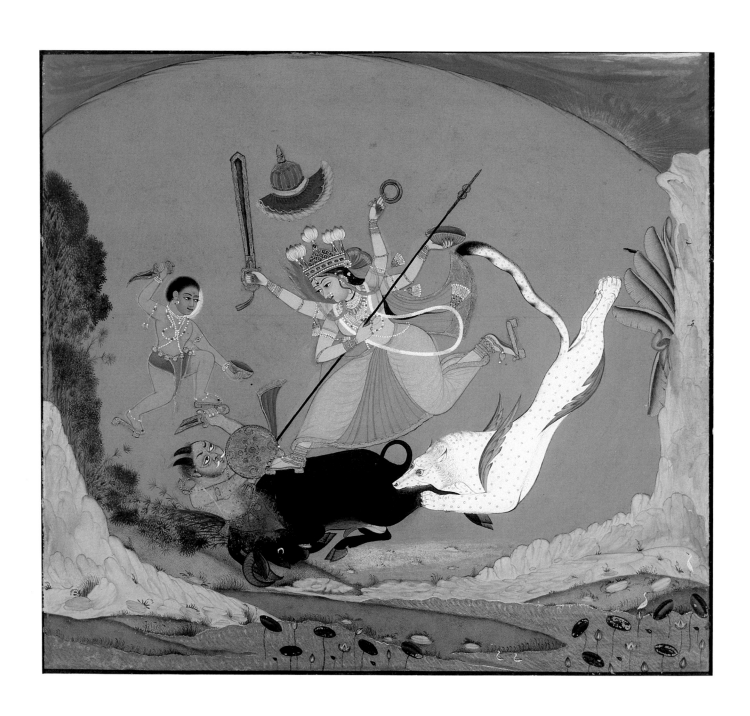

51 *The Great Goddess Durgā Slaying the Buffalo Demon*

KOTAH SCHOOL, RAJASTHAN, c. 1750
OPAQUE WATERCOLOR WITH GOLD AND SILVER OR TIN ON PAPER
10¹¹⁄₁₆ x 12³⁄₈″ (27.1 x 31.4 cm)
PRIVATE COLLECTION

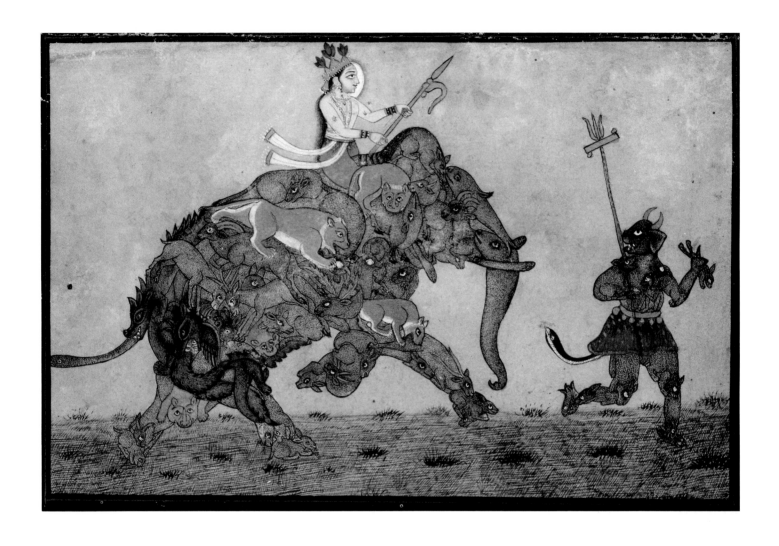

52 *Composite Elephant Carrying a Divine Rider Preceded by a Demon*
KOTAH SCHOOL, RAJASTHAN, c. 1760
OPAQUE WATERCOLOR WITH GOLD ON PAPER, 7¹⁵⁄₁₆ x 11⁵⁄₈″ (20.2 x 29.5 cm)
PHILADELPHIA MUSEUM OF ART. PURCHASED: EDGAR VIGUERS SEELER FUND
1976-15-1

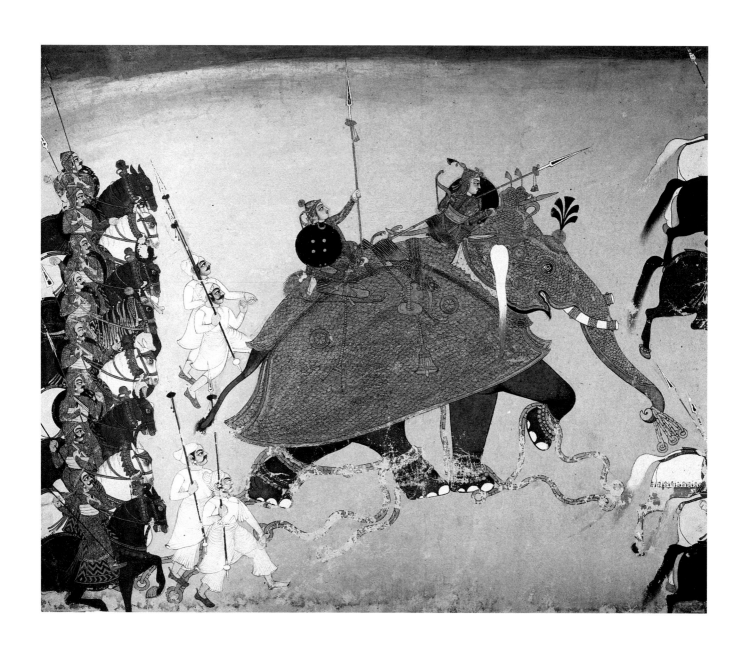

53 *Maharao Durjansāl of Kotah on His Elephant Raṇasaṅgār*

KOTAH SCHOOL, RAJASTHAN, 1750–70
OPAQUE WATERCOLOR WITH GOLD AND SILVER ON PAPER, 15¾ x 18⅞″ (40 x 47.9 cm)
PRIVATE COLLECTION

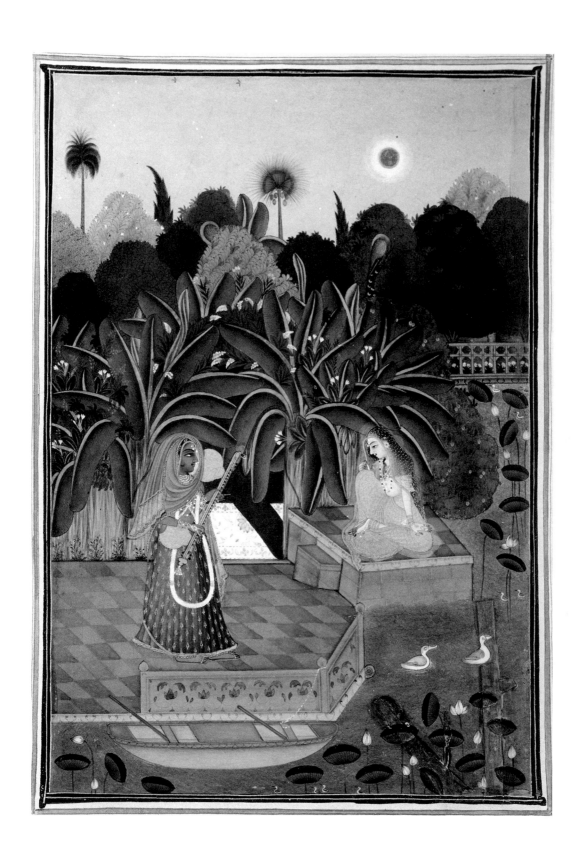

54 *Kṛṣṇa Disguised as a Woman Musician Approaches Rādhā*

KOTAH SCHOOL, RAJASTHAN, C. 1790
OPAQUE WATERCOLOR WITH GOLD ON PAPER, 11¾ x 8⁵⁄₁₆″ (29.8 x 21.1 cm)
PRIVATE COLLECTION

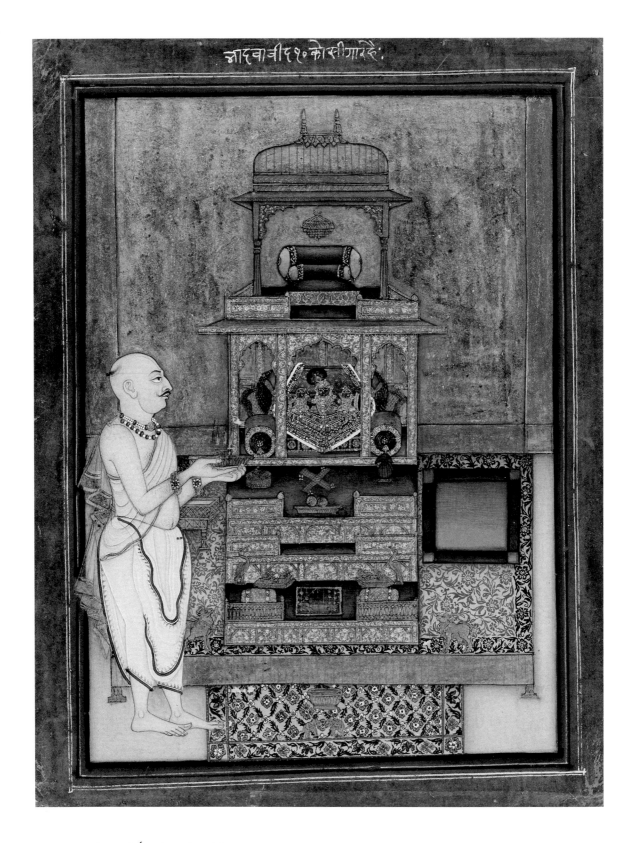

्ञादवाजीद९०कोत्तीगारदे:

55 *Worship of Śrī Viṭṭalnāthjī*

KOTAH SCHOOL, RAJASTHAN, 1830–40
OPAQUE WATERCOLOR WITH GOLD AND SILVER OR TIN ON PAPER, 10¼ x 7¹¹⁄₁₆″ (26 x 19.5 cm)
PHILADELPHIA MUSEUM OF ART. GIFT OF THE FRIENDS OF THE MUSEUM. 68-12-4

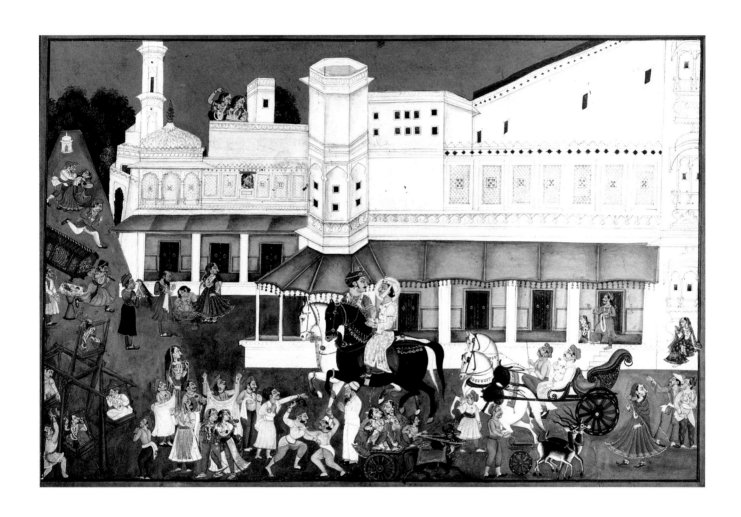

56 *A Festive Day*

KOTAH SCHOOL, RAJASTHAN, 1825–50
OPAQUE WATERCOLOR WITH GOLD ON PAPER, 14⅞ x 21½″ (37.8 x 54.6 cm)
PHILADELPHIA MUSEUM OF ART. PURCHASED: JOHN T. MORRIS FUND
1978-127-1

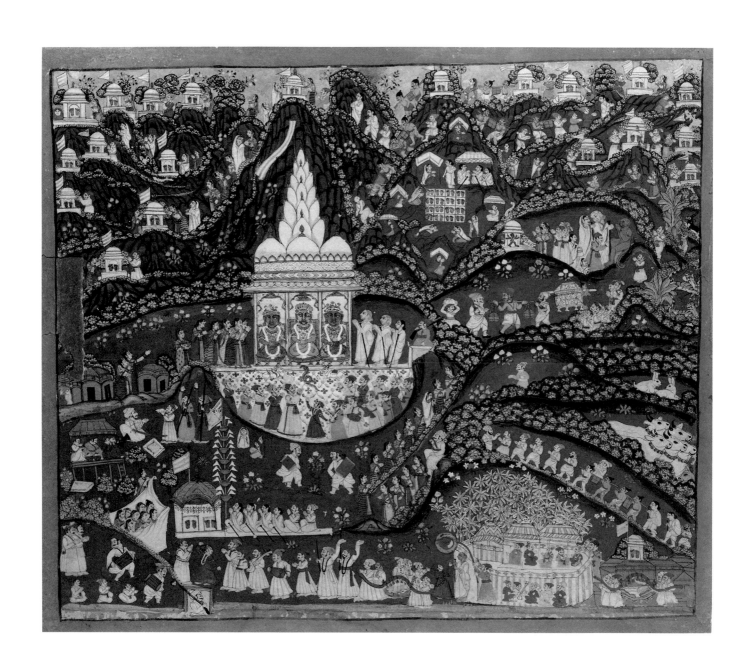

57 *Pilgrimage to a Jain Shrine of Three Tīrthaṅkaras*

KOTAH SCHOOL, RAJASTHAN, c. 1850
OPAQUE WATERCOLOR WITH GOLD ON PAPER, 11½ x 13⅞″ (29.2 x 35.2 cm)
PHILADELPHIA MUSEUM OF ART. PURCHASED: GERTRUDE SCHEMM BINDER FUND,
MARIE JOSEPHINE ROZET FUND, AND EDGAR VIGUERS SEELER FUND. 72-258-3

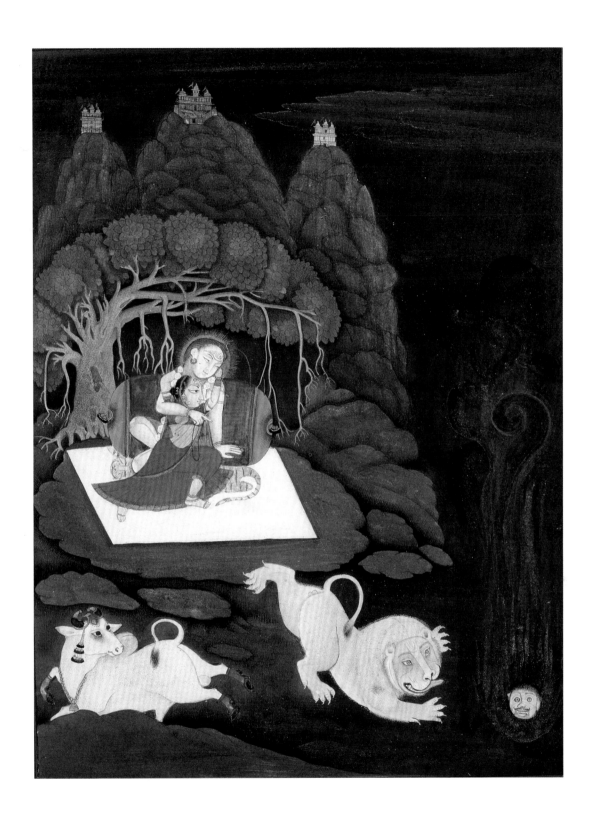

58　*The Birth of Kārttikeya*

DEVGARH SCHOOL, RAJASTHAN, 1800–1825
OPAQUE WATERCOLOR WITH GOLD ON PAPER, 11 x 8½″ (27.9 x 21.6 cm)
PRIVATE COLLECTION

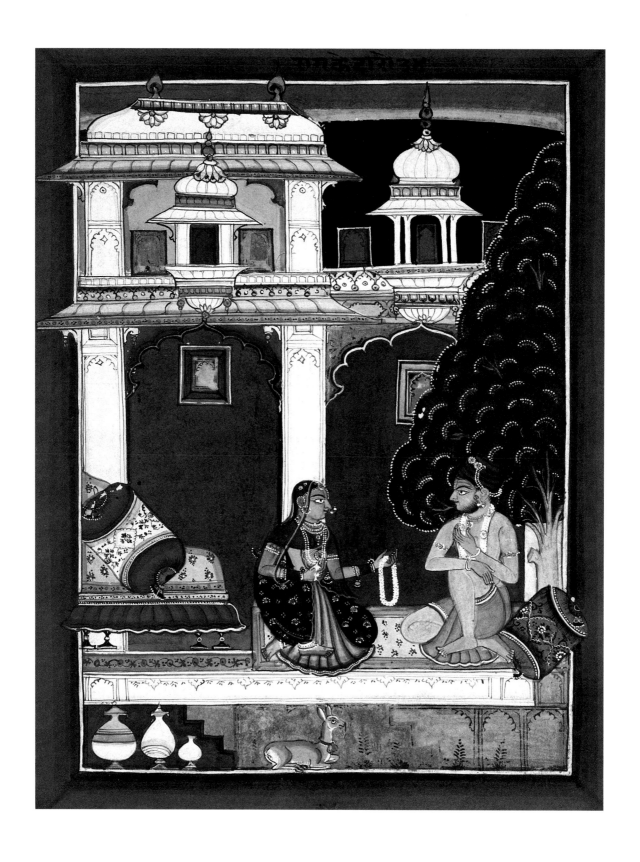

59 *Kedārā Rāga*

SIROHI SCHOOL, RAJASTHAN, C. 1680
OPAQUE WATERCOLOR ON PAPER, 9¼ x 6¹⁵⁄₁₆″ (23.5 x 17.6 cm)
COLLECTION OF DR. ALVIN O. BELLAK

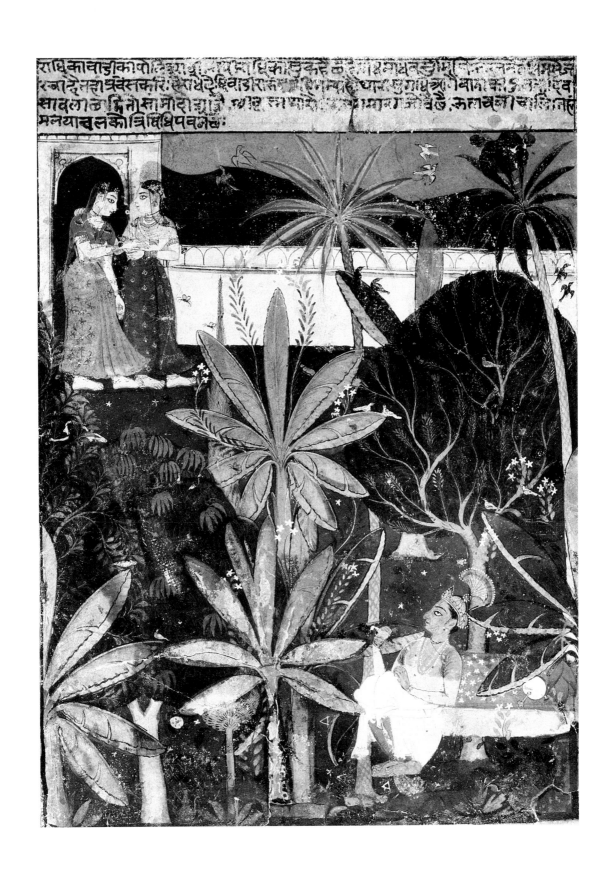

राधिकाचाड़िकायो॰ ... (Devanagari text)

60 *Rādhā Enters a Walled Garden, Where Kṛṣṇa Awaits Her*

MEWAR SCHOOL, RAJASTHAN, C. 1629
OPAQUE WATERCOLOR WITH GOLD ON PAPER, 9¾ x 7¼″ (24.8 x 18.4 cm)
PRIVATE COLLECTION

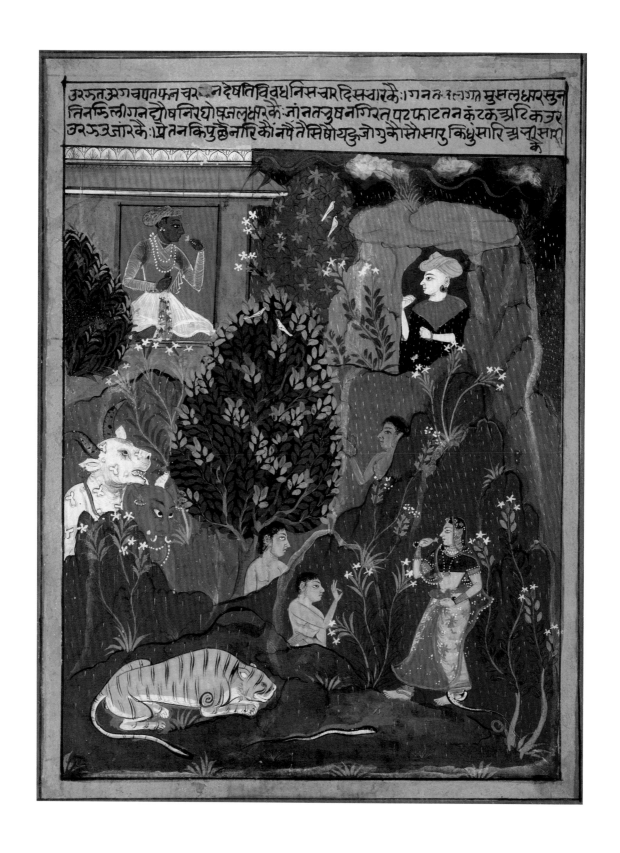

61 *The Woman Who Goes to Meet Her Lover (Abhisārikā Nāyikā)*
MEWAR SCHOOL, RAJASTHAN, C. 1630
OPAQUE WATERCOLOR WITH GOLD ON PAPER, 10¹⁄₁₆ x 8³⁄₁₆″ (25.6 x 20.8 cm)
COLLECTION OF DR. ALVIN O. BELLAK

वरसाठौ रही पवननेषे बैठे पछ्छीयोलन जमनोंकिनारें बेतन में स्यारीजमकढी

62 *The Rainy Season*

MEWAR SCHOOL(?), RAJASTHAN, 1625–50
OPAQUE WATERCOLOR ON PAPER, 9³⁄₁₆ x 15¹¹⁄₁₆″ (23.3 x 39.8 cm)
COLLECTION OF DR. ALVIN O. BELLAK

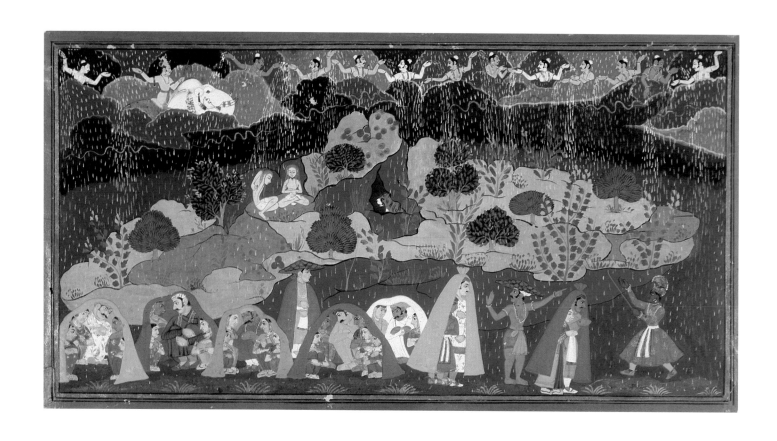

63 Kṛṣṇa Raises Mount Govardhana

MEWAR SCHOOL, RAJASTHAN, C. 1700
OPAQUE WATERCOLOR WITH GOLD AND SILVER OR TIN ON PAPER, 8½ x 16⅜″ (21.6 x 41.6 cm)
PRIVATE COLLECTION

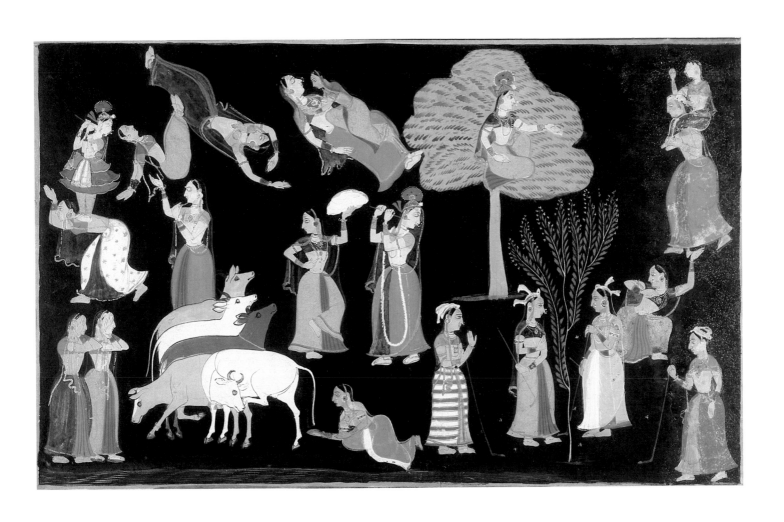

64 *The Madness of the Cowherdesses*

MEWAR SCHOOL, RAJASTHAN, C. 1720
OPAQUE WATERCOLOR WITH GOLD ON PAPER, 10⅛ x 16″ (25.7 x 40.6 cm)
PRIVATE COLLECTION

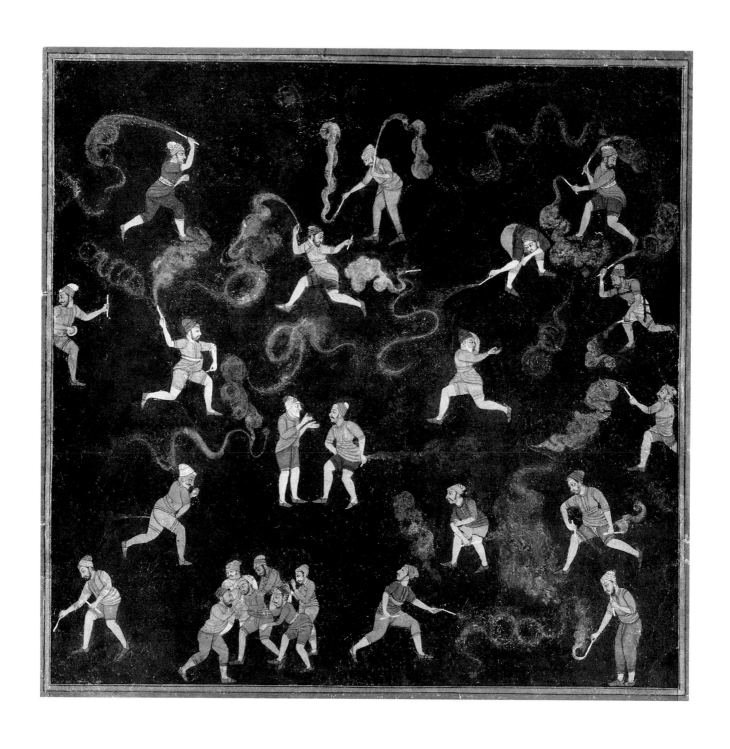

65 Men with Fireworks Celebrate Diwālī, the Festival of Lights
MEWAR SCHOOL, RAJASTHAN, 1730–40
OPAQUE WATERCOLOR WITH GOLD ON PAPER, 9¹³⁄₁₆ x 10″ (24.9 x 25.4 cm)
COLLECTION OF DR. ALVIN O. BELLAK

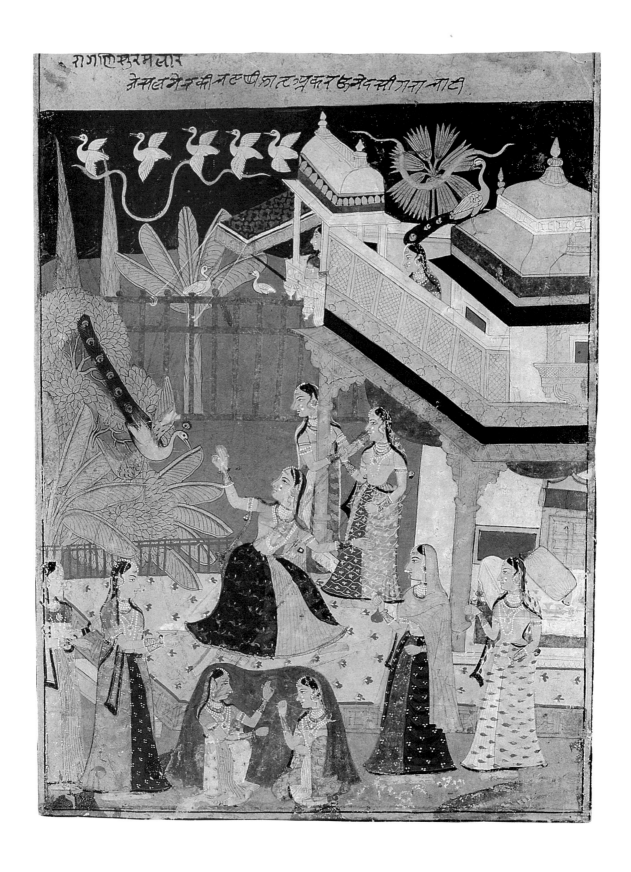

66 *Madhumādhavī Rāgiṇī*

MEWAR SCHOOL, RAJASTHAN, C. 1750
OPAQUE WATERCOLOR WITH GOLD ON PAPER, 13^{15}/$_{16}$ x 10¼" (35.4 x 26 cm)
PRIVATE COLLECTION

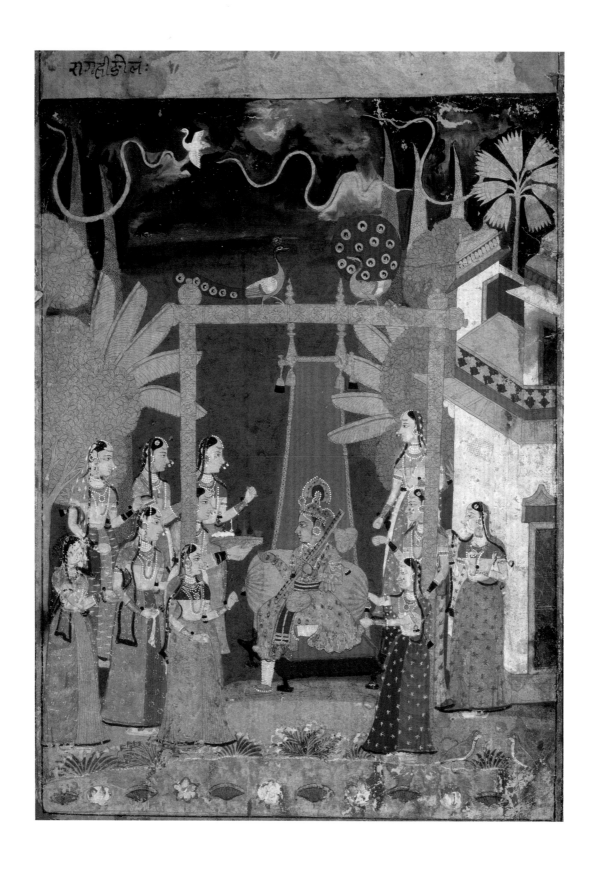

राग हिंडोलं:

67 *Hiṇḍola Rāga*
MEWAR SCHOOL, RAJASTHAN, C. 1750
OPAQUE WATERCOLOR WITH GOLD ON PAPER, 15⁷⁄₁₆ x 10¾″ (39.2 x 27.3 cm)
PRIVATE COLLECTION

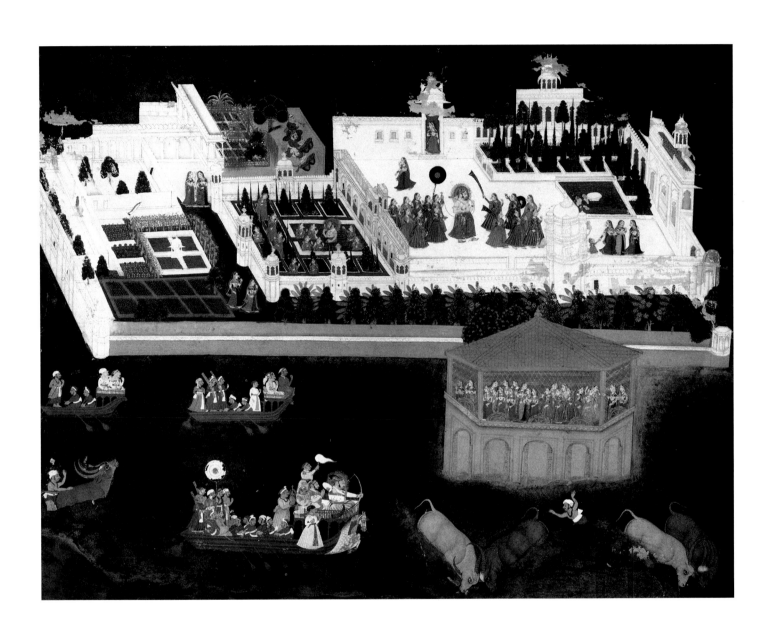

68 Water Festival at Udaipur
MEWAR SCHOOL, RAJASTHAN, C. 1750
OPAQUE WATERCOLOR WITH GOLD AND SILVER LEAF ON PAPER, 18¾ x 23⅝″ (47.6 x 60 cm)
COLLECTION OF MR. AND MRS. WILLIAM P. WOOD

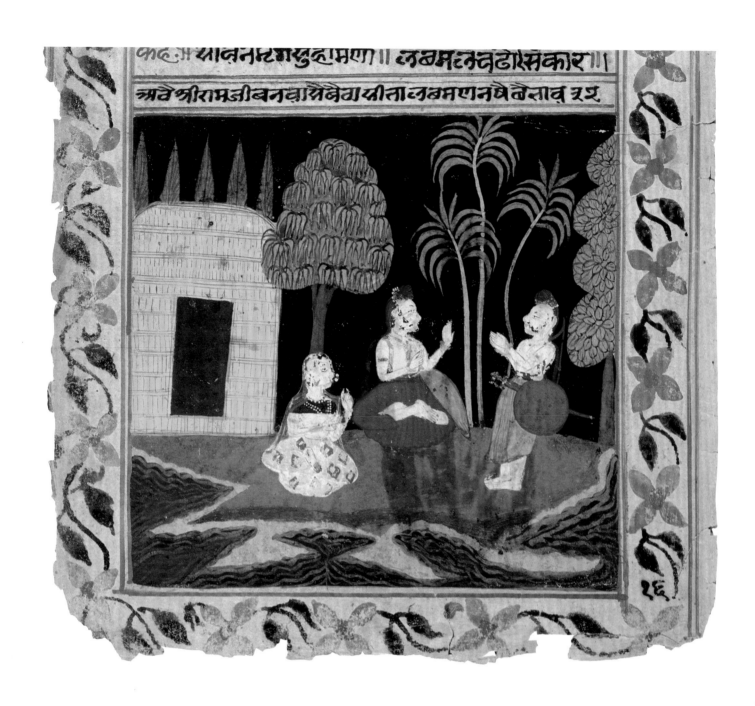

69 Rāma, Lakṣmaṇa, and Sītā in Exile in the Forest

MARWAR SCHOOL, RAJASTHAN, C. 1745
OPAQUE WATERCOLOR WITH GOLD ON PAPER, II x 7¾" (27.9 x 19.7 cm)
PRIVATE COLLECTION

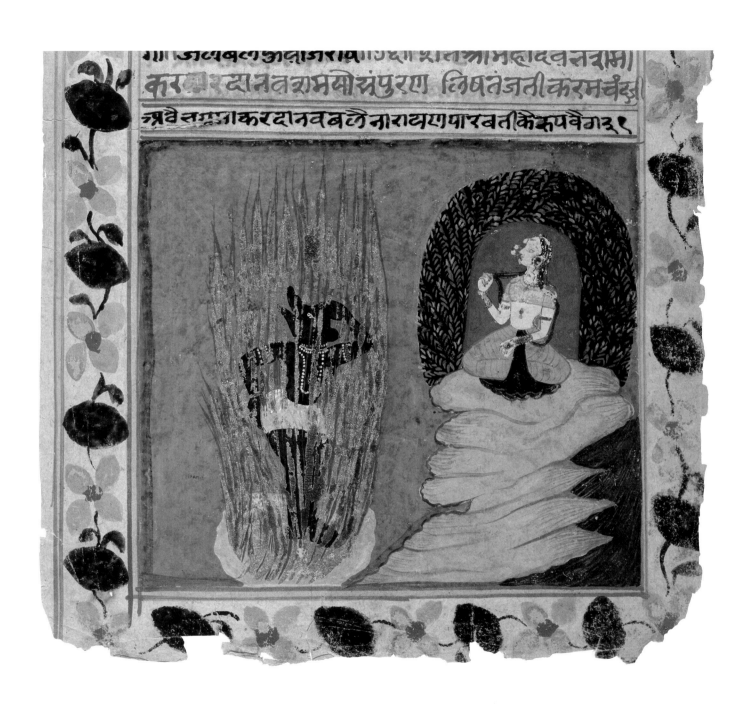

70 *Viṣṇu in the Form of Pārvatī Watches the Burning of the Demon Bhasmāsura*

MARWAR SCHOOL, RAJASTHAN, C. 1745
OPAQUE WATERCOLOR WITH GOLD ON PAPER, II X 7¾″ (27.9 X 19.7 cm)
PRIVATE COLLECTION

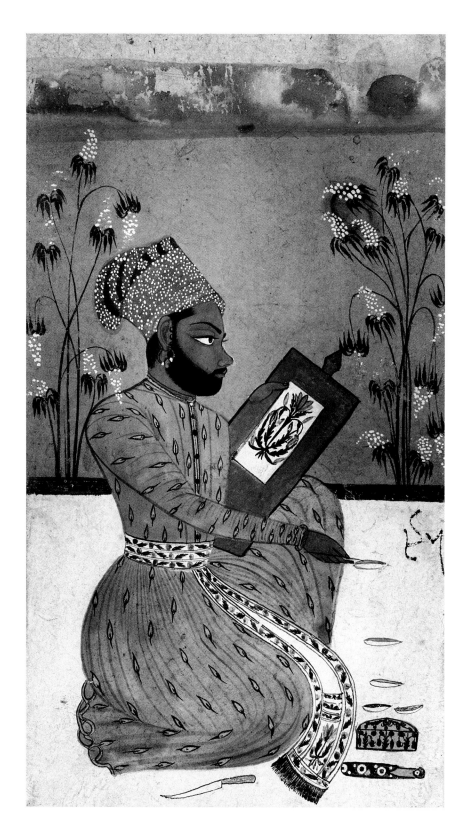

71 *Self-Portrait of a Painter at Work*

MARWAR SCHOOL, RAJASTHAN, C. 1750
DEVA
OPAQUE WATERCOLOR WITH GOLD LEAF ON PAPER, 7⅛ x 3¹¹⁄₁₆″ (18.1 x 9.4 cm)
COLLECTION OF MR. AND MRS. WILLIAM P. WOOD

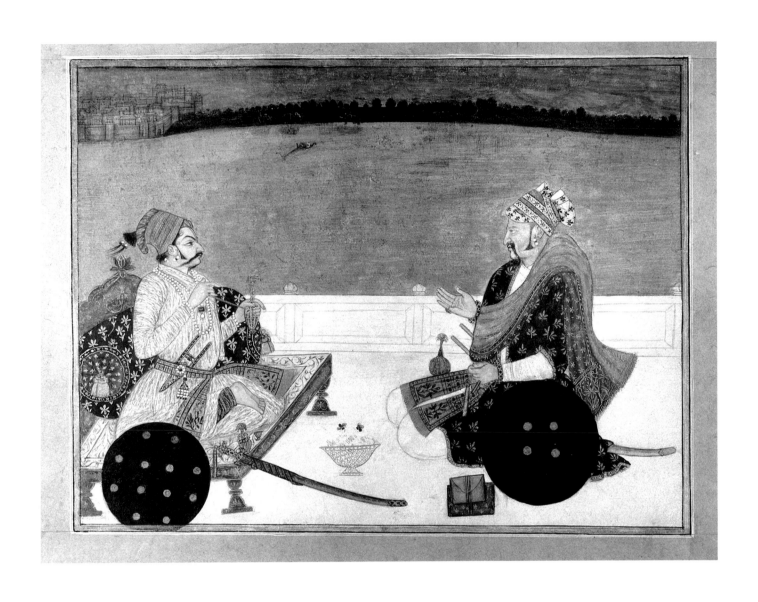

72 *Prince Padam Singh of Bikaner Sits with His Bard on a Terrace at Night*
KISHANGARH SCHOOL, RAJASTHAN, 1675–1725
OPAQUE WATERCOLOR WITH GOLD AND SILVER OR TIN AND WITH INCISED DECORATION ON PAPER
11¾ x 14″ (29.8 x 35.6 cm)
PRIVATE COLLECTION

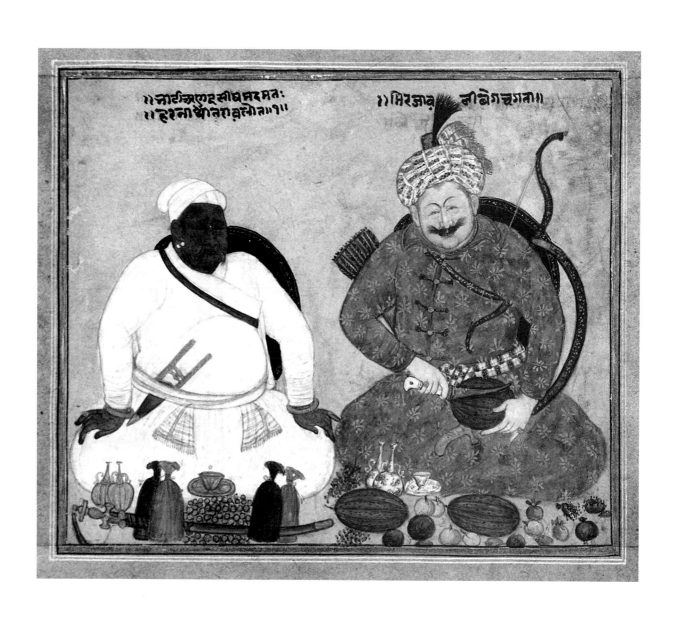

73 *Two Friends: Anad Singh Mahmat and Mirza Wali Beg Chagata*
KISHANGARH SCHOOL, RAJASTHAN, 1700–1725
OPAQUE WATERCOLOR WITH GOLD AND SILVER OR TIN AND WITH
TOOLING AND INCISED DECORATION ON PAPER, 8⅝ x 8⅞″ (21.9 x 22.5 cm)
PRIVATE COLLECTION

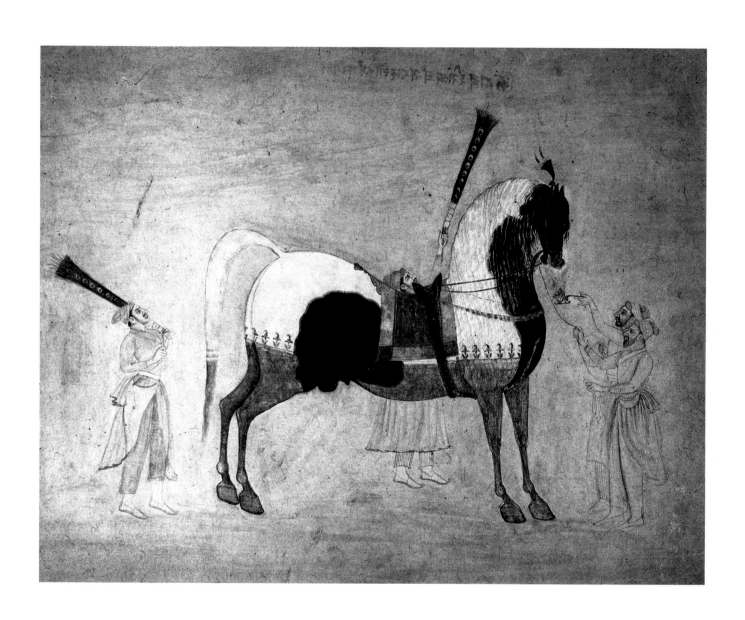

74 *The Horse Acambha*

KISHANGARH SCHOOL, RAJASTHAN, C. 1740
OPAQUE AND TRANSPARENT WATERCOLOR ON PAPER, 10 x 13⅜″ (25.4 x 34 cm)
COLLECTION OF DR. ALVIN O. BELLAK

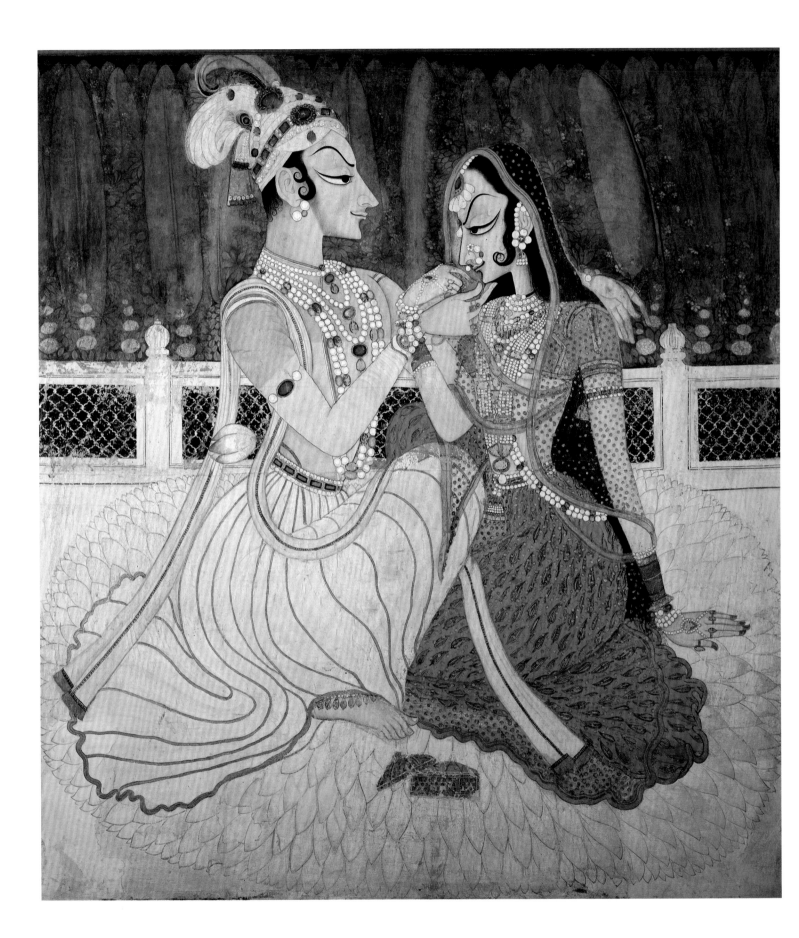

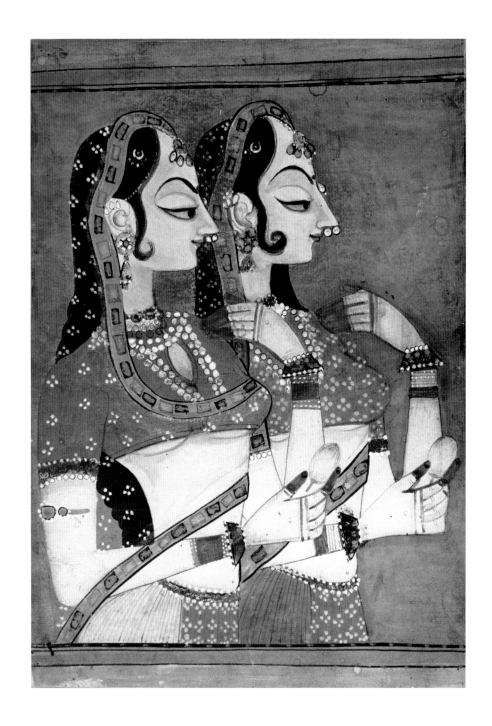

opposite

75 *Rādhā and Kṛṣṇa*

KISHANGARH SCHOOL, RAJASTHAN, C. 1750
OPAQUE WATERCOLOR WITH GOLD ON COTTON
40¾ x 37″ (103.5 x 94 cm)
PHILADELPHIA MUSEUM OF ART. PURCHASED: EDITH H. BELL FUND
1984-72-1

76 *Two Court Ladies*

KISHANGARH SCHOOL, RAJASTHAN, C. 1780
OPAQUE WATERCOLOR ON PAPER, 11½ x 8⅛″ (29.2 x 20.6 cm)
PRIVATE COLLECTION

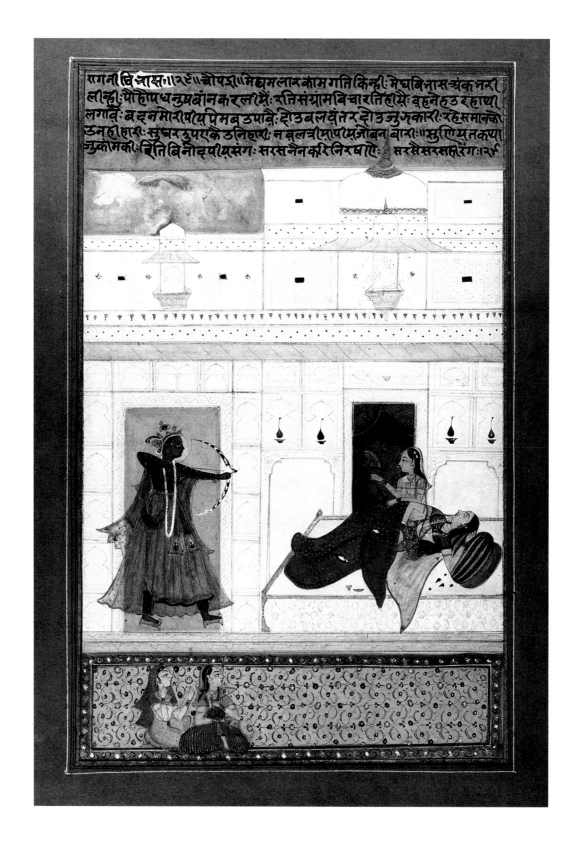

77 *Vibhāsā Rāgiṇī*

JAIPUR SCHOOL, RAJASTHAN, C. 1750
OPAQUE WATERCOLOR WITH GOLD AND SILVER OR TIN ON PAPER
11¹⁵⁄₁₆ x 8¹³⁄₁₆" (30.3 x 22.4 cm)
PRIVATE COLLECTION

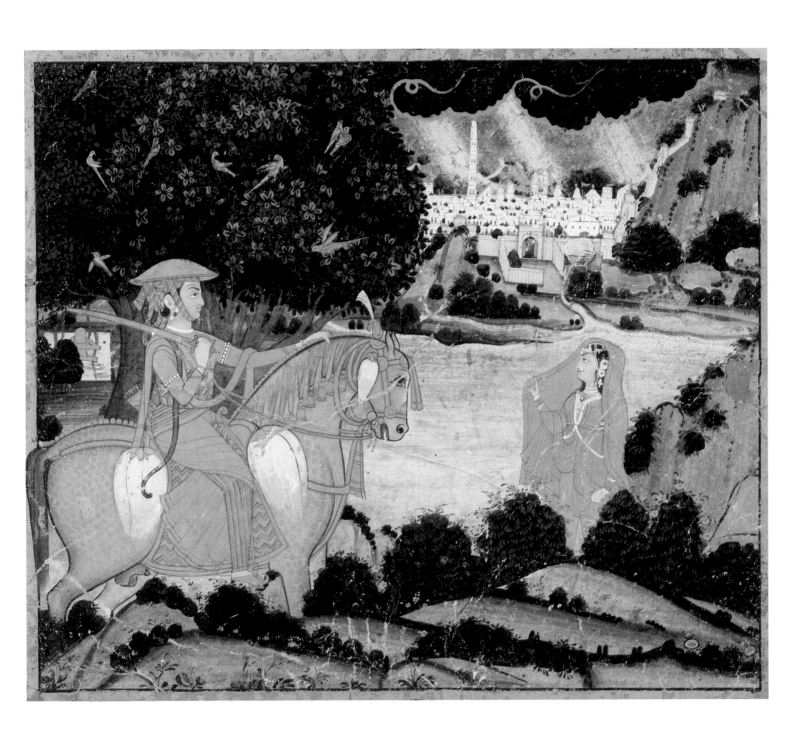

78 *The Meeting*

JAIPUR SCHOOL, RAJASTHAN, C. 1780
OPAQUE WATERCOLOR WITH GOLD ON PAPER, 10 x 11¼″ (25.4 x 28.6 cm)
PRIVATE COLLECTION

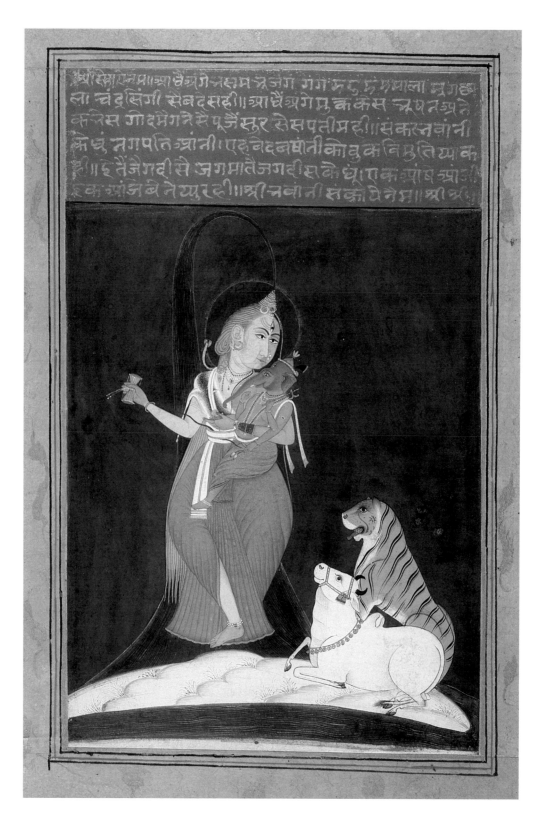

79 *Śiva Ardhanārīśvara, Carrying Gaṇeśa, Is Adored by
Nandin and a "Lion"*

MALPURA SCHOOL, RAJASTHAN, 1750–60
OPAQUE WATERCOLOR WITH GOLD ON PAPER, 11¾ x 8½" (29.8 x 21.6 cm)
PRIVATE COLLECTION

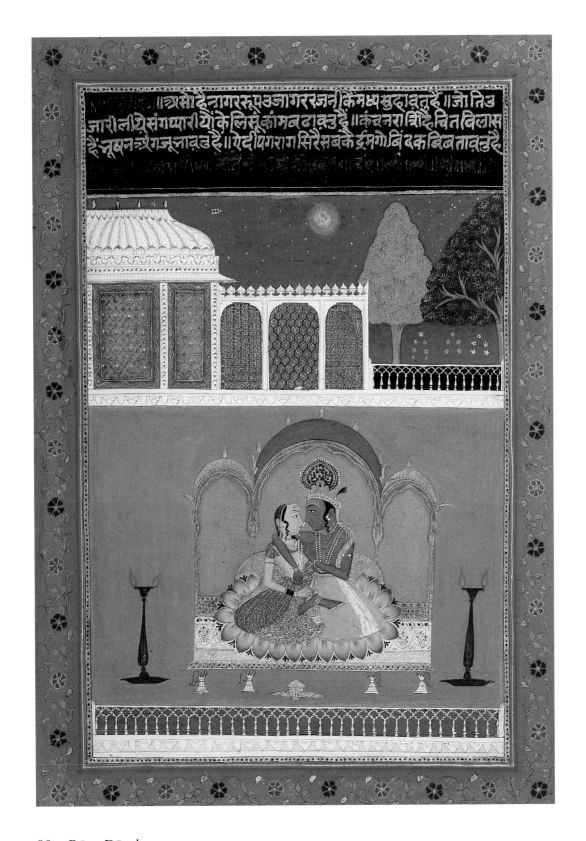

80 *Rāga Dīpaka*

MALPURA SCHOOL, RAJASTHAN, 1760–85
OPAQUE WATERCOLOR WITH GOLD AND SILVER ON PAPER, 15⅞ x 11¾″ (40.3 x 29.8 cm)
PRIVATE COLLECTION

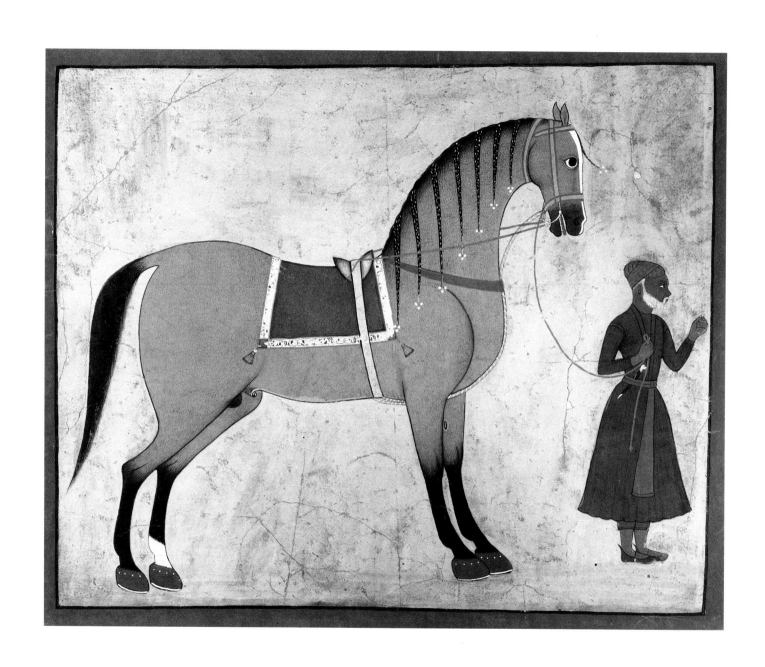

81 Horse and Groom

ISARDA SCHOOL, RAJASTHAN, C. 1690
VĀJĪDA
OPAQUE WATERCOLOR ON PAPER, 12⅝ x 15⁵⁄₁₆″ (32.1 x 38.9 cm)
COLLECTION OF DR. ALVIN O. BELLAK

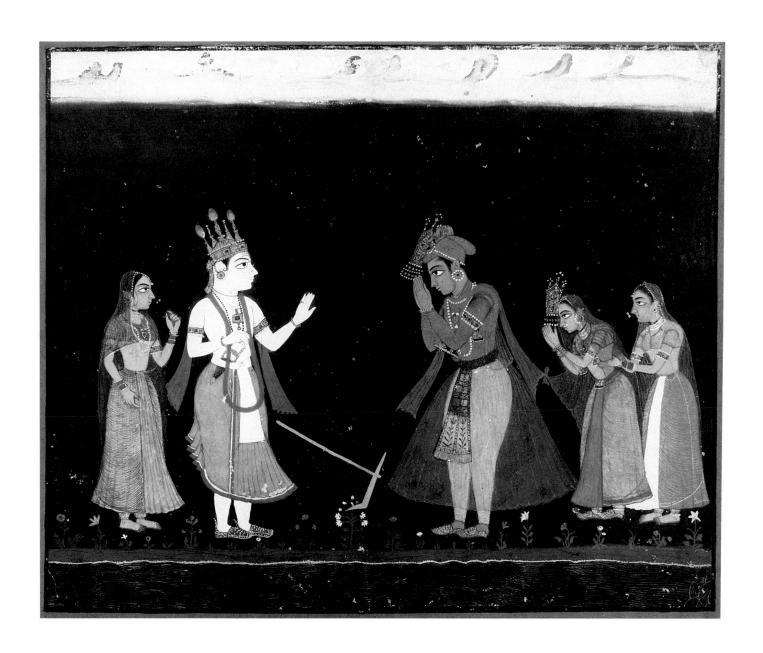

82 Kṛṣṇa and His Wife Rukmiṇī Greet Balarāma and His Wife Revatī after Their Wedding

ISARDA SCHOOL, RAJASTHAN, c. 1690

VĀJĪDA

OPAQUE WATERCOLOR WITH GOLD ON PAPER

12¼ x 14¾″ (31.1 x 37.5 cm)

COLLECTION OF DR. ALVIN O. BELLAK

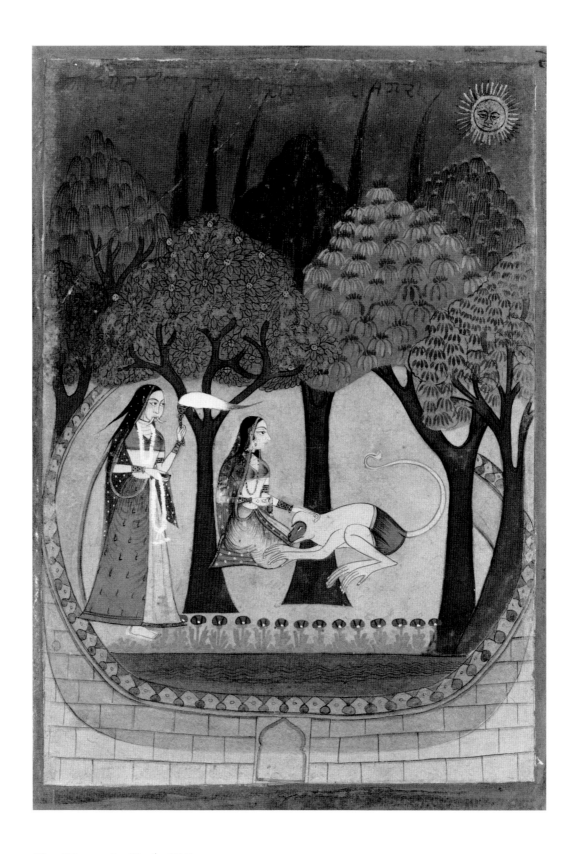

83 Hanumān Finds Sītā

NAGAUR SCHOOL, RAJASTHAN, C. 1750
OPAQUE WATERCOLOR WITH GOLD ON PAPER, 11¾ x 8″ (29.8 x 20.3 cm)
PHILADELPHIA MUSEUM OF ART. GIFT OF WILLIAM P. WOOD
67-80-4

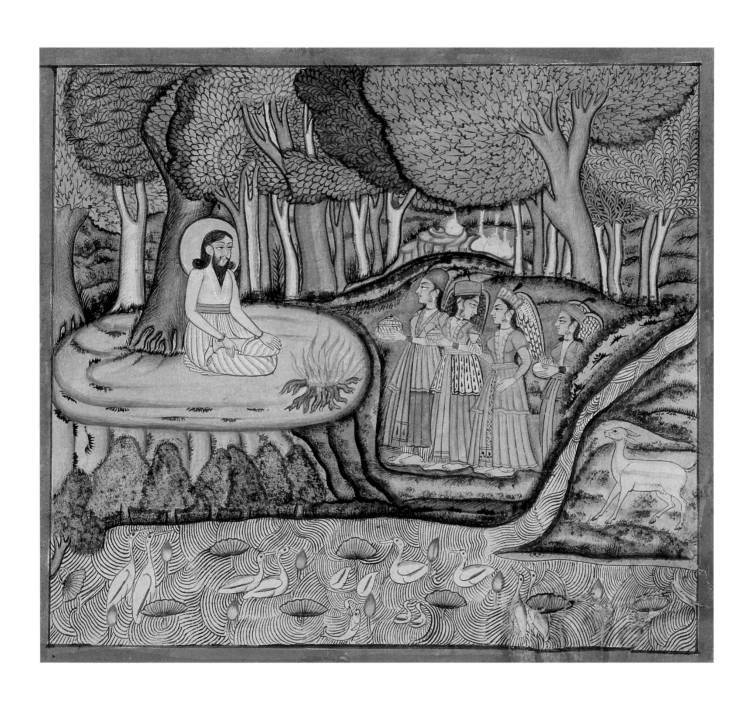

84 *Angels Visit Sultan Ibrahim ibn-Adham of Balkh*
NAGAUR SCHOOL, RAJASTHAN, 1775–1800
OPAQUE WATERCOLOR ON PAPER, 8 x 9¼" (20.3 x 23.5 cm)
PRIVATE COLLECTION

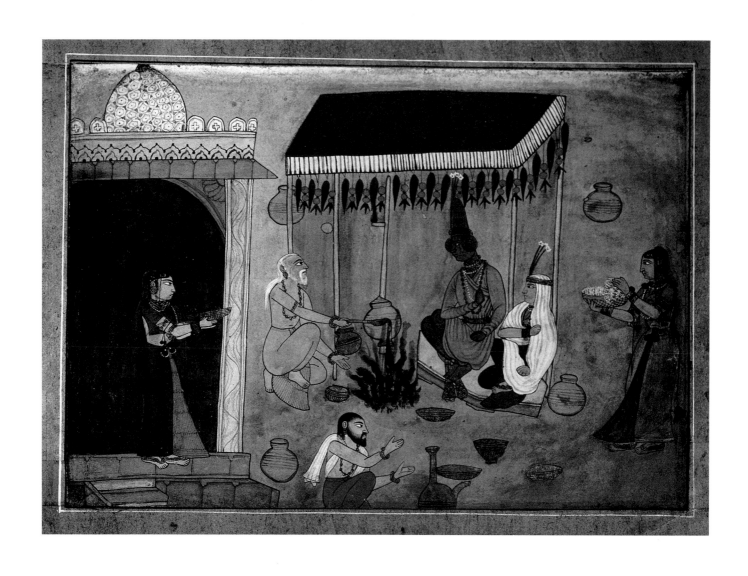

85 The Wedding of Satyabhāmā and Kṛṣṇa

BIKANER SCHOOL, RAJASTHAN, 1590–1600
OPAQUE WATERCOLOR WITH GOLD ON PAPER, 8⁷⁄₁₆ x 11¹¹⁄₁₆″ (21.5 x 29.7 cm)
COLLECTION OF DR. ALVIN O. BELLAK

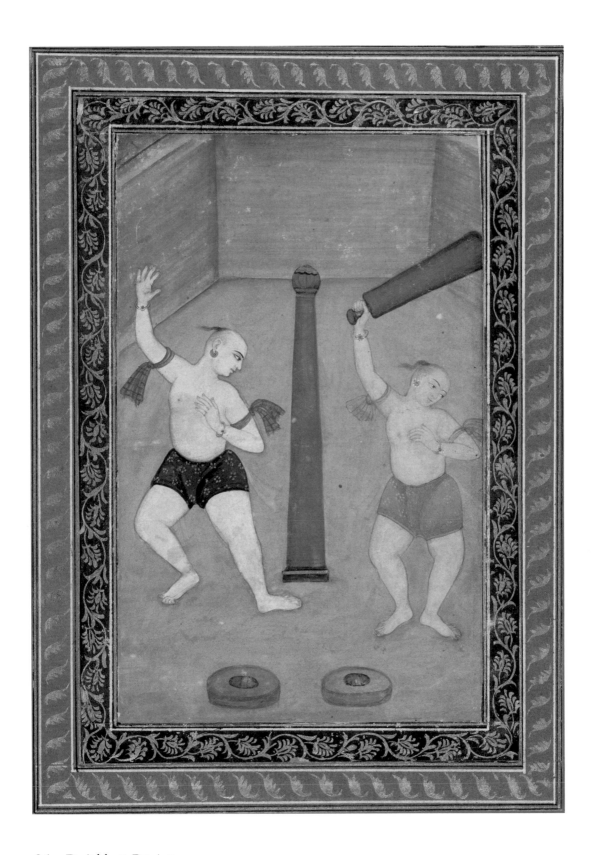

86 *Deśākhyā Rāgiṇī*

BIKANER SCHOOL, RAJASTHAN, 1675–1700
OPAQUE WATERCOLOR WITH GOLD ON PAPER, 17⅝ x 11¹⁵⁄₁₆″ (44.8 x 30.3 cm)
FREE LIBRARY OF PHILADELPHIA. RARE BOOK DEPARTMENT,
JOHN FREDERICK LEWIS COLLECTION

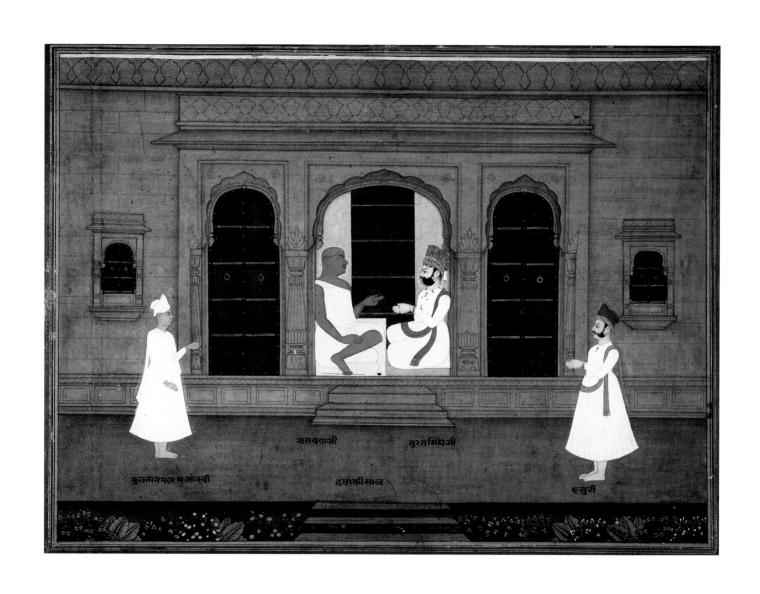

नाराय‍णजी सुरतसिंघजी

मुलतानमल बुजोन‍ची ढढोकीसाध हुज‍री

87 *Surat Singh and a Guru Sit in a Palace Chamber*
Flanked by Courtiers
BIKANER SCHOOL, RAJASTHAN, 1800–1825
OPAQUE WATERCOLOR WITH GOLD ON PAPER, 11 x 16″ (27.9 x 40.6 cm)
COLLECTION OF DR. ALVIN O. BELLAK

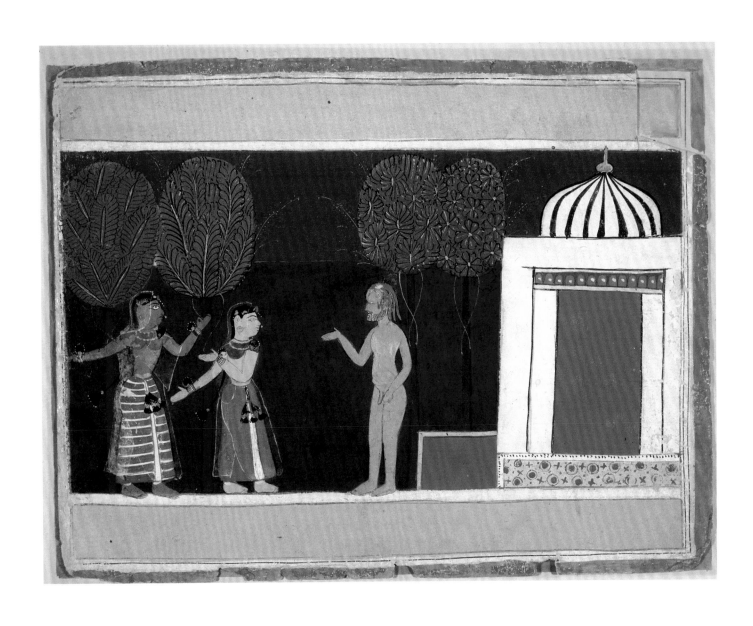

88 *The Enticement of Ṛṣyaśṛṅga*
MALWA SCHOOL, CENTRAL INDIA, C. 1635
ILLUSTRATION FROM THE *Rāmāyaṇa*
OPAQUE WATERCOLOR ON PAPER, 6⅞ x 9″ (17.5 x 22.9 cm)
PRIVATE COLLECTION

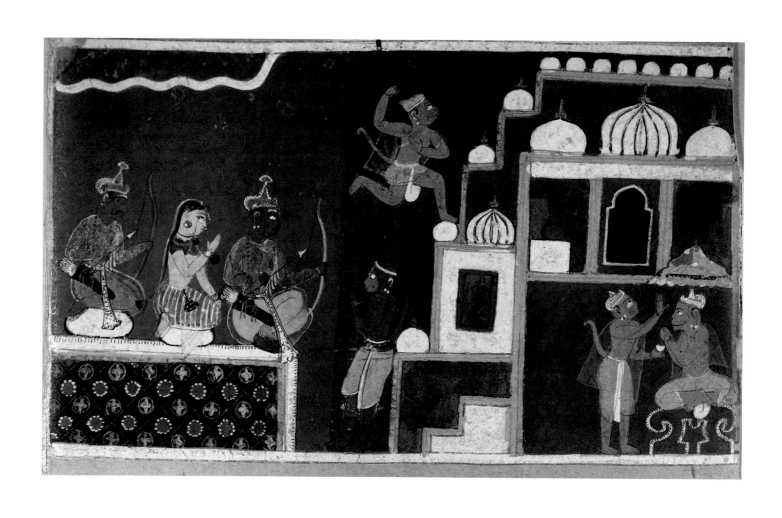

89 *Hanumān's Leap to Laṅkā*

MALWA SCHOOL, CENTRAL INDIA, c. 1635
ILLUSTRATION FROM THE *Rāmāyaṇa*
OPAQUE WATERCOLOR WITH GOLD ON PAPER, 8⅛ x 9″ (20.6 x 22.9 cm)
PRIVATE COLLECTION

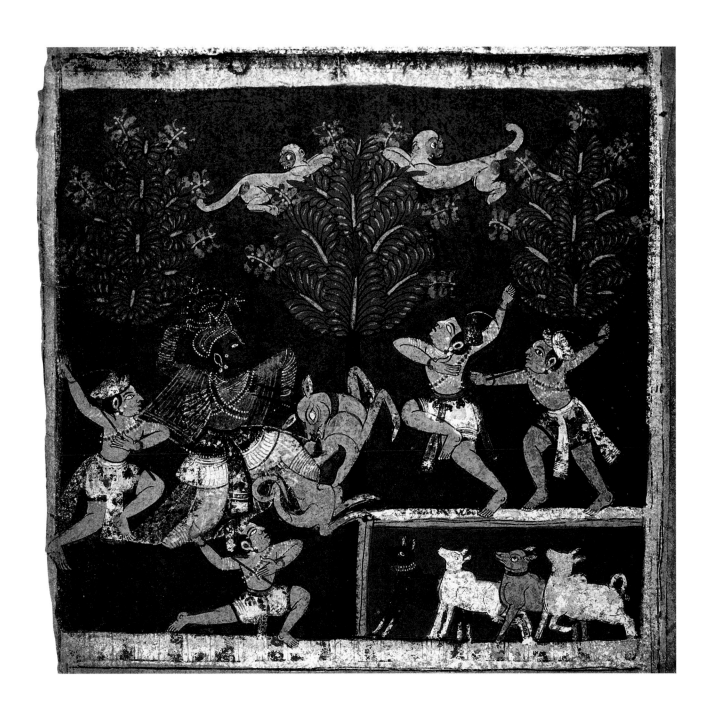

90 *Kṛṣṇa Slays Vatsāsura, the Calf Demon*

MALWA SCHOOL, CENTRAL INDIA, C. 1640
ILLUSTRATION FROM THE *Rasikapriyā*
OPAQUE WATERCOLOR WITH GOLD ON PAPER, 8 x 6⅝″ (20.3 x 16.8 cm)
COLLECTION OF DR. ALVIN O. BELLAK

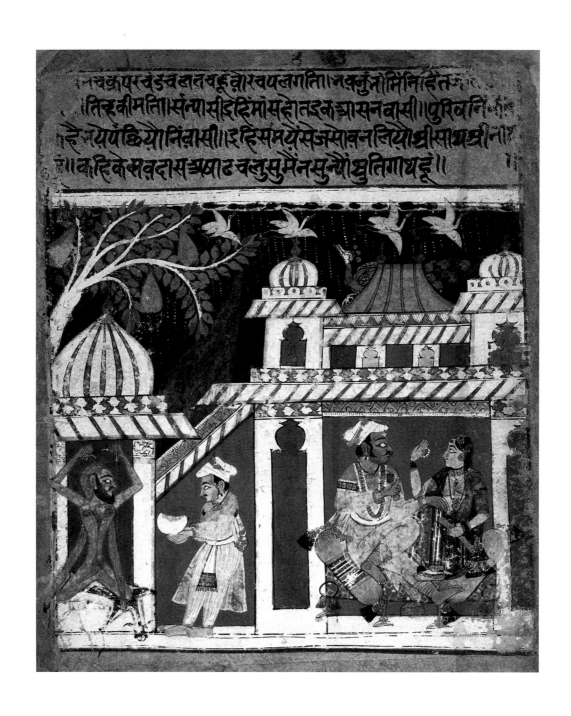

91 The Onset of the Monsoon

MALWA SCHOOL, CENTRAL INDIA, C. 1650
ILLUSTRATION FROM THE *Kavipriyā*
OPAQUE WATERCOLOR ON PAPER, 8 x 6¼" (20.3 x 15.9 cm)
PRIVATE COLLECTION

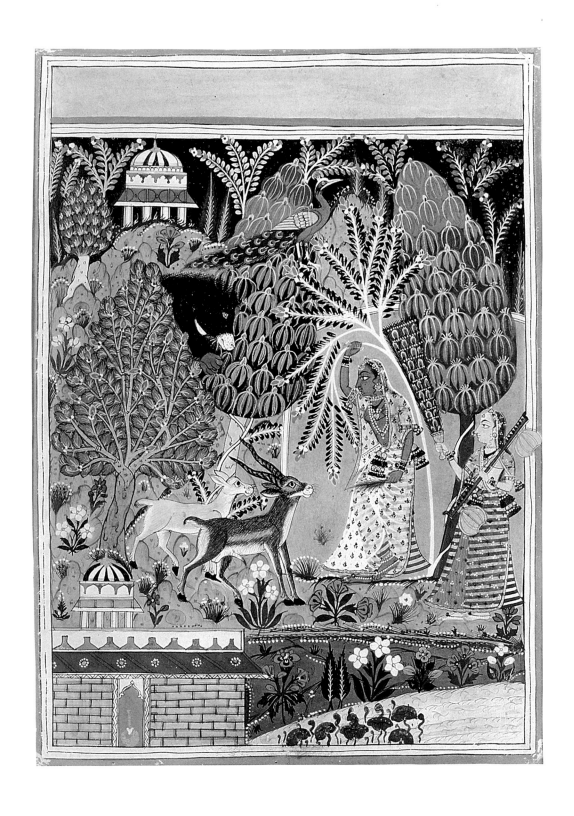

92 *Toḍī Rāgiṇī*

MALWA SCHOOL, CENTRAL INDIA, 1650–75
OPAQUE WATERCOLOR WITH GOLD ON PAPER, 8⅛ x 5¹⁵⁄₁₆″ (20.6 x 15.1 cm)
PRIVATE COLLECTION

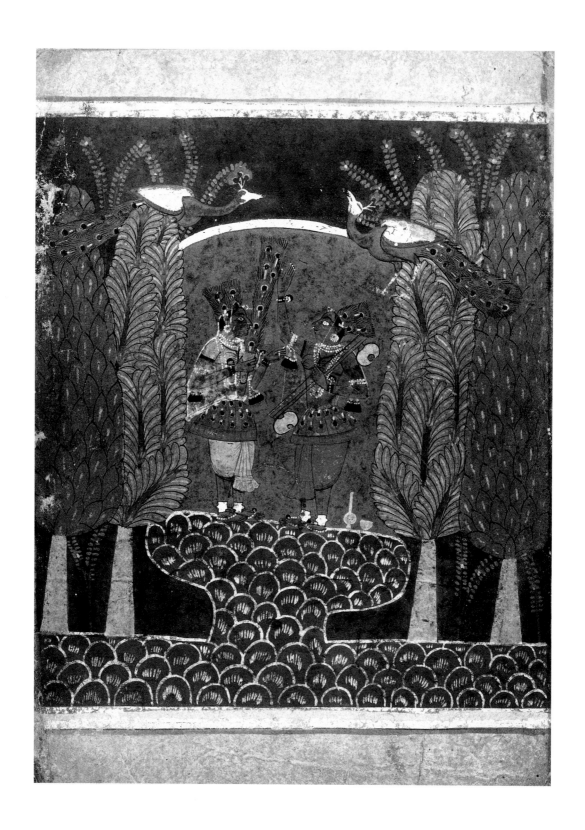

93 *Gouḍa Mallār Rāgiṇī*

MALWA SCHOOL, CENTRAL INDIA, C. 1675
OPAQUE WATERCOLOR WITH GOLD ON PAPER, 8¾ x 6¼" (22.2 x 15.9 cm)
PRIVATE COLLECTION

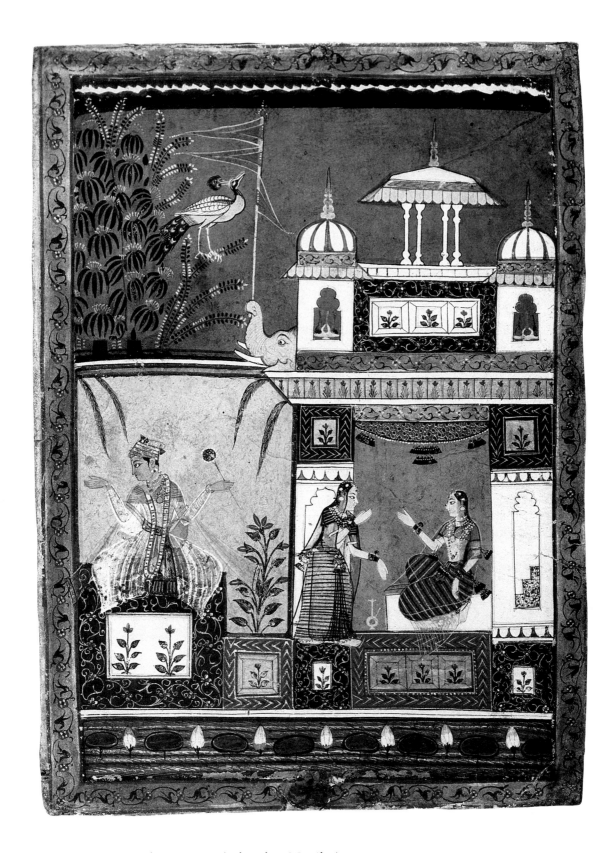

94 The Distraught Heroine (Khaṇḍitā Nāyikā)
MALWA SCHOOL, CENTRAL INDIA, c. 1675
ILLUSTRATION FROM THE *Rasikapriyā*
OPAQUE WATERCOLOR WITH GOLD ON PAPER, 9¹¹⁄₁₆ x 6⅞" (24.6 x 17.5 cm)
PRIVATE COLLECTION

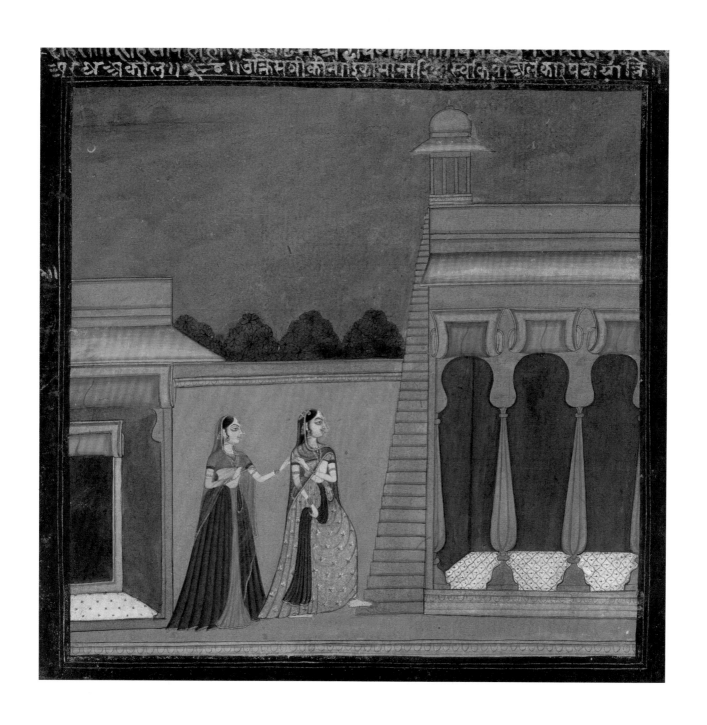

95 *The Lady Who Only Loves Her Husband (Svakīyā)*
DATIA SCHOOL, CENTRAL INDIA, 1750–75
OPAQUE WATERCOLOR WITH GOLD ON PAPER, 8¾ x 9⅛″ (22.2 x 23.2 cm)
PRIVATE COLLECTION

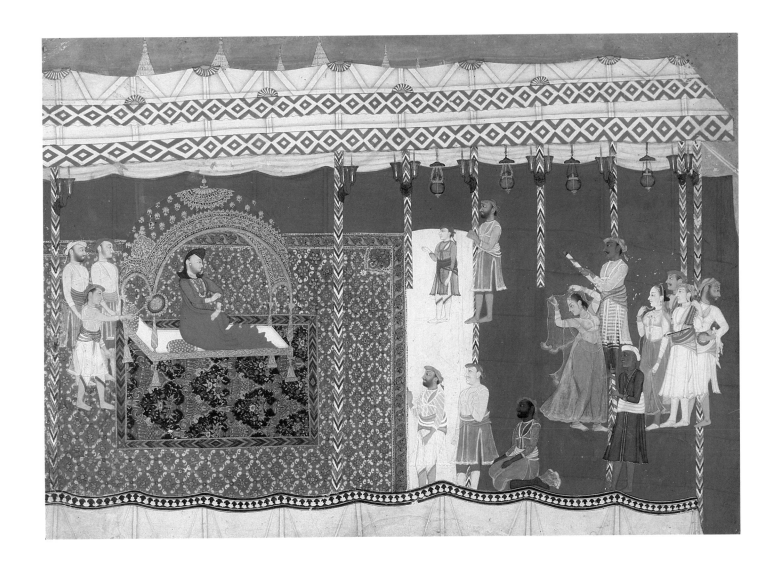

96 *Raja Mahendra Sujan Singh with Dancers and Musicians*
ORCHA SCHOOL, CENTRAL INDIA, 1852
SHIMBU
OPAQUE WATERCOLOR WITH GOLD AND SILVER OR TIN ON PAPER, 12½ x 17⅝″ (31.8 x 44.8 cm)
PRIVATE COLLECTION

RAJPUT PAINTING

IN THE

PANJAB HILLS

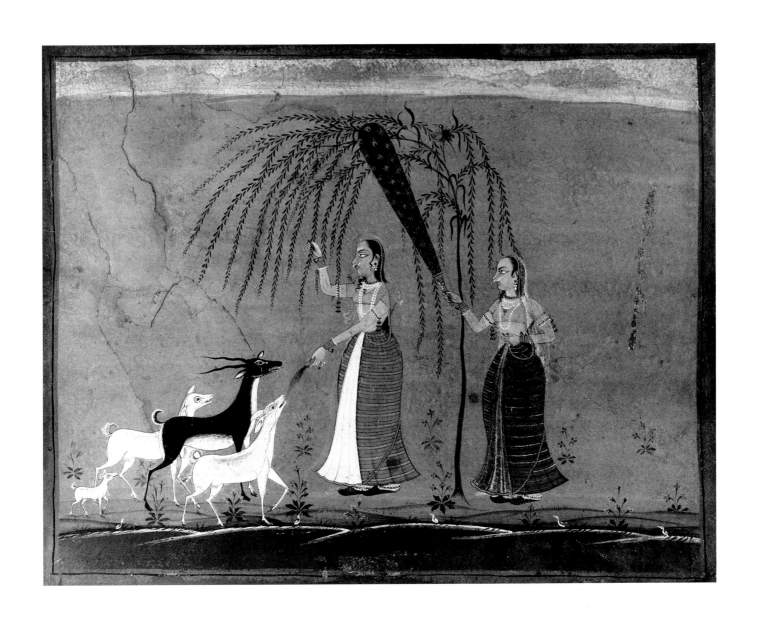

97 *A Woman Deserted (Virahinī)*

BILASPUR SCHOOL, PANJAB HILLS, C. 1725
OPAQUE WATERCOLOR WITH GOLD ON PAPER, 6¾ x 8⁹⁄₁₆″ (17.1 x 21.7 cm)
PHILADELPHIA MUSEUM OF ART. GIFT OF WILLIAM P. WOOD. 67-80-5

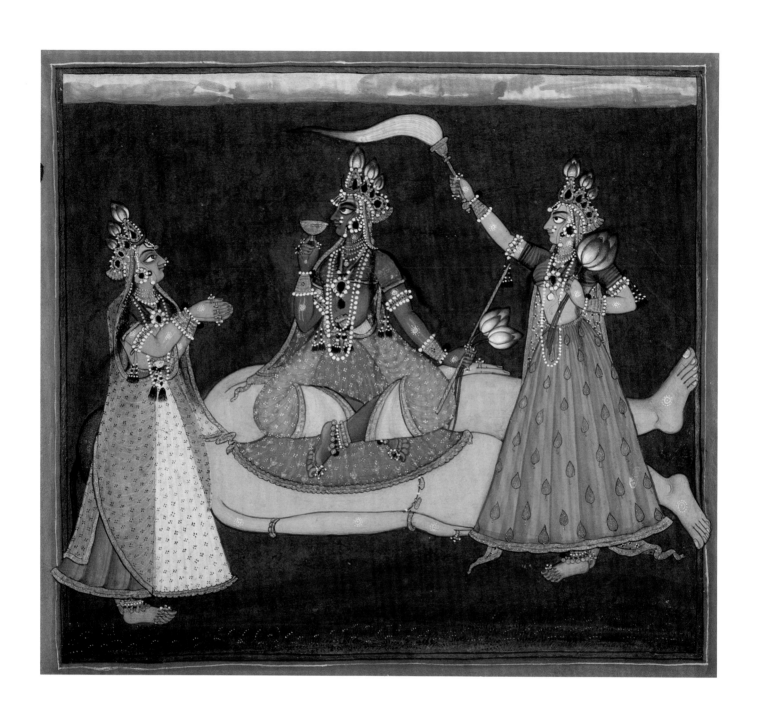

98 *Bhadrakālī and Retainers*

BASOHLI SCHOOL, 1660–70
OPAQUE WATERCOLOR WITH GOLD, SILVER, AND BEETLE-WING CASES ON PAPER
8⅛ x 8⅞" (20.6 x 22.5 cm)
COLLECTION OF DR. ALVIN O. BELLAK

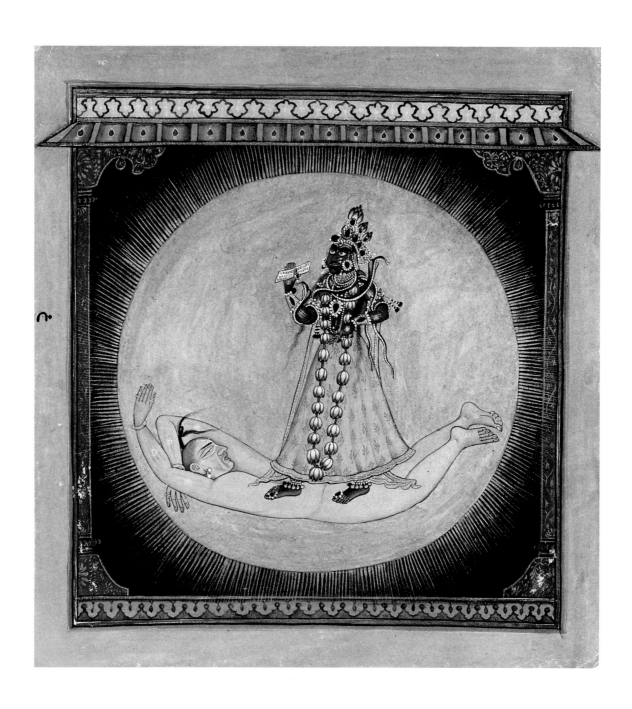

99 *The Blessed Kālī (Bhadrakālī)*

BASOHLI SCHOOL, 1660–70
OPAQUE WATERCOLOR WITH GOLD AND BEETLE-WING CASES ON PAPER
9¾ x 8¼″ (24.8 x 21 cm)
COLLECTION OF DR. ALVIN O. BELLAK

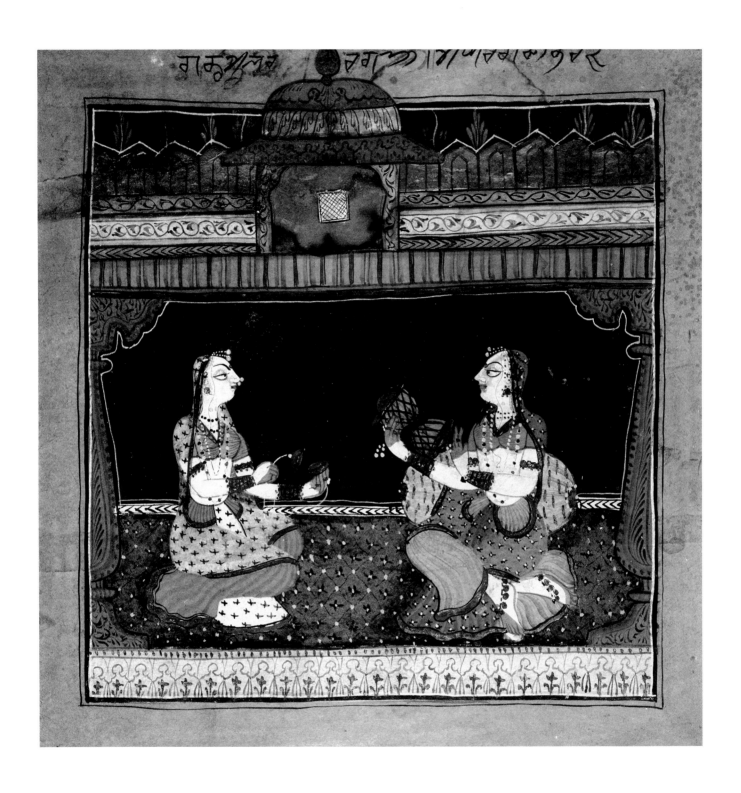

100 Gouḍa Mallār Rāgiṇī
BASOHLI SCHOOL, 1660–70
OPAQUE WATERCOLOR WITH SILVER ON PAPER, 8³⁄₁₆ x 8³⁄₁₆″ (20.8 x 20.8 cm)
PRIVATE COLLECTION

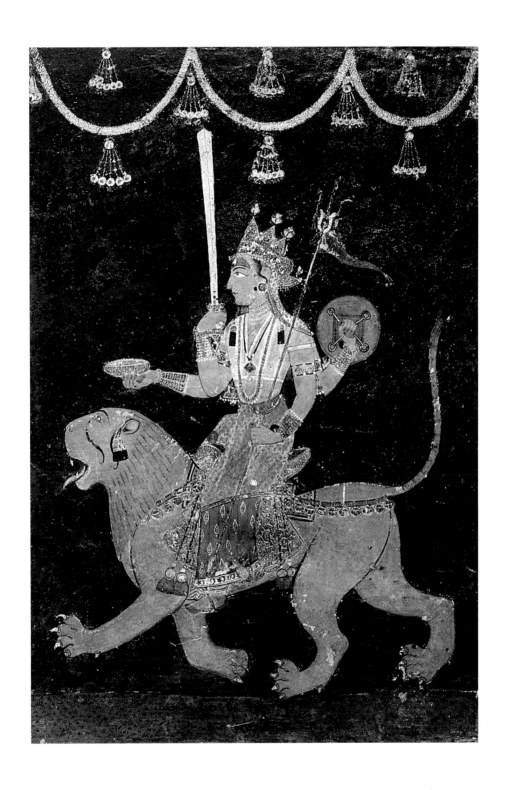

101 The Great Goddess Durgā Riding Her Lion

BASOHLI SCHOOL AT MANDI, C. 1700
OPAQUE WATERCOLOR WITH EMBOSSED GOLD ON PAPER
11⅜ x 8″ (28.9 x 20.3 cm)
PRIVATE COLLECTION

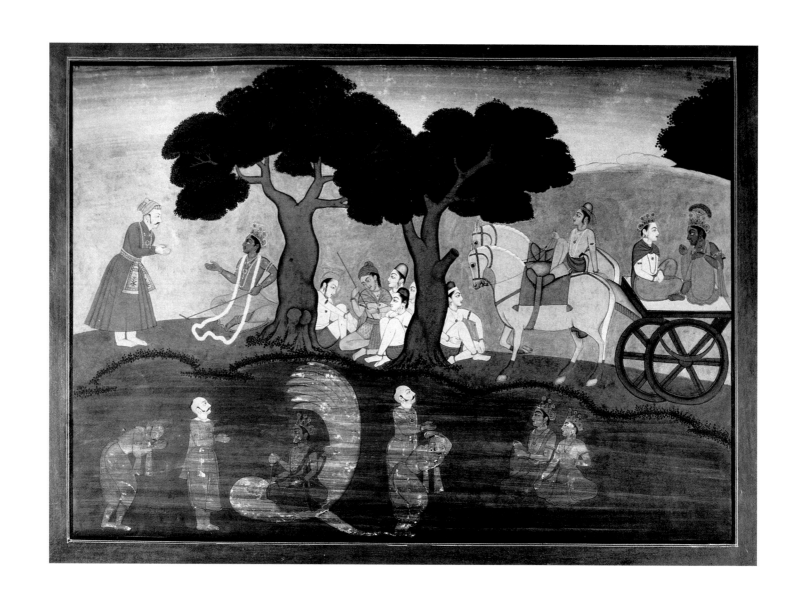

102 *Akrūra's Vision of Viṣṇu / Kṛṣṇa*

BASOHLI SCHOOL, 1769
ILLUSTRATION FROM THE *Bhāgavata Purāṇa*
OPAQUE WATERCOLOR WITH GOLD ON PAPER, 11½ x 16″ (29.2 x 40.6 cm)
PRIVATE COLLECTION

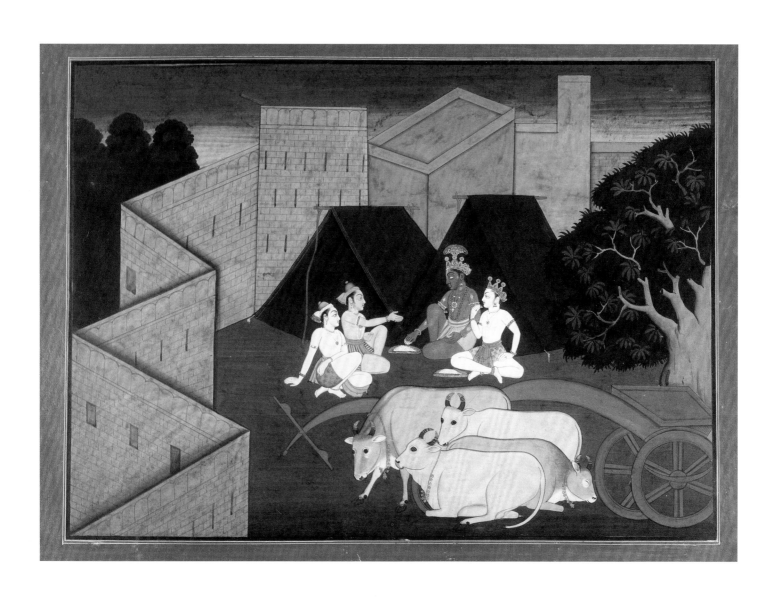

103 *Kṛṣṇa and Balarāma Take a Meal of Rice Boiled in Milk*

BASOHLI SCHOOL, 1769
ILLUSTRATION FROM THE *Bhāgavata Purāṇa*
OPAQUE WATERCOLOR WITH GOLD ON PAPER, 11¾ x 15⅞" (29.8 x 40.3 cm)
PRIVATE COLLECTION

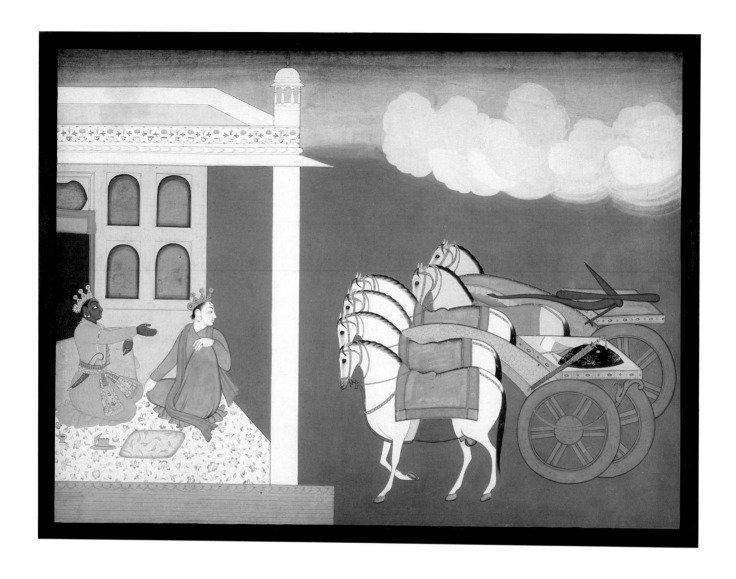

104　*Kṛṣṇa Points Out to Balarāma the Descent from the Sky of Two
Chariots Carrying Celestial Weapons*

BASOHLI SCHOOL, 1769
ILLUSTRATION FROM THE *Bhāgavata Purāṇa*
OPAQUE WATERCOLOR WITH GOLD ON PAPER, 11¾ x 16″ (29.8 x 40.6 cm)
PHILADELPHIA MUSEUM OF ART. GIFT OF WILLIAM P. WOOD. 1976-189-2

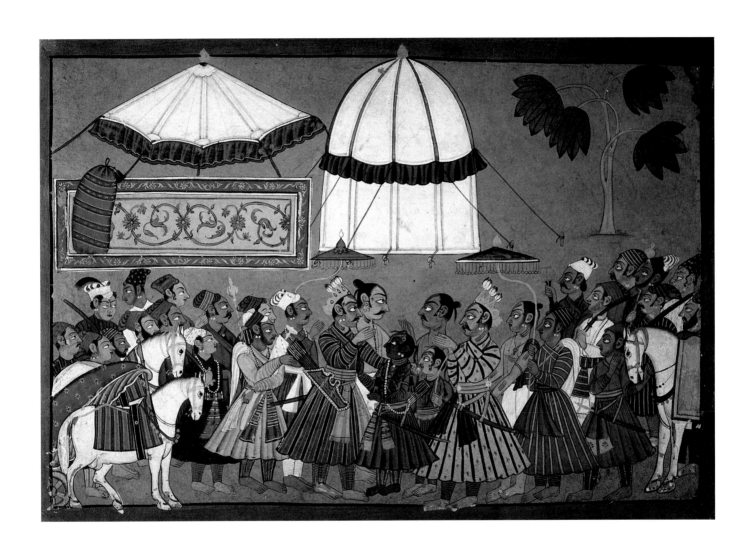

105 *King Daśaratha Goes to King Janaka's Court*

ILLUSTRATION FROM THE *Rāmāyaṇa*
KULU SCHOOL, 1690–1700
OPAQUE WATERCOLOR ON PAPER, 8¹⁵⁄₁₆ x 13″ (22.7 x 33 cm)
COLLECTION OF DR. ALVIN O. BELLAK

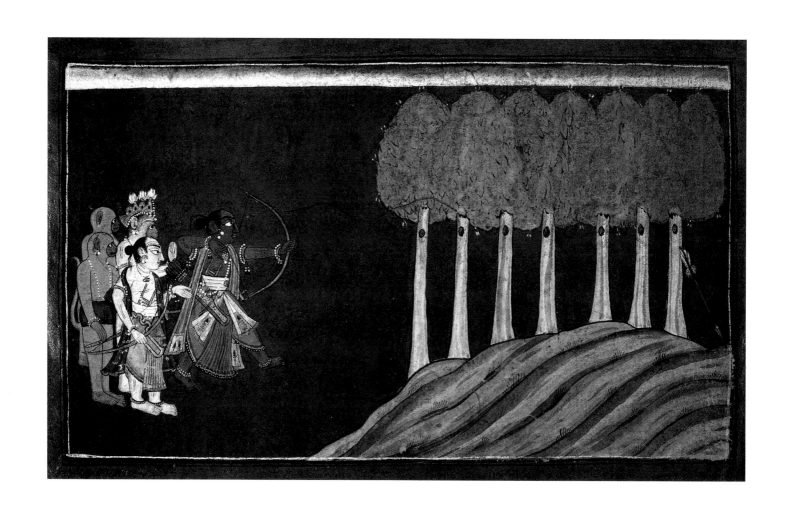

106 *Rāma Pierces the Seven Śāla Trees*

KULU SCHOOL, C. 1700
OPAQUE WATERCOLOR WITH GOLD ON PAPER, $8\frac{5}{8}$ x $13\frac{7}{8}$" (21.9 x 35.2 cm)
COLLECTION OF DR. ALVIN O. BELLAK

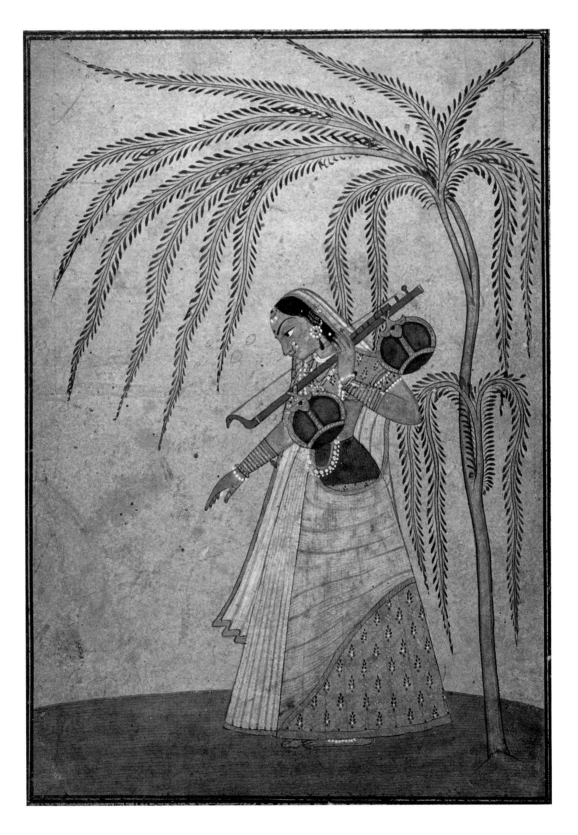

107 Todī Rāginī

KULU SCHOOL, C. 1800
OPAQUE WATERCOLOR WITH GOLD ON PAPER
9 1/16 x 7 1/4" (23 x 18.4 cm)
COLLECTION OF DR. ALVIN O. BELLAK

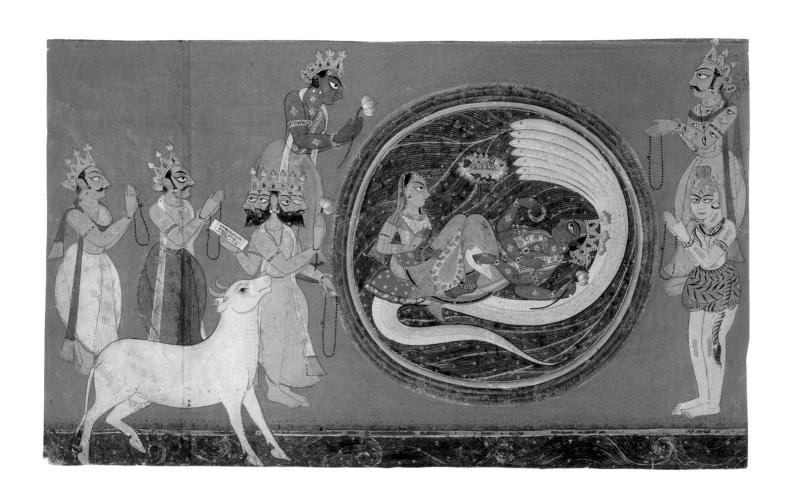

108 *Viṣṇu in the Cosmic Ocean Is Worshiped by Brahmā,*
Śiva, Indra, and Other Gods
MANKOT SCHOOL, 1710–20
OPAQUE WATERCOLOR WITH GOLD ON PAPER, 5¾ x 9⅞" (14.6 x 25.1 cm)
COLLECTION OF DR. ALVIN O. BELLAK

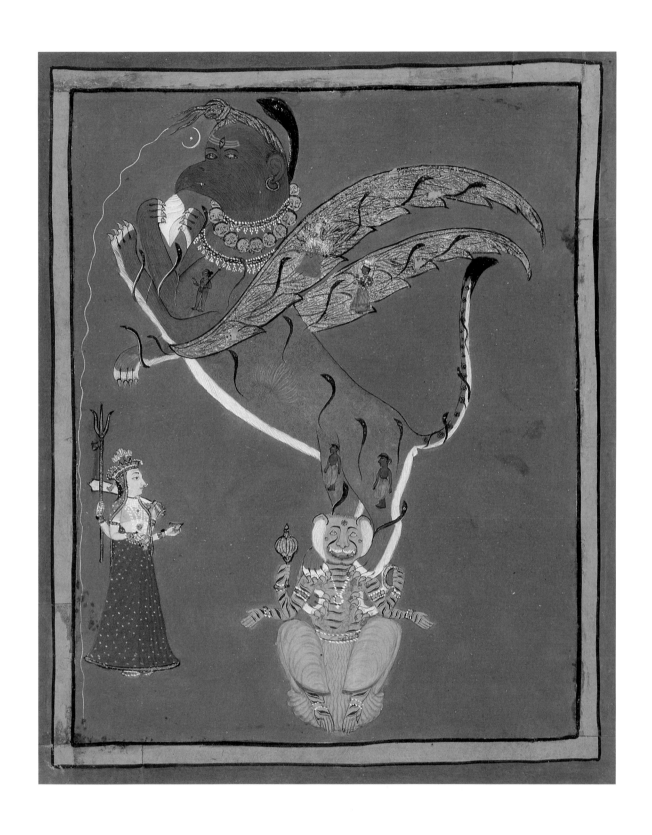

109 Śiva Śarabheśa

MANKOT SCHOOL, C. 1715
OPAQUE WATERCOLOR WITH GOLD ON PAPER, 9⁷⁄₁₆ x 7⁷⁄₈″ (24 x 20 cm)
PRIVATE COLLECTION

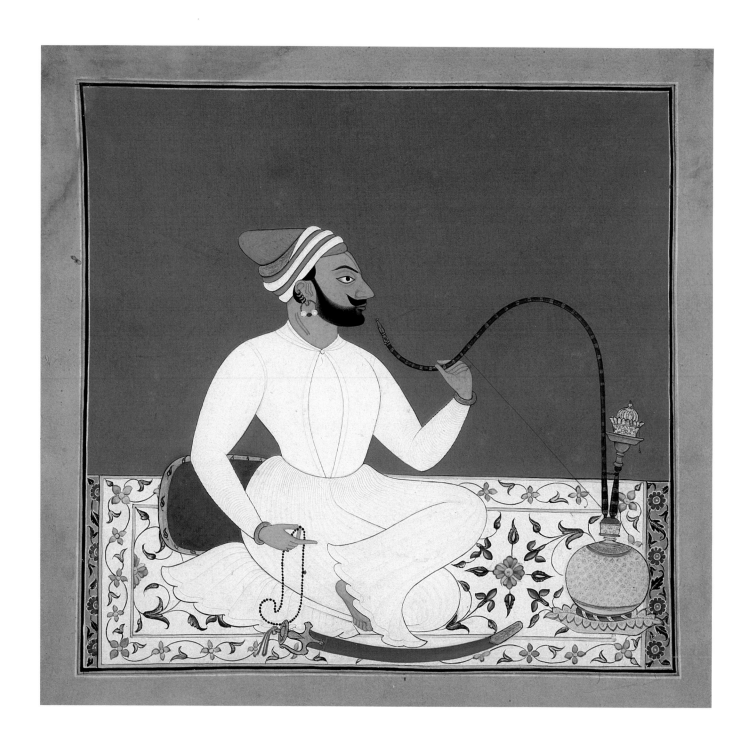

110 Raja Ajmat Dev of Mankot Smoking

MANKOT SCHOOL, 1730–35
OPAQUE WATERCOLOR WITH GOLD ON PAPER
8¹⁄₁₆ x 8½″ (20.5 x 21.6 cm)
CITY OF PHILADELPHIA. ON PERMANENT LOAN TO THE PHILADELPHIA MUSEUM OF ART

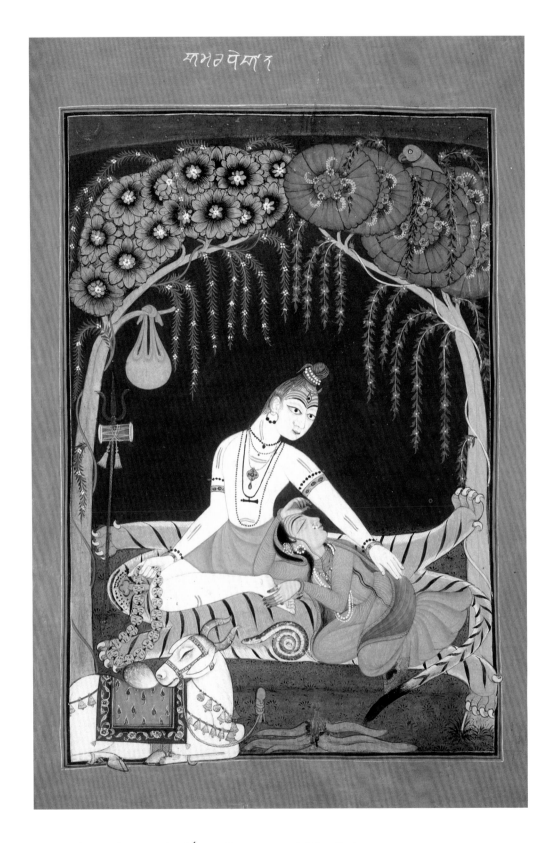

साभरपेसार

111 *The Holy Family (Śiva, Pārvatī, and Nandin)*
MANKOT SCHOOL, 1725–50
OPAQUE WATERCOLOR WITH GOLD ON PAPER, 11⅜ x 8" (28.9 x 20.3 cm)
PRIVATE COLLECTION

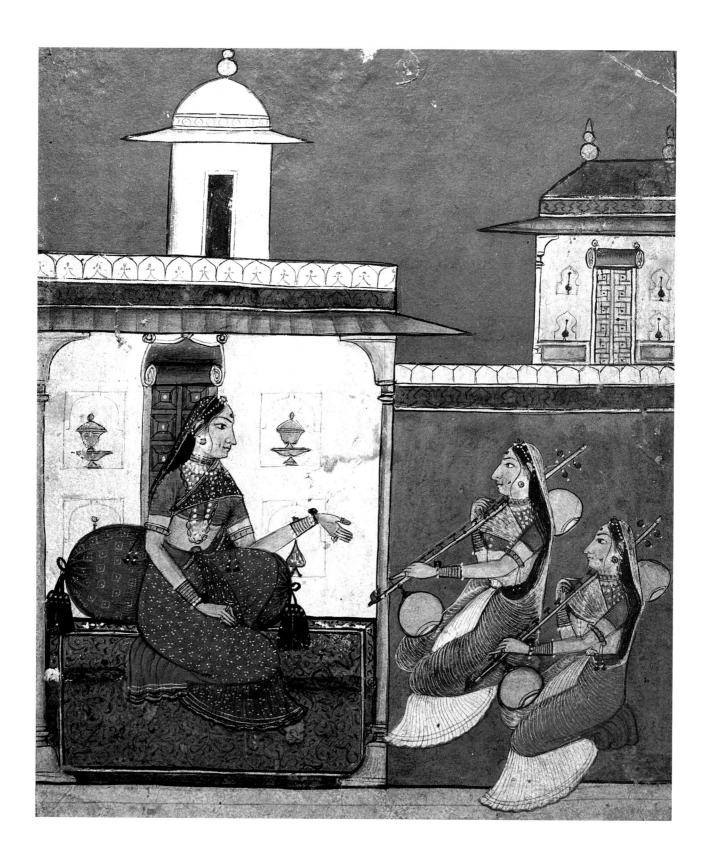

112 *Khambhāvatī Rāgiṇī*

BAGHAL (ARKI) SCHOOL, C. 1700
OPAQUE WATERCOLOR ON PAPER, 8¹⁄₁₆ x 6¹¹⁄₁₆″ (20.5 x 17 cm)
PHILADELPHIA MUSEUM OF ART. ANONYMOUS GIFT. 1983-156-2

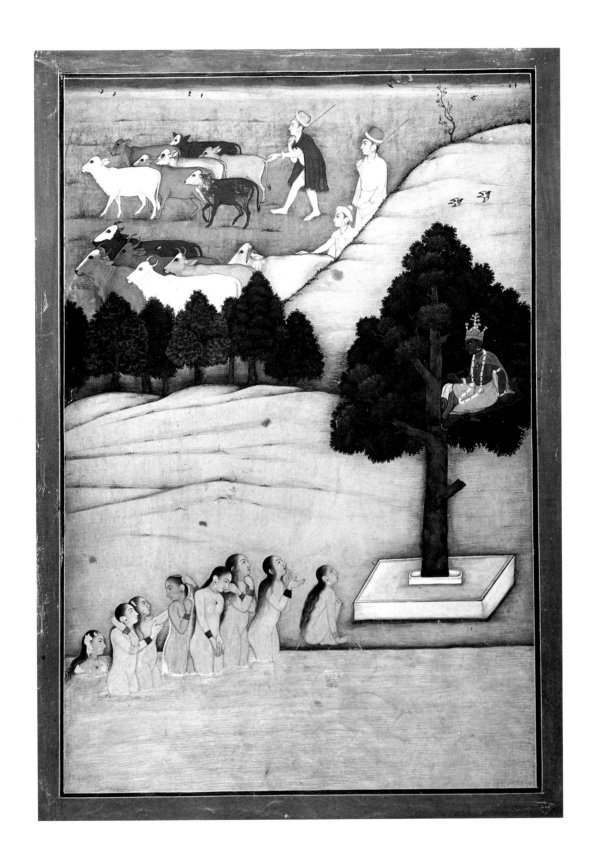

113 *Kṛṣṇa Steals the Clothing of the Cowherdesses*
MANDI SCHOOL, 1640–50
OPAQUE WATERCOLOR WITH GOLD ON PAPER, 13½ x 9½″ (34.3 x 24.1 cm)
PRIVATE COLLECTION

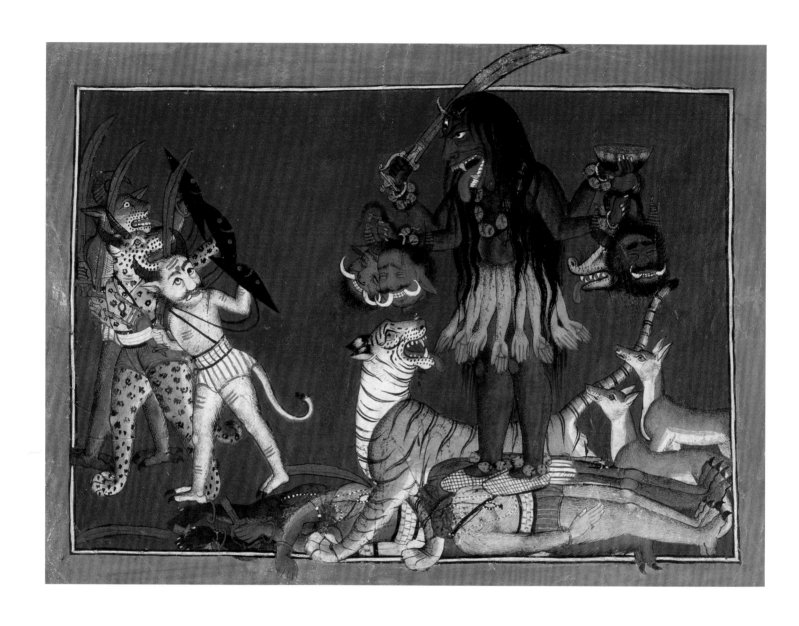

114 *The Goddess Kālī Slaying Demons*

MANDI SCHOOL, C. 1710
OPAQUE WATERCOLOR WITH GOLD ON PAPER, 8⅛ x 11¼" (20.6 x 28.6 cm)
COLLECTION OF DR. ALVIN O. BELLAK

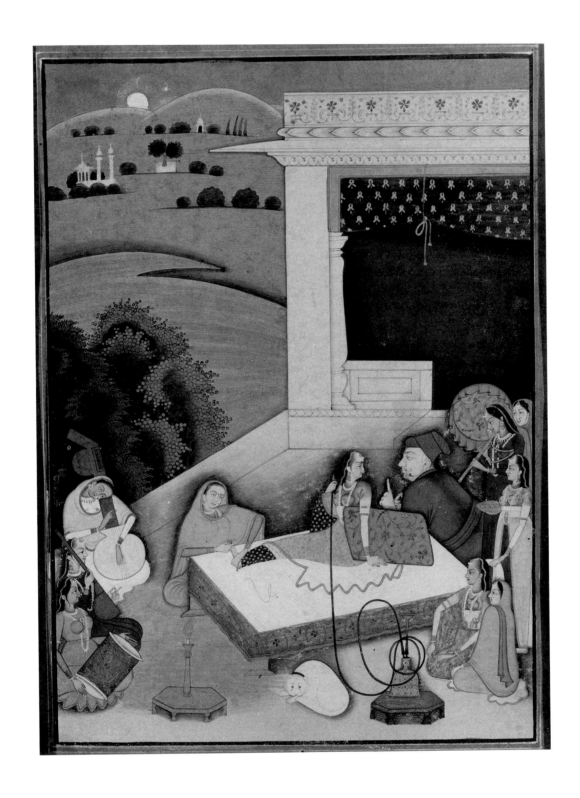

115 *Pandit Dinamani Raina Visits the Women's Quarters of*
Raja Dalip Singh of Guler

GULER SCHOOL, 1740–70
OPAQUE WATERCOLOR WITH GOLD AND SILVER OR TIN ON PAPER
11 x 8½″ (27.9 x 21.6 cm)
PHILADELPHIA MUSEUM OF ART. GIFT OF DR. AND MRS. PAUL TODD MAKLER
1976-230-1

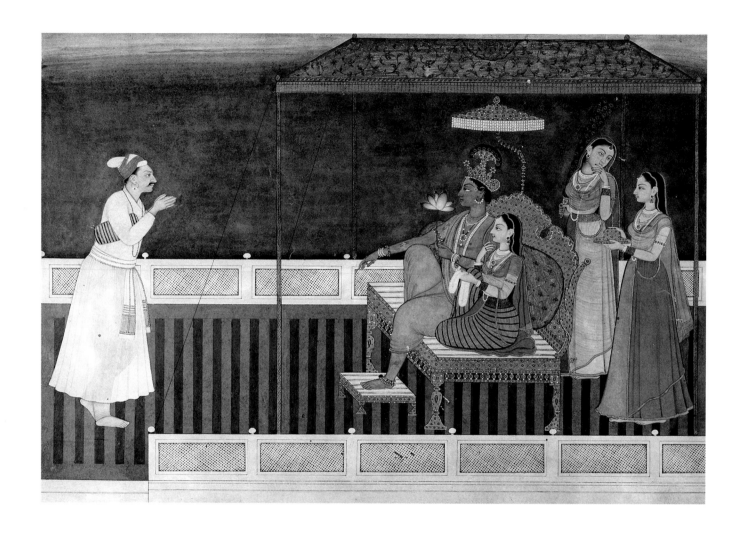

116 *Salutation to Rādhā and Kṛṣṇa*

GULER SCHOOL, C. 1750
OPAQUE WATERCOLOR WITH GOLD AND SILVER OR TIN ON PAPER, 9¾ x 12⅞″ (24.8 x 32.7 cm)
COLLECTION OF DR. ALVIN O. BELLAK

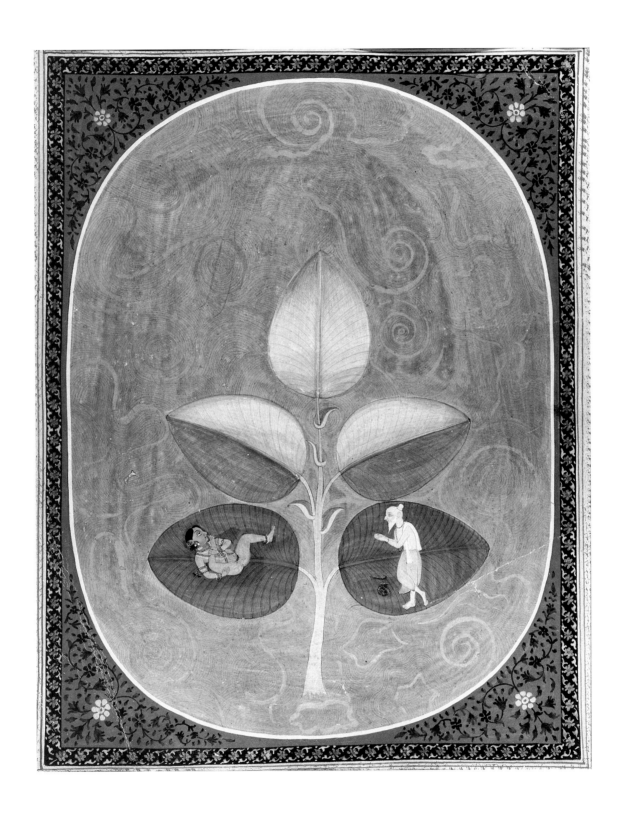

117 *The Vision of Sage Mārkaṇḍeya*

GULER SCHOOL, C. 1790
OPAQUE WATERCOLOR WITH GOLD AND SILVER OR TIN ON PAPER
12⅜ x 9¾″ (31.4 x 24.8 cm)
PRIVATE COLLECTION

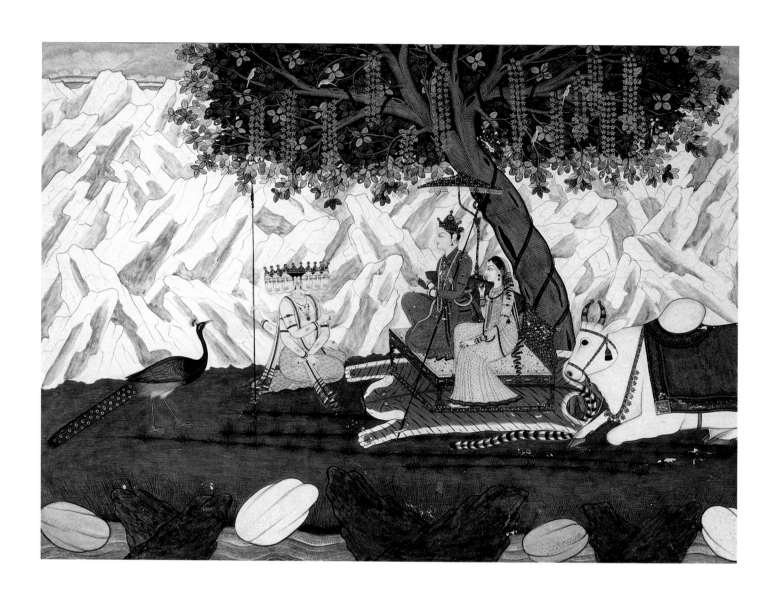

118 *Kārttikeya Addresses Śiva and Pārvatī in the Icy Himalayan Mountains*
GULER SCHOOL, 1800–1820
OPAQUE WATERCOLOR WITH GOLD ON PAPER, 14¼ x 19⅛″ (36.2 x 48.6 cm)
COLLECTION OF DR. ALVIN O. BELLAK

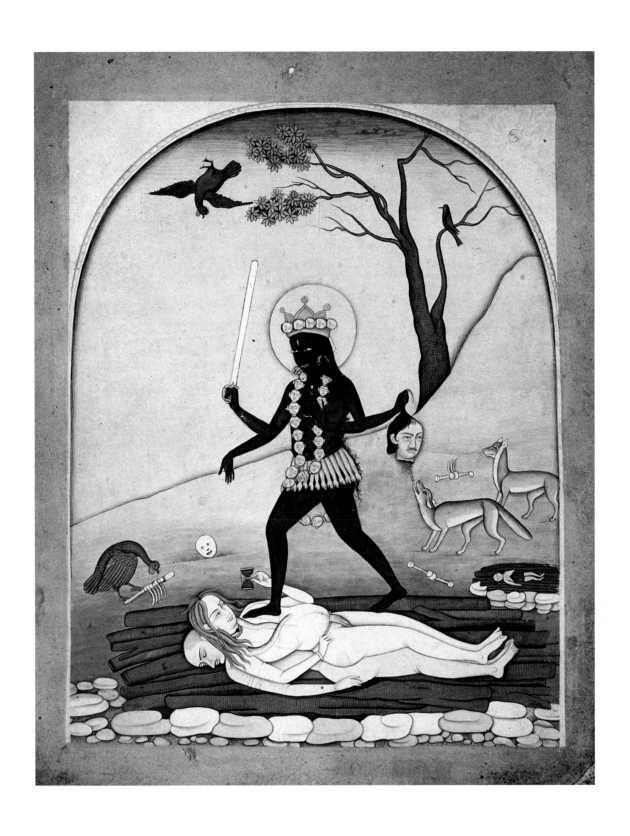

119 *The Goddess Kālī on Śiva-Śava*

GULER SCHOOL, 1820–30
OPAQUE WATERCOLOR ON PAPER, 10¼ x 8¼″ (26 x 21 cm)
PRIVATE COLLECTION

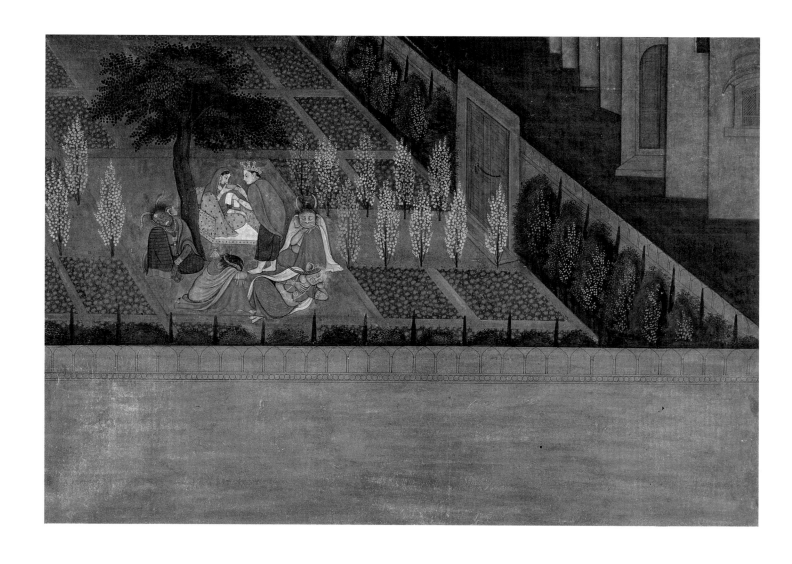

120 *God Indra Visits the Imprisoned Sītā in Rāvaṇa's Palace Garden*
While the Guardian Demonesses Sleep
KANGRA SCHOOL, 1775–80
ILLUSTRATION FROM THE *Rāmāyaṇa*
OPAQUE WATERCOLOR WITH GOLD ON PAPER, 9⅞ x 14″ (25.1 x 35.6 cm)
PHILADELPHIA MUSEUM OF ART. PURCHASED: KATHARINE LEVIN FARRELL FUND
AND JOHN T. MORRIS FUND. 1977-11-1

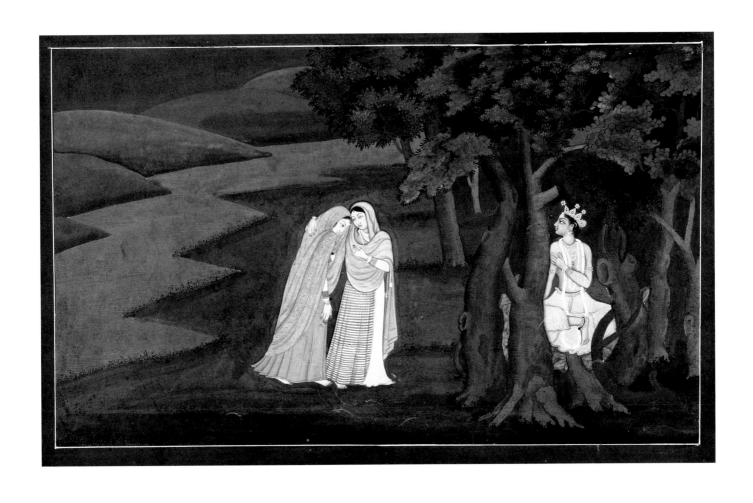

121 *Rādhā Goes to Meet Kṛṣṇa*

KANGRA SCHOOL, C. 1780
OPAQUE WATERCOLOR ON PAPER, 6¾ x 10¾" (17.1 x 27.3 cm)
COLLECTION OF DR. ALVIN O. BELLAK

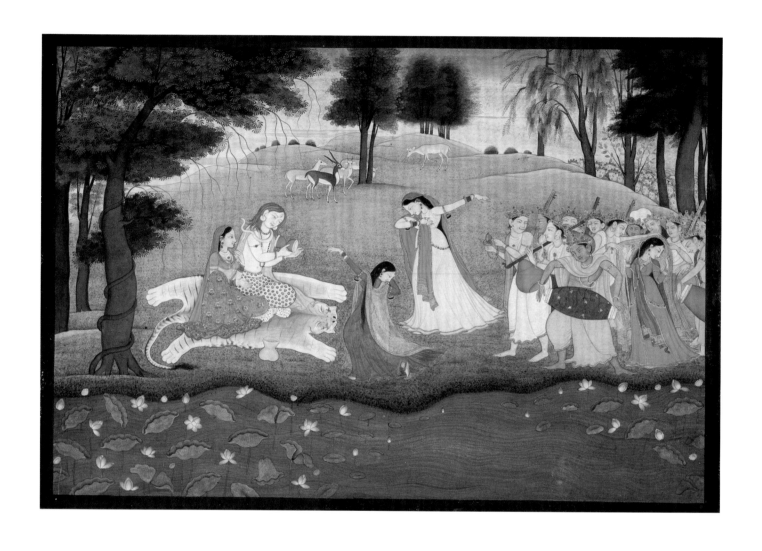

122 *Dance and Music for Śiva and Pārvatī*

KANGRA SCHOOL, 1780–90
KUSHALA AND KĀMA
OPAQUE WATERCOLOR WITH GOLD ON PAPER, 9 x 12″ (22.8 x 30.4 cm)
COLLECTION OF DR. ALVIN O. BELLAK

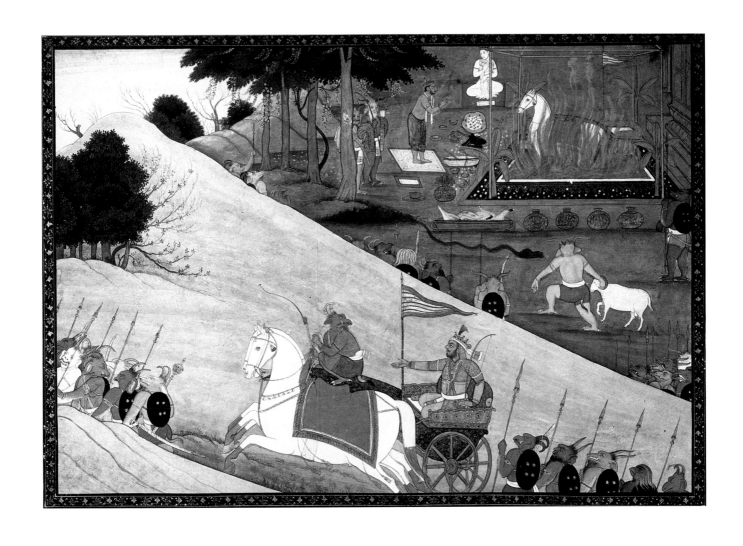

123 *The Sacrifice of Meghanāda, Son of the Demon King Rāvaṇa*

KANGRA SCHOOL, C. 1790
ILLUSTRATION FROM THE *Rāmāyaṇa*
OPAQUE AND TRANSPARENT WATERCOLOR WITH GOLD ON PAPER, 9¾ x 13⅞″ (24.8 x 35.2 cm)
PHILADELPHIA MUSEUM OF ART. PURCHASED: KATHARINE LEVIN FARRELL FUND. 1982-34-1

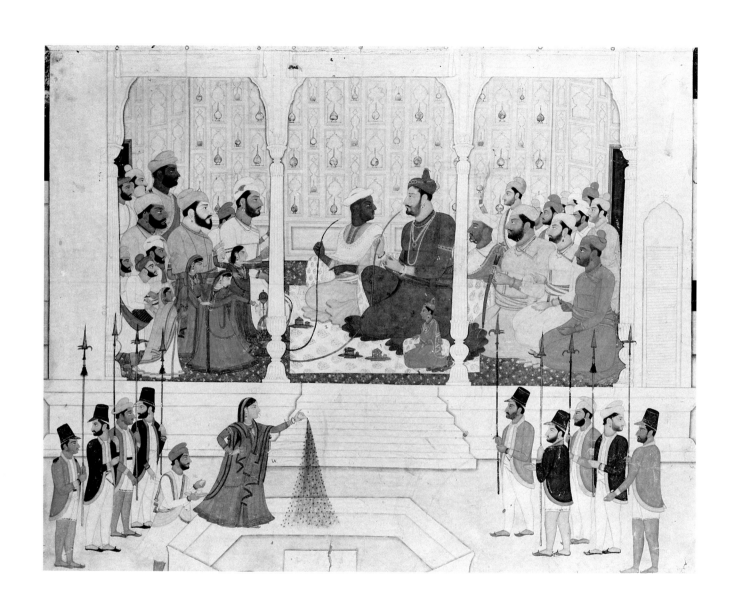

124 *Raja Sansār Chand of Kangra with His Small Son and Courtiers*
KANGRA SCHOOL, 1798–1800
OPAQUE WATERCOLOR WITH GOLD ON PAPER, 14¾ x 20″ (37.5 x 50.8 cm)
PHILADELPHIA MUSEUM OF ART. PURCHASED: JOHN T. MORRIS FUND. 55-11-3

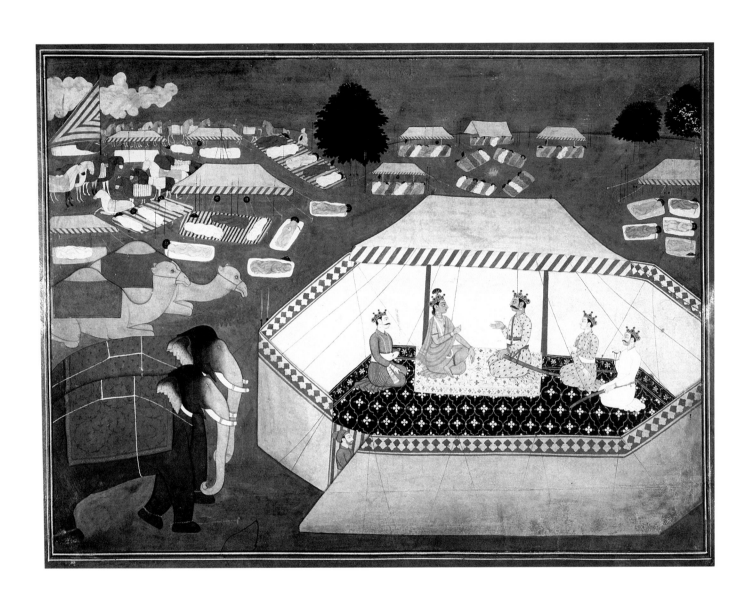

125　*The Night before the Battle*
KANGRA SCHOOL, C. 1800
ILLUSTRATION FROM THE *Mahābhārata*
OPAQUE WATERCOLOR WITH GOLD ON PAPER, 13¼ x 18½″ (33.7 x 47 cm)
PRIVATE COLLECTION

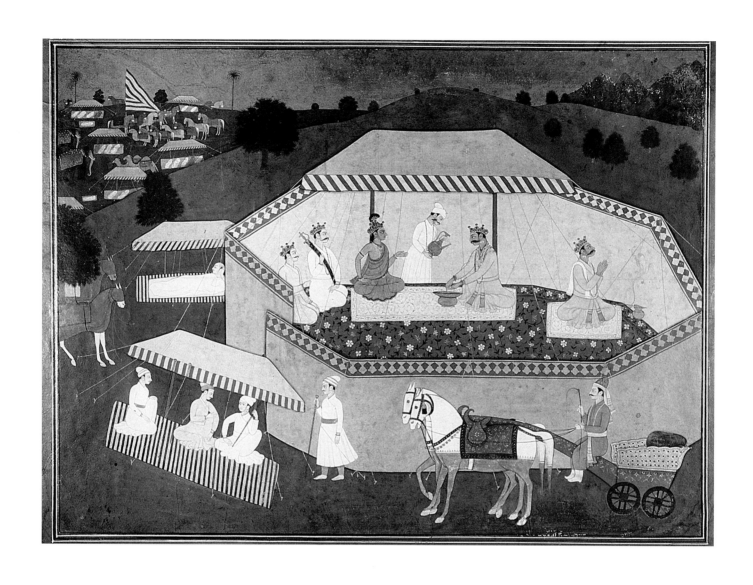

126 *Arjuna Chooses Lord Kṛṣṇa as His Charioteer*
KANGRA SCHOOL, C. 1800
ILLUSTRATION FROM THE *Mahābhārata*
OPAQUE WATERCOLOR WITH GOLD ON PAPER, 13⁹⁄₁₆ x 18⅛″ (34.4 x 46 cm)
PRIVATE COLLECTION

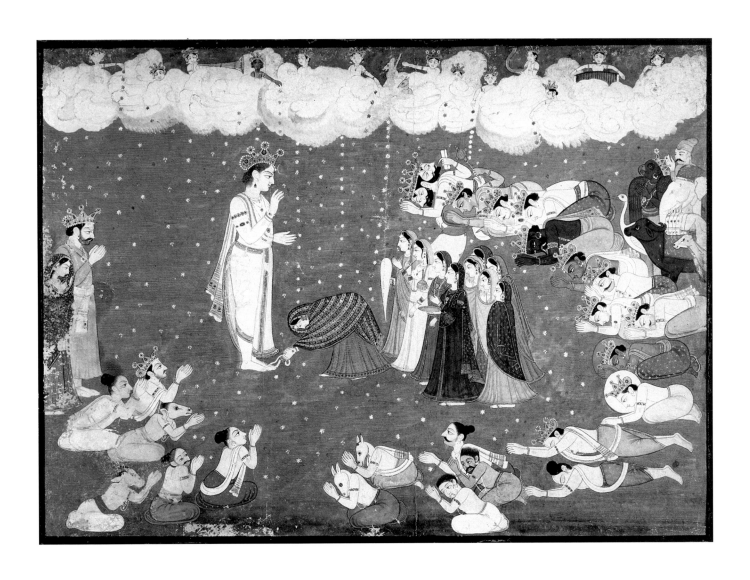

127 *Pārvatī Greets Śiva in His Beauty*

KANGRA SCHOOL, 1815–20
OPAQUE WATERCOLOR WITH GOLD ON PAPER, 13½ x 17⅞″ (34.3 x 45.4 cm)
PRIVATE COLLECTION

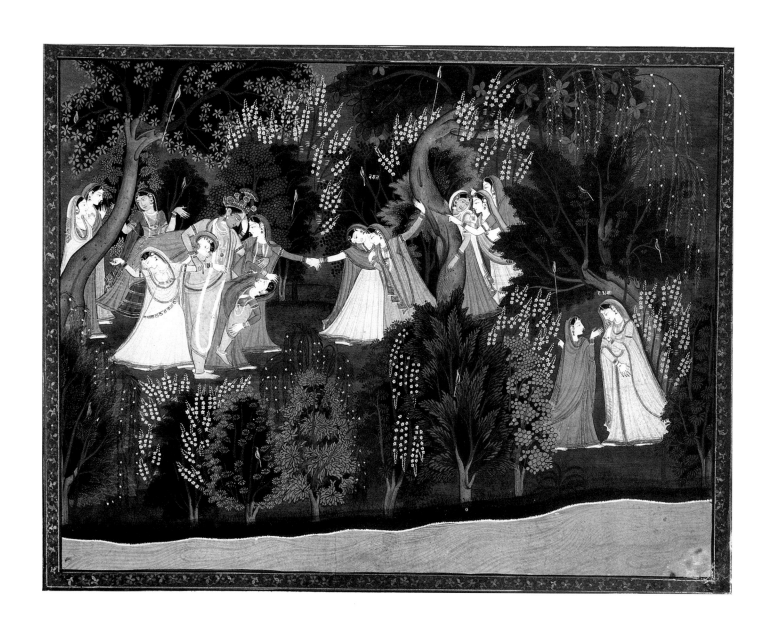

128 *Kṛṣṇa Sports with the Cowherdesses*
KANGRA SCHOOL, 1820–25
OPAQUE WATERCOLOR WITH GOLD ON PAPER, 11⅛ x 14¼″ (28.3 x 36.2 cm)
COLLECTION OF DR. ALVIN O. BELLAK

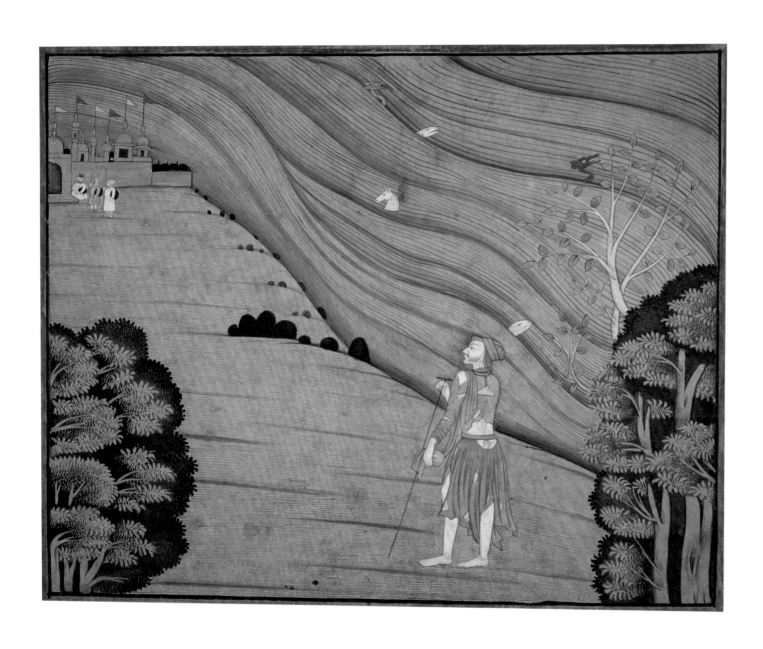

129 *Sudāman's Journey to Kṛṣṇa's Palace*
GARHWAL SCHOOL, 1775–90
OPAQUE WATERCOLOR WITH GOLD ON PAPER, 9 x 10⅞″ (22.9 x 27.6 cm)
PRIVATE COLLECTION

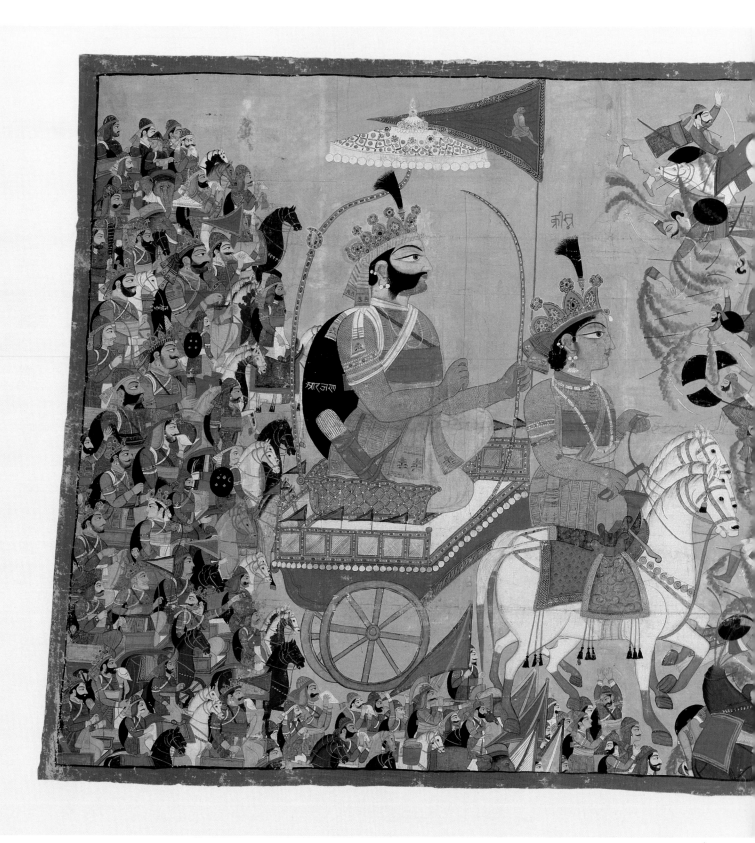

130 *Arjuna and His Charioteer Lord Kṛṣṇa Confront Karṇa*
GARHWAL SCHOOL, C. 1820
OPAQUE WATERCOLOR ON PAPER, 60 x 120″ (152.4 x 304.8 cm)
PHILADELPHIA MUSEUM OF ART. PURCHASED: EDITH H. BELL FUND. 75-23-1

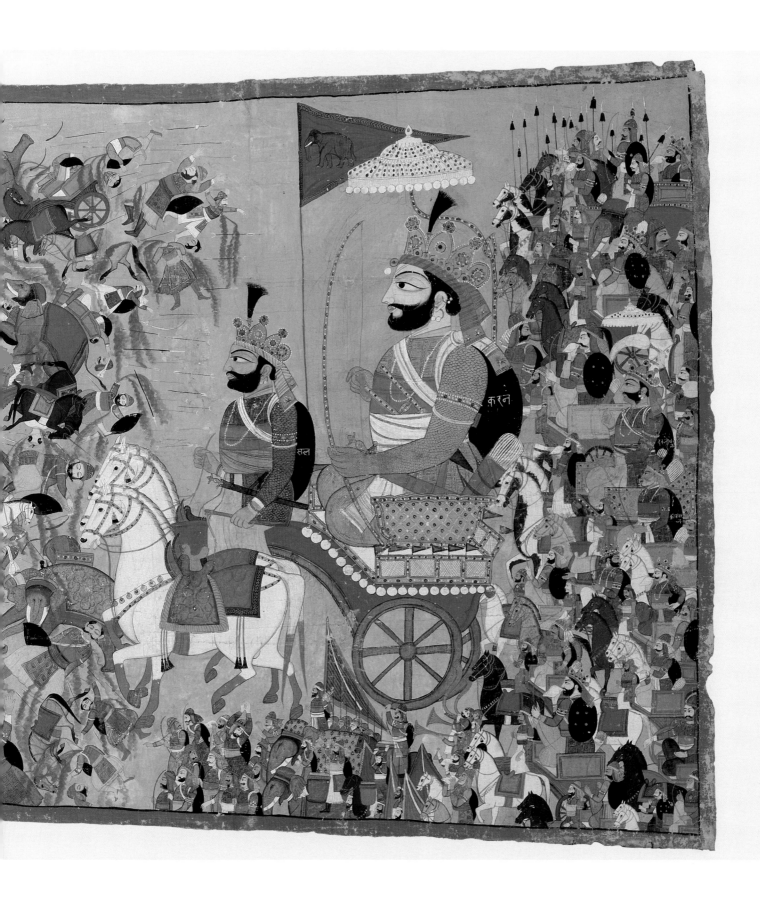

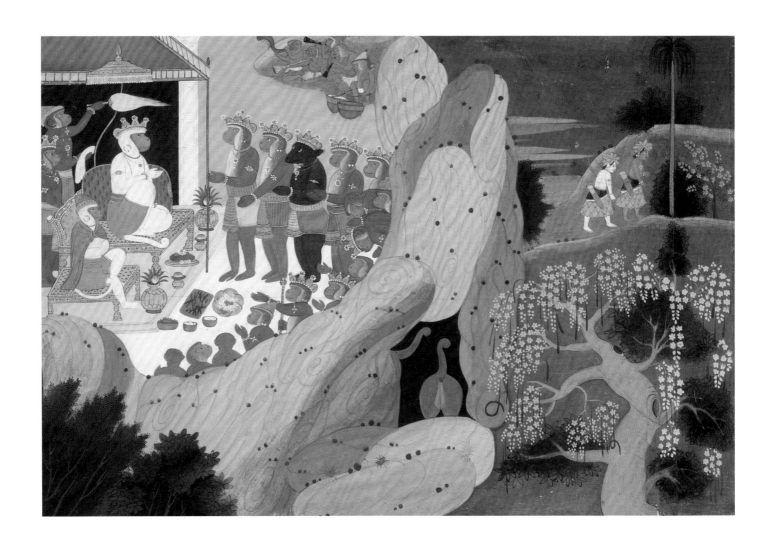

131 Coronation of Sugrīva as King of Monkeys and Installation of
Prince Aṅgada as Heir Apparent
NALAGARH (HINDUR) SCHOOL, C. 1820
ILLUSTRATION FROM THE *Rāmāyaṇa*
OPAQUE WATERCOLOR WITH GOLD ON PAPER
9⁷⁄₁₆ x 14″ (24 x 35.6 cm)
PRIVATE COLLECTION

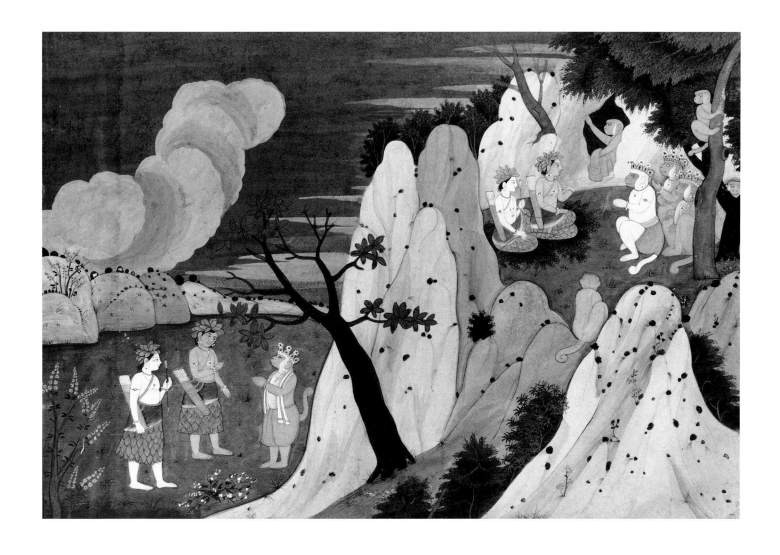

132 *Hanumān, Meeting Rāma and Lakṣmaṇa, Takes Them to the Mountain
Where Sītā's Jewels Are Kept*
NALAGARH (HINDUR) SCHOOL, C. 1820
ILLUSTRATION FROM THE *Rāmāyaṇa*
OPAQUE WATERCOLOR WITH GOLD LEAF ON PAPER
9⅜ x 13⁹⁄₁₆″ (23.8 x 34.4 cm)
PHILADELPHIA MUSEUM OF ART. GIFT OF MRS. V. K. ARORA. 1976-74-1

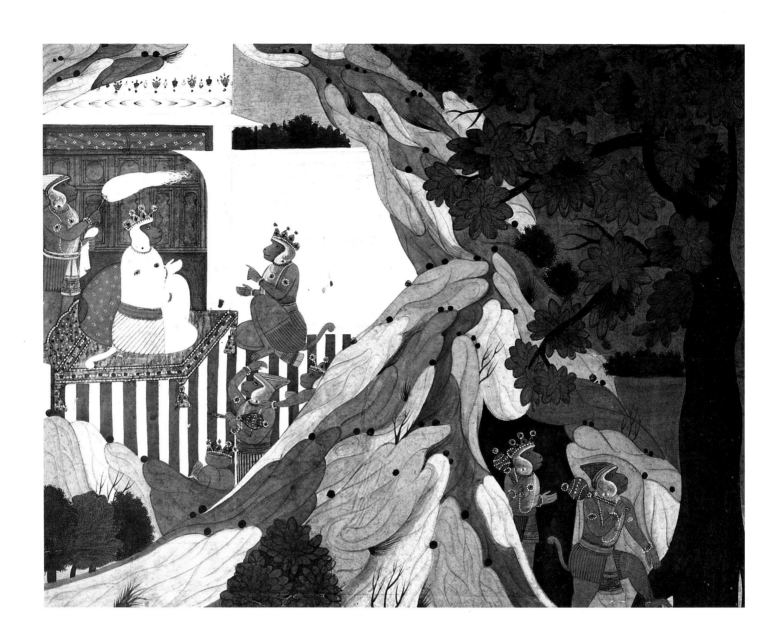

133 *The Monkey King Sugrīva Sends Emissaries Led by Hanumān to Find Sītā*

NALAGARH (HINDUR) SCHOOL, C. 1820
ILLUSTRATION FROM THE *Rāmāyaṇa*
OPAQUE WATERCOLOR WITH GOLD ON PAPER
10⅜ x 12¾" (26.4 x 32.4 cm)
PHILADELPHIA MUSEUM OF ART. GIFT OF THE BOARD OF TRUSTEES IN
HONOR OF WILLIAM P. WOOD, PRESIDENT FROM 1976 TO 1981. 1981-3-1

FOLK PAINTING

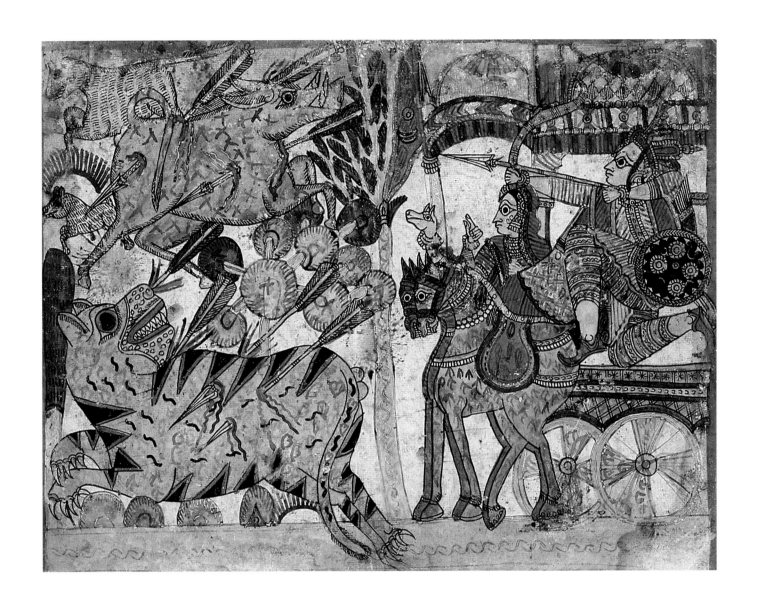

134 *Subhadrā and Abhimanyu Journey through a Forest Filled with Wild Animals*
PAITHAN SCHOOL, WESTERN DECCAN (MAHARASHTRA AND NORTHERN
KARNATAKA), AFTER 1835
OPAQUE AND TRANSPARENT WATERCOLOR ON PAPER, 12 x 15⅜" (30.5 x 39.1 cm)
PHILADELPHIA MUSEUM OF ART. GIFT OF THE FRIENDS OF THE MUSEUM. 68-12-5

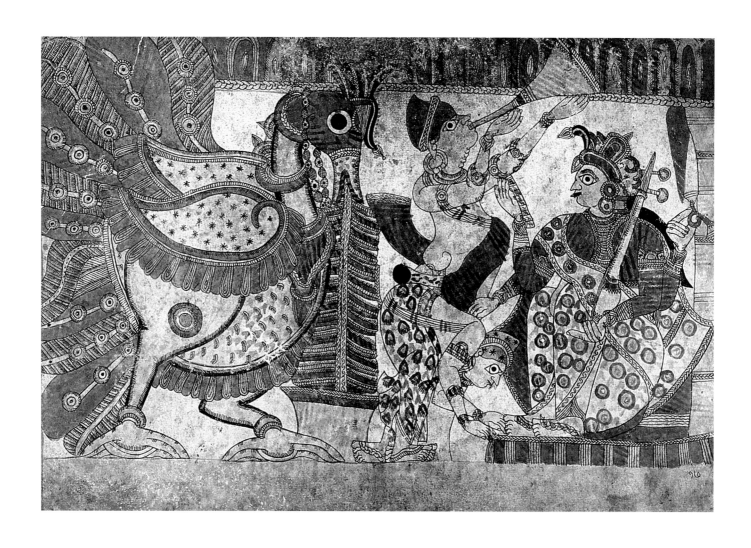

135 *The Goddess Sarasvatī and Her Peacock*
PAITHAN SCHOOL, WESTERN DECCAN (MAHARASHTRA AND NORTHERN
KARNATAKA), 1830–50
OPAQUE WATERCOLOR ON PAPER
11½ x 16½" (29.2 x 41.9 cm)
PRIVATE COLLECTION

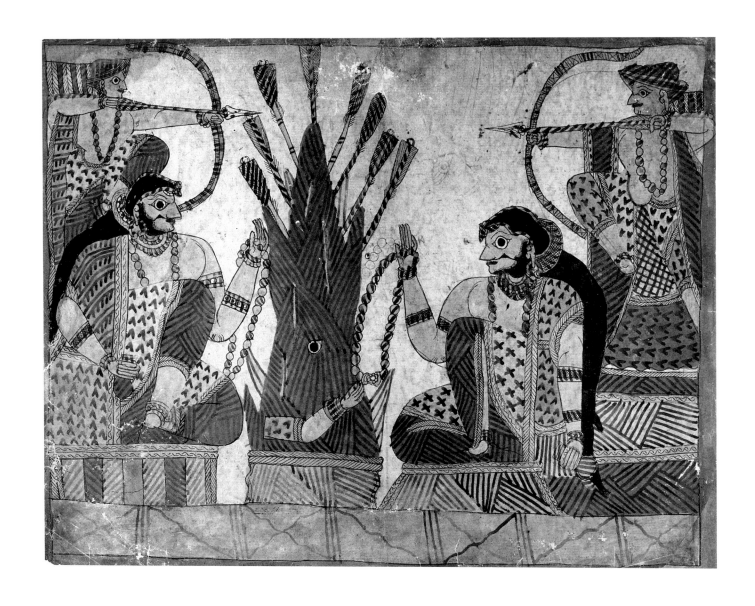

136 *Indrajit's Sacrifice*
PAITHAN SCHOOL, WESTERN DECCAN (MAHARASHTRA AND NORTHERN
KARNATAKA), 1850–75
OPAQUE WATERCOLOR ON PAPER, 12³⁄₁₆ x 15¹⁵⁄₁₆″ (31 x 40.5 cm)
PRIVATE COLLECTION

137 *Woman with a Rose*
KALIGHAT SCHOOL, WEST BENGAL, C. 1875
INK ON PAPER, 17⅞ x 10½″ (45.4 x 26.7 cm)
PRIVATE COLLECTION

138 *Woman with a Parrot*
KALIGHAT SCHOOL, WEST BENGAL, C. 1875
INK ON PAPER, 18³⁄₁₆ X 11″ (46.2 X 27.9 cm)
PRIVATE COLLECTION

CATALOGUE

PRE-MUGHAL PAINTING

1 God Indra Instructs Hariṇaigameṣin to Transfer Mahāvīra's Embryo from the Brāhmaṇī Devānandā to Queen Triśalā

WESTERN SCHOOL, NORTH GUJARAT, 1432
ILLUSTRATION FROM THE *Kalpasūtra*
OPAQUE WATERCOLOR WITH GOLD ON PAPER
5⅛ x 13" (13 x 33 cm)
PHILADELPHIA MUSEUM OF ART.
ANONYMOUS GIFT. 67-226-1(7)

2 Queen Triśalā on Her Couch

WESTERN SCHOOL, NORTH GUJARAT, 1432
ILLUSTRATION FROM THE *Kalpasūtra*
OPAQUE WATERCOLOR WITH GOLD ON PAPER
5⅛ x 13" (13 x 33 cm)
PHILADELPHIA MUSEUM OF ART.
ANONYMOUS GIFT. 67-226-1(11)

3 The Interpreters of the Fourteen Dreams

WESTERN SCHOOL, NORTH GUJARAT, 1432
ILLUSTRATION FROM THE *Kalpasūtra*
OPAQUE WATERCOLOR WITH GOLD ON PAPER
5⅛ x 13" (13 x 33 cm)
PHILADELPHIA MUSEUM OF ART.
ANONYMOUS GIFT. 67-226-1(20)

These paintings depict three events in the life of the savior Mahāvīra, the last of the twenty-four Jain saviors, who are successively born over the aeons. Their story, which is the same in each case, is told in the *Kalpasūtra,* a canonical text of the Jain religion. The savior in heaven decides to be born on earth from a woman of the Brahman, or priestly, caste. God Indra, however, instructs the genie Hariṇaigameṣin to transfer Mahāvīra's embryo from the womb of the Brāhmaṇī Devānandā to that of a woman of the ruling, or Kṣatriya, caste (no. 1). Having first induced Devānandā into a deep sleep, Hariṇaigameṣin transfers the embryo from her womb to that of the sleeping Queen Triśalā (no. 2), who has fourteen propitious dreams, which she relates to her husband. The king summons the astrologers and interpreters of dreams, who array themselves in auspicious garments and go to the palace, where seats of honor have been prepared for them. They recite the texts on dreams and assure the king that the child will be either a universal emperor or a savior (no. 3).[1]

The three illustrations are typical of fifteenth-century Jain book illustration in the ornamental disposition that divides the entire painted field into sections. Those containing the figures are separated from the architectural units, which indicate their palatial setting. Both the royal and divine protagonists, their heads surrounded by large bead-encircled nimbuses, and the lesser figures appear in similar splendor. The pattern of the astrologers' cush-

ioned seats, with its device of encircled flowers,[2] is also used for the upholstery of the queen's bedstead; her ample figure rests under a coverlet patterned with the Indian wild-gander motif. This is shown off in color against yet another pattern of a dotted veil, which forms the background of the stupendous textile display of this painting from Gujarat, which was always a center of textile production and export. The motif of the gander (whether arranged in a row in bilateral symmetry at the bottom of the painting or perched on either side of the palace architecture in the top panel), the patterned hanging in the queen's chamber, and the tasseled fan are elements of unrest gathered in waves such as those that border the dotted background of the queen. Their curves respond to those of the queen's sinuous body. Her full face in three-quarter profile has its pointed nose silhouetted against the disc of the nimbus on which the unforeshortened farther eye projects. Her eyes remain open although she is asleep.

Drapery in billowing curves binds Indra's voluminous girth and amplifies Hariṇaigameṣin's obedient figure, and it is tossed away from the body of each of the four soothsayers in gusts that blow to the right and to the left. Nervous hands gesticulate, holding the scrolls from which the soothsayers read the fortune of the savior-to-be. Pointed noses, eyes, and beards acutely convey a sense of suspension, and the fluttering garments, their ends also drawn out in points, magnify it. Triangulation of fluttering garments spread to other Indian schools, which into the sixteenth century remained free from the tensions of the Western Indian school of painting (see no. 4).

1. See Brown, 1934, pl. 4, figs. 11–12, pls. 5, 15, fig. 51.
2. The large flower pattern is peculiar to the tailored coat of the Sahi chief, whose figure is conspicuous in miniatures of the Western Indian school from the fourteenth century on; see Khandalavala and Chandra, 1969, p. 23, pl. 3; and Barrett and Gray, 1963, repro. p. 57. The coat of another northern nobleman, with its encircled animal design, in an eleventh-century wall painting in Alchi is even more splendid; see Pal, 1982, pl. D23. Turko-Iranian and Indian motifs are combined in this luxurious garment.

PUBLISHED
Philadelphia Museum of Art Bulletin, vol. 63, no. 298 (July–September 1968), cover [no. 2]; Stella Kramrisch, "Jaina Painting of Western India," in Shah and Dhaky, eds., 1975, pls. 1–2 [nos. 1–2].

4 Kṛṣṇa and Balarāma, Arriving in Mathurā, Plan to Confront Kaṁsa

DELHI-AGRA AREA, 1525–50
ILLUSTRATION FROM THE *Bhāgavata Purāṇa*
OPAQUE WATERCOLOR ON PAPER
7 x 9" (17.8 x 22.9 cm)
PRIVATE COLLECTION

Book Ten of the *Bhāgavata Purāṇa,* which relates the story of Lord Viṣṇu in his form or incarnation as Kṛṣṇa, tells of the demonic tyrant king Kaṁsa, who in order to kill Kṛṣṇa invites him to a tournament in Mathurā, the capital of his kingdom. This painting shows Kṛṣṇa and his brother Balarāma on their arrival in the city

with its crossroads and residences, rows of shops, courtyards, and stalls of different classes of artisans festively decorated with flowers and waterpots anointed with sandalwood paste. In their eagerness to see Kṛṣṇa and Balarāma, the women of the town have rushed to the roofs of their houses. As they go along, Kṛṣṇa and Balarāma are presented with garments and ornaments. The flower vendor Sudāman offers garlands of the finest and most fragrant flowers to Kṛṣṇa; he sings hymns to Kṛṣṇa and is blessed by him (*Bhāgavata Purāṇa*, 10.41).

The excitement in the busy town of Mathurā is conveyed by the group of Kṛṣṇa, Balarāma, and cowherders moving along the main road and the citizens in their various activities arranged in rectangular compartments with reference to Kṛṣṇa. The arrangement does not always work (for example, the lower group of three seated men at right in the central horizontal panel is upside down), but this does not disturb the vivacity of the presentation. The partitioning of the painted field, an ancient device, functions here in a twofold manner; it separates the scenes, each a kind of residential unit, and evokes a suggestion of crossroads. Connectedness of the panels is emphasized by the overlapping of dividing lines by leaves, the ends of garments, and even by the eager people on the roofs, who extend flower garlands into adjacent compartments. The sprightly relation of pictorial scaffold and figural composition likewise informs several groups of swaggering figures. The male figures, excluding the gods, wear tailored, transparent jamas—a Muslim fashion—and turbans around their prominent central caps.[1]

1. For other pages from this *Bhāgavata Purāṇa,* see Khandalavala, Chandra, and Chandra, 1960, p. 24, nos. 12a–b, pl. A, fig. 20; Welch and Beach, 1965, frontispiece, p. 56, pl. 36, pp. 115–16, nos. 3a–b; Museum of Fine Arts, Boston, 1966–67, p. 101, no. 146A; Portland Art Museum, 1968, pp. 4–5, nos. 1a–c; Welch, 1973, pp. 24–25, nos. 6a–b; Hutchins, 1980, p. 20, fig. 2, p. 32, fig. 6, p. 47, fig. 12, p. 53, fig. 14, p. 59, fig. 15, p. 67, fig. 18, p. 95, fig. 27; Beach, 1981, p. 35, no. 3b; Heeramaneck, 1984, pp. 32–34, pls. 6–11; Lerner, 1984, p. 143, no. 56; and Ehnbom, 1985, pp. 24–25, nos. 1–2.

5 *The Victory of Pragjyotiṣa*
DELHI-AGRA AREA, 1525–50
ILLUSTRATION FROM THE *Bhāgavata Purāṇa*
OPAQUE WATERCOLOR ON PAPER
6⅞ x 9″ (17.5 x 22.9 cm)
COLLECTION OF DR. ALVIN O. BELLAK

In the *Bhāgavata Purāṇa* the story is told of King Naraka (Hell), a demon son of Viṣṇu and Bhūmī, the Earth (10.59.1–39). Naraka steals the magic earrings ("removers of grief") of Aditi, mother of Indra and the other gods, and builds an impregnable fortress, Pragjyotiṣa, of mountains, weapons, water, fire, and wind. Viṣṇu/Kṛṣṇa and his wife Satyabhāmā, mounted on Garuḍa, his bird vehicle, fly to the city, shatter its defenses, and sever Naraka's head. Bhūmī then brings the earrings to Viṣṇu/Kṛṣṇa, who returns them to Aditi.

On the right of this painting, which is from the same manuscript as the previous illustration (no. 4), is a wide arch surrounding the impregnable fortress where Naraka sits in discussion with his mother, Bhūmī, while an attendant in an adjacent room seems to listen to them. On the left another arch rises above Viṣṇu/Kṛṣṇa, enthroned with his wife on a large lotus held high by Garuḍa, his sunbird–man carrier. Bhūmī, mother of the dead

Naraka, and his son approach Viṣṇu/Kṛṣṇa to return the stolen earrings, which she carries in a bowl.

The spontaneous and ebullient composition is made convincing by its simplicity. A painter accustomed to arranging figures in narrow strips—such as those of palm leaf—could have devised the arches combining the single scenes and articulating the context of the entire story. The painting is laid out in contrasting color fields, with glowing red areas predominating. The stepped panel between the two main sections, filled by a floral arabesque of Persian origin, is partly overlapped by Garuḍa's wing and garment; but for this detail and the figure of Naraka's son approaching Viṣṇu/Kṛṣṇa, overlapping is avoided. With archaic clarity, the figures in three-quarter profile—their faces in profile, the large eyes unforeshortened—are calm yet alert and lively in their actions. The divine manifestation of the Dark God blazes forth on his radiant lotus throne. The gestures of the figures, though immediate in expression, are restrained. As Bhūmī carefully walks behind Naraka's impetuous son, the elegant line of her figure—her long tress following the curves of her body—is emphasized by her tightly wrapped horizontally striped skirt. Naraka and his son wear jamas, a contemporary Muslim costume.

PUBLISHED
McInerney, 1982, p. 53, no. 20.

6 *Brahmā Offers Homage to Kṛṣṇa*
RAJASTHAN(?), c. 1570
ILLUSTRATION FROM THE *Bhāgavata Purāṇa*
OPAQUE WATERCOLOR ON PAPER
7¼ x 10⅛″ (18.4 x 25.7 cm)
COLLECTION OF DR. ALVIN O. BELLAK

This leaf from a *Bhāgavata Purāṇa,*[1] larger in format and later in date than the two preceding illustrations (nos. 4–5), gives to the story of Kṛṣṇa a new cast. One of the most subtle feats of the young Kṛṣṇa is his removal of Brahmā's illusion, an episode related in the *Bhāgavata Purāṇa* (10.13). After the young cowherders, Kṛṣṇa's companions, have had their evening meal and the cows are grazing, some of the calves wander into the forest. God Brahmā, eager to see another of Kṛṣṇa's heroic feats, abducts the cattle and cowherders, and hides himself also. Kṛṣṇa, at once suspecting Brahmā's misdeed, assumes the shape of the cattle and cowherders—he being identical with all of them, God being identical with the universe. In this way, "sporting with his own self," Kṛṣṇa drives back the cattle to their pens and returns the cowherders to their houses. For nearly a year life goes on as before until Brahmā suddenly sees each cowherder in the form of Viṣṇu/Kṛṣṇa, his four hands holding his divine emblems. Then Kṛṣṇa removes the illusion from Brahmā, and not a year, not even a second, has passed. Trembling, Brahmā folds his hands in worship and praises Kṛṣṇa.

A clouded sky hangs like a canopy over this scene. The divine actors are divided from cattle and cowherders by a bold framing device. The figures wear flowing Indian garments, which enhance their smooth, fulsome beauty. Their scarves terminate with a triangular flourish, a mannerism inherited from the Western Indian school of painting (see nos. 1–3). Resplendent crowns with radiant flowers draw attention to the noble figures of Kṛṣṇa and Balarāma. Brahmā, with his four faces, looks to the right and to the left; the pupils of his eyes, like those of the other figures, do not occupy the middle of the unforeshortened eyes but seem to have moved in the

153

directions toward which the faces are turned. Brahmā, holding a large book (the Vedas) and a waterpot as conspicuous marks of his identity, joins the palms of his main hands in worshipful salutation to Lord Kṛṣṇa.

Cattle and cowherders are freely, rhythmically distributed on the monochrome ground outside the enclave of the gods. Their caplike turbans neatly fit their heads; their scarves flutter, while those of Kṛṣṇa and Balarāma overlap the border. Kṛṣṇa's position links his person as god with the world of cowherders and cattle, which is his other form. The cattle below Kṛṣṇa strain forward and turn their heads in the opposite direction, further drawing attention to Kṛṣṇa's position.

The inscription above the painting renders the words spoken by Brahmā in the *Bhāgavata Purāṇa* (10.14.38):

> O Lord, to say anymore would be useless.
> He who knows you, indeed, shall always know you.
> It is beyond the power of mind, body, and
> speech to fully comprehend your majesty.

1. Other pages of this *Bhāgavata Purāṇa* are illustrated in Spink, 1971, p. 5, fig. 11, p. 102, fig. 117; Welch, 1973, pp. 26–27, no. 7; Khandalavala and Mittal, 1974, figs. 1–4; Hutchins, 1980, p. 27, fig. 4, p. 87, fig. 25, p. 89, fig. 26, p. 104, fig. 31; and Lerner, 1984, pp. 148–51, no. 58.

PUBLISHED
Christie's, London, October 16, 1980, p. 98, no. 215.

MUGHAL PAINTING

7 *King Tisūn Receives the Good News That Mahābat, Son of King Sharīf, Will Be His Ally*
MUGHAL SCHOOL, 1562–77
ILLUSTRATION FROM THE *Hamza-nāma*
OPAQUE WATERCOLOR WITH GOLD ON CLOTH
31⅛ x 24⅞″ (79 x 63.2 cm)
FREE LIBRARY OF PHILADELPHIA. RARE BOOK
DEPARTMENT, JOHN FREDERICK LEWIS COLLECTION

This is one of the 1,400 folios of the *Hamza-nāma* illustrated at the court of Akbar (see Introduction). This romantic tale is the story of Amir Hamza, a Persian insurrectionist during the reign of Harun-al-Rashid, later identified with an uncle of the Prophet Muhammad.[1] Three hundred and sixty stories, in a mixture of fact, folktale, and fiction, tell of the wild exploits and fantastic adventures of Amir Hamza.

In this illustration the large figure of King Tisūn sits on a throne under a canopy on fenced-off ground listening attentively, surprisedly, and thoughtfully to the good news that a messenger furtively whispers into his ear. The king's burly figure is modeled three-dimensionally; his head inclined, in three-quarter view, conveys a psychologically complex moment, which is also expressed by the gesture of his hands and the posture of his body. Naturalistic observation and psychological empathy are also apparent in the figure of the informant. The others within the parapet are more or less interested onlookers, who help to define the extension of the enclosure in three dimensions.

In front of the parapet are a group of horses and retainers

staggered in depth behind some rocks. Within the parapet, another group of men, several seen from behind, is stationed in front of the king's dais. To the right, before a mighty tree, six figures balance the main group of king, messenger, and three others.

Behind (that is, above) the canopy, a lattice fence surrounds the encampment. A railing of straight posts enclosing additional figures of considerable size—including a camel—extends to the top of the painting. On the left, above the lattice fence, a crowded architectural scene allows a vista of walls, pillars, and turrets, all three-dimensional, in a perspective of their own.

The angled parapets and fences represented simultaneously in front and from a bird's-eye view create space receptacles filled with modeled figures. The total effect is not that of guiding the spectator into the picture; rather, it opens up spaces that have come forth with their figures. This coming toward instead of receding from the spectator is the mode in which modeled figures, through foreshortening and overlapping, are employed by the painter. This kind of pictorial organization allows pervasive rhythms to interlace and bind the shapes in the several planes of the painting. The relative size of the figures is conditioned less by their distance in depth than by their importance in the context of the story.

However different they are in quality and manner, the some 140 preserved paintings of the *Hamza-nāma* have an unmistakable unity; their density recalls that of the wall paintings of Ajanta. This unity resulted from Akbar's vision, which initiated and inspired his artists. Whether Akbar had seen the Indian wall paintings of one thousand years earlier is not known, but his 1564 campaign in the vicinity of the Bagh cave paintings is recorded in the *Akbar-nāma*.[2]

1. Chandra, 1976, p. 62.
2. *The Akbar Nāma of Abu-l-Fazl*, trans. H. Beveridge (Delhi, 1977), vol. 2, p. 346; and Chandra, 1976, pp. 68–69. The possibility of fifth-century wall paintings still having existed on the walls of structural buildings in the sixteenth century is also considered by Chandra (p. 69 n. 52).

PUBLISHED
Pennsylvania Academy of the Fine Arts, Philadelphia, 1923–24, pp. 17, 74, no. 77.

REFERENCES
Glück, 1925; Chandra, 1976, pp. 68–69; Welch, 1978, pp. 40–45, pls. 1–3; Beach, 1981, pp. 58–65.

8 *A Follower of Amir Hamza Attacks Tahmasp*
MUGHAL SCHOOL, 1562–77
ILLUSTRATION FROM THE *Hamza-nāma*
OPAQUE WATERCOLOR WITH GOLD AND
SILVER OR TIN ON CLOTH
31 x 25½″ (78.7 x 64.8 cm)
PHILADELPHIA MUSEUM OF ART. GIFT BY EXCHANGE
WITH THE BROOKLYN MUSEUM. 37-4-1

The melee of two uneven combatants is laid out in muted colors in this illustration from the *Hamza-nāma*. The protagonists are set off on their contrasting mounts against fantastic rocks that rise in foaming curves above the dark ground, which is streaked by tufts of vegetation. The scale of the painting is set by the tree in the lower right corner; its short trunk seems to bend under the weight of ballooning masses of foliage, which vie in density with the minute patterns that fill the armor of the falling horse and the costumes of the combatants. In contrast with such elaborate minutiae is the camel's modeled body, which bulges as it is compressed by the

trappings and the costume of its rider. The animal's wide eyes, like those of the combatants, gaze out unseeing.

The forward movement of the attacker is strengthened by that of his flying scarf. The sword of Tahmasp, raised high but in vain, is a strong accent, one of the intersecting diagonal elements by which this painting, like the preceding one (no. 7), is organized. Density of form also is common to both works from the *Hamza-nāma*. The painting of King Tisūn shows space receptacles filled with objects of three-dimensional extent, be they human, animal, plant, or architecture. Here, the strong, cusped outline of the hills frames and forms the background of the main scene; above this boundary line, staggered figures of warriors fill the corners of the painting.

PUBLISHED
Maurice S. Dimand, "Several Illustrations from the Dastan-i Amir Hamza in American Collections," *Artibus Asiae,* vol. 11, nos. 1–2 (1948), p. 6, fig. 1.

9 The Holy Family
MUGHAL SCHOOL, 1585–90
OPAQUE WATERCOLOR WITH GOLD ON PAPER
18¹/₁₆ x 11″ (45.9 x 27.9 cm)
FREE LIBRARY OF PHILADELPHIA. RARE BOOK
DEPARTMENT, JOHN FREDERICK LEWIS COLLECTION

An inscription added subsequently to the second border of this painting identifies it as "painted by Mānī" (Kār Mānī Musavir). This prominent artist of the Imperial Mughal studio is known from the illustrations he contributed to several books: the *Darab-nāma* (c. 1580), *Razm-nāma* (c. 1582–86), *Bābur-nāma* (c. 1591), the *Khamsa* of Nizami (dated 1595), and *Jami-al-Tawarikh* (dated 1596).[1]

The Holy Family, although not a copy, follows the style of Italian Mannerist painting of the mid-sixteenth century. The Virgin's face is that of an Indian woman, and Saint Joseph's also has an Oriental cast. He is shown looking up from a book, an occupation not familiar in his iconography in European paintings;[2] in this respect his figure can be compared with *A Learned Man* attributed to Basawan (private collection).[3] The Virgin, enthroned on a Savonarola chair, listens as the infant with a resolute gesture turns toward Joseph, who sits on a massive couch. Both the Virgin and Joseph wear draped garments, their folds excessively exaggerated. This adds ponderousness to the group and transfers the spontaneity of their gestures into a realm of monumental grandeur, over which arch the high vaults of the architectural setting. Beyond is a view into the distant landscape, where wooded hills recede under a luminous blue sky. In the foreground are tufts of flowering plants, a cat, a vessel, and a cup.

The billowing fabric of the ample shawls draped around the figures and the convoluted folds of the curtain in the arch exceed the intricacies of contemporary Italian Mannerism. Such closely arranged, stiff and brittle folds appear earlier in some of the paintings of the *Hamza-nāma* and are reminiscent of the treatment of drapery in fourteenth-century Persian paintings from Tabriz.[4] Billowing curtains were favored motifs in other Mughal paintings in the European manner.[5]

This painting assigned to Mānī seems to be about contemporary with *Woman Nursing a Child* of about 1590 (private collection).[6] The glowing depth of color of Mānī's *Holy Family* makes this painting in European style an important work of Emperor Akbar's studio.

1. See Beach, 1981, pp. 215, 217, 221–22, 225.
2. *The Holy Family* (National Gallery, London), by the Flemish painter Joos van Cleve, shows Joseph reading a book. (This was kindly pointed out by Carl Strehlke, Assistant Curator, John G. Johnson Collection, Philadelphia.)
3. Welch, 1976, p. 35, no. 7.
4. See Gray, 1961, pp. 25, 32.
5. See Beach, 1976, p. 182.
6. Beach, 1978, pp. 51–52, no. 8.

10 Evacuation of the Royal Castle at the Battle of Asfara in May 1494
MUGHAL SCHOOL, 1589
ILLUSTRATION FROM THE *Bābur-nāma*
OPAQUE WATERCOLOR WITH GOLD AND
SILVER OR TIN ON PAPER
13½ x 8⅞″ (34.3 x 22.5 cm)
FREE LIBRARY OF PHILADELPHIA. RARE BOOK
DEPARTMENT, JOHN FREDERICK LEWIS COLLECTION

The *Bābur-nāma* is the journal of Bābur, the first Mughal emperor of India and grandfather of Emperor Akbar. Written by Bābur in Chagatai Turki, it was translated into Persian and four illustrated copies were made. This and the following two paintings (nos. 11–12) are from the first *Bābur-nāma,* from 1589, which originally had 191 illustrations.[1]

This is a scene of the battle of Asfara, which took place in 1494, long before Bābur had entered India and was proclaimed sovereign ruler after the battle of Panipat (1526). The forward thrust of the evacuation from the castle emanates from the back of the fortress, where the broad facade of a building is partly covered by an inscription. Conceptual perspective, combining a bird's-eye view with multiple perspective, allows the fortress to be seen simultaneously from within and without its walls; elements of European perspective also are combined with the Mughal—that is, Perso-Indian—perspective. The density of the figure-filled interior and exterior of the fortress is increased by shading, thus giving substantiality to the distortions of the walls and to the buildings within them. A high horizon reveals a view of the sky beyond the rocks of the hilly landscape.

The painting is mounted on a page from the *Fahrang-i-Jahangiri,* a Persian dictionary that was commissioned by Emperor Jahangir in 1607–8.[2]

1. Smart, 1973. The subjects of these paintings are identified on the basis of *The Bābur-nāma,* trans. A. S. Beveridge (1922; reprint, New York, 1971), pp. 52–53.
2. See Portland Art Museum, 1973–74, pp. 72–73, nos. 46a–b.

11 Bābur and His Men Cross the River at Bilah, near Multan
MUGHAL SCHOOL, 1589
ILLUSTRATION FROM THE *Bābur-nāma*
OPAQUE WATERCOLOR WITH GOLD LEAF ON PAPER
11¼ x 7⁵/₁₆″ (28.6 x 18.6 cm)
PHILADELPHIA MUSEUM OF ART.
GIFT OF MR. AND MRS. WILLIAM P. WOOD
IN HONOR OF DR. STELLA KRAMRISCH

In the *Bābur-nāma* Bābur tells how his forces, both men and horses

in mail, plunged into the river at Bilah and crossed to an island, some being drowned in the attempt. Most of the villagers crossed by boat to the other side of the river, but some were seen standing on the island.[1] This painting from the first *Bābur-nāma* is in three horizontal sections.[2] At top, villagers on the island present a rural idyll; in the center, others ride in their boat on the foaming waves; and at bottom, another boat is being pulled ashore. The three sections are separated by the crests of the waves; they are linked pictorially by diagonal elements in the composition. The tall boatman at right cuts across and links the two upper registers. Some of the figures in the boat and the men pulling the other boat ashore are drawn with the immediacy of actual observation.

1. *The Bābur-nāma,* trans. A. S. Beveridge (1922; reprint, New York, 1971), p. 237.
2. The painting is the right half of a double-page illustration; the left half is in the collection of Prince Sadruddin Aga Khan (letter to the author from Ellen Smart, Saunderstown, R.I., May 12, 1985).

12 At a Party in Herat Given in 1507 for Emperor Bābur, a Roast Duck Is Carved for Him by His Cousin

MUGHAL SCHOOL, 1589
ILLUSTRATION FROM THE *Bābur-nāma*
OPAQUE WATERCOLOR WITH GOLD ON PAPER
13⅞ x 9⁹⁄₁₆″ (35.2 x 23 cm)
PHILADELPHIA MUSEUM OF ART.
THE SAMUEL S. WHITE, 3RD, AND
VERA WHITE COLLECTION. 67-30-305

In this courtly picture from the *Bābur-nāma* (see nos. 10–11),[1] an open, pillared pavilion separates the host and his guest, Emperor Bābur, from three seated men having their meal outside in the court, where covered dishes are being readied. Every gesture is ceremonious, from the carrying of a spoon to the mouth to the waving of long scarves by two attendants to protect the royal meal from flies.

The painting is articulated in obtuse angles that organize its space: The open pavilion forms a transparent area in front of a simple railing on the right, which fences a slender tree indicating the outdoors. A high structure is in the distance. An arch of uncertain outline and a rectangular panel with script form planes in front and behind the roof of the pavilion, countering with their shuffled vertical planes the illusion of the third dimension.

1. *The Bābur-nāma,* trans. A. S. Beveridge (1922; reprint, New York, 1971), p. 304.

13 Abu'l Fazl Discusses the Translation of the Mahābhārata into Persian with Muslim and Hindu Scholars

SUB-IMPERIAL MUGHAL SCHOOL, 1598
DHANU
ILLUSTRATION FROM THE *Razm-nāma*
TRANSPARENT WATERCOLOR WITH GOLD ON PAPER
11⁹⁄₁₆ x 6⁵⁄₁₆″ (29.4 x 16 cm)
FREE LIBRARY OF PHILADELPHIA. RARE BOOK
DEPARTMENT, JOHN FREDERICK LEWIS COLLECTION

The *Razm-nāma,* or "Book of Wars," is a translation of the greatest epic of ancient India, the *Mahābhārata,* which was written between 400 B.C. and A.D. 400. In this illustration Abu'l Fazl, the chronicler, guide, and friend of Akbar, discusses the translation of this monumental work by Hindu and Muslim scholars. The text—written on a separated piece of paper above the painting—praises the *Mahābhārata* as the "most honored, largest, and clearest book of the Indian people." It also praises both Hindu and Muslim scholars for their cooperation in translating and interpreting the epic.

This painting is from the second *Razm-nāma,* illustrated in the sub-Imperial Mughal style in 1598 (see also nos. 14–17).[1] (The earlier *Razm-nāma,* of about 1582–86, is in the City Palace Museum, Jaipur.) The artist of this illustration is Dhanu, who worked in the Imperial studio, where he won recognition and contributed, as painter and designer, to the illustrations of a number of manuscripts between 1580 and 1595.[2] It was the general practice in the Imperial studio to have different artists work on the same painting. Dhanu also contributed to the sub-Imperial style, a designation generally used for paintings like this one from the *Razm-nāma* that lack the delicacy and minute finish of those from the Imperial studio, are less crowded and compact, and have fewer figures. Paintings of this kind were commissioned by patrons other than the emperor, whose aim was to encourage the dissemination of Hindu thought among his entourage by making it available in translations and with illustrations.

In washes of buff, light blue, and pink, this painting depicts in its two superimposed registers the ongoing discussion of the scholars. Those in the upper register display calm attentiveness very different from the agitation of the scholars below. The participants, except for the one who is standing and dressed in flowing garments in the Hindu manner, wear Muslim jamas, which are fastened under the right arm; some also wear shawls. Two attendants wave folded cloths above the upper group of scholars.

Each group is accommodated on a patterned spread on the floor, on which books, a casket, and other objects have been placed. A polygonal architectural arrangement on top unifies the spatial context—the outcome of a perspective that shows recession in space by a superposition of the two groups. Dhanu was more successful in modeling his figures by shading; he also connected them by natural and expressive gestures but seems to have had difficulty when introducing the tall standing figure in the lower right corner.

1. The first account of this manuscript was given by G. Meredith-Owens and R. H. Pinder-Wilson, "A Persian Translation of the *Mahābhārata,*" *British Museum Quarterly,* vol. 20, no. 3 (1956), pp. 62–65, pls. xix–xx. For other pages from this *Razm-nāma,* see Stuart Carey Welch, "Early Mughal Miniature Paintings from Two Private Collections Shown at the Fogg Art Museum," *Ars Orientalis,* vol. 3 (1959), pp. 137–38, fig. 6; Gangoly, 1961, pp. 10–14; Losty, 1982, pp. 123–24, no. 88; and Ehnbom, 1985, pp. 44–45, no. 13.
2. Beach, 1981, pp. 90–91, 215, 217–23, 225. The books are the first *Akbar-nāma* (c. 1590 or earlier), *Darab-nāma* (c. 1580), *Timur-nāma* (c. 1584), the *Khamsa* of Nizami (c. 1585), *Iyar-i-Danish* (c. 1590–95), and *Jami-al-Tawarikh* (dated 1596).

14 Aśvatthāman Shoots an Arrow of Fire at the Pāṇḍavas

SUB-IMPERIAL MUGHAL SCHOOL, 1598
ASI
ILLUSTRATION FROM THE *Razm-nāma*
OPAQUE AND TRANSPARENT WATERCOLOR
WITH GOLD ON PAPER
12 x 6⅞" (30.5 x 17.5 cm)
FREE LIBRARY OF PHILADELPHIA. RARE BOOK
DEPARTMENT, JOHN FREDERICK LEWIS COLLECTION

On hearing that his father, Droṇa, had been slain, Aśvatthāman, the hero of the Kauravas, resolved to avenge his death by killing all the Pāṇḍavas. Taking an arrow that Droṇa had given him, Aśvatthāman strung his bow and let fly his arrow, which blazed like a million arrows of fire (*Mahābhārata*, 7.142.13–15).

This illustration from the *Razm-nāma* is steeped in an ominous atmosphere; movements of hero and victims alike appear suspended in its haze. This is a painting more of a mood than of an event, a transposition of the fierceness of what is described in the text into a picture of doom as seen by the artist Asi. The imploring gestures of the group of the Pāṇḍavas on the right, the rocks on the left with their scant and "sympathetic" vegetation, the curve of the hill vaulting over the mass of fire, the victims standing by—all form a symphony of shapes. The hazy view into the distance appears as if filled with smoke from the fire of the arrow. The atmospheric tonality of this painting with its soft browns and pale blues differs from the clear-cut, bright colors of the Imperial Mughal school.

Asi, son of the painter Mahesh, was brother of the famed artist Miskin. One of the foremost painters of Akbar's atelier, Miskin was responsible for the *Razm-nāma* of about 1582–86 (Maharaja Sawai Man Singh II Museum, City Palace, Jaipur). Asi was given both Imperial and sub-Imperial commissions.[1]

1. See Beach, 1981, pp. 24, 85, 102, 124, 219, 222, 225.

15 The Churning of the Ocean

SUB-IMPERIAL MUGHAL SCHOOL, 1598
FATU
ILLUSTRATION FROM THE *Razm-nāma*
OPAQUE AND TRANSPARENT WATERCOLOR
WITH GOLD ON PAPER
11⅝ x 6½" (29.5 x 16.5 cm)
FREE LIBRARY OF PHILADELPHIA. RARE BOOK
DEPARTMENT, JOHN FREDERICK LEWIS COLLECTION

Inscribed on the bottom margin of this painting from the *Razm-nāma* is "Viṣṇu churns the Ocean for the production of the fourteen gems."[1] Within the same tonality as Dhanu's illustration (no. 13) but of sharper contrasts, this work depicts the striving of gods and demons for immortality. The myth was first told in the *Mahābhārata* (1.16.33–36). Both gods and demons were eager to obtain the drink of immortality (*amṛta*) from the waters of the Cosmic Ocean. Using Mount Mandara as the churning stick they churned the ocean. The serpent king Vāsuki served as the rope; the gods pulled from its tail end, the demons from its head. The trees and animals on the mountain fell into the sea in the terrific commo-

tion. Out of the waters, now of milky thickness, miraculous things arose one by one: Uccaiḥśravas, the archetypal horse; the four-tusked elephant, mount of Indra, king of the gods; the wish-fulfilling cow; the paradisiacal tree; Dhanvantari, the physician among the gods with his flask; the crescent of the moon; the goddess Lakṣmī (Luck); the goddess Surā (Liquor); the bow; the magic jewel Kaustubha; and other auspicious objects. Then a burning black mass arose, which threatened universal destruction, but it was swallowed by the god Śiva. (The painting does not include this phase of the myth.)

Here, the gods have lined up on one side at the edge of the ocean; one demon—representing all the demons—is on the other side. All are calmly at work while the ocean foams with mighty waves around Mount Mandara. Mist and vapor fill the valley behind the rising verdant landscape. Heavy clouds screen the brightness of the sky beyond the cosmic turmoil, where all is clear. The power of mythic narrative indwells the composition of this painting. Its deft asymmetry conveys the instability of the perilous cosmic situation. The vapors in the valley behind the firm, hilly ground of the earth are part of an ingenious representation. They are accentuated by shapes of trees of Indo-European ancestry.

1. The inscription is not quite correct. It is the gods and demons who churn the ocean, while Viṣṇu, as tortoise, forms the base of the churning stick, Mount Mandara. This is not shown in the painting, but Viṣṇu appears as one of the gods churning the ocean at right.

PUBLISHED
Pennsylvania Academy of the Fine Arts, Philadelphia, 1923–24, p. 45, no. 193.

16 The Teaching of the Schoolmaster and the Explanation by the Teacher of the Necessity of Wise Tradition

SUB-IMPERIAL MUGHAL SCHOOL, 1598
ASI THE YOUNGER
ILLUSTRATION FROM THE *Razm-nāma*
OPAQUE AND TRANSPARENT WATERCOLOR
ON PAPER
11⅝ x 6¾" (29.5 x 17.1 cm)
FREE LIBRARY OF PHILADELPHIA. RARE BOOK
DEPARTMENT, JOHN FREDERICK LEWIS COLLECTION

The caption of this illustration from the *Razm-nāma* tells of "the teaching of the schoolmaster and the explanation by the teacher of the necessity of wise tradition." These are specified in the text of the Persian translation of the *Mahābhārata*, which stresses particularly the service of mother and father and of the teacher who guides to divine truth. Withdrawal from worldly life and the distractions of the affairs of the court is also counseled.

This painting does not refer to a particular episode in the *Mahābhārata*, but applies its teachings to contemporary everyday life and places the scene in a landscape outside the walls of a city. An open-walled, simple structure accommodates teacher and students. Outside the schoolhouse are groups of other students studying, resting, fighting, or being attended to. The tall figure of a mother bringing her child to school occupies an axial position and is equally conspicuous by the spontaneity of her anxious, trusting glance of approval at the schoolmaster absorbed in teaching. The schoolhouse is situated in an idyllic landscape that includes a cow-

herder and his cattle. A fortified city in the background completes a picture of appealing sincerity though of modest achievement. The heavy shadows of the city wall and the blotched masses of foliage of the awkwardly positioned trees are indebted to European influence. Whereas each of the previous illustrations from the *Razm-nāma* (nos. 13–15), though of sub-Imperial standard, is an organic work of art, this and the following painting (no. 17) more or less skillfully use current formulas in building up the compositions.

PUBLISHED
Pennsylvania Academy of the Fine Arts, Philadelphia, 1923–24, p. 26, no. 187, p. 44.

17 *King Yudhiṣṭhira and His Wife Draupadī Give Their Possessions to the Brahmans*
SUB-IMPERIAL MUGHAL SCHOOL, 1598
SARUN (SARVAN)
ILLUSTRATION FROM THE *Razm-nāma*
OPAQUE AND TRANSPARENT WATERCOLOR
ON PAPER
11⅞ x 6⅝" (30.2 x 16.8 cm)
FREE LIBRARY OF PHILADELPHIA. RARE BOOK
DEPARTMENT, JOHN FREDERICK LEWIS COLLECTION

The caption and the illustration of this scene from the *Razm-nāma* are based on a freely translated version of the *Mahābhārata* (2.60.15–47). Although this painting is closely linked in palette and composition to the preceding illustration from the *Razm-nāma* (no. 16), the figures do not always relate to their setting nor the architecture to the space it demands. The canopy of the structure in which King Yudhiṣṭhira sits and whence he gives away his cattle seems to collide with the building behind it; the foreshortened axial wall obliges the happy recipient of his gift to cling to its sharp edge. Nonetheless, the general commotion, a mixture of eager human figures and forlorn-looking cattle, catches the spirit of the scene although many of its components are derived from well-established formulas.

Sarun (Sarvan), the painter of this illustration, also worked in the Imperial studio.[1] His figures are drawn more expertly than those of Asi the Younger (see no. 16), though with less conviction. The delicate color composition, however, is attuned to the mood of the scene.

1. See Beach, 1981, pp. 99, 215, 217, 220–22, 226.

18 *A Composite Elephant Is Led by Demons*
MUGHAL SCHOOL, 1575–1600
OPAQUE WATERCOLOR WITH GOLD ON PAPER
15⅞ x 23⁷⁄₁₆" (40.3 x 59.5 cm)
FREE LIBRARY OF PHILADELPHIA. RARE BOOK
DEPARTMENT, JOHN FREDERICK LEWIS COLLECTION

A strange procession moving along a hillside is led by a tall man holding up cymbals and by a herald blowing a large curved trumpet. The herald's muscular, serpent-wreathed legs have feet of bird claws; snakes wriggle around his figure and on the ground. His face, neither human nor animal, sprouts forth excrescences that grip the bulging luggage on his back and belly. Thus intro-duced by music and fiercely elegant whimsy, the central figure, an elephant, proceeds behind small, carefully spaced rocks with flower arrangements. The elephant consists of figures both animal and human, which commingle in intestinal convolutions, each subtly characterized and modeled; there is no part of its body that is not something else.

The elephant has two riders: The one in front, a demon whose composite complexity matches that of the elephant, wields an elephant goad; the other, in back, of human body but with horns and a tail, makes a bold gesture with one hand and holds a staff topped by a windblown shape in the other. The procession ends with a horned flag-bearer.

Bronzes of the "animal style" of the first millennium B.C. seem to be the most ancient predecessors of this artistic category; its nearest contemporaries are the fruity, flowery paintings by the sixteenth-century Milanese painter Arcimboldo. In the twentieth century, Orissan paintings and Bengali embroideries show Indra or Kṛṣṇa on mounts composed of human figures, the combined shape of their constituents resulting in an animal of surpassing power. With it goes the sheer delight of the creative imagination recognizing itself in the symplegma.[1]

1. For a similar drawing, from the collection of Edwin Binney, 3rd, see Welch, 1976, pp. 40–41, no. 11; see also Portland Art Museum, 1973–74, p. 6, no. 31. The most inventive compositions of this kind belong to the sixteenth century; compare *An Elephant of Many Parts* (c. 1600) in Welch and Welch, 1982, pp. 184–88, no. 62.

19 *Akbar's Expedition by Boat to the Eastern Provinces*
MUGHAL SCHOOL, 1602–4
ILLUSTRATION FROM THE *Akbar-nāma*
OPAQUE WATERCOLOR WITH GOLD ON PAPER
13½ x 9⅛" (34.3 x 23.2 cm)
PHILADELPHIA MUSEUM OF ART.
THE SAMUEL S. WHITE, 3RD, AND
VERA WHITE COLLECTION. 67-30-389

The grand array of various types and sizes of boats in this illustration from the *Akbar-nāma*[1] shows Mughal miniature painting in its most sumptuous and stately phase. Gone are the impetuous spontaneity of the *Hamza-nāma* (see nos. 7–8) and the animated inventiveness of the *Bābur-nāma* (see nos. 10–12). The boats are depicted one above the other according to the ancient formula of showing above, on the field of representation, what in reality is behind, so that nothing is lost to the sight, no part covered or overlapped. The boats appear to have halted although they are being rowed; only the one at top left speeds along.

In his later years Akbar was particularly interested in portraiture. Some of the miniatures illustrating this book of Akbar's life were, however, animated glorifications of the respective scenes rather than records of his unique personality. Of the thirty-nine men who are shown accompanying Akbar here, some are portraits of particular individuals while others are types. The emperor's large figure, in the second boat from the bottom, carries itself with relaxed ease.

1. The painting is the right half of a double-page illustration; see Beach, 1981, p. 122. The subject of the painting is referred to in *The Akbar Nāma of Abu-l-Fazl,* trans. H. Beveridge (Delhi, 1977), vol. 3, pp. 122–25.

20 Yogi of the Mountains

MUGHAL SCHOOL, 1600–1610
OPAQUE WATERCOLOR WITH GOLD ON PAPER
10¼ x 7″ (26 x 17.8 cm)
PRIVATE COLLECTION

High in the mountains a yogi sits in front of a shrine or shrinelike hut, addressing himself to a disciple reverently standing before him. On the dome of the shrine is written "Yogi of the Mountains." At the foot of the mountains, a spring hidden in the rocks fills two reservoirs with clear, fresh water, conducted through a channel whose course corresponds with the unevenness of the terrain. Amidst flowering shrubs, banana plants, cypresses, and other trees, a Kānphaṭa ("split ear") yogi leisurely walks along, carrying his alms bowl and accompanied by a dog. He wears a wide, deep ocher red shawl; broad red turban; necklace strung with pendants; and the distinctive heavy earrings, of agate or crystal, of Kānphaṭa yogis. His burly figure sharply contrasts with the slim shapes of the yogi and his disciple, both clad only in loincloths.[1]

Yogis, saints, and recluses were held in high esteem by the Mughal emperors, and a portrayal of their mode of life therefore had its place in Imperial albums. This painting, with its delicate muted colors, is steeped in an atmosphere of serene detachment although the rocky boulders are effervescent tumultuous shapes tossed up from Mughal pictorial imagination.

1. Kānphaṭa yogis in Kutch wear turbans and ocher red shawls to this day (letter to the author from Jasleen Dhamija, Swastik Society, Ahmadabad, May 20, 1985). The neophyte is initiated into the cult by the ritual piercing of his ears and insertion of the earrings in front of an image of Bhairon. Kānphaṭa yogis hold dogs in high esteem, for Śiva as Bhairava (Bhairon) has the dog for his vehicle.

21 Meeting in a Garden

MUGHAL SCHOOL, C. 1610
OPAQUE WATERCOLOR WITH GOLD ON PAPER
18⁹⁄₁₆ x 12⅜″ (47.1 x 31.4 cm)
FREE LIBRARY OF PHILADELPHIA. RARE BOOK
DEPARTMENT, JOHN FREDERICK LEWIS COLLECTION

Glowing with deep, luminous color, this painting shows an elegant young man of veiled glance who holds aloft a book, its pages opening. He approaches a young woman, also in motion, who wields a flower wand and holds a flowering plant. Both seem to tread lightly, as if they have become aware of each other in a dream. Two slender cypress trees, outside their fenced-in path, stand guard amidst dense shrubs, one full of flowers.

The long, flowing lines of the man's Persian coat and sashes frame his slenderness. The woman's draped shawl and loosely fitting garments augment her shape as she raises her wand; a hood-like nimbus encircles her head. Whatever the rendering of her costume may owe to European influence, it is transformed into a rich pattern of light and shade whence emerge her slender arms, which echo the movements of the young man as he holds up the book.[1] Large birds flutter out from the verdant background toward a cloud-streaked sky. In traditional Sufi thought, birds are symbols of the human soul set free.

1. Although the rendering of the figures is westernized, the painting bears some affinity with *Youth Holding a Narcissus* by Farrukh Beg, c. 1610, which is in the Deccani style; see Beach, 1978, pp. 158, 163, no. 59, repro. p. 161.

22 The Descent of the Ganges

MUGHAL SCHOOL, 1605–10
OPAQUE WATERCOLOR WITH GOLD ON PAPER
6 x 3⅞″ (15.2 x 9.8 cm)
PRIVATE COLLECTION

This unusually small miniature is a painting of surpassing greatness. Lord Śiva, colored in a powder blue that suggests the ash-smeared body of the ascetic god and clad in a tiger-streaked pale yellow loincloth, wears a large, dark elephant skin, which falls over his shoulders and back. It serves also as his seat on the rocky ground. Large boulders surround and delimit the seated figure against a view into the distant landscape.

Śiva is seated at ease. His bare feet rest on rocks that skirt a pool caused by the descent of the river Ganges from the hair at the apex of his head. A large chignon of the ascetic god's coiled and matted hair curves over the falling stream of water, above which floats the crescent of the moon. Śiva's young, powerful body has two arms. His hands are empty; they carry no attributes. A small earring, a garland of white skulls, and two rearing black serpents encircling the god's head are the ornaments of his person. The crescent moon and the trident and rattle drum on a long staff planted to the god's left, and his vehicle, the bull Nandin, are part of his ambience. Every detail, visually and by symbolic implication, conveys the nature of the Great God, who is shown here not as a many-armed cult image but as deity incarnate as man.

This painting is inscribed in Persian: "Bud kar-e Manohar ain Mahadev" (This Mahādeva is the work of Manohar).[1]

1. The sprawling inscription in nastaliq script along the top of this painting is of particular interest because it provides an ascription to the great artist Manohar, who was active at the Mughal court between the years 1580 and 1630. There are two probable authors for this remarkable inscription: the Emperor Jahangir (1569–1627) or his grandson Prince Dara Shikoh (1616–1659). On occasion, both men wrote pithy inscriptions of this type—in a bold yet careless nastaliq—on the actual surface of the paintings they possessed. Yet this rather intrusive inscription is also noteworthy for the information it provides. The ascription to Manohar is indeed convincing because the painting is very close in style to another work by that artist, the portrait *Akbar in Old Age,* of approximately the same date, which is now in the Cincinnati Art Museum; see Welch, 1978, p. 69, pl. 15; and Beach, 1978, p. 133, fig. 11. (This note was provided by Terence McInerney.)

PUBLISHED
Soustiel and David, 1973, vol. 3, no. 8.

REFERENCE
Beach, 1978, p. 136.

23 Lion Attacking a Man

MUGHAL SCHOOL, C. 1613
NĀNHĀ
OPAQUE WATERCOLOR WITH GOLD AND
SILVER OR TIN ON SILK
9¾ x 14⅝″ (24.8 x 37.1 cm)
FREE LIBRARY OF PHILADELPHIA. RARE BOOK
DEPARTMENT, JOHN FREDERICK LEWIS COLLECTION

The studied naturalism of the lion's attack succeeds best where the forepart of the animal is shown mauling the diminutive figure of a man. The conventionally rendered shape of the man sets off the naturalistically modeled head and paws of the lion. The rest of the lion's body, though of elegant line, lacks energy. The deep shadows

above and below the animal suggest the fateful outcome, which the small figure of the man, his sword raised, is incapable of preventing. An undulating ground of pale verdure is animated by the foreground grass rendered with quick brushstrokes. Small stones punctuate the fallow ground, and diminutive trees with their agitated foliage are a subtle visual comment on the scene.

Nature studies vie with the rich narrative book illustrations of the Mughal school, particularly those from the reign of Emperor Jahangir (1605–27). The studied poise and naturalistic intent of this work by Nānhā, identified by an inscription on a rock in the foreground, may be compared with the ebullient, imaginative rendering of the same subject in an earlier Mughal painting from the *Tūtī-nāma* in Cleveland.[1] Nānhā, however, succeeds more by the spacing of his picture than by his rendering of the animal's shape. The bleak spaciousness of the terrain focuses concentration on the animal's mighty head and the intimate, fateful grip of its paws.

1. Chandra, 1976, pl. 55.

PUBLISHED
Welch, 1985, p. 221, no. 146.

24 *Kalij Pheasant*
MUGHAL SCHOOL, C. 1620
TRANSPARENT AND OPAQUE WATERCOLOR AND
MARBLED PAPER WITH GOLD ON PAPER
12⅞ x 8⅛" (32.7 x 20.6 cm)
FREE LIBRARY OF PHILADELPHIA. RARE BOOK
DEPARTMENT, JOHN FREDERICK LEWIS COLLECTION

Bird, animal, and flower studies are among the most captivating works of the Imperial Mughal school under the reign of Emperor Jahangir, who succeeded Akbar, his father, in 1605. The great age of Mughal book illustration, with its sequences of hundreds of paintings, dynamically creative early in Akbar's reign in the large folios of the *Hamza-nāma* (see nos. 7–8) and ending with the resplendent turbulence of the *Akbar-nāma* (see no. 19), had passed. A more intimate brand of art under Jahangir included not only the human physiognomy but other shapes of life as well—animals, birds, insects, plants, and flowers. These were the subjects of some of the most sensitively realistic portraits patronized by Jahangir, while at the same time, and more frequently, the Imperial splendor was displayed in works of ceremonial court art. Jahangir's artists accompanied the emperor on his travels, ready to observe, sketch, and paint the portrait of whatever creatures attracted their eyes.

This diminutive portrait of a Kalij pheasant,[1] painted on "marbled" paper of Persian origin, renders the tactile quality of the bird's plumage and its strutting stance. It is accompanied by a few brushstrokes indicating nature. The hazy pattern of the mount gives it an atmosphere of mystery and vastness.

1. The identification of this bird was made by Mark Robbins, Collections Manager of Ornithology, Academy of Natural Sciences, Philadelphia.

25 *The Repast*
SUB-IMPERIAL MUGHAL SCHOOL, C. 1620
OPAQUE WATERCOLOR WITH GOLD ON PAPER
7¹⁵⁄₁₆ x 12⁷⁄₁₆" (20.2 x 31.6 cm)
CITY OF PHILADELPHIA. ON PERMANENT LOAN TO
THE PHILADELPHIA MUSEUM OF ART

With its unassuming domestic setting, this painting reduces to almost pre-Mughal, planar dimension the disposition of its figures, set here against rectangular color fields that allow shallow spaces to accommodate gestures rendered in slow motion. The antelope at rest in the right foreground, the sparsely flowering branches at upper left, and the view toward distant buildings sustain the quiet domesticity of the scene.

The inscription at bottom within the painting, the characters "Hun Kara Nama" enclosed in a rectangle and written downward (which is unusual), may provide the painter's name.

26 *Mādhava Bids Farewell to Kāmakandalā*
SUB-IMPERIAL MUGHAL SCHOOL, C. 1620·
OPAQUE WATERCOLOR ON PAPER
9¾ x 7⅝" (24.8 x 19.4 cm)
COLLECTION OF DR. ALVIN O. BELLAK

Mādhava, a Brahman youth of great beauty, intelligence, and accomplishments, much loved by the women of the city, is banished when the king receives complaints about him. On his wanderings in another kingdom he falls in love with Kāmakandalā, an accomplished courtesan. Mādhava's connoisseurship of music is noticed by the king, who rewards him with a gift, which he in turn gives to his love Kāmakandalā. Angered, the king banishes him, leaving Kāmakandalā to become a recluse. In Ujjain, King Vikrama becomes acquainted with Mādhava's poetry and seeks him out. Impressed with Mādhava's love for Kāmakandalā, Vikrama sets out to find Kāmakandalā and reunite the two lovers. First, however, Vikrama decides to test the steadfastness of Kāmakandalā's love for Mādhava by making advances to her. Repelled, Vikrama tells her that Mādhava is dead, whereupon she faints and dies. When Mādhava hears this news, he too dies. Learning of their deaths, Vikrama wants to end his own life, but a vampire (*vetāla*) brings the lovers back to life.[1]

The farewell of Mādhava, who is shown as a musician carrying his lute (*vīṇā*), is painted with much feeling; the intervals between the figures are as telling as their gestures. The spacing of the composition in large units—the group of figures, rocks, trees, and the wide emptiness between them—has an ominous quality. The flamboyance of Mughal rocks has here been converted into a monument to loneliness.

1. The story of Mādhava is abbreviated from a summary in Khandalavala, Chandra, and Chandra, 1960, pp. 27–29, where other illustrations from the Mādhavānala-Kāmakandalā series are listed; see also Portland Art Museum, 1973–74, pp. 62–63, no. 38.

27 Casket

MUGHAL SCHOOL, SIND, 1600–1650
WOOD AND METAL; INTERIOR DECORATED WITH
PAINT AND GOLD LEAF OR FOIL, POSSIBLY OVER
GESSO
10¾ x 18½ x 11¼″ (27.3 x 47 x 28.6 cm)
COLLECTION OF MRS. HARVEY Z. YELLIN, FROM
THE SAMUEL YELLIN COLLECTION

This wooden casket, presumably a dowry chest made in Sind,[1] has a shape that is reminiscent of wooden and painted ivory caskets familiar in the Islamic world of the twelfth and thirteenth centuries.[2] Whereas the exteriors of those caskets are painted and richly carved, the outside of this Indian casket is covered with an overall pattern of applied geometric ironwork, while its painted decoration appears on each surface of the interior.

The lid of the casket has the shape of a mansard roof, its four sides sloping from the horizontal, rectangular top. The casket has two levels within. Three horizontal planks attached to the back and sides of the casket leaving a large, open rectangular area toward the front form the upper level. The bottom of the casket, its lower level, is seen through this open space.

The painted panels on the inside of the lid, on its horizontal top and slanted sides, are each framed by wooden moldings covering the joints. The horizontal panels marking the floor of the upper level are also filled by pictorial compositions. The bottom is also covered by a painting; its figures are on a larger scale than those of the panels of the upper level and are less carefully executed.

The main panel of the lid shows a party for a burly young man with dance, music, and refreshments. He is seated on a rug under a canopy, conversing with another young man more slight in appearance and looking somewhat impoverished. The festivities in the open are protected by a second, larger canopy indicated at the upper margin of the painting. Two dancers perform classical Indian dance movements, one turning toward the seated figures, the other, in the opposite direction, toward three musicians. These groups of primary interest are supplemented on the right by an attendant waving a fly whisk and by two additional figures.

In front—that is, below these figures—are other participants in the feast, somewhat smaller than the figures in the main line. All but the central young man, with his somewhat Mongolian countenance, are shown with their bodies more or less in front view. The ground is strewn with plants that have large flowers. This panel has equivalents in contemporary painted coverlets from Golconda.[3]

Scenes of the hunt appear on the longer side panels of the lid,[4] and scenes of amorous discourse, on each of the shorter sides; scenes of leisure and the story of the lovers Layla and Majnun are painted on the planks of the first floor along with a purely decorative flower panel. On the bottom of the casket is a scene of two embracing lovers accompanied by girls carrying refreshments; a cat with a bushy tail walks along in the foreground.

1. See Victoria and Albert Museum, London, 1982, p. 546.
2. For wooden caskets with ivory from Sicily, see Glück and Diez, 1925, pp. 483, 485, pl. 37.
3. See Irwin, 1959, p. 31, pl. A, figs. 18, 20.
4. Scenes of the hunt also figured in some of the Islamic ivory carvings (see above, note 2).

PUBLISHED
Copley Hall, Boston, *Retrospective Exhibition of the Decorative Arts* (1911), p. 25, no. 531.

28 Emperor Muhammad Shah, Mounted on an Elephant, Rides to Battle

MUGHAL SCHOOL, C. 1740
OPAQUE WATERCOLOR WITH GOLD ON PAPER
13 x 18⅛″ (33 x 46 cm)
PRIVATE COLLECTION

After the death of Emperor Akbar, Imperial taste took its delight in the single miniature. The album of superb single paintings became a new way of choosing, collecting, and discriminatingly examining the single painting. Following upon the connoisseurship of Jahangir, his successor Shah Jahan (1628–58) found architecture preferable to painting, which became increasingly an art of official representation. The iconoclastic outlook of his successor Aurangzeb (1658–1707) did not further creativity in the Imperial workshop. The weak successors of Aurangzeb caused the breakup of the Mughal empire, and under Muhammad Shah (1719–48) court painting decayed along with the empire. This portrait of Muhammad Shah riding to battle mounted on an elephant shows a lifeless figure of the emperor with his son behind him, aggrandized by the colorful rug thrown over the elephant. The animal moves listlessly in front of a hill preceded and followed by the army, while countless, minute figures of the emperor's forces and entourage move through the landscape.[1]

1. A painting similar in composition (see Welch, 1973, p. 115, no. 68) shows Ahmad Shah, Muhammad Shah's son, in procession with his entourage, riding a horse in place of the elephant. There, Ahmad Shah is shown as a bearded man; he is a beardless youth in this painting.

PAINTING IN THE DECCAN

29 Lady Carrying a Peacock

BIJAPUR SCHOOL, C. 1660
OPAQUE WATERCOLOR AND MARBLED PAPER
ON PAPER
8 x 5¼″ (20.3 x 13.3 cm)
FREE LIBRARY OF PHILADELPHIA. RARE BOOK
DEPARTMENT, JOHN FREDERICK LEWIS COLLECTION

Marbled paper is used both as a part of this picture and as a frame for it. Frame and picture are, in fact, elements of one composition in which two different kinds of patterned paper are combined with great decorative effect. The large leaf pattern of the frame appears also in the dress and turban of the sullen-faced young woman. The painted figure of the peacock extends across the speckled background and the woman's dress. In her extended right hand she holds what appears to be a flower.

The few marbled drawings that are known come from the Bijapur school during the mid-seventeenth century.[1] In the technique of marbling, according to Stuart Cary Welch, the "artist covered with a resistant gum the area of the paper to be left unadorned. Next he floated and swirled pigments in oil on the surface of a vat of water. The paper was then either raised or lowered to contact the pigment."[2]

1. See Zebrowski, 1983, pp. 135–38.
2. Welch, 1976, p. 74.

30 Elephant Rider and Horseman
BIJAPUR SCHOOL, 1650–1700
OPAQUE WATERCOLOR AND MARBLED PAPER
ON PAPER
7⅛ x 10¹⁵⁄₁₆″ (18.1 x 27.8 cm)
FREE LIBRARY OF PHILADELPHIA. RARE BOOK
DEPARTMENT, JOHN FREDERICK LEWIS COLLECTION

Marbled paper is used here both as a frame and as part of the picture, an elephant rider and a horseman set against speckled paper. Each sits on his unsaddled mount, the sword-wielding horseman cutting a poor figure in comparison with the large elephant and his gesticulating rider.

31 Equestrian Portrait of a Young Prince
DECCAN SCHOOL, 1675–1700
OPAQUE WATERCOLOR ON PAPER
11 x 7¾″ (27.9 x 19.7 cm)
COLLECTION OF DR. ALVIN O. BELLAK

The image of a rider on a horse at full gallop, leaping or rearing forward, first appeared in Indian painting in pre-Mughal days in miniatures that, though of Indian workmanship, followed Persian prototypes.[1] The horse with its rider is similarly shown in numerous Mughal miniatures.[2] The theme by itself, not part of a narrative context, was given its supreme form in a Deccani painting from Bijapur of about 1590 showing Sultan Ibrahim Adil Shah hawking; in that painting of unearthly beauty, horse and rider form an archetypal image of nobility.[3]

In the seventeenth century, in Deccani as well as in Mughal painting, the theme of the noble horseman became standardized. Horse and rider soar above the ground, the horse's forepart raised, its legs in vibrant motion. Apart from portrait figures, this is the only subject known to have been painted on a neutral, otherwise empty, pale background. The ground whence they have taken off is indicated here by a horizontal stretch of darker color while toward the upper margin of the painting bands of clouds streak the sky. Costume and physiognomy of the rider, who sits lightly on the leaping horse, identify him as a Deccani prince.

1. See Chandra, 1976, pl. 99.
2. See Sen, 1984, pls. 20, 40.
3. Zebrowski, 1983, p. 89, pl. IX, pp. 92–94.

32 A Lady of the Court
GOLCONDA SCHOOL, C. 1700
OPAQUE WATERCOLOR WITH GOLD ON PAPER
15⅛ x 9¾″ (38.4 x 24.8 cm)
COLLECTION OF DR. ALVIN O. BELLAK

A stolid, amply endowed young woman holds a glass between the hennaed fingertips of her left hand. In her right hand, a flask ready for pouring stabilizes the carefully arranged counterpoint of the curves of her body accoutrements. This is a decorative representation of a type of female figure that as a rule is more animatedly seductive than the one shown here. The modeling of her fulsome shape is purely Indian, without any naturalistic Western trace. The wealth of her flowing black hair sets off the rich, yet cool, color of her complexion and attire. The striped fabric and folds and the dotted pattern of her short bodice were drawn as meticulously as her jewelry and the calculated curves of the brow and lock of hair that grace her profile.[1]

1. This painting is a left-hand page; for the corresponding right-hand page, see Smart and Walker, 1985, no. 25. Compare Zebrowski, 1983, p. 199, fig. 166, p. 206, fig. 179.

33 Toḍī Rāgiṇī
DECCAN SCHOOL, 1700–1750
OPAQUE WATERCOLOR WITH GOLD AND
SILVER OR TIN ON PAPER
17 x 9⁹⁄₁₆″ (43.2 x 24.3 cm)
PHILADELPHIA MUSEUM OF ART. PURCHASED:
KATHARINE LEVIN FARRELL FUND. 1977-12-1

Rāgas, or melody types, are visualized in Indian painting. A rāgiṇī is the feminine form of rāga, and five or six rāgiṇīs are associated with each rāga as his consorts. The visualization of melody types is a uniquely Indian art form. Indian musical theory distinguishes the "sound form" (nādamaya-rūpa) from the "divine essence of the sound form" (devatamaya-rūpa).[1] It distinguishes the musical form as such from its god-inspired reality, which creates and sustains the audible pattern. Like other divinities represented in Indian art, those active in melody types were given iconographic shapes with human lineaments resembling those of the other gods. The names of these music-formed divinities, moreover, are inscribed with their representations. They are the names of the respective rāga or melody type and are known from a Kalpasūtra manuscript of about 1475.[2] The deific musical essences as anthropomorphic icons, however, were superseded in the sixteenth century by miniature paintings of scenes having, as a rule, a personified rāga or rāgiṇī as the main actor and trees or a building and other figures as part of a scene that conjures the mood of the melody type. In these paintings, as also in the earlier iconic versions, contemplation was aided by the inscribed verses identifying the melody type and its image.

The word rāga stems from a root denoting color; each rāga or rāgiṇī "colors" the soul of the listener with a definite sentiment. The effect of listening to a rāga or looking at a rāga painting varies according to the specific melody type. Each is to be sung at a specific time of day and in a specific season.

Toḍī Rāgiṇī personifies a melody type whose mood is tender and lovely, but also sad, expressing the sentiment of a young woman passionately in love.[3] The rāgiṇī is represented as a young woman carrying a lute (vīṇā), which rests on her shoulder. Accompanied by four deer, she appears in a gently undulating landscape, where a calm river flows in the foreground. Two large trees on each side of the rāgiṇī, accompanied by slender trees with delicate branches, send up their compact foliage. It is a cloudless day, the disc of a pale winter sun floating in the sky.

This painting translates poem and melody into the calm radiance of colors heightened by gold and the stillness of symmetrical

rhythms that link the listening deer and the trees with the pensive figure of the *rāgiṇī*. The Deccani style contributes a lingering quality to the mood of the melody. It saturates and nourishes the trees with their trim, dark-edged tops.

1. Waldschmidt and Waldschmidt, 1967, p. 16.
2. See Nawab, 1956, pp. 1–7.
3. Dahmen-Dallapiccola, 1975, p. 206.

34 Prince Manohar Receives a Magic Ring from a Wizard

DECCAN SCHOOL, 1743
ILLUSTRATION FROM THE *Gulshan-i-Ishq*
OPAQUE WATERCOLOR WITH GOLD ON PAPER
14 x 10″ (35.6 x 25.4 cm)
PHILADELPHIA MUSEUM OF ART. GIFT OF MRS. PHILIP
S. COLLINS IN MEMORY OF HER HUSBAND. 45-65-22

This and the following painting (no. 35) are illustrations from the *Gulshan-i-Ishq,* or "Rose Garden of Love," by the poet Nuṣratī, which is one of the major works of the Sufi religious experience written in an Indian language. Nuṣratī was the court poet of Ali Adil Shah II of Bijapur, who reigned from 1656 to 1672. According to its inscriptions, this manuscript was written in 1742 and the illustrations were completed in 1743. The paintings show a mixture of several Deccani styles and cannot be assigned to any definite school.

The story Nuṣratī used, entitled *Madhumālatī,* was written in Avādhī, a northern Indian language spoken around Lucknow. Nuṣratī transferred this Hindu story into the ambience of the Indo-Persian culture of the Deccan, giving it the significance of a quest such as that of the *Iskandar-nāma,* the "Romance of Alexander." Through Nuṣratī's introduction of the poem runs the Sufi theme of the world as a creation of God's love, which is manifest in many forms, including seemingly endless suffering and separation from the source of love; it also is imbued with the hope that all obstacles will be overcome and finally there will be union with God in love. For these reasons Sufis saw in the great love stories of worldly couples, parables or metaphors for their relation with God.[1]

This illustration shows young Prince Manohar searching for his love Madhumālatī in a snake-infested wilderness, facing a serpent-wreathed skeletal wizard of Deccani subtlety and elegance. Tigers snarl at the prince and a beast of unknown ancestry has its eyes set on him. Above, out of the dense tapestry of vegetation that fills the painting, an enormous dragon has emerged, an embodiment of menace itself. The birds in the dense clusters of foliage look up to it, spellbound.[2]

1. Information about the history and themes of the *Gulshan-i-Ishq* was contributed by Peter Gaeffke, Professor of South Asia Regional Studies and Modern Indian Literature, University of Pennsylvania, who is preparing a translation of the 4,500 double verses of the poem.
2. Seven folios from an identical illustrated manuscript were sold at Christie's, London, October 11, 1979, pp. 52–55, nos. 183–89. Two illustrations of the *Gulshan-i-Ishq* are published in Zebrowski, 1983, p. 224, figs. 195–96, as from an unidentified Urdu manuscript, Deccan, c. 1700.

PUBLISHED
Philadelphia Museum of Art, *Treasures of the Philadelphia Museum of Art* (1973), p. 30.

35 Flying Fairies Carry Raja Bikram toward Kanakgir

DECCAN SCHOOL, 1743
ILLUSTRATION FROM THE *Gulshan-i-Ishq*
OPAQUE WATERCOLOR WITH GOLD ON PAPER
14 x 10″ (35.6 x 25.4 cm)
PHILADELPHIA MUSEUM OF ART. GIFT OF MRS. PHILIP
S. COLLINS IN MEMORY OF HER HUSBAND. 45-65-22

In this illustration from the *Gulshan-i-Ishq* (see no. 34), a cluster of winged fairies supported by wind that makes their skirts balloon flies above the anxieties of the dark night below. Their coronets are unruffled as they carry the weight of Raja Bikram's sturdy shape. Two antelopes, magically illumined in the darkness of the starry night, raise their heads toward the flight of the fairies. Two trees stand by, their diverse foliage neatly circumscribed.

36 Dying Jaṭāyus Tells Rāma and Lakṣmaṇa about Sītā

RAJAMUNDRY SCHOOL, C. 1750
OPAQUE WATERCOLOR ON PAPER
13¾ x 13⅞″ (34.9 x 35.2 cm)
PHILADELPHIA MUSEUM OF ART. PURCHASED:
KATHARINE LEVIN FARRELL FUND. 75-149-1

The *Rāmāyaṇa* (3.64.1–36) and the *Mahābhārata* (3.262.40–263.6) tell the story of the bird Jaṭāyus, a vulture chief. Jaṭāyus attempts to stop the demon king Rāvaṇa from abducting Rāma's wife Sītā to his kingdom of Laṅkā. Rāvaṇa mortally wounds Jaṭāyus, but when found by Rāma and his brother Lakṣmaṇa, he is able to tell them that Sītā still lives and to indicate the direction in which Rāvaṇa has taken her.

This painting shows a mighty bird in conversation with Rāma, dark in color, and with his brother. A strip filled with a pattern of miniature curving hills and trees whence rise two spectacular trees is the locale in which the noble bird speaks his last words to Rāma. The two bifurcating trees send up discs of foliage toward an ominous sky crossed by the flight of white birds. The painting with its wide, cinnabar red field of strong color has a monumental simplicity not unlike that of folk art.[1]

1. In an unpublished article Jagdish Mittal (Jagdish and Kamla Mittal Museum of Indian Art, Hyderabad) tells of a "manuscript," or rather a picture album, in the South and East Asia Department of the Museum für Völkerkunde (Ms. As. 4673), Hamburg, in which this painting occupied a full page. The colophon of this *Rāmāyaṇa* album states that it was executed in Rajamundry in 1757. A group of paintings in a similar style, probably from this series, was sold at Sotheby's, London, December 13, 1972, nos. 55–65; see also Arthur Tooth & Sons, London, November 12–December 12, 1975, nos. 46–47 (letter to the author from Catherine Glynn).

37 Bangālī Rāgiṇī

DECCAN SCHOOL, 1740–60
OPAQUE WATERCOLOR WITH GOLD AND
SILVER OR TIN ON PAPER
11⅞ x 7³⁄₁₆″ (30.2 x 18.2 cm)
PRIVATE COLLECTION

The musical mode Bangālī Rāgiṇī is shown in this painting as a woman worshiping the moon as she stands on the terrace of her house.[1] This way of depicting the rāgiṇī is rare, and peculiar to the Deccan. Generally, this rāgiṇī—a woman separated from her husband—is represented as an ascetic.[2] In this painting the architectural setting, though conventional, accompanies and augments the mood of the two figures who stand averted from each other. The loneliness of the rāgiṇī and her prayer hover in subtle gradations of blue and mauve under the dark sky of a moonlit night. The Deccani schools, even in their provincial offshoots, are unrivaled in the subtle nuances and the emotional depth of their color compositions.

1. Compare Ebeling, 1973, p. 264, no. 273.
2. Dahmen-Dallapiccola, 1975, p. 347.

38 Lady Watching Her Maid Kill a Snake

BIJAPUR SCHOOL, 1775–1800
OPAQUE WATERCOLOR WITH GOLD ON PAPER
12 x 6¹³⁄₁₆″ (30.5 x 17.3 cm)
PHILADELPHIA MUSEUM OF ART. PURCHASED:
KATHARINE LEVIN FARRELL FUND. 72-160-2

This is a version of a painting from Bijapur of about 1620; three other versions of the lost original are known.[1] One is a mirror image, while this painting changes the original square format to an oblong. The composition was adjusted to the longer format by increasing the height of the palatial structure on the left and allowing the lady, or princess, only one companion, omitting a chaperone on the right. In enlarging the distance between the princess and the maid, details were omitted: a cat in the foreground, birds in the tree, ducks in the pond. A tree of a coarse-leafed variety replaced the more delicate one in the original, and the top of a similar tree replaced a branch where the railing meets the building. Further simplifications, linearization of costume, and change of position of the faces of the figures—shown here in profile—widen the gap in style and quality between this and the three other known versions. Nonetheless, this painting has a consistency of its own; it should be assigned to the Deccan in the later part of the eighteenth century.

1. One is in the India Office Library, London (see Zebrowski, 1983, p. 88, fig. 66; and Falk and Archer, 1981, pp. 137, 436, no. 239). The other two are in the State M. E. Saltykov-Shchedrin Public Library, Leningrad (see Glück and Diez, 1925, p. 521).

RAJPUT PAINTING IN THE PLAINS

Gujarat

39 Gaṇeśa and Sarasvatī

GUJARAT SCHOOL, 1625–50
ILLUSTRATION FROM THE Bhāgavata Purāṇa
OPAQUE WATERCOLOR WITH GOLD AND
SILVER ON PAPER
10³⁄₁₆ x 8¾″ (25.9 x 22.2 cm)
PRIVATE COLLECTION

Gaṇeśa, the elephant-headed god who creates and removes obstacles, and Sarasvatī, goddess of learning and the arts—invoked at the beginning of every Indian literary enterprise—are represented on this first folio from a Bhāgavata Purāṇa (see also nos. 40–42).[1] In an arcade of cusped arches, Gaṇeśa, in front view, is seated to the left of a slender pillar; Sarasvatī is to the right of it, her face turned in profile toward Gaṇeśa.

Wearing a helmetlike crown, the four-armed god holds each of his two upper hands in the gesture of giving exposition in silence (vyākhyānamudrā); his trunk, turned to his left, reaches for sweetmeats in a bowl held in his lower left hand while his lower right hand rests below a garland on his plump, naked belly. A diminutive mouse, the god's vehicle, makes its way toward him on the left, and another small animal is walking below his seat. This unusual depiction of Gaṇeśa, with squinting eyes and a string of pearls edging his crown, ears, and trunk, a battle axe on each side, is set off against a mustard yellow ground strewn with foliage arabesques. Gaṇeśa's helmet and his square outline are reminiscent of Persian paintings in the Timurid style.

More lavish vegetation motifs help fill Sarasvatī's compartment. Her smaller figure is amplified by her garment, and the ends of her scarf flutter to the right and left. Her vehicle, a peacock, here looks more like a duck. She holds a lute (vīṇā), book, and a rosary, and her energetic profile shows her eye practically unforeshortened.

Above the arcades and their spandrels extends a broad strip filled with bending palm trees and large flower motifs that balance and sum up the composition of the entire painting. Architectural, iconographic, and plant motifs fill the page with ingenuity and ease.

1. See Goetz, 1952; other folios from the same dispersed Bhāgavata Purāṇa are published in Welch and Beach, 1965, pp. 65, 118, no. 15; Spink, 1971, p. 20, fig. 28, p. 40, fig. 51; Welch, 1973, pp. 38–39, no. 15; Pal, 1978, pp. 64–65, no. 9; Chhavi, 1971, pl. E; Chhavi-2, 1981, pl. 12; and Dallapiccola, ed., 1982, pp. 42–43, figs. 39–40.

40 Kṛṣṇa Splitting the Yamalārjuna Tree

GUJARAT SCHOOL, 1625–50
ILLUSTRATION FROM THE Bhāgavata Purāṇa
OPAQUE WATERCOLOR WITH GOLD ON PAPER
10¼ x 9″ (26 x 22.9 cm)
PRIVATE COLLECTION

Here, in an illustration from a Bhāgavata Purāṇa manuscript (see also nos. 39, 41–42), one of the pranks of Lord Kṛṣṇa's early childhood has been given a most decorative treatment. The Bhāga-

vata Purāṇa (10.9.1–23; 10.10.23–38) tells that when his foster-mother Yaśodā is occupied elsewhere, Kṛṣṇa steals butter and distributes it to the monkeys. When Yaśodā discovers this, she goes after Kṛṣṇa with a rod, but he runs away. Yaśodā chases him and ties him to a wooden mortar. As Kṛṣṇa sits there he notices an *arjuna* tree with two trunks. Dragging the mortar, Kṛṣṇa places it between the trunks and sits on it, whereupon the tree splits and out come two beautiful youths. In fact, these are the two wanton, inebriate, and arrogant sons of Kubera, god of riches, who were reduced to the shape of the *yamalārjuna* tree by a curse of sage Nārada in order to prevent their further movements. When Kṛṣṇa splits the *yamalārjuna* tree two beautiful persons emerge, the sons of Kubera, who worship Kṛṣṇa.

In this illustration, pomegranates on leafy, bending branches, in which the worshiping figures of the liberated sons stand, form a bower and shrine around the seated Kṛṣṇa, still tied to the mortar that split the tree.

41 Kṛṣṇa Dancing with a Single Cowherdess

GUJARAT SCHOOL, 1625–50
ILLUSTRATION FROM THE *Bhāgavata Purāṇa*
OPAQUE WATERCOLOR WITH GOLD AND
SILVER ON PAPER
10⅜ x 8¹⁵⁄₁₆″ (26.4 x 22.7 cm)
PHILADELPHIA MUSEUM OF ART. GIFT OF
MR. AND MRS. LESSING J. ROSENWALD. 59-93-61

Crowned Kṛṣṇa's somewhat rustic invitation to the dance is welcomed by his partner. Her scarf flutters in a long, extended triangular shape, an archaism of style harking back to Gujarat paintings of the fifteenth to sixteenth century. In this painting it goes hand in hand with the four-pointed jamas worn by Kṛṣṇa and several other participants. Other cowherdesses accompany the dance with music and gestures. Those at bottom right, though seated, participate joyfully in the rhythm of the dance, and those at left who have just arrived are entranced by the divine spectacle. Although the marginal figures at bottom are small in size, their groups strengthen the rhythm emanating from the larger figures, and the floral pattern of the ground adds to this vibrancy.

A peculiarity of some of the paintings from this *Bhāgavata Purāṇa* is a rectangular panel on top (see also no. 39). Here it is occupied by five seated figures in yogic posture, their arms flung open and their large eyes squinting toward their noses.

42 Kṛṣṇa Dances with the Cowherdesses (Rāsamaṇḍala)

GUJARAT SCHOOL, 1625–50
ILLUSTRATION FROM THE *Bhāgavata Purāṇa*
OPAQUE WATERCOLOR WITH GOLD ON PAPER
10⅜ x 9″ (26.4 x 22.9 cm)
PHILADELPHIA MUSEUM OF ART. GIFT OF
MR. AND MRS. LESSING J. ROSENWALD. 59-93-60

The *rāsamaṇḍala,* the circle dance with Kṛṣṇa in which each cowherdess (*gopī*) feels that Kṛṣṇa dances with her exclusively, is accompanied by musicians in the four corners of the painting. The musicians face the dance, and those at the bottom of the painting

are shown upside down like the dancers on the lower rim of the magic circle, which is visualized as a flower-speckled ground.

The four margins are occupied by female figures seated in profile. They are onlookers watching the dance as if from a gallery. Like the horizontal compartments atop other paintings from this *Bhāgavata Purāṇa* (see nos. 39, 41), the borders are used here as a theme that adds to the effect and meaning of the entire illustration. Spontaneity and archaism commingle in the execution of the illustrations of this manuscript.

Rajasthan

BUNDI

43 The Account of the Confidante

BUNDI SCHOOL, RAJASTHAN, C. 1660
ILLUSTRATION FROM THE *Rasikapriyā*
OPAQUE WATERCOLOR WITH GOLD ON PAPER
11¾ x 7¾″ (29.8 x 19.7 cm)
PRIVATE COLLECTION

Three figures are shown in this scene from the *Rasikapriyā* (The Connoisseur's Favorite) of Keśavadās (1555–1617). Their positions—lying down, standing, and sitting—are emphasized architecturally. The heroine lies sprawled on her bed in an airy, pillared pavilion on the ground floor of a three-storied structure. Its second floor has a wide terrace jutting in the picture space at an angle similar to that of the heroine's bed. Their directions cut into the shuffled order of vertical pillars and horizontal parapets.

The nexus between the right of the painting, with the figure of the heroine in the house, and the left, with the hero seated outside under a canopy in front of a walled garden, is brought about by the woman standing in front of this structure. Her body is turned toward the heroine, her hands pointing to her, while she faces in the opposite direction, toward the hero. Indeed, she is the go-between and in the verse from the *Rasikapriyā* (5.2) inscribed on the top of the painting, she exclaims:

> O Keśava [Kṛṣṇa], the cowherdess you saw yesterday,
> still somehow has not gotten hold of herself.
> Her body is once cold, and then very hot.
> As she lives, so does her desire.
> Friends seek countless ways to cool her fire,
> showering her with cures.
> Kṛṣṇa, bear no grudge if I say your glance
> is full of poison!

The separation of the two will not last long; it is but a passing phase. The hero, who is the gallant, who is Kṛṣṇa, is ready to get up from his seat.

The painting visualizes a relationship between a man and a woman, but it is an image of the relation of God and the human being, here figured metaphorically as Kṛṣṇa and the cowherdess. Though the setting is of a standard type derived from Mughal conventions, the two buildings convey the tension between the helpless abandon of the heroine's reclining body and the observant gallant. Placement and gesture of the confidante show her role as go-between.

44 *Kṛṣṇa and Two Cowherdesses Beheld by a Herdsman*

BUNDI SCHOOL, RAJASTHAN, C. 1675
OPAQUE WATERCOLOR ON PAPER
7 x 4⅝" (17.8 x 11.7 cm)
PRIVATE COLLECTION

The plain red ground of this small but exceptional painting of the Bundi school glows with an intensity of vision. It is concentrated in the central group of Kṛṣṇa and the two cowherdesses (*gopīs*) with searching eyes and miraculous lotuses rising large and rose-tipped white from their hands. A small figure of a worshiping herdsman at left and a tree rising into the picture at right witness the divine manifestation.

45 *Kṛṣṇa Sports with the Cowherdesses*

BUNDI SCHOOL, RAJASTHAN, C. 1680
OPAQUE WATERCOLOR WITH GOLD ON PAPER
12⅜ x 9¹⁄₁₆" (31.4 x 23 cm)
PHILADELPHIA MUSEUM OF ART. PURCHASED:
KATHARINE LEVIN FARRELL FUND AND
MARGARETTA S. HINCHMAN FUND. 1981-92-1

Between a lotus pond and the dense verdure of a grove the cowherd-esses (*gopīs*) rush to be embraced by Kṛṣṇa, who has just arrived. A row of pert, short-chinned faces, a patter of small feet, billowing skirts, doll-like bodies—all are in motion. Kṛṣṇa's long flower garland sums up the movement in front of the stillness of the deep green grove behind. White specks of flowering shrubs are set out against the dark tapestry of the grove, light feet move on the ground, lotuses open in the pond, and the two girls in the pond hold in their entranced gestures this movement of rejoicing, of which the Dark God is the cause. Bundi paintings excel in the still luxuriance of vegetation, an ordered jungle of fulfilled desire.

46 *Madhumādhavī Rāgiṇī*

BUNDI SCHOOL, RAJASTHAN, 1660–80
OPAQUE WATERCOLOR WITH GOLD ON PAPER
11⅛ x 7⅞" (28.3 x 20 cm)
COLLECTION OF DR. ALVIN O. BELLAK

Architectural shapes are depicted in this painting of the musical mode Madhumādhavī Rāgiṇī as expressive means for conveying emotion in articulate pictorial forms. They are ordered three-dimensionally by schematic and exaggerated shading. The build-ing is seen in multiple perspective, thrusting itself forcefully into space, an amplifying accompaniment to the *rāgiṇī*'s stance on the patterned terrace. It welcomes her approach as, surprised by a storm, she hurries toward the house yet looks backward toward a peacock, her raised arm holding up a necklace or garland to the bird. Her windblown shawl reveals the zigzag torsions of her figure and allows her anxious face to be silhouetted against the deep green ground.[1] Serpentine lightning flashes on the dark, cloud-laden sky as rain starts pouring down.

The Sanskrit inscription at the bottom is almost identical with the inscription in the Braj language on top. The Sanskrit verses say:

Her body clothed in a blue bodice,
lightning flashes, her body bends.
She proceeds in the darkness,
to the edge of the Tamāla grove,
out of passion for her lover.
This is Madhumādhavī.

1. The composition of this Madhumādhavī Rāgiṇī is very closely related to that of Mālava Rāga; see Beach, 1974, fig. 62, in which the building in its angular view fulfills the same compositional function; it follows a stock-in-trade formula. The face of the *rāgiṇī*, however, conforms with a Bundi rather than a Kotah type. A painting of Madhumādhavī also closely related to this one is assigned to Bundi, c. 1680, in Dahmen-Dallapiccola, 1975, p. 237, no. 18.18. See also Ehnbom, 1985, pp. 128–29, no. 58.

47 *The Boar Hunt*

BUNDI SCHOOL, RAJASTHAN, 1785–1800
OPAQUE WATERCOLOR WITH GOLD ON PAPER
14 x 9½" (35.6 x 24.1 cm)
PHILADELPHIA MUSEUM OF ART. PURCHASED:
GEORGE W. B. TAYLOR FUND. 1977-10-1

From a boar hunt, it is said, only one returns alive, the hunter or the boar. A boar hunt is more than a dangerous sport; it is a ritual performed in the springtime in honor of Durgā, the Great God-dess. In this pallid hunting scene, a boar attacks a rearing horse, whose rider slashes its throat, while a dog leaps on another boar, whose hunter is about to release an arrow from his raised bow. Two other hunters with guns appear at the crest of the hill crowned with large white trees. Sparsely foliated or barren trees send up their tortuous branches on each level of the hill, and they abound at the bottom of the painting, where white birds strut amidst the tracery of their branches and on the ground. A small white shrine on a second hill, at right, rises between rocklike shapes as emasculated and eerie as are the trees.

Although this painting very closely resembles hunting scenes painted in Kotah,[1] its facial types seem to conform with Bundi physiognomies.

1. See Beach, 1974, figs. 93, 111.

UNIARA

48 *Kṛṣṇa Surveys the Madhyā Types of Heroines*

UNIARA SCHOOL, RAJASTHAN, C. 1760
ILLUSTRATION FROM THE *Rasikapriyā*
OPAQUE WATERCOLOR WITH GOLD ON PAPER
11 x 8¹⁵⁄₁₆" (27.9 x 22.7 cm)
PHILADELPHIA MUSEUM OF ART. PURCHASED:
JOHN T. MORRIS FUND. 69-262-3

Framed by a border with a floral wave design, this painting is divided into four panels. The one on top carries a long inscription; the one at bottom illustrates the verses written above. In the middle zone, in the center of the left panel, a woman reaches up to a branch of a tree; in each corner stands a woman, three of them holding trays with carafes and glasses. The second panel, at right, is with-out figures. It is a composition whose subject is the dark, cloudy

sky in a thunderstorm and includes also a crescent moon and raindrops.

The inscription in Braj language taken from the *Rasikapriyā* (The Connoisseur's Favorite) (3.32–34)[1] of Keśavadās (composed in 1591) describes and classifies types of heroes, as well as heroines, or women in love, specifically the *ārūḍhayauvanā*, or sexually experienced heroine. She is one of four who form a subset of the *madhyā*, or middle, class of heroines (*nāyikā*). The inscription reads:

> Now the *madhyā* heroine.
> Know there are four types of *madhyā* heroines:
> *ārūḍhayauvanā* [sexually experienced heroine],
> *pragalbhavacanā* [outspoken heroine],
> *prādurbhūtamanobhavā* [demonstrative heroine],
> *suratavicitrā* [heroine enterprising in sex].
> The *ārūḍhayauvanā* is always happy, fortunate,
> and loves her husband with all her heart.
> O Gopāla, I saw a goddesslike cowherdess,
> whose forehead resembled the crescent moon;
> with piercing eyes and eyebrows;
> like Kāmadeva's arrow and bows;
> with breath smelling of the lotus,
> teeth like seeds of the pomegranate,
> a laugh bright as lightning,
> neck and arms like jars,
> belly as the betel leaf,
> feet as the lotus, gait like the swan,
> body the color of gold, redolent like the earth
> when wetted by the monsoon's first shower.

In the bottom panel the heroines stand aligned looking toward Krṣṇa. Two antelopes facing one another and a solitary gander complete the figures in this part of the painting. In the middle, the woman grasping a blossoming tree branch—an ancient symbol of love fulfillment—refers to the *madhyā* heroine, "redolent like the earth," and the "monsoon's first shower" comes down in the lightning-streaked cloud pattern of the panel on the right.

Although the painting lacks technical mastery it illustrates the text imaginatively, associating Keśavadās's codification of erotic types with the age-old Indian woman-and-tree symbol. The painter, moreover, contributed a composition of his own, the cloud and lightning panel, and he combined the parts of the painting—script, cloud, tree, and figural panels—with the painted frame in one original composition.

This painting is closely related to another painting from Uni-ara, a small state bordered by Bundi on the south, Kotah on the east, and Jaipur in the northeast. It represents a palace scene, and has, as part of it, an altogether painterly cloud-formed zone with the full moon beside it.[2]

1. The *Rasikapriyā* was published by the National Museum of India, New Delhi, in 1962; an English translation by K. P. Bahadur was issued in New Delhi in 1972.
2. Beach, 1974, fig. 55.

KOTAH

49 Apparition of a Wish-Granting Tree Spirit during Worship of the Liṅga
KOTAH SCHOOL, RAJASTHAN, C. 1700
OPAQUE WATERCOLOR ON PAPER
10½ x 8⅝″ (26.7 x 21.9 cm)
PRIVATE COLLECTION

In this unusual symbol-laden painting, an elegant woman, accompanied by a friend, comes to worship a *liṅga*, the symbol of God Śiva. She has brought flowers and holds a bowl, while her friend offers a garland. As she places flowers on the *liṅga*, the tree next to it bursts into bloom. Pairs of white birds wing their way across the sky in front of a large tree that is rich with foliage. The tree mediates between the two women who have come to worship and another of veiled glance, who emerges, arms raised, from a banana plant. This miraculous apparition is a tree goddess (*vṛkṣa devī*); she will grant the wish of the worshiping woman, whose face is raised toward her.[1] Two small monkeys have seated themselves on a shrub under the banana plant.

1. In a Buddhist relief of the second century B.C. from Bharhut, arms proffering food and drink to two men reach out from a tree; see Ananda K. Coomaraswamy, *La Sculpture de Bharhut* (Paris, 1956), p. 89, pl. XLV, fig. 180.

50 The Great Goddess Durgā Slaying Demons
KOTAH SCHOOL, RAJASTHAN, C. 1740
OPAQUE WATERCOLOR WITH GOLD ON PAPER
12⅜ x 17¼″ (31.4 x 43.8 cm)
PRIVATE COLLECTION

Durgā, the Great Goddess, the demon slayer, keeps the world free from ills and afflictions. She is the most formidable fighter; she fights with the weapons of all the gods. Here, she shatters a ring of assailing demons, while her vehicle, the lion, in the shape of a white dragon,[1] fiercely attacks them. His tail swishes in a wide arc around her arms, which are tensed to the fingertips. Two small acolytes, at bottom left and upper right, fill in the picture. Rugged rock shapes, on the right, frame this scene of combat. Three lotus flowers in full bloom rise unruffled from the crown of the Great Goddess as slayer of demons.[2]

1. Welch, 1973, pp. 46–47, points out the Turkman *divs* (monsters) of fifteenth-century Tabriz as ancestors of the griffinlike lion and the demons.
2. Four other paintings of this subject from Kotah have been published: Lee, 1960, pp. 38–39; Welch, 1973, pp. 46–47, no. 21; Kramrisch, 1981, pp. 214–15, no. P-46; and Ehnbom, 1985, pp. 136–37, no. 62.

51 The Great Goddess Durgā Slaying the Buffalo Demon
KOTAH SCHOOL, RAJASTHAN, C. 1750
OPAQUE WATERCOLOR WITH GOLD AND
SILVER OR TIN ON PAPER
10¹¹⁄₁₆ x 12⅜″ (27.1 x 31.4 cm)
PRIVATE COLLECTION

Durgā, the Great Goddess, is shown here as the slayer of the greatest of all demons, the buffalo demon, who is an embodiment of stupidity. As Durgā leaps from her "lion" vehicle onto the back of the falling buffalo and spears the beast,[1] his demon shape emerges from the dying animal's body. It is an act of grace that she performs at the edge of the world. It is there in the turquoise green vastness framed by the glow of a sun that has risen over the nascent vegetation of this earth that the battle takes place. A hat, its shape of remotely Chinese provenance, dislodged from its demonic owner's head, floats in undefined space. While the great master of the Durgā painting followed the myth of the goddess as told in the *Mārkaṇḍeya Purāṇa* (82–92),[2] he followed his own vision in depicting its locale.

1. Doris Wiener Gallery, New York, 1970, no. 53, shows a similar, though simpler, composition. There the vehicle of the goddess is a tiger.
2. *Mārkaṇḍeya Purāṇa*, trans. F. E. Pargiter (Benares, 1969), pp. 473–522.

52 Composite Elephant Carrying a Divine Rider Preceded by a Demon
KOTAH SCHOOL, RAJASTHAN, C. 1760
OPAQUE WATERCOLOR WITH GOLD ON PAPER
7¹⁵⁄₁₆ x 11⅝" (20.2 x 29.5 cm)
PHILADELPHIA MUSEUM OF ART. PURCHASED:
EDGAR VIGUERS SEELER FUND. 1976-15-1

A nimbed celestial holding an elephant goad rides this running elephant, while a demon trots in front, wielding a trident as he looks back. Although more coarsely drawn than the previous composite elephant (no. 18), this one is made up of animals devouring—or nibbling or confronting—one another while the complete composite creature, the elephant, moves on.

53 Maharao Durjansāl of Kotah on His Elephant Raṇasaṅgār
KOTAH SCHOOL, RAJASTHAN, 1750–70
OPAQUE WATERCOLOR WITH GOLD AND
SILVER ON PAPER
15¾ x 18⅞" (40 x 47.9 cm)
PRIVATE COLLECTION

The inscription on the verso of this painting reads: "The battle on Pauṣa Vadi II, Samvat 1780 [1724], between Śyām Singhji and Maharao Durjansālji, astride his elephant Raṇasaṅgār." The painting shows Maharao Durjansāl (1723–56) riding to battle against his elder brother, Śyām Singh, who perished in the war. It is a posthumous portrait of Durjansāl in a style like that of paintings executed in Maharao Chattarsāl's time (1758–70).[1] The armor of the elephant, rendered in great detail in silver and gold and enhanced by the clear yellow ground of the painting, does not interfere with the portraitlike depiction of Raṇasaṅgār.

1. See Beach, 1974, fig. 82; another posthumous portrait of Durjansāl is dated 1771 (fig. 128).

54 Kṛṣṇa Disguised as a Woman Musician Approaches Rādhā
KOTAH SCHOOL, RAJASTHAN, C. 1790
OPAQUE WATERCOLOR WITH GOLD ON PAPER
11¾ x 8⁵⁄₁₆" (29.8 x 21.1 cm)
PRIVATE COLLECTION

A pallid sun shines over this encounter of Rādhā and Kṛṣṇa. The assertive stance of Kṛṣṇa disguised as a lute player, the almost swooning coyness of Rādhā, and the arching leaves of the banana plants that ensconce them prepare for the step the lovers will take toward the red boat that awaits them in the foreground.

55 Worship of Śrī Viṭṭalnāthjī
KOTAH SCHOOL, RAJASTHAN, 1830–40
OPAQUE WATERCOLOR WITH GOLD AND
SILVER OR TIN ON PAPER
10¼ x 7¹¹⁄₁₆" (26 x 19.5 cm)
PHILADELPHIA MUSEUM OF ART. GIFT OF THE
FRIENDS OF THE MUSEUM. 68-12-4

This sumptuous painting shows the iconic installation of an image of Śrī Viṭṭalnāthjī and its worship by a Brahman. According to the Hindu Vallabhācārya sect, Kṛṣṇa has seven principal forms, or images, that of Śrī Viṭṭalnāthjī being one of them. The image of Śrī Viṭṭalnāthjī was housed in Kotah in the early part of the nineteenth century,[1] and it now is enshrined in a temple in Nathadvar, the center of the sect. The image shown here in a painting of the Kotah school is that of Śrī Viṭṭalnāthjī. It is contemporary with the presence of that image in Kotah. The naturalistic, portraitlike rendering of the large figure of the Brahman draws as much attention to itself as the installation of the image.[2]

The inscription on top of the painting tells that the celebration shown here was for the day preceding Kṛṣṇa's birthday on the eleventh of the dark half of the month Bhadrapāda (August–September).

1. Skelton, 1973, p. 83.
2. For a similar painting and the identical figure of the unidentified Brahman, see Beach, 1974, p. 43, fig. 118.

56 A Festive Day
KOTAH SCHOOL, RAJASTHAN, 1825–50
OPAQUE WATERCOLOR WITH GOLD ON PAPER
14⅞ x 21½" (37.8 x 54.6 cm)
PHILADELPHIA MUSEUM OF ART. PURCHASED:
JOHN T. MORRIS FUND. 1978-127-1

A large, white, palatial building forms the background for a young prince—he is nimbed—on horseback accompanied by a nobleman, also on horseback. A European-type carriage accommodates a well-dressed man holding a flower, and his driver, but the back seats of the carriage are empty. From the opposite direction come a small, empty carriage drawn by two antelopes and a

carriage occupied by two ladies and a driver and drawn by two bulls. Behind the bullock-drawn carriage two men fight while people look on; next to them a man prominently holding up a cloth draws attention to himself. An amusement resembling a Ferris wheel forms the last of this line of attractions.

Beyond, in a recess at the side of the building, a child is given a bath and a man stands nearby holding what may be a hawk. At that point the perspective gets out of hand, as it shows in the farthest distance a shrine, and between that small structure and the palace, a woman being attacked. A man runs away toward the palace, where, behind the man with the hawk, two vendors display their goods. From the roof terrace and a palace window, women look on the scene with keen interest.

57 *Pilgrimage to a Jain Shrine of Three Tīrthaṅkaras*

KOTAH SCHOOL, RAJASTHAN, C. 1850
OPAQUE WATERCOLOR WITH GOLD ON PAPER
11½ x 13⅞" (29.2 x 35.2 cm)
PHILADELPHIA MUSEUM OF ART. PURCHASED:
GERTRUDE SCHEMM BINDER FUND,
MARIE JOSEPHINE ROZET FUND, AND
EDGAR VIGUERS SEELER FUND. 72-258-3

On the chalky mauve ground of the painting, many flowered paths lead pilgrims, monks, and laymen to the shrine of three Jain saviors, Śāntinātha, Pārśvanātha, and Ṛṣabhanātha. The sixteenth, twenty-third, and first saviors (*tīrthaṅkaras*) of the Jain religion, they are identified by their cognizances, an antelope, a snake, and a bull, whose diminutive shapes are painted below them on the semicircular platform in front of the temple. The images of the saviors do not conform to established iconographic types. Their large, crowned heads sit on disproportionately small bodies; the naturalistic modeling of their lifeless faces in front view also contrasts with the liveliness of the pilgrims' figures shown mainly in profile. Singly, or in groups, the pilgrims follow paths tracing a rhythmic pattern around the main shrine. Ingenuity and immediate observation define the groups, such as the women in purda screened off in the lower left corner, the group halting in the loop drawn around a wayside shrine in the upper left, or the cows at right. The imposing building at front with its domes, verandas, and richly foliated trees is as competently drawn as are the many small shrines near the upper margin of the painting. The spire (*śikhara*) of the main temple with its flag appears set off against "hills" of a mountain ensemble.

DEVGARH

58 *The Birth of Kārttikeya*

DEVGARH SCHOOL, RAJASTHAN, 1800–1825
OPAQUE WATERCOLOR WITH GOLD ON PAPER
11 x 8½" (27.9 x 21.6 cm)
PRIVATE COLLECTION

From a dark leaden gray ground three mountains emerge, each crested with a castle. In front of the mountains a banyan tree bends under its load of ballooning foliage, each a tree in itself. Long, sleek branches and pendant roots frame the seated figures of God Śiva and his consort, Pārvatī. The goddess is frightened; she has thrown her arms around Śiva's neck. He embraces her with his right arm and points with his finger down to the right where a burning fire sends up smoke, rising, curling mountain high. From the bottom of the fire stares a round, tusked face. A lion runs toward the fire; a bull speeds in the opposite direction. Both animals have left their stations at the feet of god and goddess; they are fleeing in fear.

The myth visualized here tells of the birth of Kārttikeya, Śiva's son. He was born from the unending lovemaking of the god, who did not shed his seed—he was a yogi—until Agni, the Fire god, disturbed Śiva and Pārvatī, and Śiva's seed spurted into the Fire. The Fire could not bear it; it burned hotter than fire.[1] It is this moment in the myth of the birth of Kārttikeya that is shown in the painting.

The three castles and the large tree have no place in the mythical narrative. The painter saw them because Śiva is the Destroyer of the Three Fortified Cities of the Demons. Śiva also is known to be seated under the cosmic banyan tree; the landscape in the painting is Śiva's mythical ambience.

Śiva's round, ashen countenance seems to float in a sensuous dream; Pārvatī's profile, too, although alert, is steeped in sensuality of a similarly cloying nature. The same trait marks the face of Layla in a drawing of the lovers Layla and Majnun by Chokha,[2] an artist of Devgarh, a feudal estate in Mewar. It is to him that *The Birth of Kārttikeya* should be attributed.

1. *Vāmana Purāṇa*, 28, 38–43; *Śiva Purāṇa*, 2.4.2.1–11. The local countryside, "strewn with black igneous rocks" (Andhare and Singh, 1977, p. 1), might have inspired the artist.
2. Welch, 1976, p. 107, no. 59; see also Welch, 1973, pp. 52–53, no. 24; and Hayward Gallery, London, 1982, p. 139, figs. 155, 160.

PUBLISHED
Kramrisch, 1981, pp. 196–97, no. P-32.

SIROHI

59 *Kedāra Rāga*

SIROHI SCHOOL, RAJASTHAN, C. 1680
OPAQUE WATERCOLOR ON PAPER
9¼ x 6¹⁵⁄₁₆" (23.5 x 17.6 cm)
COLLECTION OF DR. ALVIN O. BELLAK

The inscription at the top of this painting speaks of the musical mode Kedāra Rāga. It shows a sad-faced woman seated in front of a well-appointed building. She holds out a flower garland and looks toward an ascetic seated opposite her. Fingering his flower garland, he looks at her. She is distressed because her husband has left her.

Various descriptions classify Kedāra as either a *rāga* or a *rāgiṇī* (his feminine consort). These also fluctuate with regard to the

asceticism practiced by Kedāra Rāga or by Kedāra Rāgiṇī.[1] The painting combines aspects of the several descriptions: It shows a sad woman, and it shows an ascetic. The action of offering the flower garland connects these figures. A mood of separation and asceticism pervades the scene. Its color is hot and strident, as is frequent in Sirohi paintings.[2]

1. Kedāra is classified as both a *rāga* and a *rāgiṇī*. As a *rāgiṇī*, she is a woman separated from her husband suffering "(pangs of) separation" but it is also said that she "took the male garb" (Ebeling, 1973, p. 134). The *rāgiṇī* is generally described as an ascetic (p. 134) whereas, in yet another tradition, it is said that *he* took the guise of an ascetic (p. 140).
2. For other *rāgamālā* pages from Sirohi, see Ebeling, 1973, p. 87, pl. C31, p. 107, pl. C41, p. 115, pl. C45, p. 237, fig. 173, and p. 268, fig. 286.

MEWAR

60 *Rādhā Enters a Walled Garden, Where Kṛṣṇa Awaits Her*

MEWAR SCHOOL, RAJASTHAN, C. 1629
OPAQUE WATERCOLOR WITH GOLD ON PAPER
9¾ x 7¼" (24.8 x 18.4 cm)
PRIVATE COLLECTION

Rādhā is being ushered by her friend through the gate of a walled garden where Kṛṣṇa awaits her, seated on a couch sheltered by trees and shrubs. The rich vegetation is laid out in the painting in a balanced sequence of several shapes, and the relation of Rādhā and her confidante to the structure of the gate shows equal concern for the clarity of the composition. The wall of the garden in the back and the couch in the foreground are placed with the same stabilizing, clarifying concern. The bold and sober organization is made even more effective by the strong and somewhat harsh color areas. Four other versions of this painting are known, the original of 1629 being the work of Sāhibdīn.[1]

1. The four versions have been published: (1) possibly the original of 1629 (in the Bhārat Kalā Bhavan, Benares), in Topsfield, 1981, p. 237, fig. 512; (2) Coomaraswamy, 1926, p. 86, pl. XVIII, frontispiece; (3) possibly a copy by a pupil (Prince of Wales Museum, Bombay), in Archer, 1960, pl. 39; and (4) University of Wisconsin, Elvehjem Art Center, 1971, pp. 55–56, no. 87.

61 *The Woman Who Goes to Meet Her Lover (Abhisārikā Nāyikā)*

MEWAR SCHOOL, RAJASTHAN, C. 1630
OPAQUE WATERCOLOR WITH GOLD ON PAPER
10¹⁄₁₆ x 8³⁄₁₆" (25.6 x 20.8 cm)
COLLECTION OF DR. ALVIN O. BELLAK

The love-driven heroine (*abhisārikā*) on the way to her tryst braves the dangers, beasts, and demons of a stormy night to find her way to her lover, the Dark God Kṛṣṇa. Snakes lie in her path and coil around her foot, a tiger is ready to pounce, female ghouls ogle and address her, and another beastly monster thirsts for her with lolling tongue. This creature is of particular significance for it is marked all over with a three-lobed motif that made its first appearance in Indian art in about the second millennium B.C. on the garment worn by a priestly figure carved in stone from Mohenjo-Daro.[1] Flowering trees and shrubs are staggered from the bottom to the

top of the painting, where on the left, Kṛṣṇa, calm and beautiful, is seated in the open porch of a firmly constructed building. On the right, a figure of pensive mien, seated in a rock shelter, looms large; he is a Kānphaṭa ("split-ear") yogi, his large earring of rhinocerous horn, large turban, and elegant robe identifying him.[2] Deep red rocks behind the heroine reach up toward the yogi. Magic moves through the figures, clefts, and trees; it emanates from the *abhisārikā* and confronts her. Raindrops, blossoms, and birds keep astir the atmosphere of the painting.

This painting appears to belong to a *Rasikapriyā* series attributed to Sāhibdīn. The inscription—in Braj—from the *Rasikapriyā* of Keśavadās says:

> Demons watch her from all sides,
> as her feet trample the hood of a coiled snake.
> She neither heeds nor senses the gathering storm,
> nor hears the crickets, or sounds of thunder.
> Oblivious of her lost trinkets, or her torn clothing,
> she feels not the thorn's cut on her breast.
> The ghouls ask: "O Woman! How did you acquire
> such fortitude, to pursue this tryst?"

1. Sivaramamurti, 1977, pl. 29; Susan L. Huntington, *The Art of Ancient India* (New York, 1985), pp. 12–13, fig. 22.
2. Kānphaṭa yogis were held in high esteem. The painting *Rao Lakhpatji in Darbar* shows the pir of the Kānphaṭas wearing a turban and shawl; see Goswamy and Dallapiccola, 1983, pl. III. At a recent fair in Girnar, many of the Kānphaṭas present wore turbans.

REFERENCE
Ehnbom, 1985, pp. 110–11, no. 48.

62 *The Rainy Season*

MEWAR SCHOOL(?), RAJASTHAN, 1625–50
OPAQUE WATERCOLOR ON PAPER
9³⁄₁₆ x 15¹¹⁄₁₆" (23.3 x 39.8 cm)
COLLECTION OF DR. ALVIN O. BELLAK

This landscape illustrates a passage from the *Bhāgavata Purāṇa* (10.20.5–12). It is exceptional, for no human figure is included to convey its mood. The verses are inscribed on the back of the painting in characters contemporary with the work:

> The earth's moisture, sucked up by the sun's rays for eight months, in good time is returned by the raincloud Parjanya. Great clouds, charged with lightning, tossed about by violent winds, discharge their soothing, life-giving rain, as if feeling compassion for the dry world below. The earth, parched by summer's heat, flourishes under the cloud's soaking, as the body weakened by ascetic rigor becomes renewed upon achieving its fruit. During the all-encompassing darkness of the night, not stars but glowworms shine, as during the Kali age, those who are learned are blighted by the sin of those who are evil. Hearing Parjanya's thunder, frogs, who had been silent, begin to croak, like Brahmans reciting at the close of their daily routine. Small streams, once dried up, now tumultuously overflow their banks, as one who allows his body to be dependent on passion strays on the wrong path. Verdant with grass, in some places red from infestation of the *indragopa* [insects], the earth is covered with umbrella-like mushrooms, suggestive of the wealth of kings. Farmers, delighted with the abundance of

grain in the fields, think not of their success dependent upon chance.

A more recent inscription, beneath the painting, says: "While it rains, birds perch singing on the hills, and jackals appear in the fields by the banks of the river Yamunā." The painting shows the bank of the river lined with rock cubes on which the figures of fish and animals are painted.

63 Kṛṣṇa Raises Mount Govardhana

MEWAR SCHOOL, RAJASTHAN, C. 1700
OPAQUE WATERCOLOR WITH GOLD AND
SILVER OR TIN ON PAPER
8½ x 16⅜" (21.6 x 41.6 cm)
PRIVATE COLLECTION

The *Bhāgavata Purāṇa* (10.24–25) tells of Kṛṣṇa raising Mount Govardhana. While the herdsmen in Braj are preparing their annual sacrifice to God Indra, lord of clouds, dispenser of rain, to whom they attribute their livelihood, Kṛṣṇa makes them realize that they actually owe their well-being to the mountain, with its woodlands, where their cattle graze. Following Kṛṣṇa's command, they sacrifice to the mountain, but when Indra does not receive his annual sacrifice he showers torrents of rain, which threaten to deluge Braj. Kṛṣṇa, however, uproots Govardhana with one hand and holds it in the air, providing a shelter under which the herdsmen, with their families and cattle, can take refuge. Indra stops his clouds from their deluge and the herdsmen are saved.

In the painting, Indra, riding on his elephant, commands the clouds to shower torrential rain on the mountain; the herdsmen and their families huddle under their wraps, and yogis and tiger alike seek shelter in their caves. Kṛṣṇa arrives (at lower right) and holds up his hand, on which he will raise the mountain. One herdsman has arisen, for he has seen Kṛṣṇa arriving, and while he points toward the god, the herdsmen begin to worship him.

The rivalry of cults and the pride and envy of gods are resolved in this painting in its deep purple-mauve, dark gray, and green zones brightened by red, yellow, and white in short, recurrent, horizontal rhythms. Long twigs and large leaves confirm the importance of the woodlands and connect the zones of the painting.[1]

1. A painting of this *Bhāgavata Purāṇa* series with Kṛṣṇa holding Mount Govardhana aloft on one finger of his raised hand is illustrated in Chandra, 1957, pl. 8.

64 The Madness of the Cowherdesses

MEWAR SCHOOL, RAJASTHAN, C. 1720
OPAQUE WATERCOLOR WITH GOLD ON PAPER
10⅛ x 16" (25.7 x 40.6 cm)
PRIVATE COLLECTION

The *Bhāgavata Purāṇa* (10.29–30) tells how Kṛṣṇa decides to sport in the coming night. As the moon rises Kṛṣṇa plays on his flute and entrances the cowherdesses (*gopīs*); they hasten to meet him, but Kṛṣṇa bids them to return to their work, their husbands, and their homes. The women beseech him; he walks with them into the forest, caressing them, and each of the *gopīs* feels that she is Kṛṣṇa's

chosen one. Seeing that each is engulfed in pride, Kṛṣṇa instantly vanishes.

The *gopīs* remain in Kṛṣṇa's thrall, completely absorbed in his being. They imitate his movements, glances, actions. Maddened, they identify themselves with Kṛṣṇa, and they wander about in their madness in quest of him. Here, they mimic all his various sports. One sucks the breast of another, as he sucked the breast of Pūtanā, the demoness; another throws herself down and kicks with her legs, while yet another thinks herself the cart that Kṛṣṇa, as an infant, had overturned (*Bhāgavata Purāṇa,* 10.7.5–7). Another cowherdess steals the clothes of the *gopīs,* as Lord Kṛṣṇa did; another holds Mount Govardhana in her raised hand, and the one next to her plays the flute as Lord Kṛṣṇa does. Thus the *gopīs,* crazed with love and longing for Kṛṣṇa, sport because Kṛṣṇa has vanished from their midst. The madness of the cowherdesses wreathes, in this painting on black ground, around the cows and Kṛṣṇa's tree.

65 Men with Fireworks Celebrate Diwālī, the Festival of Lights

MEWAR SCHOOL, RAJASTHAN, 1730–40
OPAQUE WATERCOLOR WITH GOLD ON PAPER
9¹³⁄₁₆ x 10" (24.9 x 25.4 cm)
COLLECTION OF DR. ALVIN O. BELLAK

Diwālī, the Festival of Lights, celebrates on a day in October or November the reappearance of the sun after the rainy season. It also celebrates Lakṣmī, the goddess of luck or good fortune, which it is hoped she will bring during the coming year. Houses throughout India are brightly lit and decorated with rows of oil lamps, lighted lamps are set afloat in rivers, and fireworks are displayed. The darkness of night—the black ground of the painting—is astir with the light in which figures of men, lit up by their fire sticks, scintillate like sparks. The sharp contrast of ground and figures is, however, softened by the trails of smoke. Black, as ground color, is used to very different effect in the previous painting (no. 64) and this one.[1]

1. In a realistic, and at the same time, lyrical way, the night of Diwālī has been painted in Kishangarh; see Dickinson and Khandalavala, 1959, pl. 11.

66 Madhumādhavī Rāgiṇī

MEWAR SCHOOL, RAJASTHAN, C. 1750
OPAQUE WATERCOLOR WITH GOLD ON PAPER
13¹⁵⁄₁₆ x 10¼" (35.4 x 26 cm)
PRIVATE COLLECTION

This version of the Madhumādhavī Rāgiṇī—while based on the same iconographic theme as that of a preceding Bundi painting (no. 46)—makes three-dimensional organization in the plane its main concern. The slanted parapet of the top floor of the building and the fence at the back set the scene for the tilt of the *rāgiṇī's* figure and for her peacock. The other women are impassive figures who mediate between the pillars and the space of the *rāgiṇī's* performance. The flight of white cranes on top at the far end of the courtyard delimits the wider ambience of the scene. The pavilion

on the top floor firms the structure of the painting. The angular view of the building is a powerful, three-dimensional theme that carries the mood of expectation expressed by the movement of the melody of the *rāgiṇī*. The color of the painting is pallid, or bleached.

The inscription at top reads: "Jaisalmer princess, Hata Akara, wife of Umeda Singh." This may refer to Umeda Singh (1739–70), a ruler of Bundi.

67 *Hiṇḍola Rāga*
MEWAR SCHOOL, RAJASTHAN, C. 1750
OPAQUE WATERCOLOR WITH GOLD ON PAPER
15⁷⁄₁₆ x 10¾″ (39.2 x 27.3 cm)
PRIVATE COLLECTION

Hiṇḍola Rāga, the "swing" melody, is in the light vein of love's foreplay. The *raga,* shown here as a young prince, has many women and is faithful to none. Hiṇḍola Rāga became associated with the cult of Kṛṣṇa.[1] Although this and the preceding painting (no. 66) belong to the same *rāga* series, its saturated color is its main asset, particularly in the contrast of the sultry sky and the glowing red swing. The painter, however, had difficulties with the scaffold supporting the swing and the group of women beside it, on the right. Birds, clouds, and lightning swing along with the melodic theme.

1. Dahmen-Dallapiccola, 1975, p. 185.

68 *Water Festival at Udaipur*
MEWAR SCHOOL, RAJASTHAN, C. 1750
OPAQUE WATERCOLOR WITH GOLD AND
SILVER LEAF ON PAPER
18¾ x 23⅝″ (47.6 x 60 cm)
COLLECTION OF MR. AND MRS. WILLIAM P. WOOD

The painting presents, as if on a tray, the buildings within the precincts of one of the newly built water pavilions of Lake Pichola, in the city of Udaipur. The figure of Rana Jagat Singh II of Mewar (1734–52), himself the architect of the complex, appears thrice in the painting, his portly shape most conspicuous in the middle of the large courtyard behind the water pavilion. Stuart Cary Welch has given a lively enumeration of a "few simple Rajput pleasures" shown in this painting: "singing and dancing girls, boating, gardening, swimming, watching water buffalo combats, promenading in the women's quarter, and listening to music."[1]

The painting gives more than a bird's-eye view of the lake, the buildings, and life in and around them. It shows them in more than one perspective following the practice introduced by Mughal painting two centuries earlier; this in turn had revived the ancient Indian perspective and subsequently, in the last quarter of the sixteenth century, let European perspective enter the painted illusion of reality.

1. Welch, 1973, p. 28.
PUBLISHED
Welch, 1973, pp. 28–29, no. 8.

69 *Rāma, Lakṣmaṇa, and Sītā in Exile in the Forest*
MARWAR SCHOOL, RAJASTHAN, C. 1745
OPAQUE WATERCOLOR WITH GOLD ON PAPER
11 x 7¾″ (27.9 x 19.7 cm)
PRIVATE COLLECTION

70 *Viṣṇu in the Form of Pārvatī Watches the Burning of the Demon Bhasmāsura*
MARWAR SCHOOL, RAJASTHAN, C. 1745
OPAQUE WATERCOLOR WITH GOLD ON PAPER
11 x 7¾″ (27.9 x 19.7 cm)
PRIVATE COLLECTION

These paintings are recto and verso of a page possibly from a *Rāmāyaṇa.*[1] Each illustration is conceived in an original manner and has a color scheme of its own. The first shows Rāma, his wife Sītā, and his younger brother Lakṣmaṇa exiled in the forest, the broken edge of the clearing in front of their hut supporting their plight. The second illustrates a different story. It shows a lovely woman seated on a pile of cushionlike mountain crags; she looks with noble detachment at a demon surrounded by flames.

This scene depicts the punishment of Bhasmāsura, the ash demon, who attempts to seduce Pārvatī, Śiva's wife. He intends to burn Śiva to ashes with an amulet and then to take Pārvatī away. Śiva flees and hides in a cave but the demon follows him. Viṣṇu then takes Pārvatī's form and leads Bhasmāsura away. Bhasmāsura prepares to fulfill his desire but Viṣṇu, in the form of Pārvatī, says, "My lord first dances and then [he fulfills] his desire." Bhasmāsura then begins to dance, and as he dances, Pārvatī tells him to place his hands on his head. When the amulet touches his head, Bhasmāsura is burned to ashes.[2]

1. For related illustrated pages, see Czuma, 1975, no. 93.
2. See O'Flaherty, 1973, p. 287, citing Verrier Elwin, *Myths of Middle India* (Oxford, 1949), p. 348.

71 *Self-Portrait of a Painter at Work*
MARWAR SCHOOL, RAJASTHAN, C. 1750
DEVA
OPAQUE WATERCOLOR WITH GOLD LEAF ON PAPER
7⅛ x 3¹¹⁄₁₆″ (18.1 x 9.4 cm)
COLLECTION OF MR. AND MRS. WILLIAM P. WOOD

This proud statement by the artist Deva—a self-portrait—follows those of the masters of the Mughal school, who had set the example of self-portraits while at work.[1] The orderliness of the painter's neatly arranged tools is more impressive than the finished painting propped up on his knee. This illustration is candid and its colors are light and refreshing.

1. For portraits and self-portraits of Mughal painters, see Das, 1981, figs. 276–85; and Beach, 1978, p. 151, fig. 13.

72 Prince Padam Singh of Bikaner Sits with His Bard on a Terrace at Night
KISHANGARH SCHOOL, RAJASTHAN, 1675–1725
OPAQUE WATERCOLOR WITH GOLD AND SILVER OR
TIN AND WITH INCISED DECORATION ON PAPER
11¾ x 14" (29.8 x 35.6 cm)
PRIVATE COLLECTION

Prince Padam Singh (1645–1683) was the third son of Maharaja Karan Singh of Bikaner.

[He was] regarded as the bravest man of his time and has become almost a legendary hero of Bikaner. Reckless courage and great personal strength were the characteristics which distinguished this young prince. Few could survive the terrific blow of his sword and everyone treated him with due deference for fear of provoking his anger. . . . His famous sword measuring 3 ft. 11 inches and 2½ inches broad and his exercising sword weighing 25 lbs. and 4 ft. 6 inches long and 2½ inches broad, are preserved in the Bikaner Armoury and his sword is worshipped on a special day every year.[1]

The inscriptions in Hindi and Persian on the reverse of the painting give the name of the bard (charan), Gordhar, who is depicted here with Prince Padam Singh, and further particulars about him. It is stated that he had composed many six-line poems in honor of the prince's bravery, generosity, fierce independence, and devotion to religion.[2] The realistic portraits of the prince and his bard show the artist's indebtedness to the Mughal school. The patterns of the fabrics and of the hilt of the sword render Mughal and Rajasthan designs.

1. Karni Singh, *The Relations of the House of Bikaner with the Central Powers, 1465–1949* (New Delhi, 1974), pp. 94–95.
2. This information was provided by Terence McInerney.

73 Two Friends: Anad Singh Mahmat and Mirza Wali Beg Chagata
KISHANGARH SCHOOL, RAJASTHAN, 1700–1725
OPAQUE WATERCOLOR WITH GOLD AND SILVER OR
TIN AND WITH TOOLING AND INCISED DECORATION
ON PAPER
8⅝ x 8⅞" (21.9 x 22.5 cm)
PRIVATE COLLECTION

Two friends, one a Hindu, the other a Muslim, enjoy each other's company at a fruity meal. Anad Singh Mahmat, the Hindu, of shorter stature though not narrower girth, looks on while Mirza Wali Beg Chagata cuts open a melon. Each wears his shield at his back, slung over his left shoulder, the straps emphasizing the rotundities of their bodies. Mirza Wali Beg Chagata wears his turban well; its feather ornament and his bow curve to the right, enhancing his physiognomy. The dark Hindu is sedate; his hands seem to listen and make their comment on his friend's remark. The orange-yellow ground and margin add their warmth to the repast.

74 The Horse Acambha
KISHANGARH SCHOOL, RAJASTHAN, C. 1740
OPAQUE AND TRANSPARENT WATERCOLOR
ON PAPER
10 x 13⅜" (25.4 x 34 cm)
COLLECTION OF DR. ALVIN O. BELLAK

This portrait of the horse Acambha shows a high-strung animal, full of vitality, splendidly rigged out and colored. Four men, two who have come with fans made of peacock feathers (morchal), attend to Acambha. The men are drawn in the most elegant Kishangarh style, which, while indebted to the Mughal school, has a relaxed grace and subtlety of its own.

The painting is probably the work of Sawant Singh, ruler of Kishangarh. A drawing attributed to this maharaja has been published;[1] others are said to be preserved in the collection of the Kishangarh palace. The best examples of the Kishangarh school of painting of the mid-eighteenth century are mostly attributed to or influenced by Nihal Chand, and the role of Sawant Singh as creative artist within this milieu is yet to be defined.

1. Dickinson and Khandalavala, 1959, p. 19, fig. 5.

75 Rādhā and Kṛṣṇa
KISHANGARH SCHOOL, RAJASTHAN, C. 1750
OPAQUE WATERCOLOR WITH GOLD ON COTTON
40¾ x 37" (103.5 x 94 cm)
PHILADELPHIA MUSEUM OF ART. PURCHASED:
EDITH H. BELL FUND. 1984-72-1

On a white terrace, seated on a large lotus like images of deity, a princely figure in a gesture of endearment offers a betel leaf to the lips of his beloved. The sharp-featured slender figures resemble one another; they carry the dream of each other under brows vaulting high above lowered lids that veil their emotion. Theirs is the intimacy of lovers and the stillness of icons. Like another lotus, the man's garment envelops his seated posture. In his belt is a lotus bud, as tender as the touch of the woman's hand that rests on the floor.

Composed with utmost subtlety of line and color, the painting might be the work of Nihal Chand, a master of the Kishangarh school trained at the Imperial court in Delhi, to whom only a few paintings can be attributed.[1]

1. Only two paintings are assigned to Nihal Chand by inscription, none is signed by him; see Dickinson and Khandalavala, 1959, pls. 7, 9. Among the paintings attributed to Nihal Chand, *Rādhā* (pl. 4) is closest in style to this *Rādhā and Kṛṣṇa* (no. 75). Related to these two paintings is a portrait showing only the heads of these two figures (Randhawa and Galbraith, 1968, p. 102, pl. 20). A large painting (27⅛ x 20½") in the Maharaja Sawai Man Singh II Museum, City Palace, Jaipur; another in a private collection (Archer, n.d., pl. 39); as well as a smaller painting (Welch and Beach, 1965, pp. 93, 123, no. 55) are versions of this theme. Dr. Asok Kumar Das, Director of the Maharaja Sawai Man Singh II Museum, kindly supplied a photograph and measurements of the painting in Jaipur.

76 Two Court Ladies
KISHANGARH SCHOOL, RAJASTHAN, C. 1780
OPAQUE WATERCOLOR ON PAPER
11½ x 8⅛″ (29.2 x 20.6 cm)
PRIVATE COLLECTION

Rādhā, as perhaps painted by Nihal Chand (see no. 75), became the archetype of feminine beauty in many paintings of the Kishangarh school. Here, two ladies of the court reflect her allure in their enigmatic, sharp-featured, high-browed faces. While their figures obey the same rhythms and resemble each other, the one on the right seems more experienced and somewhat blasé; the younger one, on the left, is inquisitively observant and amused. Their arms and midriffs form a pattern of abstract shapes. Though the painting is rough in its execution and heavy if compared with the previous painting of *Rādhā and Kṛṣṇa,* it is still informed by the mysterious elegance of that work.

JAIPUR

77 Vibhāsā Rāgiṇī
JAIPUR SCHOOL, RAJASTHAN, C. 1750
OPAQUE WATERCOLOR WITH GOLD AND
SILVER OR TIN ON PAPER
11¹⁵⁄₁₆ x 8¹³⁄₁₆″ (30.3 x 22.4 cm)
PRIVATE COLLECTION

The melody type Vibhāsā Rāgiṇī is played at dawn in a loving mood. In this painting the lover is about to let fly an arrow at the cock (not shown) whose early morning crowing has disturbed him and his lady.[1] The lover appears here in the likeness of Kāma, the god of love, with his bow and arrow. The painting is conceived in geometrical terms with corresponding areas allotted for the inscription above and the attendant figures seated on a rug below. In the scene between these areas, the lover's stride deftly exceeds the large rectangle of the door opening against which his figure is set. The beloved, lying on her couch, attended to by her confidante, resolves the balance of the composition by the smaller, doorlike rectangle assigned to her group. The entire white facade of the palace is divided into rectangular areas variously accentuated in calmly arresting rhythms.

1. Dahmen-Dallapiccola, 1975, p. 335.

78 The Meeting
JAIPUR SCHOOL, RAJASTHAN, C. 1780
OPAQUE WATERCOLOR WITH GOLD ON PAPER
10 x 11¼″ (25.4 x 28.6 cm)
PRIVATE COLLECTION

On the shore of a lake, a horseman halts before a woman who unveils her face as she looks at him. A sword rests on his shoulder, and a bow hangs from it. The shore is rocky, set with trees and shrubs; it leads, by the foot of a hill, along a narrow path to a fortified city in the far distance. There, over its crowded buildings and shrines, a thunderstorm—a great cloudburst—is raging. On the opposite shore, birds fly in and out of the dense foliage of mighty trees sheltering a small *liṅga* shrine. The dark green foliage

sets off the golden-clad horseman on his golden steed as he halts in front of the lady with her golden veil.

The perspective of this unidentified romantic encounter is derived from Western art. The figures of rider and horse are reminiscent of those in a fresco of *Saint George and the Princess* in Verona by the fifteenth-century Italian painter Pisanello, and the town in the distance also has Quattrocento precedents. The horseman's hat (which could also be a shield to ward off the downpour) is unusual; it, too, relates to work by Pisanello.[1] The "European" style of this painting is similar to that of a painting of Śiva and Pārvatī assigned to Jaipur.[2]

1. Medals by Pisanello (1395–1455) show heads in profile, wearing types of headgear similar to that in this painting; other medals show cityscapes (information provided by Carl Strehlke, Assistant Curator, John G. Johnson Collection, Philadelphia). See Gian Alberto Dell'Acqua and Renzo Chiarelli, *L'Opera completa del Pisanello* (Milan, 1972), pls. 20–21, 41, 54–62.
2. Portland Art Museum, 1968, p. 49, no. 38; Kramrisch, 1981, p. 203, no. P-36.

MALPURA

79 Śiva Ardhanārīśvara, Carrying Gaṇeśa, Is Adored by Nandin and a "Lion"
MALPURA SCHOOL, RAJASTHAN, 1750–60
OPAQUE WATERCOLOR WITH GOLD ON PAPER
11¾ x 8½″ (29.8 x 21.6 cm)
PRIVATE COLLECTION

Śiva Ardhanārīśvara is god and goddess in one. On his left, or female, half he holds his son Gaṇeśa, seated on the hip of the goddess (Pārvatī). Śiva amuses Gaṇeśa by shaking the rattle drum (*ḍamaru*), symbol of primordial sound. Nandin, Śiva's mount, and the "lion," the vehicle of the goddess, listen, raising their heads. The scene plays on Mount Meru, the top of the world.

The inscription above describes Śiva:

> He is everywhere; [his] ashen half-body has a snake, the Ganges, the hour-glass drum, a garland of headless corpses, an antelope skin, and the crescent moon. [Sitting] in his lap, Gaṇeśa worships the one whose half-body is adorned with disheveled hair, ornaments, and variegated clothing: the lord of the earth, the gods, and Śeṣa [the cosmic serpent].

A wide mustard yellow border frames the scene painted on a black ground. The red panel of the inscription, the red of Pārvatī's garment, the ash blue color of Śiva, and the white bull and yellow tiger on the white mountain translate myth into color harmony.[1]

1. A painting of Ardhanārīśvara showing the Descent of the Ganges (Kramrisch, 1981, p. 166, no. P-6) is from the same series as this.

80 Rāga Dīpaka
MALPURA SCHOOL, RAJASTHAN, 1760–85
OPAQUE WATERCOLOR WITH GOLD AND
SILVER ON PAPER
15⅞ x 11¾″ (40.3 x 29.8 cm)
PRIVATE COLLECTION

Rāga Dīpaka, the fire *rāga,* inflames the beautiful young woman with love; she is conscious of her youth and beauty.[1] Here, her

heavy-cheeked physiognomy is typical of Malpura paintings. Flames burn on the stands on each end of the couch on which the young woman and her lover are seated. An altarlike structure arches behind their figures and surrounds them. Arches and railings are traced in delicate patterns on the plain, luminous color fields of the painting. Trees, flowers, and a pale moon above soften the contrast between the color fields and the white architecture.

Rāga Dīpaka is played in the evening. The verses inscribed above, although not descriptive of the painting, define one aspect of the significance of this musical mode:

> Full of light, the city's form is charming in the night.
> The beloved brings a glowing lamp to the tryst, so that the lovemaking may be enhanced with amorous play.
> The myriad gold ornaments soothe the spirit.
> Thus the poet, Govinda, assigns Dīpaka the foremost position amongst *rāgas*.

The performance of the Rāga Dīpaka is awaited at the third hour of evening.

1. Dahmen-Dallapiccola, 1975, p. 238.

ISARDA

81 *Horse and Groom*
ISARDA SCHOOL, RAJASTHAN, C. 1690
VĀJĪDA
OPAQUE WATERCOLOR ON PAPER
12⅝ x 15⁵⁄₁₆″ (32.1 x 38.9 cm)
COLLECTION OF DR. ALVIN O. BELLAK

The artist Vājīda inscribed his name on the reverse of this portrait of the horse Bado Samandu (Big Ocean) and its groom. Although Vājīda's portrait is somewhat wooden—its ancestors are met in Mughal paintings[1]—its clear-cut silhouette and the sense of readiness for the rider conveyed in posture and spacing of horse and groom are impressive.

The feudatory court (*thikana*) of Isarda, situated about eighty miles southeast of Jaipur, has only recently become known as the seat of a school of painting.[2]

1. See Pal, 1983, pp. 168–69, pls. M51–52.
2. Indar Pasricha, "Painting at Sawar and at Isarda in the 17th Century," *Oriental Art,* n.s., vol. 28, no. 3 (Autumn 1982), p. 259.

82 *Kṛṣṇa and His Wife Rukmiṇī Greet Balarāma and His Wife Revatī after Their Wedding*
ISARDA SCHOOL, RAJASTHAN, C. 1690
VĀJĪDA
OPAQUE WATERCOLOR WITH GOLD ON PAPER
12¼ x 14¾″ (31.1 x 37.5 cm)
COLLECTION OF DR. ALVIN O. BELLAK

In this forthright painting, the gods, except Balarāma, elder brother of Kṛṣṇa, show no divine attributes. The crown he wears is that of a bridegroom (the wedding of Balarāma is referred to in the *Bhāgavata Purāṇa,* 9.3.29–36); Balarāma's plowshare, which rests conspicuously next to him, is his cognizance. Once, when he

had drunk the juice of the flowers of the *kadamba* tree, Balarāma had become inebriated and shouted to the river goddess Yamunā to come to him for he wanted to bathe in her. The river goddess, however, continued on her course. Balarāma, with his plowshare, dragged her to him and did not release her during his wanderings until all the lands were well watered (*Viṣṇu Purāṇa,* 5.25).

Here, Kṛṣṇa, the Dark God, salutes Balarāma by raising his folded hands. Rukmiṇī, Kṛṣṇa's wife, a particularly moving figure filled with true emotion, repeats the gesture, while her attendant ushers her forward. A sense of deep devotion pervades this group. The bejeweled objects above the folded hands of Kṛṣṇa and Rukmiṇī seem to be upheld as offerings to Balarāma. The jewelry worn by the figures is represented with minute care. A few blossoms are gathered around Balarāma's plowshare.

The spacing of the figures avoids alignment and monotony on the plain, monochrome ground. A strip of cloudy sky stretches along the upper margin of the painting.

NAGAUR

83 *Hanumān Finds Sītā*
NAGAUR SCHOOL, RAJASTHAN, C. 1750
OPAQUE WATERCOLOR WITH GOLD ON PAPER
11¾ x 8″ (29.8 x 20.3 cm)
PHILADELPHIA MUSEUM OF ART. GIFT OF
WILLIAM P. WOOD. 67-80-4

Although this painting has two identical inscriptions (one on the border and the other below it on the sky) reading "Rāgiṇī Rāmakalī of Śrī Dhyān Dīpak Rāga," the figures do not conform with any text describing the melody type Rāmakalī Rāgiṇī.

A woman sits in a walled-in portion of a grove; behind her, an attendant demoness (*rākṣasī*) holds a fly whisk and flower garland. In front of the seated woman is a monkey that has just leaped forward and reverently bows to her. She places her left hand on the monkey's head and holds a rosary (*akṣamālā*) in her right hand.

The scene refers to the story of Sītā, Rāma's wife, who was abducted and kept imprisoned in an *aśoka* grove by Rāvaṇa, the demon king of Laṅkā. The monkey is Hanumān, the commander of the army of monkeys, who helps Rāma by finding Sītā in the grove (*Rāmāyaṇa,* 5.40.20). The enclosing wall with its broad and halting curve, seen simultaneously from inside and out, the trees as if spellbound, and the distraught aspect of the seated woman convey the sense of Sītā as Rāvaṇa's prisoner.

84 *Angels Visit Sultan Ibrahim ibn-Adham of Balkh*
NAGAUR SCHOOL, RAJASTHAN, 1775–1800
OPAQUE WATERCOLOR ON PAPER
8 x 9¼″ (20.3 x 23.5 cm)
PRIVATE COLLECTION

Sultan Ibrahim ibn-Adham of Balkh, who lived in the eighth century, was a Sufi, a mystic, who forsook his kingdom and lived withdrawn from the world. He is revered to this day as a saint. In this painting, the saint seated on a mountain plateau, the angels who bring food and drink to him, the deer across the river, the lotus pond, and the forest are each in a separate enclave bounded by

rhythmically flowing, dark, shaded limits. Though linear, these suggest layered depth in muted tones of moss green, ocher, mauve, and pink. The waves of the river and pond play around lotus leaves, buds, and aquatic plants, while the leaves of the trees each vibrate in its own measure. The entire painting is a place where angels tread as they visit a saint.

BIKANER

85 *The Wedding of Satyabhāmā and Kṛṣṇa*
BIKANER SCHOOL, RAJASTHAN, 1590–1600
OPAQUE WATERCOLOR WITH GOLD ON PAPER
8⁷⁄₁₆ x 11¹¹⁄₁₆″ (21.5 x 29.7 cm)
COLLECTION OF DR. ALVIN O. BELLAK

This scene of the wedding of Satyabhāmā and Kṛṣṇa—identified by the title inscribed on the back—has the look of a humble marriage ceremony; it takes place in the open, the bridal pair seated on a couch under a flimsy canopy. In front, a Brahman priest offers an oblation into the fire, while two female attendants come toward the group, one out of the domed building, each carrying a basket.

Ritual vessels, holding water for ablutions and for sipping, and other pots are placed on the ground around the nuptial canopy. Kṛṣṇa, dressed in a loose jama, inclines his head forward in the direction of the priest; Satyabhāmā, small and resolute, sits on his left. Kṛṣṇa wears a tall, conical bridegroom's crown crested with flowers; Satyabhāmā's shawl is fastened to her head by a band that holds similar, long-stemmed flowers. The eyes of all the figures have an intent, somewhat fierce, look, their pupils close to the inner corners.

The style of this work is similar to that of sub-Imperial Mughal painting while the setting is planar rather than spatial.[1]

1. Other paintings from the same manuscript are illustrated in Pal, 1978, pls. 4a–b.

86 *Deśākhyā Rāgiṇī*
BIKANER SCHOOL, RAJASTHAN, 1675–1700
OPAQUE WATERCOLOR WITH GOLD ON PAPER
17⁵⁄₈ x 11¹⁵⁄₁₆″ (44.8 x 30.3 cm)
FREE LIBRARY OF PHILADELPHIA. RARE BOOK
DEPARTMENT, JOHN FREDERICK LEWIS COLLECTION

The musical mode Deśākhyā Rāgiṇī—judging from its name, which may be derived from the word *deśī,* or rural—would seem to be based on a rural solstitial rite of athletic performances.[1] The *rāgiṇī* is depicted by a representation of athletes practicing for the celebration. The practice post, the club, and the weights—to be lifted—are their equipment. In many representations of Deśākhyā Rāgiṇī the athletes are corpulent, but the cloths tied around their upper arms are not generally present. Their shaved heads, with only a strand left at the apex, recall traditional Brahmanical practice.

In this painting the athletes are practicing in an empty room. The modeling of their bodies and equipment, as much as the perspective of the room, aims at European realism. The softly

glowing colors are the painting's most musical and outstanding feature; it bathes the ponderous shapes in its glow.

1. Dahmen-Dallapiccola, 1975, p. 213.

87 *Surat Singh and a Guru Sit in a Palace Chamber Flanked by Courtiers*
BIKANER SCHOOL, RAJASTHAN, 1800–1825
OPAQUE WATERCOLOR WITH GOLD ON PAPER
11 x 16″ (27.9 x 40.6 cm)
COLLECTION OF DR. ALVIN O. BELLAK

Academic formalism, realistic portraiture, and iconic symmetry combine to make this painting a punctilious record of its time. Puppetlike and as if arrested by a spell, the figures are redeemed by the utterly unrealistic spontaneity of the color of the painting. In keeping, however, with its ostentation, the names of the personages represented are identically inscribed on the painting and on its verso.

Central India

MALWA

88 *The Enticement of Ṛṣyaśṛṅga*
MALWA SCHOOL, CENTRAL INDIA, c. 1635
ILLUSTRATION FROM THE *Rāmāyaṇa*
OPAQUE WATERCOLOR ON PAPER
6⁷⁄₈ x 9″ (17.5 x 22.9 cm)
PRIVATE COLLECTION

The story of the hermit Ṛṣyaśṛṅga is told in the *Rāmāyaṇa* (1.9.1–32) and the *Mahābhārata* (3.110–13). Seeking a remedy for a severe drought that has besieged the kingdom of Anga, the priests advise the king to take advantage of the magical powers of a young hermit, Ṛṣyaśṛṅga. If he comes to Anga, a gentle, invisible rain will accompany him as he roams about in the forest and will refresh trees and plants. The priests suggest that as a reward for coming the king give his daughter in marriage to Ṛṣyaśṛṅga. But first Ṛṣyaśṛṅga must be enticed to come to Anga. The most beautiful courtesans are sent to the forest, and when Ṛṣyaśṛṅga, who has never seen a woman, beholds these creatures, a strange longing comes over him. He invites them to his hermitage and entertains them, but suddenly they leave. Overcome with restlessness, Ṛṣyaśṛṅga walks in the forest; the girls invite him to follow them. Entranced, he follows, and when they arrive in the kingdom of Anga, rain begins to fall and the king rewards the hermit with his daughter in marriage.

This painting from a manuscript of the *Rāmāyaṇa*[1] shows the critical moment in the legend: The girls plead with the entranced young hermit to follow them to their "cottage," that is, the king's castle. The building on the right, the hermit, the pleading and inviting girls, the spaced-out trees that stand for the forest, and the distances between the actors as much as their angular, telling gestures create an emotional intensity that the color fields of the painting have absorbed and deepened. The alignment of the figures, treetops, and dome, the horizontals and verticals of the

architecture, and the width of the upper and lower margin combine in subtle simplicity.

1. For other pages from this *Rāmāyaṇa*, see Lee, 1960, pp. 18–19, no. 6; Khandalavala, Chandra, and Chandra, 1960, p. 41, no. 49a, fig. 47; Archer, 1960, pl. 34; and Portland Art Museum, 1968, p. 55, nos. 39a–b.

89 Hanumān's Leap to Laṅkā
MALWA SCHOOL, CENTRAL INDIA, c. 1635
ILLUSTRATION FROM THE *Rāmāyaṇa*
OPAQUE WATERCOLOR WITH GOLD ON PAPER
8⅛ x 9" (20.6 x 22.9 cm)
PRIVATE COLLECTION

The *Rāmāyaṇa* tells of Hanumān, the commander of the army of monkeys, who helps Rāma search for his wife Sītā, whom Rāvaṇa, the demon king, has abducted to his capital in Laṅkā. In one leap, Hanumān jumps from India to Laṅkā, and finds Sītā imprisoned by Rāvaṇa in a walled-in grove of *aśoka* trees (see no. 83).

The busy city of Laṅkā with its buildings and many domes is shown on the right; on the left sit Rāma, Sītā, and Lakṣmaṇa. Hanumān worshipfully looks up to them. Their image is always in front of him—and he carries them in his heart (as is shown in Kalighat paintings). On the right are Sugrīva, king of the monkeys, attended by Aṅgada, his brother's son. A cloudy sky occupies the top left corner.

Set motifs and formulas for their employment are brought to life here by their shape and placement. The angularity of the stepped buildings receives Hanumān's leap, which bridges the distance from India to Laṅkā. The dignity of heroes and heroine is assured by their posture and thronelike carpet of stylized forest flowers on which the royal exiles are seated.

90 Kṛṣṇa Slays Vatsāsura, the Calf Demon
MALWA SCHOOL, CENTRAL INDIA, c. 1640
ILLUSTRATION FROM THE *Rasikapriyā*
OPAQUE WATERCOLOR WITH GOLD ON PAPER
8 x 6⅝" (20.3 x 16.8 cm)
COLLECTION OF DR. ALVIN O. BELLAK

One day when Kṛṣṇa, his brother Balarāma, and the other cowherders are looking after their cattle on the bank of the river Yamunā, a demon in the shape of a calf comes along with the intention of killing Kṛṣṇa. The Dark God Kṛṣṇa takes hold of the calf demon, whirls him around in the air, and throws him up onto the top of a tree. The demon and the tree come down with a crash.

This exploit, told in the *Bhāgavata Purāṇa* (10.11.35–43), is illustrated here with gusto. Kṛṣṇa puts down the demon with his foot, and the cowherders leap and run, ecstatic with joy that Kṛṣṇa has killed the demon. Their sturdy, gesticulating shapes create strong rhythms. All the trees remain intact; they stand unruffled by the commotion. Two monkeys leap symmetrically from treetop to treetop, sharing the exuberance of the boys. From a rectangular enclosure some cows look up toward the turmoil. The distortions of the large-headed figures and of the calf demon refer, as do the trees and monkeys, indeed the whole event, to the plane of the painting.

This folio, inscribed at the back, belongs to a manuscript of the *Rasikapriyā* of Keśavadās, the introductory verses of which relate to the Vatsāsura incident as described in the *Bhāgavata Purāṇa*.

91 The Onset of the Monsoon
MALWA SCHOOL, CENTRAL INDIA, c. 1650
ILLUSTRATION FROM THE *Kavipriyā*
OPAQUE WATERCOLOR ON PAPER
8 x 6¼" (20.3 x 15.9 cm)
PRIVATE COLLECTION

This painting depicts the month Āṣāḍha (mid-May to mid-June), the time of the onset of the monsoon. The wind-tossed tree, the flight of the white cranes, the ascetic having been given shelter and provided with food by the householder, the "windswept" awnings with their diagonal stripes—all set the tone for the freedom of gestures and postures, the facial cast and expression of the figures, and even for their somewhat careless drawing.

The painting was part of a series illustrating the "Twelve Months," a section of the *Kavipriyā* by Keśavadās. It is said that the poet composed the *Kavipriyā* as a manual of prosody for his students, and particularly for the singer-courtesan Pravīṇarāye, a favorite at the court of Maharaja Indrajit Singh of Orcha.

The inscription above reads:

> The swift, furious winds in all directions whirling,
> are likened to the thoughts of those far from wife and home.
> Even the ascetic, during this month, remains in one posture.
> Nor is it just a human concern—the birds, too, remain
> grounded [though not as shown in the painting].
> At this time, even Lord Viṣṇu reclines in sleep with Śrī.
> Keśavadās says: "While the winds of Āṣāḍha blow, I don't
> even listen to the Vedas!"[1]

1. *Kavipriyā* of Keśavadās, ed. Lakṣmīnidhi Chaturvedi (Prayag, 1966), p. 166, v. 27.

92 Toḍī Rāgiṇī
MALWA SCHOOL, CENTRAL INDIA, 1650–75
OPAQUE WATERCOLOR WITH GOLD ON PAPER
8⅛ x 5¹⁵⁄₁₆" (20.6 x 15.1 cm)
PRIVATE COLLECTION

Toḍī Rāgiṇī represents the sentiment of a young, unmarried girl passionately in love.[1] The loving tenderness and also sadness of the melody type are here conveyed by a mixture of stylistic elements. While the richness of vegetation and the shaded bricks of the wall below are due to the influence of contemporary Bundi-Kotah paintings, the awkwardness in which the *rāgiṇī* clutches the frail branch of a tree within an area outlined and reserved for her shows the artist's uneasiness with new stylistic elements. Conspicuous, also, is the large, dark, modeled shape of a bear wedged between two treetops. Equally innovative are the pale colors used in lieu of the somber richness of the Malwa palette.

1. Dahmen-Dallapiccola, 1975, p. 206.

177

93 Gouḍa Mallār Rāgiṇī
MALWA SCHOOL, CENTRAL INDIA, C. 1675
OPAQUE WATERCOLOR WITH GOLD ON PAPER
8¾ x 6¼" (22.2 x 15.9 cm)
PRIVATE COLLECTION

Two women stand on top of a mountain range, one holding a lute (*vīṇā*), the other a fan of peacock feathers. Both wear headgear and short skirts of peacock feathers, draped dhoti-like lower garments, and tasseled bead armlets. The one on the left wears a transparent wrap around her shoulders. Against a high horizon, two peacocks perch on and shriek from tall trees, whose symmetry and poplar-like shapes are of pure Malwa vintage.

The inscription on the back of the painting reads: "She carries sprouts in her sproutlike hands, knowing her beloved is coming. Drawing the string of her bowlike brow, her eyes outsparkle the god of love." The mood of the *rāgiṇī* is tender and also sad, its flavor is that of unfulfilled love.[1]

1. Dahmen-Dallapiccola, 1975, p. 410. This does not, however, agree with the inscription on the back of the painting.

94 The Distraught Heroine (Khaṇḍitā Nāyikā)
MALWA SCHOOL, CENTRAL INDIA, C. 1675
ILLUSTRATION FROM THE *Rasikapriyā*
OPAQUE WATERCOLOR WITH GOLD ON PAPER
9¹¹⁄₁₆ x 6⅞" (24.6 x 17.5 cm)
PRIVATE COLLECTION

In her house, the distraught heroine talks with her confidante, while the hero, his face averted, sits outside. He holds a flower in his left hand, and both his hands are raised as if weighing the situation. The house of the heroine is well appointed. Everything is dainty, from the roof to the slender, arched niches and the flowers painted within their rectangular frames. The subtlety and boldness of the earlier phase of Malwa painting gave way here to elegance, the strong, though muted, color contrasts, to mild, tempered harmonies. Everything in this illustration from the *Rasikapriyā*—proportions, gestures, motifs—is attuned to a changed scale of values owing to the influence of Mughal taste.

DATIA

95 The Lady Who Only Loves Her Husband (Svakīyā)
DATIA SCHOOL, CENTRAL INDIA, 1750–75
OPAQUE WATERCOLOR WITH GOLD ON PAPER
8¾ x 9⅛" (22.2 x 23.2 cm)
PRIVATE COLLECTION

In this painting, the heavy-handed manner of the Datia school agrees with its theme. Elements of attempted realism by means of Mughal residues are successful in places but elsewhere get out of hand, as may be seen with the steps, which lead not to the turret as intended, but to infinity. The noble stride of the ladies, the plant-like transformation of the pillars, the mysterious depth of the interiors of the buildings opening on the right as well as on the left, even the standard black border characteristic of the Datia miniatures, cooperate in this painting and render its mood.

The lady who only loves her husband is classified as the *svakīyā* type of heroine. She represents the wife whose husband is for some reason not present and who continually awaits his return with passionate desire. Here the *svakīyā* prepares to climb the steps to the top of the palace, where there is an observation tower. She is experiencing feelings of longing for her husband, and perhaps intends to meditate upon their relationship while observing the moon. Her *sakhī*, or friend, however, suggests that she not ascend the stairs, for the moon is not full, and its incomplete state may remind her of her own unfulfilled desire: "Wait O Friend! Do not climb the stairs. Observe and consider. A partial moon rises, the time is not right."[1]

1. For another illustration from the same series of the *Satsai*, or "Seven Hundred" couplets, of Bihārī-lāl (1595–1664), see Czuma, 1975, no. 75.

ORCHA

96 Raja Mahendra Sujan Singh with Dancers and Musicians
ORCHA SCHOOL, CENTRAL INDIA, 1852
SHIMBU
OPAQUE WATERCOLOR WITH GOLD AND
SILVER OR TIN ON PAPER
12½ x 17⅝" (31.8 x 44.8 cm)
PRIVATE COLLECTION

Carpets, curtains, lamps, and streamers help organize this complex, sumptuous painting. A monochrome, chocolate-colored ground depicts the curtain stretched along the entire length of the tent. It is the background for the individual figures and groups of performers and retainers. They are modeled and, like cutouts, they appear affixed to this monochrome ground. The royal couch, duly foreshortened with its baldachin, and the figure of the king together with the space around him, rise from the patterned ground of the rugs. They are raised at a right angle to the ground on which the royal couch and the attendant figures stand in order to form their background. The white area separating the performers from the royal family appears to suggest the world outside.

The inscription on the back of the painting gives the name of the patron, the artist Shimbu, and the date of the picture, 1852. Raja Mahendra Sujan Singh of Orcha state in Bundelkhand ruled from 1841 until 1854, the year of his death.

RAJPUT PAINTING IN THE PANJAB HILLS

BILASPUR

97 A Woman Deserted (Virahinī)

BILASPUR SCHOOL, PANJAB HILLS, C. 1725
OPAQUE WATERCOLOR WITH GOLD ON PAPER
6¾ x 8⁹⁄₁₆″ (17.1 x 21.7 cm)
PHILADELPHIA MUSEUM OF ART. GIFT OF
WILLIAM P. WOOD. 67-80-5

Virahinī, the woman separated from her lover, finds her comfort in feeding antelopes. She derives strength from reaching up to a tree, which communicates its life force to her when she touches it. This motif is an ancient one; it appeared in Indian sculpture over two thousand years before this painting was executed. A woman attendant stands by and fans the lonely lady with a whisk of peacock feathers. A group of antelopes enlivens the painting; a sequence of diminutive birds in the foreground on what appears to be a riverbank and small plants dotting the ground sustain the blending of familiar motifs.

The motif of the woman and the willowy tree represented in Rajput painting in the plains (see no. 48) is rendered in its most expressive form in paintings of several hill schools of the Panjab, particularly in Kulu (no. 107) and in Bilaspur. The measured gestures of the woman and her companion in this painting, as well as their facial type, belong to Bilaspur whereas their skirts, billowing around the hips and silhouetted in an S curve, are familiar from Mewar paintings of the mid-seventeenth century. A survival of this kind has hardly a place in the more powerful, idiomatic hill schools of the first quarter of the eighteenth century in Basohli, Kulu, and Mankot.[1]

1. For related paintings, see Archer, 1973, vol. 2, p. 173, no. 10, p. 174, nos. 13(i–ii); and Sotheby's, New York, May 21, 1981, nos. 87–88.

BASOHLI

98 Bhadrakālī and Retainers

BASOHLI SCHOOL, 1660–70
OPAQUE WATERCOLOR WITH GOLD, SILVER, AND
BEETLE-WING CASES ON PAPER
8⅛ x 8⅞″ (20.6 x 22.5 cm)
COLLECTION OF DR. ALVIN O. BELLAK

This painting illustrated an unidentified text in praise of the dark Tantric goddess Bhadrakālī. Seated on an enormous corpse (the *preta,* or spirit of a Brahman), the goddess raises a goblet to her lips with her right hand and holds a large lotus and what appears to be a spear in her left, which rests on the left hand of the corpse. She is flanked by two female acolytes, who gaze at her. The figure on the left, which overlaps the head of the supine corpse, joins her hands in adoration, while the other extends her right arm and waves a fly whisk over the head of the goddess. All three figures wear golden crowns inlaid with gleaming beetle-wing jewels and crested with lotus flowers.

Their gestures are immediate yet timeless. They are those of

icons fixed at the highest pitch of concentration. Their wide-open eyes are steeped in awareness. "From the closing and opening of . . . [her] eyes the earth is dissolved and created."[1] The power of consciousness has saturated the colors of the painting, which glow on a dark ground. By contrast a streak of cloudy sky above the dark area sets off the spellbinding composition.[2]

1. *The Saundaryalaharī, or Flood of Beauty,* 56, ed. and trans. W. Norman Brown (Cambridge, Mass., 1958), p. 70.
2. For related paintings, see Archer, 1973, vol. 1, pp. 33–35, nos. 1–3, vol. 2, pp. 16–17, pls. 1–3; Aijazuddin, 1977, pp. 3–4, pls. 1(i–iv), pp. 11–13, pls. 6–7(i–xi); Princeton University, The Art Museum, 1982, cover, p. 28, no. 18; and Lerner, 1984, pp. 158–61, nos. 61–62.

PUBLISHED
McInerney, 1982, pp. 70–71, no. 30.

99 The Blessed Kālī (Bhadrakālī)

BASOHLI SCHOOL, 1660–70
OPAQUE WATERCOLOR WITH GOLD AND
BEETLE-WING CASES ON PAPER
9¾ x 8¼″ (24.8 x 21 cm)
COLLECTION OF DR. ALVIN O. BELLAK

Different from her image of fierce nobility (no. 98), the Dark Goddess Bhadrakālī appears here within an effulgent orb holding her balance on the naked corpse of a giant Brahman, which is suspended in the luminous circle. Wreathed in pearl strings and serpents, the burly figure carries a book; her staring eyes, crown, jewels, and long lotus garland punctuate her stocky figure while loose meshes of hair and serpent tails float down along her.

The power of this image of the goddess illumines the darkness in an orb of light. Its rays shimmer on the black ground. Framed by pilasters and a roof, this home of the goddess is hinged to the border of the painting by the projecting eaves. Iconography neither describes nor provides for a setting like this. It is the painter's own creation, his own "frame of reference" in which he is accustomed to seeing the presence and action of gods, heroes, and kings.[1]

1. For related paintings, see no. 98, n. 2.

PUBLISHED
Kramrisch, 1981, pp. 216–17, no. P-47.

REFERENCE
Ehnbom, 1985, pp. 182–85, nos. 87–88.

100 Gouḍa Mallār Rāgiṇī

BASOHLI SCHOOL, 1660–70
OPAQUE WATERCOLOR WITH SILVER ON PAPER
8³⁄₁₆ x 8³⁄₁₆″ (20.8 x 20.8 cm)
PRIVATE COLLECTION

Two women, seated on a carpet, listen to music. The larger, commanding figure has a bolster at her back but does not lean on it; in her right hand she holds a large kettledrum. The women have a proud, sullen look; their faces with large bulging eyes beneath high brows and with slanting foreheads are typical of early Basohli paintings. The distance between the figures is filled with the invisible currents that go from one to the other and are caught in the

shapes and colors of their garments. The roof of the house, with its eaves, crenellation, and kiosk, gives an atmosphere of wealth to the room below.

The composition of this painting resembles that of *The Proud Beauty* illustrated by Archer.[1] There, however, the two women are engaged in conversation, whereas here they listen to music.

The painting is inscribed in Tākrī: "Gouḍa Mallār Rāgiṇī of Megha Rāga,"[2] but it is an unusual representation of this melody type.

1. Archer, 1973, vol. 2, p. 21, pl. 4(x).
2. The painting does not correspond to the description of Gouḍa Mallār Rāgiṇī given by Dahmen-Dallapiccola, 1975, p. 410, nor by Ebeling, 1973, p. 134, where the *rāgiṇī* is assigned to Dīpak Rāga.

101 *The Great Goddess Durgā Riding Her Lion*
BASOHLI SCHOOL AT MANDI, C. 1700
OPAQUE WATERCOLOR WITH EMBOSSED GOLD
ON PAPER
11⅜ x 8″ (28.9 x 20.3 cm)
PRIVATE COLLECTION

Holding trident, sword, shield, and bowl, the Great Goddess Durgā rides on her lion. The animal is shown striding in profile view with all the flexibility of limbs proper to the great cat, whose tail is held high in a powerful curve. Durgā displays more decorum than power; her large sword is emblematic rather than trenchant. Her gold-embossed saddle, crown, and ornaments add sumptuousness, which is heightened by the black ground. Swags and tassels above are festive decorations that greet her arrival. They do not conform with the repertory or the style of Basohli. The figure of Durgā lacks the grace inherent in the trenchant power of her image as painted in Basohli[1] and seems to act with the slow-paced gravity of the figures painted by the school of Mandi.

1. See Archer, 1973, vol. 2, p. 17, pls. 2–3.

102 *Akrūra's Vision of Viṣṇu/Kṛṣṇa*
BASOHLI SCHOOL, 1769
ILLUSTRATION FROM THE *Bhāgavata Purāṇa*
OPAQUE WATERCOLOR WITH GOLD ON PAPER
11½ x 16″ (29.2 x 40.6 cm)
PRIVATE COLLECTION

Intending to kill Kṛṣṇa, the tyrant king Kaṁsa sends the Yādava chief, Akrūra, to bring the Dark God to Mathurā for a great festival and tournament. Akrūra, who has outwardly accepted the mission, in his heart is overjoyed by the prospect of seeing his God Kṛṣṇa.

Kṛṣṇa accepts the invitation, and he, his brother Balarāma, and the other young cowherders leave for Mathurā. On their way, they halt on the bank of the river Kālindī. Kṛṣṇa and Balarāma wait in their chariot as Akrūra performs his ablutions. He dives into the river, where he sees Kṛṣṇa and Balarāma as well as Kṛṣṇa/Viṣṇu seated on Viṣṇu's thousand-hooded serpent Ananta (Endless)—a vision granted to him by Kṛṣṇa. Akrūra bows to Kṛṣṇa and praises him (*Bhāgavata Purāṇa,* 10.39.40–57).

In this illustration from a manuscript of the *Bhāgavata Purāṇa,*[1]

the chariot of Kṛṣṇa and Balarāma has just arrived at the bank of the river Kālindī and the cowherders are resting. Akrūra, in the river, sees both Kṛṣṇa and Balarāma and Kṛṣṇa as Viṣṇu enthroned on his serpent. Akrūra, on land at left, bows to Kṛṣṇa and praises the god. The halt in the journey and the vision under water are simultaneous—the scene on land painted in brilliant daylight, the other below in the water, incorporeal. Only the head of Akrūra as he stands in the river, shown twice beholding the vision, is distinctly seen.

1. For other illustrations from the same manuscript, see nos. 103–4; Portland Art Museum, 1968, pp. 74–75, nos. 55a–b; Archer, 1973, vol. 1, pp. 49–50, nos. 22(i–xiv), vol. 2, pp. 36–39, pls. 22(i–xiii); Archer, 1976, pp. 14–19, nos. 8–10; and Ehnbom, 1985, pp. 226–27, no. 112.

103 *Kṛṣṇa and Balarāma Take a Meal of Rice Boiled in Milk*
BASOHLI SCHOOL, 1769
ILLUSTRATION FROM THE *Bhāgavata Purāṇa*
OPAQUE WATERCOLOR WITH GOLD ON PAPER
11¾ x 15⅞″ (29.8 x 40.3 cm)
PRIVATE COLLECTION

Before the tournament to which Kaṁsa has enticed Kṛṣṇa can take place (see illustration from the same manuscript, no. 102), Kṛṣṇa breaks Kaṁsa's sacrificial bow and destroys an army of demons dispatched by the tyrant king. Kṛṣṇa and Balarāma roam the countryside during the day, attracting the interest of the cowherders, who have heard of their exploits against Kaṁsa. Afterward, as shown in this illustration, they return to where they had unyoked their bullocks; the sun has set behind the western mountain, and they have a meal of rice and sweetened milk, as described in the *Bhāgavata Purāṇa* (10.42.25): "Having washed their feet, they had a meal of rice and sweetened milk. Aware of Kaṁsa's intentions, they passed the night in contented sleep."

Outside the walled city of Mathurā, Kṛṣṇa, Balarāma, and the cowherders have pitched their tents. It is a calm moment. The painting holds and structures it in sharp angles and planes in the gray, salient walls of the city and the black tents in front; their geometry gives way to the verdure of the tree nearby, the circle of the repast, and the curve of the chariot vaulting over the bullocks. On the other side of the walls a row of trees faces the evening sky. In this superb painting the myth of Kṛṣṇa, who is god and cowherder in one, has its monument.[1]

1. For an illustration of the same moment by the Kangra artist Purkhu (c. 1790) painted in a different light, see Archer, n.d., pl. 16.

104 *Kṛṣṇa Points Out to Balarāma the Descent from the Sky of Two Chariots Carrying Celestial Weapons*
BASOHLI SCHOOL, 1769
ILLUSTRATION FROM THE *Bhāgavata Purāṇa*
OPAQUE WATERCOLOR WITH GOLD ON PAPER
11¾ x 16″ (29.8 x 40.6 cm)
PHILADELPHIA MUSEUM OF ART. GIFT OF
WILLIAM P. WOOD. 1976-189-2

In this illustration from the same *Bhāgavata Purāṇa* manuscript as the previous paintings (nos. 102–3), Kṛṣṇa speaks to his brother Balarāma of the various uses of his avatars, or descents to earth in human form. It is a fateful moment, for the Māgadha king, Jarāsandha, has surrounded Mathurā with his powerful army. As Kṛṣṇa mentions his duty to protect holy men (*sādhus*) and to guard against those who would sponsor injustice, the action of the painting begins.

As Kṛṣṇa meditates, two chariots descend from the sky, shining like the sun, outfitted for battle, and unexpectedly carrying their celestial, eternal weapons. Seeing them, Kṛṣṇa says to Balarāma: "O Noble one, see, you are also a protector of those Yādavas, whom a great misfortune has befallen. O Lord, your beloved chariot and weapons have also arrived. Ascend your chariot, and rescue your kinsmen. O Master, we were both born to protect holy men. Drive this army's awful weight from the face of the earth!" (*Bhāgavata Purāṇa,* 10.50.11–15). The sky glows, a wide red plane suffused with the light from the celestial chariots, its luminosity intensified by a white cloud bank.

PUBLISHED
Philadelphia Museum of Art, *Gifts to Mark a Century* (February 18–March 20, 1977), no. 80, repro.

KULU

105 *King Daśaratha Goes to King Janaka's Court*
ILLUSTRATION FROM THE *Rāmāyaṇa*
KULU SCHOOL, 1690–1700
OPAQUE WATERCOLOR ON PAPER
8¹⁵⁄₁₆ x 13″ (22.7 x 33 cm)
COLLECTION OF DR. ALVIN O. BELLAK

King Daśaratha of Kosala, father of Rāma, meets with King Janaka of Mithila, father of Sītā, in preparation for the marriage of their children. Rāma, on a visit to Janaka's court, had bent the bow of Śiva, which none before him could even lift, and this feat had won Rāma the love of Sītā (*Rāmāyaṇa,* 1.69).

This illustration from the Shangri manuscript of the *Rāmāyaṇa*[1] shows the meeting of the two kings, accompanied by their priests, courtiers, and armies. Rāma and his brother Lakṣmaṇa, who have come with King Janaka and are shown here as children, greet their father. A royal umbrella is held above the head of each king. Two white tents have been pitched, one on an ornamental rug on which a bolster is placed. A tree with huge leaves on the right completes the scene. Its vivid color; the sturdy figures wearing plain or striped coats of green, mauve, and blue; and the white horses form a multicolored band on the yellow ground.

This zestful image, which is blunt and close in style to that of folk art, represents but one aspect of the Shangri *Rāmāyaṇa* and of the Kulu school of painting.

1. See also Archer, 1973, vol. 1, pp. 325–28, nos. 1–5, vol. 2, pp. 238–43, pls. 1–5; Archer, 1976, pp. 86–95, nos. 47–51; and Pal, 1978, pp. 162–63, no. 56. For colorplates of pages from this *Rāmāyaṇa,* see Grace Morley, "The Rāma Epic and Bharat Kala Bhavan's Collection," in *Chhavi-2,* 1981, pp. 241–51, pls. S, T, U; and Ehnbom, 1985, pp. 198–201, nos. 95–97.

PUBLISHED
McInerney, 1982, pp. 74–75, no. 33.

106 *Rāma Pierces the Seven Śāla Trees*
KULU SCHOOL, c. 1700
OPAQUE WATERCOLOR WITH GOLD ON PAPER
8⅝ x 13⅞″ (21.9 x 35.2 cm)
COLLECTION OF DR. ALVIN O. BELLAK

When the throne of Sugrīva, king of the monkeys, is usurped by his brother Bālin, Sugrīva tests Rāma's strength to see if he is able to fight Bālin. The monkey king asks Rāma to pierce a *śāla* tree with an arrow, whereupon with a single shot Rāma pierces not one but seven *śāla* trees (*Rāmāyaṇa,* 4.12.1–4).

This painting shows Rāma with his brother Lakṣmaṇa, Sugrīva, and two monkeys behind him. Rāma has shot the bow, released his arrow, and pierced the seven trees lined up in a row; the arrow, after having passed through the seventh tree, falls to the ground. The hill of seven ranges, from which rise the seven *śāla* trees, looms large in this condensed visual narrative. It is the artist's contribution, by which he enhances the formidable task and the power of Rāma.

107 *Toḍī Rāgiṇī*
KULU SCHOOL, c. 1800
OPAQUE WATERCOLOR WITH GOLD ON PAPER
9¹⁄₁₆ x 7¼″ (23 x 18.4 cm)
COLLECTION OF DR. ALVIN O. BELLAK

The melody type Toḍī Rāgiṇī is here reduced to her essential motif, that of woman and tree. The tree encompasses her; its wildly waving branches resonate with the music of the tender but sad tune she plays. The angular movement of her body and the intensity of her facial expression are characteristics of the Kulu school of painting. The antelopes that are usually shown passionately looking up at the lady playing a lute are absent from this version of Toḍī Rāgiṇī.[1] An inscription on the back of the painting in *doha* meter, in the Braj language, allows for the physical absence of the antelopes: "Rāgiṇī Toḍī of Dīpaka [Rāga]: As it were a lotus her face, the antelope's manner and gait her body, Toḍī bends her neck, holding a *vīṇā* on her shoulder."

The branches of the *rāgiṇī*'s tree are swayed by the mood conveyed by the melody pattern. Their movement, however, also expresses the mood of a painting that has no musical mode for its theme.[2] In a *rāgiṇī* painting, however, the pattern of the branches graphically corresponds to the melody pattern. Thus, in another painting, the distraught mood of Gujari Rāgiṇī tosses skyward the branches of the *rāgiṇī*'s tree.[3]

1. See Archer, 1973, vol. 2, p. 250, pl. 16.
2. See Pal, 1978, p. 21, fig. 8.
3. See Archer, 1973, vol. 2, p. 254, pl. 32. Almost every school of the Panjab Hills employs the motif of the tree expressively in its own way; see also p. 4, pls. 4–6.

108 Viṣṇu in the Cosmic Ocean Is Worshiped by Brahmā, Śiva, Indra, and Other Gods
MANKOT SCHOOL, 1710–20
OPAQUE WATERCOLOR WITH GOLD ON PAPER
5¾ x 9⅞″ (14.6 x 25.1 cm)
COLLECTION OF DR. ALVIN O. BELLAK

Encircled by the Cosmic Ocean, Viṣṇu rests in yogic slumber—his eye wide open—on the serpent Ananta (Endless), shown here with seven heads, while the goddess Lakṣmī, seated on her lotus afloat in the ocean, massages Viṣṇu's right foot. Gods Śiva, Indra, Brahmā, and others, along with the Earth Cow, stand worshipfully outside the circle of the Cosmic Ocean. In one of his four hands, Brahmā holds an open book whose text invoking Lord Viṣṇu and Lakṣmī is legible in part: "Bhagavān Vāsudevatā Śrī."

The framed circle of the Cosmic Ocean with its turbulent waves, on which floats the serpent Ananta carrying Viṣṇu and Lakṣmī, has magnetically attracted the crowned figures of the gods and keeps the Earth Cow spellbound. All show their noble, wide-eyed profiles—except for Śiva, the ascetic god, who faces forward in front view. His limbs, including his knees, are marked with *tripuṇḍra* marks (three ashen lines). His loins are draped with an animal skin and its tail dangles along his left leg.

The Hindu painter knew and venerated his gods. He lived with them on terms so intimate that he could—in other paintings of the Panjab Hills—depict the inebriation of Śiva, his unforeseen fall from his mount, Nandin.[1]

1. See Kramrisch, 1981, pp. 200–201, no. P-34.

109 Śiva Śarabheśa
MANKOT SCHOOL, C. 1715
OPAQUE WATERCOLOR WITH GOLD ON PAPER
9⁷⁄₁₆ x 7⅞″ (24 x 20 cm)
PRIVATE COLLECTION

Śiva took the form of Śarabheśa—a fabulous man-lion-bird creature—when he defeated Viṣṇu in his incarnation as the man-lion Narasiṁha. Narasiṁha had assumed his man-lion shape when he disemboweled the demon Gold Cloth, who dared to doubt the omnipresence of God Viṣṇu, but after his victory Viṣṇu became overbearing and was subdued by Śiva in the form of Śarabheśa.

Śiva's overwhelming power is shown by the gigantic size of his monstrous shape, which has taken its stand on Narasiṁha's shoulders and rises, carried by its wings filled with gods and serpents. Snakes encircle Śarabheśa's front and hind legs as well as his tail. The crescent moon hovers in front of Śiva-Śarabheśa's forehead and a thin wavy line—the river Ganges—descends from his head to the bottom of the painting.

Narasiṁha sits in grieving agony. His lion body wears ornaments, and one of his four hands holds his mace. The impassive figure of Devī, the Goddess, approaches. She shoulders her sword, carries Śiva's trident, and holds a cup. The blue intensity of a monochrome ground makes credible the sectarian phantasmagoria as seen by an artist.[1]

1. For illustrations of the Narasiṁha myth in a style resembling that of this painting, see Hayward Gallery, London, 1982, p. 203, figs. 375–76.

110 Raja Ajmat Dev of Mankot Smoking
MANKOT SCHOOL, 1730–35
OPAQUE WATERCOLOR WITH GOLD ON PAPER
8¹⁄₁₆ x 8½″ (20.5 x 21.6 cm)
CITY OF PHILADELPHIA. ON PERMANENT LOAN TO
THE PHILADELPHIA MUSEUM OF ART

Seated on a rug of a large floral pattern, Raja Ajmat Dev is portrayed in three-quarter view, his head in profile. His burly figure is clad in a closely fitting white jama fastened at the neck; it is tight at the waist so that it opens elliptically along the chest, allowing the white undergarment to show. The skirtlike lower part of the jama is draped around his legs and on the rug. The raja holds the pipe of the hookah in his left hand and a rosary in his right. His boldly featured face is framed by his beard, and the tips of his mustache curve upward. His turban is held with three white bands; its conical shape points backward. His ear is pierced by small golden rings; a large earring set with pearls and a ruby is inserted in his earlobe.

The Mankot painter gave special importance to the pipe of the hookah. It rises in a firm vertical line and bends in an S-shaped curve as Ajmat Dev directs it to his mouth. The curve of the pipe, which responds to those of his body, is compositionally upheld by that of the sword that lies on the rug at bottom. Economy of shapes, purity of line and color, subtlety of disposition, and delicacy of detail combine in this portrait.[1]

1. Other portraits of Raja Ajmat Dev showing him younger and of slimmer build appear in Archer, 1973, vol. I, p. vi, colorplate B, vol. 2, pp. 294–95, pls. 33–34.

111 The Holy Family (Śiva, Pārvatī, and Nandin)
MANKOT SCHOOL, 1725–50
OPAQUE WATERCOLOR WITH GOLD ON PAPER
11⅜ x 8″ (28.9 x 20.3 cm)
PRIVATE COLLECTION

Śiva, seated on a tiger skin spread on grassy ground, holds out his left arm protectively, his hand laid on Pārvatī's back. She has fallen asleep; her head rests on Śiva's lap and her left hand on his right foot. Śiva's right hand, on his knee, holds a garland of human heads. It is a cold night; a fire has been lit. Pārvatī wears a warm dress, but the ashen white body of the Great Yogi is naked except for an ocher cloth covering his loins. A serpent has curled up on the tiger skin; the bull Nandin, tethered to a post and asleep, wears a rug for his saddle cloth. Śiva's trident and drum (*ḍamaru*) are planted in front of him. His forehead, limbs, and body are marked with *tripuṇḍra* marks—drawn here as two, or more, lines—and he is richly bejeweled; he is god—an ascetic and therefore naked—but he is also married to Pārvatī. The inscription in Tākṛī on the deep ocher border entitles the painting "Amara Beah" (The Immortal Marriage).

Two trees of different bloom and foliage bend over the holy family. Creepers entwined with the trees extend their flower-laden twigs toward the figures while Śiva's bundle bulging with the intoxicant *bhang* is hung on a dead branch of the tree near him. From the top of the opposite tree a green parrot looks over the scene.

The painting combines the contradictory attributes of Śiva with the conviction and spontaneity that the nature of Śiva demands.

These qualities give form to the inclination of the god's head, the angle at which his left arm is stretched, and the arches of the tree canopy. Śiva's face, of pure Mankot style, expresses concern and aloofness. He alone is awake and protects goddess and bull sleeping beneath the high and pointed arch of the two flowering trees.

BAGHAL (ARKI)

112 *Khambhāvatī Rāgiṇī*
BAGHAL (ARKI) SCHOOL, C. 1700
OPAQUE WATERCOLOR ON PAPER
8¹⁄₁₆ x 6¹¹⁄₁₆″ (20.5 x 17 cm)
PHILADELPHIA MUSEUM OF ART. ANONYMOUS GIFT.
1983-156-2

Khambhāvatī Rāgiṇī is a "lady devoted to pleasure or entertainment."[1] She is "the giver of pleasure and knows all the secrets of passion. . . . She is fond of songs, her voice is like that of a cuckoo, she is sweet in her words."[2] She is awaiting her lover. The mood is one of expectation.[3]

In this painting the *rāgiṇī* is comfortably seated in her house on a high couch, a bolster at her back. She listens to two women musicians who sit outside and play the lute (*vīṇā*). Their facial profiles, garments, and instruments harmonize, creating an insistent rhythm. The *rāgiṇī* responds to it with her left hand held out, while her right hand, although resting on her lap, betrays her listening with nervous intensity. A peculiar feature that marks the three women is a dot on the cheek near a thin strand of hair, the latter of which also occurs in the preceding painting from Mankot (no. 111).

The interlocking rectangular color fields and the shape and position of the kiosks vary from painting to painting in this *rāgiṇī* series from Baghal.[4]

1. Ebeling, 1973, p. 82.
2. Ibid., p. 130.
3. Dahmen-Dallapiccola, 1975, p. 144.
4. See Archer, 1973, vol. 2, pp. 3–4, pls. 2(i–iii).

MANDI

113 *Kṛṣṇa Steals the Clothing of the Cowherdesses*
MANDI SCHOOL, 1640–50
OPAQUE WATERCOLOR WITH GOLD ON PAPER
13½ x 9½″ (34.3 x 24.1 cm)
PRIVATE COLLECTION

The cowherdesses (*gopīs*), each having her heart set on union with Lord Kṛṣṇa, have made a vow to worship the goddess Kātyāyanī every morning on the bank of the river Kālindī. After worshiping the goddess one morning, as the weather is growing cold, the cowherdesses undress, leave their clothes on the bank, and bathe in the river. Kṛṣṇa, accompanied by the cowherders, comes by and quickly gathers the clothes. He takes them with him while he climbs a *kadamba* tree, and then calls the girls to come and get their clothes. Startled by his prank and although overwhelmed with feelings of love for Kṛṣṇa, the cowherdesses do not leave the water because they are naked. When Kṛṣṇa warns that he will not return their clothes unless they come for them, the *gopīs* come out of the

water, shivering with cold. Kṛṣṇa pities them and returns their clothes. The cowherdesses are not angry; rather, they are delighted because they enjoy the company of their beloved. He has stolen their hearts. After they put on their clothes Kṛṣṇa asks them to go back home and says they will enjoy the following night with him. Then Kṛṣṇa, with the cowherders and cattle, goes far away (*Bhāgavata Purāṇa*, 10.22.1–38).

This allegory of the soul's relation to God is represented with an unusual economy that has no room for the cowherdesses' clothes either shed on the riverbank or stolen by Kṛṣṇa and hung up on the *kadamba* tree. Only the god himself is there, looking at the naked, bashful, shivering, adoring girls, the souls that have been in search of him and to whom he now reveals himself. In the bleak landscape of a morning in winter, the cowherders stoically look after their cattle.

The diction of this visualized narrative is clipped in accordance with the small-figured style of the Mandi school based on sub-Imperial Mughal conventions.[1]

1. See Glynn, 1983, figs. 8–12.

114 *The Goddess Kālī Slaying Demons*
MANDI SCHOOL, C. 1710
OPAQUE WATERCOLOR WITH GOLD ON PAPER
8⅛ x 11¼″ (20.6 x 28.6 cm)
COLLECTION OF DR. ALVIN O. BELLAK

In surrealistic naturalism this painting creates the horror of the Dark Goddess Kālī in the light of its own vision. Having based his work on Hindu iconography and village performances by masked actors, the artist presented the substantiality of his creatures lit up by the gleam of eyes, fangs, tusks, and teeth—clenched in the faces of demons and gleaming in the wide-open jaws of the goddess and her tiger. Mounted on stiff, silent corpses, wearing anklets of severed heads, Kālī stands on swollen legs. She wears a skirtlike girdle of severed, putrified arms, and her long strands of hair fall over them. With open jaws and lolling tongue she howls, as does her tiger, while two startled antelopes gaze silently at her. Her upper right hand wields a sword, in the upper left is a bowl of blood; large demon heads in her two lower hands complete her iconography.

At left are three challenging yet retreating demons. Staring and practically naked, the smallest bears *tripuṇḍra* marks (the horizontal lines of ashes) and sports a tail. A larger, spotted monster behind, a coarsened version of early Mughal monsters, walks on feet coiled up in serpentine shapes. The three brandish swords and raise their shields, but these will be of no use, for the mighty sword of Kālī will cut through them. It is held high by the goddess and exceeds the area of the painting.

One would look in vain in this tormented Mandi creation of the early eighteenth century for the prim and measured application of Mughal conventions seen in the previous painting (no. 113); one must turn, however, to other paintings—the *Harihara Sadāśiva* in London[1] or the *Tripurasundarī* in Benares[2]—to fathom the range of Tantric painting under Raja Sidh Sen of Mandi (1684–1727).

1. Kramrisch, 1981, pp. 168–69, no. P-9; and Archer, 1973, vol. 1, p. 356, no. 15, vol. 2, p. 267, pl. 15.
2. Archer, 1973, vol. 1, p. 356, no. 17, vol. 2, p. 266, pl. 17.

115 Pandit Dinamani Raina Visits the Women's Quarters of Raja Dalip Singh of Guler
GULER SCHOOL, 1740–70
OPAQUE WATERCOLOR WITH GOLD AND
SILVER OR TIN ON PAPER
11 x 8½″ (27.9 x 21.6 cm)
PHILADELPHIA MUSEUM OF ART. GIFT OF DR. AND
MRS. PAUL TODD MAKLER. 1976-230-1

On a terrace projecting from a massive building is an unusual assembly of figures. One, of very large size, is that of an elderly man, Pandit Dinamani Raina, the *rājguru* (keeper of the raja's conscience) of Raja Dalip Singh, who reigned from 1695 to 1741.[1] He makes a point while discussing an important matter with the young rani, who has stopped smoking her hookah and listens with interest. The pandit's size is large, not only because the other figures are women but also because he is given the greatest importance among those present. The figures of pandit and rani and that of a seated woman who massages her foot are surrounded by zones of dark shadows—the painter's attempt to throw them into relief. The shadow has greater credibility on the left of the woman musician who sits near the edge of the terrace. Two musicians in front of her accompany her on their instruments while the pandit, with five attendants at his side, seems oblivious of their music.

The pandit's psychological portrait and forward-leaning posture are of Mughal vintage, the dark shadow zones a mannerism intended to give corporeality to the surrounded figure. Conceptual and naturalistic formulas commingle, or are juxtaposed, on the terrace and also in the landscape. A curtain is drawn across the interior of the women's quarters. The cumbersome boldness of the surrounding architecture dominates in this picture of mixed styles in which Nurpur elements also have a share in the trees that dot the landscape.[2]

1. Archer, 1973, vol. 1, p. 127.
2. Ibid., vol. 2, p. 309, pls. 14(v–vi).

116 Salutation to Rādhā and Kṛṣṇa
GULER SCHOOL, C. 1750
OPAQUE WATERCOLOR WITH GOLD AND
SILVER OR TIN ON PAPER
9¾ x 12⅞″ (24.8 x 32.7 cm)
COLLECTION OF DR. ALVIN O. BELLAK

During the mid-eighteenth century the painters of the Guler school created the most serene works of all the schools of the Panjab Hills. Calmly dignified human types of ideal beauty people landscapes of softly curving hills or add their noble presence to wide interior spaces of buildings and to their terraces. These wide and still arenas, however, are also capable of sustaining other modes of feeling.

On a long terrace covered by a striped carpet, Viṣṇu/Kṛṣṇa and Rādhā are enthroned under a canopy. An umbrella rises above the head of Kṛṣṇa, who sits at ease holding a lotus flower; beside him, Rādhā holds a garland. Two women attendants, one carrying a tray with refreshments, approach the throne of the divine couple. The terrace is fenced in by a perforated balustrade divided into equal rectangular panels; steps lead up to it on the left. A tall, middle-aged man who is simply but elegantly dressed in a long white jama has entered. Under his right arm he holds a satchel made of a striped fabric. As he faces the gods he raises his hands in salutation. He looks worried; the inclination of his body and the angle of his folded hands convey apprehension and imploration. His head and hands are silhouetted against the background of the painting. The wide space between him and the throne is left empty.

Inscribed on the upper margin of the painting are the words of his prayer: "Remove for me the pain of being—this worldly cycle, Rādhā, you whose mere reflection turns Kṛṣṇa's hue into green." This verse is the introductory invocation by the great early seventeenth-century poet Bihārī-lāl in his work *Satsaī*.[1] The painting shows the image of a troubled poet; it is possibly a posthumous portrait of Bihārī-lāl (1595–1664).

1. B. N. Goswamy translated the passage and identified the inscription.

117 The Vision of Sage Mārkaṇḍeya
GULER SCHOOL, C. 1790
OPAQUE WATERCOLOR WITH GOLD AND
SILVER OR TIN ON PAPER
12⅜ x 9¾″ (31.4 x 24.8 cm)
PRIVATE COLLECTION

At the time of the great dissolution, when all had become flood, an old sage, Mārkaṇḍeya, wandered in distress for he could find no place on which to rest. But he beheld a child lying on a bough of a banyan tree. The child beckoned Mārkaṇḍeya to enter its body through the mouth. Having done so Mārkaṇḍeya beheld there the whole world with all the gods and all that exists. He wandered about the world for ages. Suddenly, by a gust of wind, he was projected outside the mouth—and knew himself transformed. He wanted to know the child's name but was told that even the gods did not know him truly, when Viṣṇu revealed himself in his true being as the entire cosmos, all ages having sprung from him, and he was Death. Yet, although he was very old, he stayed where he was in the form of a little boy. Viṣṇu then disappeared and Mārkaṇḍeya beheld creation stir into life (*Mahābhārata*, 3.186.77–120).

This very moment of the myth is represented in the painting: The dawn of a new morning unfolds in the colors of the leaves of the tree of life in the midst of the flood. Even the frame of the painting with a flower in each of the four corners is significant of this cosmos in which the painter realized this myth of initiation.

118 Kārttikeya Addresses Śiva and Pārvatī in the Icy Himalayan Mountains
GULER SCHOOL, 1800–1820
OPAQUE WATERCOLOR WITH GOLD ON PAPER
14¼ x 19⅛″ (36.2 x 48.6 cm)
COLLECTION OF DR. ALVIN O. BELLAK

Snow-covered, icy mountain crags rise in a wall behind the plateau where Śiva and Pārvatī sit. The massive foliage of a tree, its trunk bending protectively, forms a canopy over god and goddess, who sit on a raised seat that rests on an animal-skin rug. They are fashionably and warmly dressed—and so to some extent is the bull Nandin, whereas six-headed Kārttikeya faces his parents in iconographic nudity down to the waist. His peacock vehicle completes

the group of celestials in this painting from a hitherto unidentified series.[1]

1. For other paintings from this series, see Pal, 1978, pp. 194–95, nos. 72a–b; Kramrisch, 1981, pp. 222–24, nos. P-52a–c; and Ehnbom, 1985, pp. 252–53, no. 127.

119 The Goddess Kālī on Śiva-Śava
GULER SCHOOL, 1820–30
OPAQUE WATERCOLOR ON PAPER
10¼ x 8¼" (26 x 21 cm)
PRIVATE COLLECTION

At the touch of the foot of the goddess Kālī as she steps onto his chest, Śiva as a corpse (śava)—lying supine on the funeral pyre in the cremation ground—is awakened and turned into God (Śiva). This illustrates the vitalizing force of the Dark Goddess, the primordial power. A cremation ground is the scene; it is the place where "all creatures are merged as corpses in the Great dissolution"[1] at the end of the world. Carnivorous scavenger birds, skeletal fragments, a corpse, a skull, jackals, and a dying tree beyond the hill complete the scene where Śiva calmly shakes his drum (ḍamaru), whose sound awakens a new creation.

1. *Hymn to Kālī: Karpūrādi-Stotra*, 7, ed. and trans. John Woodroffe (Arthur Avalon), 2d ed., rev. and enl. (Madras, 1953), p. 62.

PUBLISHED
Kramrisch, 1981, p. 218, no. P-48.

KANGRA

120 God Indra Visits the Imprisoned Sītā in Rāvaṇa's Palace Garden While the Guardian Demonesses Sleep
KANGRA SCHOOL, 1775–80
ILLUSTRATION FROM THE *Rāmāyaṇa*
OPAQUE WATERCOLOR WITH GOLD ON PAPER
9⅞ x 14" (25.1 x 35.6 cm)
PHILADELPHIA MUSEUM OF ART. PURCHASED:
KATHARINE LEVIN FARRELL FUND AND
JOHN T. MORRIS FUND. 1977-11-1

Within high, golden walls, Sītā is imprisoned in a garden of blossoming trees and row upon row of flower beds. It is night; the demonesses, the warders of her solitude in the impregnable fortress, have fallen asleep under a large tree. Sītā, starved to a mere phantom of herself, is clandestinely served food by God Indra, who has just arrived.[1] His figure is crowned and wrapped in garments that allow a view of his arms and legs, which are marked by eyes, a bodily characteristic that identifies him. The demonesses are marvels of draftsmanship and expression. Huge ears and horns are their cognizances—the one whose face is hidden displays her garment draped as if in a Mughal painting.

The perspective of this garden prison offering its stark wall in frontal view across the entire width of the painting carries the full impact of Sītā's solitude, which is also expressed by the endless sequence of flower beds seen from a bird's-eye view. The staggered, bleak palace walls on the right seem to confirm the hopeless

situation, but a magic light announces the arrival of a god and savior. It also flickers in the young trees flanking the path from the closed entrance to Sītā's tree behind the sleeping demonesses.

The picture as a construct of geometrical forms based on architectural concepts ensconces the group of Sītā, Indra, and the demonesses, forming a circle lit up by a magic light. It also shimmers in the flowering trees distributed formally and leading toward Sītā and Indra under the large tree, whose naturalism emphatically rivets attention on the main group. Naturalism and formalism are combined in the alignment of trees along the walls of the garden, mitigating the stark succession of angular planes of the palace walls.

1. The scene appears in Appendix 12 of the *Rāmāyaṇa, Critical Edition*, vol. 3 (Baroda, 1963), pp. 388–90. For other illustrations of this *Rāmāyaṇa* series, see Pal, 1978, pp. 184–85, nos. 67a–b; and Ehnbom, 1985, pp. 234–37, nos. 116–18.

121 Rādhā Goes to Meet Kṛṣṇa
KANGRA SCHOOL, c. 1780
OPAQUE WATERCOLOR ON PAPER
6¾ x 10¾" (17.1 x 27.3 cm)
COLLECTION OF DR. ALVIN O. BELLAK

The landscape of love in this painting, even more than the figures, is part of an enchanted world. Conjoined trees in front of Kṛṣṇa's bower throw velvet shadows onto the warm brown ground; nameless shapes—the bank of the river—enter from the left. They thrust forward as sharp darts surmounted by another more bodily entry, suffused with a nascent glow. More than the human/divine figures brightly singled out in the darkness of the night and the lush trees, do the surreal land formations along the river convey the emotion-charged moment in the "Love Song of the Dark Lord."

The inscription on the back of the painting is from the *Gītagovinda* (The Song of Lord Kṛṣṇa) by Jayadeva (11.13–16).

> Seeing Hari light the deep thicket
> With brilliant jewel necklaces, a pendant,
> A golden rope belt, armlets, and wrist bands,
> Rādhā modestly stopped at the entrance,
> But her friend urged her on.
> Revel in wild luxury on the sweet thicket floor!
> Your laughing face begs ardently for his love.
> Rādhā, enter Mādhava's intimate world!
>
> Revel in a bright retreat heaped with flowers!
> Your tender body is flowering.
> Rādhā, enter Mādhava's intimate world![1]

The series of which this *Gītagovinda* illustration formed part[2] is ascribed to Kushala, the favorite artist of Raja Sansār Chand of Kangra, assisted by his cousin Gaudhū.[3]

1. Miller, ed. and trans., 1977, p. 118.
2. For other leaves from this series, see Randhawa, 1963, pl. 9, colorplates 2–3, 11; Chandra, 1965; Archer, 1973, vol. 1, pp. 291–93, nos. 33 (i–vii), vol. 2, pp. 205–8, nos. 33(i–vii); and Ehnbom, 1985, pp. 238–39, no. 119.
3. Archer, 1973, vol. 1, p. 292.

PUBLISHED
Randhawa, 1963, pl. 12; Chandra, 1965, pl. 10.

122 Dance and Music for Śiva and Pārvatī

KANGRA SCHOOL, 1780–90
KUSHALA AND KĀMA
OPAQUE WATERCOLOR WITH GOLD ON PAPER
9 x 12" (22.8 x 30.4 cm)
COLLECTION OF DR. ALVIN O. BELLAK

In an ideal Kangra landscape, on the bank of a lotus-studded river, verdant, undulating hills form the background for Śiva and Pārvatī seated on a tiger skin spread on the grassy ground. Śiva, of dreamy face and flowing ash-bleached hair, a serpent encircling his neck, shakes his rattle drum (ḍamaru). The celestial throng of musicians responds with the sound of cymbals, lute, and drums. The two dancers ahead of them carry the music in their bodies, limbs, and garments toward the god and goddess. Another dancer, raising her golden veil, sways along with the musicians, her face averted from Śiva and Pārvatī. The dancer nearest the seated couple, her movement intensified, raises her arm and extends her hand toward Śiva's drum, the origin of the rhythms that sway the dancers and the universe. Pārvatī—her right hand confidently held out toward Śiva, her left raised, her golden, flower-studded skirt gleaming—is the queen of this heavenly Kangra scene.

Clusters of trees most delicately attuned with dark green foliage and swaying branches mark the cadence of the hilly slopes, behind which, on the extreme right, the faces of celestial musicians crowd into the picture from infinity. A timeless blue sky, blushing pink with dawnlike streaks, allows gazelles to go their way with calm assurance. Burning ocher and red, lilac and purple, light yellows and white, pale complexions, and random sparkles of gold are part of the theophany.

The illustration (possibly from a manuscript of the Śiva Purāṇa) is the work of two artists according to the inscription on the back: "Twenty paintings. Design by Kushala. Painted by Kāma."

Kushala was the son of the painter Manaku, who changed the style of the Basohli school (1730–35);[1] Kāma was Kushala's cousin.[2] The division of work on one painting between two artists, the more accomplished artist the designer, was a feature of the early Mughal school.[3]

1. See Archer, 1973, vol. 2, pp. 32–33, pls. 18(i–v).
2. For a portrait of Kushala, see Archer, 1973, vol. 1, p. 287, no. 19(ii), and vol. 2, p. 201, pl. 19(ii). Portraits of Manaku and Gaudhụ are illustrated in pls. 19(i, iii). For the genealogy of both artists, see Khandalavala, 1958, pp. 185–86.
3. For a painting of this series showing Śiva and Pārvatī bathing in a pond, see Apollo, vol. 121, no. 276 (February 1985), p. 15.

123 The Sacrifice of Meghanāda, Son of the Demon King Rāvaṇa

KANGRA SCHOOL, C. 1790
ILLUSTRATION FROM THE Rāmāyaṇa
OPAQUE AND TRANSPARENT WATERCOLOR
WITH GOLD ON PAPER
9¾ x 13⅞" (24.8 x 35.2 cm)
PHILADELPHIA MUSEUM OF ART. PURCHASED:
KATHARINE LEVIN FARRELL FUND. 1982-34-1

When Rāvaṇa, the demon king of Laṅkā, abducts Rāma's wife Sītā, Rāma and his brother Lakṣmaṇa set out to find her. Aided by an army of monkeys, the Vānaras, and their commander Hanumān, they go to Laṅkā, where they plan to rescue Sītā and conquer the city. To do so they must defeat Rāvaṇa's son Meghanāda, a demon-sorcerer whose great power has won him the name Indrajit (Victor over Indra).

To confuse his enemies Indrajit causes Hanumān to hallucinate, making him believe that he, Indrajit, has killed Sītā and cut her in two. Rāvaṇa's brother Vibhīṣaṇa, though born a demon, opposes Rāvaṇa and reveals to Rāma that Hanumān's vision is only an illusion and that Indrajit intends to destroy Rāma, Lakṣmaṇa, and the Vānaras by performing a sacrifice at Nikumbhila, where a large banyan tree grows. On completion of the sacrifice, which all the gods will attend, Indrajit will become invincible. If Indrajit fails to complete the sacrifice and he is attacked, however, God Brahmā has ordained that he must die.

Vibhīṣaṇa, aware of Brahmā's decree, plans to accompany Lakṣmaṇa and interrupt the sacrifice. Anticipating this, Indrajit orders his troops to surround the site. Vibhīṣaṇa and Lakṣmaṇa arrive at Nikumbhila before Indrajit, and the Vānaras attack the demon army. When Indrajit arrives on his chariot he issues a counterattack and commands his charioteer to drive toward Hanumān and challenge him to a duel.

Vibhīṣaṇa points out to Lakṣmaṇa the sacrificial ground and asks him to destroy Indrajit before he reaches the banyan tree. Lakṣmaṇa, seeing Indrajit in his resplendent chariot, challenges him. Although Vibhīṣaṇa reminds Indrajit that fighting Lakṣmaṇa will mean certain death, the two engage in combat and the demon is slain (Rāmāyaṇa, 6.58–62).

This painting, divided diagonally, shows the beginning of the sacrifice in the upper section. Indrajit stands worshipfully on a rug near the dark banyan tree. Articles of the sacrifice are laid out before him and flames envelop a white horse. Behind—that is, above—this scene, the phantom Sītā that Hanumān was made to see sits calmly, like an image, her gaze fixed on Indrajit. A demon drags a reluctant ram to be sacrificed, the blood of slaughtered animals flows on the green ground, and the demon army is stationed, albeit sparsely, around the place of sacrifice.

In the lower half of the painting, Indrajit—in his resplendent chariot, flag flying—speeds along, preceded and followed by his demon soldiers. Serenely elegant, the figures fall into place. Indrajit looms large in the swift action of the lower panel while a foreboding gloom is cast over the scene of the sacrifice. The story is told with candor. The anonymous demon dragging a ram to the sacrifice is as important visually as the major participants in the story. Indrajit in his chariot, however, is unmistakably the protagonist and the largest figure in this depiction.[1] The drawing in this illustration is less sensitive than that of the previous Rāmāyaṇa (no. 120).

1. For other paintings from this Rāmāyaṇa, see Pal, 1978, pp. 186–87, nos. 68a–b.

124 Raja Sansār Chand of Kangra with His Small Son and Courtiers
KANGRA SCHOOL, 1798–1800
OPAQUE WATERCOLOR WITH GOLD ON PAPER
14¾ x 20″ (37.5 x 50.8 cm)
PHILADELPHIA MUSEUM OF ART. PURCHASED:
JOHN T. MORRIS FUND. 55-11-3

In this formal group portrait Raja Sansār Chand of Kangra (1775–1825) and a dark-skinned figure, probably a pandit and family priest, occupy the center of the assembly. Both are smoking a hookah. They are seated in an open, pillared hall, Sansār Chand watching the performance of three dancers at left while the pandit, apparently conversing with Sansār Chand, looks toward him. While the right section of the pillared hall is occupied by figures observing the dance, those in the left part seem oblivious of it and look at the central group. Steps lead from the hall to a lower level, where a woman demonstrates fireworks and soldiers in British uniforms stand guard on either side.[1]

Realistic portraiture, gradation of the size of the figures according to their importance, and a concern for decorative balance of figures and their architectural setting are here combined and enlivened by the position of the woman with the fireworks.

1. British uniforms were introduced by William O'Brien, an Irish adventurer who reorganized the Kangra forces; see Archer, 1973, vol. I, p. 253.

PUBLISHED
Stella Kramrisch, "Four Kangra Paintings," *The Philadelphia Museum Bulletin,* vol. 50, no. 244 (Winter 1955), p. 40.

125 The Night before the Battle
KANGRA SCHOOL, c. 1800
ILLUSTRATION FROM THE *Mahābhārata*
OPAQUE WATERCOLOR WITH GOLD ON PAPER
13¼ x 18½″ (33.7 x 47 cm)
PRIVATE COLLECTION

126 Arjuna Chooses Lord Kṛṣṇa as His Charioteer
KANGRA SCHOOL, c. 1800
ILLUSTRATION FROM THE *Mahābhārata*
OPAQUE WATERCOLOR WITH GOLD ON PAPER
13⁹⁄₁₆ x 18⅛″ (34.4 x 46 cm)
PRIVATE COLLECTION

The Pāṇḍavas, having lost their kingdom and lived in exile for twelve years, try to win it back from the Kauravas. Both groups seek the help of Kṛṣṇa, who gives the Pāṇḍava prince Arjuna the choice of an army or having Kṛṣṇa unarmed as his charioteer. Arjuna deliberates and chooses unarmed Kṛṣṇa as his charioteer (*Mahābhārata,* 5.7.1–36).

The deliberation between Kṛṣṇa and Arjuna takes place in Kṛṣṇa's palace (here a tent) at night while the army sleeps (no. 125).[1] In the morning (no. 126) Kṛṣṇa's army is already beginning to leave when Arjuna confirms his choice by a solemn vow (water, as witness, being poured over his hands). Although it is still dark the dawn of the day of decision is evoked by the glow of the red rug on the floor of the tent. In the night scene the carpet within the tent is black.

Multiple perspective and bird's-eye view create the space within the tent. Outside, the sleeping army is distributed on the ground in superimposed units producing the effect of a high horizon although it is intended to suggest recession in space.

1. For the scene immediately preceding the deliberation, see Dahmen-Dallapiccola, ed., 1982, p. 91.

127 Pārvatī Greets Śiva in His Beauty
KANGRA SCHOOL, 1815–20
OPAQUE WATERCOLOR WITH GOLD ON PAPER
13½ x 17⅞″ (34.3 x 45.4 cm)
PRIVATE COLLECTION

God Śiva has many shapes he assumes at will; he is essentially an ascetic god. Pārvatī, herself a goddess of ascetic disposition, falls in love with the homeless, ungainly god against her mother's will. Pārvatī, however, is steadfast and when her marriage is to be celebrated Śiva appears—ugly, disheveled, and with five faces and ten arms. Pārvatī's mother swoons, but when Pārvatī explains that Śiva has many forms—both awful and wonderful—or no shape at all, her mother consents to their marriage provided Śiva shows himself in his beauty (*Matsya Purāṇa,* 154.275–92).

In this painting Śiva is seen in his beauty, Pārvatī reverently touches his feet with a rosary of flowers, and the gods, who have dismounted their vehicles, prostrate themselves. Pārvatī's mother, a small figure, stands at the left edge of the painting next to her husband. Celestials up in the clouds scatter flowers over the turquoise ground.

This painting is from a series of over one hundred large depictions of scenes from the myth of Śiva created at the court of Sansār Chand (see no. 124).[1] Sansār Chand was a great lover, connoisseur, patron, and collector of paintings.

1. See Randhawa, 1953, pp. 23–39.

PUBLISHED
Kramrisch, 1981, p. 190, no. P-27.

128 Kṛṣṇa Sports with the Cowherdesses
KANGRA SCHOOL, 1820–25
OPAQUE WATERCOLOR WITH GOLD ON PAPER
11⅛ x 14¼″ (28.3 x 36.2 cm)
COLLECTION OF DR. ALVIN O. BELLAK

This painting illustrates the next to last verse of the fourth song of the first part of the *Gītagovinda* by the twelfth-century poet Jayadeva.

> When he quickens all things
> To create bliss in the world,
> His soft black sinuous lotus limbs
> Begin the festival of love
> And beautiful cowherd girls wildly
> Wind him in their bodies.
> Friend, in spring young Hari plays
> Like erotic mood incarnate.[1]

Like a garland suspended between two convoluted trees the group of Kṛṣṇa and the cowherdesses is spotlighted in the forest's dark, dense tapestry. Its pattern is traced and dotted by flower sprays around the central group of the *gopīs,* whose wide-flung arms communicate their rapture.[2]

1. Miller, ed. and trans., 1977, p. 77; see also no. 121.
2. For other leaves from this series, see Karl Khandalavala, "A Gīta Govinda series in the Prince of Wales Museum," *Bulletin of the Prince of Wales Museum* (Bombay), no. 4 (1954), pp. 1–18, colorplates A–B; Portland Art Museum, 1968, pp. 120–21, nos. 92a–b; Archer, 1973, vol. 1, pp. 307–8, nos. 67(i–iii), vol. 2, pp. 230–31, nos. 67(i–iii); Pal, 1978, pp. 204–5, no. 77; and Ehnbom, 1985, pp. 250–51, nos. 125–26.

GARHWAL

129 Sudāman's Journey to Kṛṣṇa's Palace
GARHWAL SCHOOL, 1775–90
OPAQUE WATERCOLOR WITH GOLD ON PAPER
9 x 10⅞" (22.9 x 27.6 cm)
PRIVATE COLLECTION

Sudāman, a young Brahman of deep spiritual insight with no concern for the outer world, has remained poor for many years. When his wife can no longer bear their poverty she asks Sudāman to visit his friend Kṛṣṇa and ask for help. She gives Sudāman a few handfuls of rice, which is all they can spare, as a present for Kṛṣṇa, and he sets out on his journey. When he arrives at Kṛṣṇa's palace he is recognized and welcomed by his old friend, who accepts his gift, honors and entertains him, and asks him to stay overnight. The next morning, without mentioning his wife's request, Sudāman sets out for home, his heart full of happiness for having seen Kṛṣṇa. When he nears his hut, he finds it is not there; instead, a splendid palace has taken its place. His wife, beautifully dressed and accompanied by attendants, comes to greet him (*Bhāgavata Purāṇa,* 10.80.6–81.41).

In this painting Sudāman—in tattered garments and holding the pouch of rice—nears Kṛṣṇa's palace in Dvāraka, flags waving from its towers. The wide ocean with waves, fish, and a "sea horse"; the trees with clumps of dark foliage; a tree with leaves that seem to tremble in the breeze; and the distance between Sudāman and the palace are elements of the painter's inner vision of the legend's meaning. The muted greens and the tender grays support it.[1]

1. For a similar, more stylized and dramatic—though less expressive—version, see Archer, 1973, vol. 2, p. 80, pl. 7(ii).

130 Arjuna and His Charioteer Lord Kṛṣṇa Confront Karṇa
GARHWAL SCHOOL, C. 1820
OPAQUE WATERCOLOR ON PAPER
60 x 120" (152.4 x 304.8 cm)
PHILADELPHIA MUSEUM OF ART. PURCHASED:
EDITH H. BELL FUND. 75-23-1

The *Mahābhārata* tells of the war between the Pāṇḍavas and the Kauravas (see nos. 125–26). In preparing for the great battle, both parties seek the help of Kṛṣṇa. This large painting shows the Pāṇḍava Arjuna in his chariot with Kṛṣṇa as his charioteer on the battlefield in the plain of Kurukṣetra, confronting Karṇa, commander of the army of the Kauravas. Between these heroes and their armies the carnage of the battle is shown rising like a gory fountain.

It was just before this battle that Kṛṣṇa, the charioteer, spoke to Arjuna the words of the *Bhagavad-gīta* (The Song of the Lord), India's most widely revered religious-philosophical poem, contained in Book Four of the *Mahābhārata.*

NALAGARH (HINDUR)

131 Coronation of Sugrīva as King of Monkeys and Installation of Prince Aṅgada as Heir Apparent
NALAGARH (HINDUR) SCHOOL, C. 1820
ILLUSTRATION FROM THE *Rāmāyaṇa*
OPAQUE WATERCOLOR WITH GOLD ON PAPER
9⁷⁄₁₆ x 14" (24 x 35.6 cm)
PRIVATE COLLECTION

Book Four of the *Rāmāyaṇa* tells of the kingdom of monkeys and their alliance with Rāma in his search for and rescue of his abducted wife Sītā. In this painting Sugrīva, with Rāma's help, has just been reinstated as king of the monkeys. The mountain palace is resplendent with riches and the throng of councilors, among them Jāmbavat, king of the bears, and guests, who are still arriving. The last one, shown in back view, hurries into the entrance hall of the palatial cave. Rāma has refused the invitation to the royal city because he is living in exile and strictly observes its rules. He and his brother Lakṣmaṇa, seen in the distance, return to the richly wooded hill where they will spend the rainy season.

A tree laden with flowers—in saturated splendor—fills the night with fragrance and sustains Rāma's path of sorrow and longing. The night scene carries the mood of Rāma's search for Sītā, but the mountain palace and the coronation are depicted with as much humor as pictorial fantasy.

132 Hanumān, Meeting Rāma and Lakṣmaṇa, Takes Them to the Mountain Where Sītā's Jewels Are Kept
NALAGARH (HINDUR) SCHOOL, C. 1820
ILLUSTRATION FROM THE *Rāmāyaṇa*
OPAQUE WATERCOLOR WITH GOLD LEAF ON PAPER
9⅜ x 13⁹⁄₁₆" (23.8 x 34.4 cm)
PHILADELPHIA MUSEUM OF ART. GIFT OF
MRS. V. K. ARORA. 1976-74-1

After Rāvaṇa abducts Sītā they fly in his aerial chariot to his kingdom of Laṅkā. During the flight Sītā throws down her jewels, which are collected and kept in a cave (*Rāmāyaṇa,* 4.6.12–13).

The mountains in this painting vie with the cloud banks that spiral in foaming shapes in a world where noble monkeys, who carry the weight of the story, along with Rāma and Lakṣmaṇa are seated in front of the cave. Whereas a spritely monkey free from protocol and etiquette climbs a tree, another seated on the rocks watches Rāma, Lakṣmaṇa, and the noble, crowned monkeys.

Rock and mountain configurations as structural volumetric

shapes were employed in the paintings of Ajanta and in Mughal paintings, the latter based on Persian prototypes. A third variety of pictorial rock formations seen in these three illustrations (nos. 131–33) is a type particularly elaborated in the Nalagarh school.

133 *The Monkey King Sugrīva Sends Emissaries Led by Hanumān to Find Sītā*
NALAGARH (HINDUR) SCHOOL, C. 1820
ILLUSTRATION FROM THE *Rāmāyaṇa*
OPAQUE WATERCOLOR WITH GOLD ON PAPER
10⅜ x 12¾″ (26.4 x 32.4 cm)
PHILADELPHIA MUSEUM OF ART. GIFT OF THE BOARD
OF TRUSTEES IN HONOR OF WILLIAM P. WOOD,
PRESIDENT FROM 1976 TO 1981. 1981-3-1

This illustration from the *Rāmāyaṇa* (4.39–43) is from a different manuscript than that of the preceding paintings (nos. 131–32) and shows a slight variation of style. The rocks and cave in this painting—dotted with vegetation and lined with veins of precious metals—are less volumetric and more sharply edged. They form a pattern that contrasts, but also corresponds, with that of the large leaves tossed over the rocks.

FOLK PAINTING

134 *Subhadrā and Abhimanyu Journey through a Forest Filled with Wild Animals*
PAITHAN SCHOOL, WESTERN DECCAN
(MAHARASHTRA AND NORTHERN KARNATAKA),
AFTER 1835
OPAQUE AND TRANSPARENT WATERCOLOR
ON PAPER
12 x 15⅜″ (30.5 x 39.1 cm)
PHILADELPHIA MUSEUM OF ART. GIFT OF
THE FRIENDS OF THE MUSEUM. 68-12-5

The son of Subhadrā, sister of Kṛṣṇa, is Abhimanyu, whose father is the great Pāṇḍava hero Arjuna. Abhimanyu is engaged to Vatsalā, but when her parents hear that the Pāṇḍavas have lost everything they want Vatsalā to break the engagement. The news dismays Subhadrā, and Abhimanyu takes Arjuna's chariot to Dvāraka, the home of his mother. With Subhadrā as charioteer, Abhimanyu fights the wild beasts and terrible dangers of their journey. After many adventures all ends well, and the wedding of Vatsalā and Abhimanyu is celebrated with great splendor.[1]

The stark boldness of Abhimanyu's movement, the wooden-toy legs of the horse, the detailed ornamentation of chariot and costume—all are set off against the unpainted ground of the paper. Abhimanyu's flying arrows in the left half of the picture commingle with flowers, foliage, and the bodies of the wild beasts to such an extent that the tiger's stripes become pointed darts on the beast's body.[2] Heroic stance and dynamic turbulence, convention and spontaneity on right and left are coordinated.[3]

1. Dallapiccola, 1980, p. 43.
2. Triangular tiger stripes are a convention of Paithan paintings; see Dallapiccola, 1980, p. 115.

3. The Britannia watermark of the imported paper fixes the *terminus post quem* for the painting.

PUBLISHED
Ray, 1978, p. 255, fig. 1; Dallapiccola, 1980, p. 367, no. D.II 1.

135 *The Goddess Sarasvatī and Her Peacock*
PAITHAN SCHOOL, WESTERN DECCAN
(MAHARASHTRA AND NORTHERN KARNATAKA),
1830–50
OPAQUE WATERCOLOR ON PAPER
11½ x 16½″ (29.2 x 41.9 cm)
PRIVATE COLLECTION

This painting is the obligatory second picture—the first being that of Gaṇeśa—exhibited by the village picture showman as he would tell and illustrate the cycle of a myth or legend such as that of Abhimanyu (see no. 134).

The figures of heroic proportion are laid out in the picture plane on the sheet of paper that is their ground. The virile figure of Sarasvatī, goddess of literature and music, holds in her two main hands her cognizances, a book (the Vedas) and a lute. Though a work of folk art, this painting is neither primitive nor schematic; its formulas carry conviction.

The size of the peacock, Sarasvatī's vehicle, exceeds that of the goddess, who is shown in active worship. An exultant musician blows a horn and a devotee bends over so that his worshiping hands touch her feet. The figures in Paithan paintings do not look at each other; they confront one another. The large circular eye is the full stop to the portentous presence of each figure.

136 *Indrajit's Sacrifice*
PAITHAN SCHOOL, WESTERN DECCAN
(MAHARASHTRA AND NORTHERN KARNATAKA),
1850–75
OPAQUE WATERCOLOR ON PAPER
12³⁄₁₆ x 15¹⁵⁄₁₆″ (31 x 40.5 cm)
PRIVATE COLLECTION

Although Indrajit—son of Rāvaṇa, the demon king of Laṅkā—defeats Indra, king of the gods, later he is killed in battle and his head is cut off. His widow, carrying his head, enters the sacrificial fire.[1] Two noble male figures seated on either side of the fire offer garlands and two warriors aim their arrows at the funeral pyre already struck by many arrows. The arm of Indrajit's widow reaches out from the fire, and a circular eye stares from the rising flames.

More reticent in the conduct of its lines and simpler in ornamentation than most Paithan paintings, the composition is as monumental as it is expressive in conveying heroic grief. Tense stillness pervades the nearly geometrical solemnity of horizontals and verticals. The angles of the arrow-pierced pyre and the raised arm are infused with pain, to which the staring eye is a witness.

1. For a painting in which Indrajit's wife carries his severed head yet he stands within the flames, see Dallapiccola, 1980, pp. 180–81, no. A.X5.

PUBLISHED
Ray, 1978, p. 267, fig. 26.

137 *Woman with a Rose*
KALIGHAT SCHOOL, WEST BENGAL, C. 1875
INK ON PAPER
17⅞ x 10½" (45.4 x 26.7 cm)
PRIVATE COLLECTION

138 *Woman with a Parrot*
KALIGHAT SCHOOL, WEST BENGAL, C. 1875
INK ON PAPER
18³⁄₁₆ x 11" (46.2 x 27.9 cm)
PRIVATE COLLECTION

The paintings and brush drawings from Kalighat, near Calcutta, were produced for the edification and entertainment of the pilgrims who had come to worship at the temple of the goddess Kālī rather than for the local villagers. They were souvenirs produced locally by painters who had branched off from professional and traditional itinerant village painter-bards. Settling near the precincts of the temple of the dreaded goddess Kālī, these painters were close to Calcutta and contemporary British art. They depicted not only popular Hindu gods but also figures, objects, and scenes of contemporary life—one or two figures occupying a sheet of paper.[1] In sweeping brushstrokes they infused British classicism into the ample countenance of their ideal of beauty and achieved a quality of the modeling line that can lay claim to having descended from Ajanta.

1. For a drawing nearly identical to *Woman with a Parrot* (no. 138), see Welch, 1976, p. 32, no. 5; and Sharma, 1974, no. 92.

PUBLISHED
Kramrisch, 1955, p. 214 [no. 137]; Kramrisch, 1968, pl. 34, no. 390 [no. 138].

BIBLIOGRAPHY

Texts

A'in-i Akbari of Abu'l Fazl Allami. H. Blochmann, trans. Vol. I. Calcutta, 1873. H. S. Jarrett, trans. Vols. 2–3. Calcutta, 1891.

Akbar Nāma of Abu-l-Fazl. H. Beveridge, trans. 3 vols. Calcutta, 1897–1921; reprint, Delhi, 1972–77.

Bābur-nāma. A. S. Beveridge, ed. and trans. London, 1922; reprint, New York, 1971.

Bhāgavata Purāṇa. P. R. Śāstrī, ed. Benares, 1962.

Bhāgavata Purāṇa. N. Raghunathan, trans. Madras, 1976.

Bhāgavata Purāṇa. G. V. Tagare, trans. Delhi, 1978.

Bihārī-Satsaī. Nemichand Jain, ed. Jaipur, 1968.

Hamza-nāma: Vollständige Wiedergabe der bekannten Blätter der Handschriften aus dem Bestānden aller erreichbaren Sammlungen. Codices selecti phototypice impressi, vol. 52. 2 vols. Graz, 1974–.

Kavipriyā of Keśavadās. Lakṣmīnidhi Chaturvedi, ed. Prayag, 1966.

Mahābhārata. V. S. Sukthankar et al., eds. 19 vols. Poona, 1933–59.

Mahābhārata. J. A. B. van Buitenen, ed. and trans. 3 vols. [bks. I–5]. Chicago, 1973–78.

Matsya Purāṇa. Nārāyaṇa Āpṭe, ed. Ānandāśrama Sanskrit Series, no. 54. Poona, 1907.

Rāmāyaṇa of Vālmīki. G. H. Bhatt et al., eds. 7 vols. Baroda, 1960–75.

Rāmāyaṇa of Vālmīki. H. P. Shāstri, trans. 3 vols. London, 1962–70.

Rasikapriyā of Keśavadās. Sardar, ed. Bombay, 1931.

Rasikapriyā of Keshavadāsa. K. P. Bahadur, trans. New Delhi, 1972.

Vāmana Purāṇa. A. S. Gupta, ed. S. M. Mukhopadhyaya et al., trans. Benares, 1968.

Sources

AIJAZUDDIN, 1977
AIJAZUDDIN, F. S. *Pahari Paintings and Sikh Portraits in the Lahore Museum.* London, 1977.

ANDHARE and SINGH, 1977
ANDHARE, SHRIDHAR, and SINGH, RĀWAT NAHAR. *Deogarh Painting.* New Delhi, 1977.

ARCHER, n.d.
ARCHER, WILLIAM GEORGE. *The Loves of Krishna in Indian Painting and Poetry.* New York, n.d.

———. *Indian Painting in the Punjab Hills: Essays.* London, 1952.

———. *Indian Painting.* London, 1956.

———. *Central Indian Painting.* London, 1958.

ARCHER, 1960
———. *Indian Miniatures.* Greenwich, Conn., 1960.

ARCHER, 1973
———. *Indian Paintings from the Punjab Hills: A Survey and History of Pahari Miniature Painting.* 2 vols. London, 1973.

ARCHER, 1976
———. *Visions of Courtly India.* Washington, D.C., 1976.

ARNOLD, SIR THOMAS W. *The Library of A. Chester Beatty: A Catalogue of the Indian Miniatures.* 3 vols. Oxford, 1936.

ASHTON, LEIGH, ed. *The Art of India and Pakistan.* London, 1950. Exhibition, Royal Academy of Arts, London, 1947–48.

ASKARI, S. H. "Kutban's Mrigavat: A Unique Ms. in Persian Script." *Journal of the Bihar Research Society,* vol. 46 (1955), pp. 452–87.

BARRETT, DOUGLAS E. *Painting of the Deccan, XVI–XVII Century.* London, 1958.

BARRETT and GRAY, 1963
BARRETT, DOUGLAS, and GRAY, BASIL. *Painting of India.* Lausanne, 1963.

BEACH, MILO CLEVELAND. "Painting at Devgarh." *Archives of Asian Art,* vol. 24 (1970–71), pp. 23–35.

BEACH, 1974
———. *Rajput Painting at Bundi and Kota.* Ascona, 1974.

BEACH, 1975
———. "The Context of Rajput Painting." *Ars Orientalis,* vol. 10 (1975), pp. 11–17.

BEACH, 1976
———. "A European Source for Early Mughal Painting." *Oriental Art,* n.s., vol. 22, no. 2 (Summer 1976), pp. 180–88.

BEACH, 1978
———. *The Grand Mogul: Imperial Painting in India 1600–1660.* Williamstown, Mass., 1978. Exhibition (traveling), Sterling and Francine Clark Art Institute, Williamstown, Mass., September 25–November 5, 1978.

BEACH, 1981
———. *The Imperial Image: Paintings for the Mughal Court.* Washington, D.C., 1981. Exhibition, Freer Gallery of Art, Washington, D.C., September 25, 1981–January 10, 1982.

BINYON, LAURENCE. *A Persian Painting of the 16th Century: Emperors and Princes of the House of Timur.* London, 1930.

BINYON, LAURENCE, and ARNOLD, THOMAS W. *The Court Painters of the Grand Moguls.* Oxford, 1921.

BINYON, LAURENCE; WILKINSON, J. V. S.; and GRAY, BASIL. *Persian Miniature Painting Including a Critical and Descriptive Catalogue of the Miniatures Exhibited at Burlington House January–March 1931.* London, 1933.

BRECK, JOSEPH. "An Early Mughal Painting." *Metropolitan Museum Studies,* vol. 2 (1929–30), pp. 133–34.

BRIJBHUSHAN, JAMILA. *The World of Indian Miniatures.* New York, 1979.

BRITISH MUSEUM, LONDON. *Paintings from the Muslim Courts of India.* Exhibition, April 13–July 11, 1976.

BROWN, PERCY. *Indian Painting under the Mughals, A.D. 1550 to A.D. 1750.* Oxford, 1924.

BROWN, 1934

BROWN, W. NORMAN. *Miniature Paintings of the Jaina Kalpasūtra.* Washington, D.C., 1934.

CHANDRA, 1957

CHANDRA, MOTI. *Mewar Painting in the Seventeenth Century.* New Delhi, 1957.

———. *Indian Art,* 2d ed., rev. and enl. Bombay, 1964.

CHANDRA, 1965

———. *Gītā Govinda.* Lalit Kalā Series, nos. 2–3. New Delhi, 1965.

———. *Studies in Early Indian Paintings.* New York, 1970.

CHANDRA, PRAMOD. "A Series of Ramayana Paintings of the Popular Mughal School." *Bulletin of the Prince of Wales Museum of Western India,* vol. 6 (1957–59), pp. 64–70.

———. "Ustād Sālivāhana and the Development of Popular Mughal Art." *Lalit Kalā,* no. 8 (1960), pp. 25–46.

CHANDRA, 1976

———. *The Tūti-nāma of The Cleveland Museum of Art and Origins of Mughal Painting.* Graz, 1976.

CHHAVI, 1971

Chhavi: Golden Jubilee Volume. Benares, 1971.

CHHAVI-2, 1981

Chhavi-2: Rai Krishnadasa Felicitation Volume. Benares, 1981.

P. & D. COLNAGHI & CO. LTD., LONDON, 1978

P. & D. COLNAGHI & CO. LTD., LONDON. *Indian Painting: Mughal and Rajput and a Sultanate Manuscript.* Exhibition, April 5–May 3, 1978.

COOMARASWAMY, ANANDA K. "Rajput Paintings." *Burlington Magazine,* vol. 20, no. 108 (March 1912), pp. 315–24.

———. *Rajput Paintings.* 2 vols. London, 1916.

COOMARASWAMY, 1926

———. *Catalogue of the Indian Collections in the Museum of Fine Arts, Boston. Part V: Rajput Painting.* Cambridge, Mass., 1926.

———. "Notes on Mughal Painting, 2." *Artibus Asiae,* vol. 2, no. 3 (1927), pp. 202–12.

COOMARASWAMY, 1929

———. *Les Miniatures orientales de la collection Goloubew au Museum of Fine Arts.* Paris, 1929.

———. *Catalogue of the Indian Collections in the Museum of Fine Arts, Boston. Part VI: Mughal Painting.* Cambridge, Mass., 1930.

CZUMA, 1975

CZUMA, STANISLAW. *Indian Art from the George P. Bickford Collection.* Cleveland, 1975. Exhibition (traveling), Cleveland Museum of Art, January 14–February 16, 1975.

DAHMEN-DALLAPICCOLA, 1975

DAHMEN-DALLAPICCOLA, ANNA LIBERA. *Rāgamālā-Miniaturen von 1475 bis 1700.* Wiesbaden, 1975.

DALLAPICCOLA, 1980

DALLAPICCOLA, ANNA LIBERA. *Die „Paithan"—Malerei.* Wiesbaden, 1980.

DALLAPICCOLA, ed., 1982

———. *Krishna the Divine Lover.* London, 1982.

DAS, ASOK KUMAR. *Treasures of Indian Painting from the Maharaja Sawai Man Singh II Museum,* ser. 1. Jaipur, 1976.

———. *Mughal Painting During Jahangir's Time.* Calcutta, 1978.

———. *Treasures of Indian Painting from the Maharaja Sawai Man Singh II Museum,* ser. 3. Jaipur, 1979.

DAS, 1981

———. "Calligraphers and Painters in Early Mughal Painting." In *Chhavi-2,* 1981, pp. 92–97.

———. *Treasures of Indian Painting from the Maharaja Sawai Man Singh II Museum,* ser. 4. Jaipur, 1983.

DICKINSON and KHANDALAVALA, 1959

DICKINSON, ERIC, and KHANDALAVALA, KARL. *Kishangarh Painting.* Lalit Kalā Series of Indian Art, no. 4. New Delhi, 1959.

DIMAND, MAURICE S. "An Exhibition of Islamic and Indian Paintings." *The Metropolitan Museum of Art Bulletin,* n.s., vol. 14, no. 4 (December 1955), pp. 85–102.

DOSHI, SARYU. "An Illustrated Manuscript from Aurangabad Dated 1650 A.D." *Lalit Kalā,* no. 15 (1972), pp. 19–28.

EBELING, 1973

EBELING, KLAUS. *Ragamala Painting.* Basel, 1973.

EHNBOM, 1985

EHNBOM, DANIEL J. *Indian Miniatures: The Ehrenfeld Collection.* New York, 1985. Exhibition organized by the American Federation of Arts, 1985.

ETTINGHAUSEN, RICHARD. *Paintings of the Sultans and Emperors of India in American Collections.* Delhi, 1961.

FALK and ARCHER, 1981

FALK, TOBY, and ARCHER, MILDRED. *Indian Miniatures in the India Office Library.* London, 1981.

FRAAD, IRMA L., and ETTINGHAUSEN, RICHARD. "Sultanate Painting in Persian Style, Primarily from the First Half of the Fifteenth Century: A Primary Study." In *Chhavi,* 1971, pp. 48–66.

GANGOLY, 1961

GANGOLY, O. C. *Critical Catalogue of Miniature Paintings in the Baroda Museum.* Baroda, 1961.

GLÜCK, 1925

GLÜCK, HEINRICH. *Die indischen Miniaturen des Haemzae Romanes.* Zurich, 1925.

GLÜCK and DIEZ, 1925

GLÜCK, HEINRICH, and DIEZ, ERNST. *Die Kunst des Islam.* Berlin, 1925.

GLYNN, 1983

GLYNN, CATHERINE. "Early Painting in Mandi." *Artibus Asiae,* vol. 44, no. 1 (1983), pp. 21–64.

GOETZ, HERMANN. *Geschichte der indischen Miniaturmalerei.* Berlin, 1934.

GOETZ, 1950

———. *The Art and Architecture of Bikaner State.* Oxford, 1950.

GOETZ, 1952

———. "A New Key to Early Rajput and Indo-Muslim Painting." *Roopa Lekhā,* vol. 23, nos. 1–2 (1952), pp. 1–16.

GOSWAMY, BRIJINDER N. "The Problem of the Artist Nainsukh of Jasrota." *Artibus Asiae,* vol. 28, nos. 2–3 (1966), pp. 205–10.

GOSWAMY, 1968

———. "Pahari Painting: The Family on the Basis of Style." *Marg,* vol. 21, no. 4 (1968), pp. 17–62.

GOSWAMY and DALLAPICCOLA, 1983

GOSWAMY, BRIJINDER N., and DALLAPICCOLA, ANNA LIBERA. *A Place Apart: Painting in Kutch, 1720–1820.* Delhi, 1983.

GRAY, BASIL. "Deccani Paintings: The School of Bijapur." *Burlington Magazine,* vol. 73 (1938), pp. 74–76.

GRAY, 1961
———. *Persian Painting*. Lausanne, 1961.

GRAY, ed., 1981
———. *The Arts of India*. Ithaca, 1981.

GRUBE, ERNST J. *Muslim Miniature Paintings from the XIII to XIX Century from Collections in the United States and Canada*. Venice, 1962. Exhibition, Centro di Cultura e Civiltà, Venice, 1962.

GUPTA, S. N. *Catalogue of Paintings in the Central Museum, Lahore*. Calcutta, 1922.

HAYWARD GALLERY, LONDON, 1982
HAYWARD GALLERY, LONDON. *In the Image of Man: The Indian Perception of the Universe through 2000 Years of Painting and Sculpture*. Exhibition, March 25–June 13, 1982.

HEERAMANECK, 1984
HEERAMANECK, ALICE N. *Masterpieces of Indian Painting*. New York, 1984.

HENDLEY, THOMAS H. *Memorials of the Jeypore Exhibition 1883*. 4 vols. London, 1883.

HUTCHINS, 1980
HUTCHINS, FRANCIS G. *Young Krishna*. West Franklin, N.H., 1980.

IRWIN, 1959
IRWIN, JOHN. "Golconda Cotton Paintings of the Early Seventeenth Century." *Lalit Kalā*, no. 5 (1959), pp. 11–48.

KAUFMANN, WALTER. *The Ragas of North India*. Bloomington, Ind., 1968.

KHANDALAVALA, KARL J. "Leaves from Rajasthan," *Marg*, vol. 4, no. 3 (1951), pp. 2–24, 49–56.

KHANDALAVALA, 1958
———. *Pahāri Miniature Painting*. Bombay, 1958

———. "The Mrigavat of Bharat Kala Bhavan: As a Social Document and Its Date and Provenance." In *Chhavi*, 1971, pp. 19–36.

———. "Two Bikaner Paintings in the N. C. Mehta Collection and the Problem of Mandi School." In *Chhavi-2*, 1981, pp. 301–4.

KHANDALAVALA, KARL, and CHANDRA, MOTI. "A Ms. of the Laur Chandā in the Prince of Wales Museum." *Bulletin of the Prince of Wales Museum of Western India*, no. 7 (1959–62), pp. 27–31.

———. *Miniatures and Sculptures from the Collections of the Late Sir Cowasji Jehangir*. Bombay, 1965.

KHANDALAVALA and CHANDRA, 1969
———. *New Documents of Indian Painting—A Reappraisal*. Bombay, 1969.

———. *An Illustrated Aranyaka Parvan in the Asiatic Society of Bombay*. Bombay, 1974.

KHANDALAVALA, CHANDRA, and CHANDRA, 1960
KHANDALAVALA, KARL; CHANDRA, MOTI; and CHANDRA, PRAMOD. *Miniature Painting*. New Delhi, 1960. Exhibition, Lalit Kalā Akademi, New Delhi, 1960.

KHANDALAVALA and MITTAL, 1974
KHANDALAVALA, KARL, and MITTAL, JAGDISH. "The Bhagavata Mss from Palam and Isarda: A Consideration in Style." *Lalit Kalā*, no. 16 (1974), pp. 28–32.

KRAMRISCH, STELLA. *A Survey of Painting in the Deccan*. London, 1937.

KRAMRISCH, 1955
———. *The Art of India*, 3d ed. London, 1955.

KRAMRISCH, 1968
———. *Unknown India*. Philadelphia, 1968. Exhibition (traveling), Philadelphia Museum of Art, January 20–February 26, 1968.

KRAMRISCH, 1981
———. *Manifestations of Shiva*. Philadelphia, 1981. Exhibition (traveling), Philadelphia Museum of Art, March 29–June 7, 1981.

KRISHNA, ANAND. *Malwa Painting*. Benares, 1963.

———. "An Illustrated Manuscript of the Laur-Chanda in the Staatsbibliothek Berlin." In *Chhavi-2*, 1981, pp. 275–89.

KRISHNADASA, RAI. *Mughal Miniatures*. New Delhi, 1955.

———. "An Illustrated Avadhī Ms. of Laur Chandā in the Bhārat Kalā Bhavan, Banaras." *Lalit Kalā*, nos. 1–2 (1955–56), pp. 66–71.

KÜHNEL, ERNST, and GOETZ, HERMANN. *Indian Book Painting from Jahangir's Album in the State Library in Berlin*. London, 1926.

LEE, 1960
LEE, SHERMAN. *Rajput Painting*. New York, 1960. Exhibition, Asia House Gallery, New York, 1960.

LERNER, 1984
LERNER, MARTIN. *The Flame and the Lotus: Indian and Southeast Asian Art from the Kronos Collections*. New York, 1984. Exhibition, The Metropolitan Museum of Art, New York, September 20, 1984–March 3, 1985.

LOSTY, 1982
LOSTY, JEREMIAH P. *The Art of the Book in India*. London, 1982. Exhibition, British Library, London, April 16–August 1, 1982.

MARTIN, FREDRIK R. *The Miniature Painting and Painters of Persia, India, and Turkey from the 8th to the 18th Century*. 2 vols. London, 1912.

MASSON, J. L., and PATWARDHAN, M. V. *Aesthetic Rapture*. Poona, 1970.

MCINERNEY, 1982
MCINERNEY, TERENCE. *Indian Painting 1525–1825*. London, 1982. Exhibition, David Carritt Limited, London, April 1–30, 1982.

MCNEAR, ANN. *Persian and Indian Miniatures from the Collection of Everett and Ann McNear*. Chicago, 1974. Exhibition (traveling), Art Institute of Chicago, 1974–75.

MEHTA, NANALAL CHAMANLAL. *Studies in Indian Painting: A Survey of Some New Material Ranging from the Commencement of the VIIth Century to Circa 1870 A.D.* Bombay, 1926.

MILLER, ed. and trans., 1977
MILLER, BARBARA STOLER, ed. and trans. *Love Song of the Dark Lord: Jayadeva's Gītagovinda*. New York, 1977.

MITTAL, JAGDISH. "Deccani Paintings at the Samasthans of Wanaparthy, Gadwal, and Shorapur." *Marg*, vol. 26, no. 2 (March 1963), pp. 57–64.

———. *Andhra Paintings of the Rāmāyana*. Hyderabad, 1969.

MUSEUM OF FINE ARTS, BOSTON, 1966–67
MUSEUM OF FINE ARTS, BOSTON. *The Arts of India and Nepal: The Nasli and Alice Heeramaneck Collection*. Exhibition (traveling), November 21, 1966–January 8, 1967.

NAWAB, 1956
NAWAB, SARABHAI MANILAL. *Masterpieces of the Kalpasutra Paintings of the Western Indian School*. Ahmadabad, 1956.

O'FLAHERTY, 1973
O'FLAHERTY, WENDY DONIGER. *Asceticism and Eroticism in the Mythology of Siva*. London, 1973.

OHRI, V. C. "Kangra Painting of Pre-Sansār Chand Period." *Lalit Kalā*, no. 17 (1974), p. 43.

PAL, PRATAPADITYA. *Rāgamālā Paintings in the Museum of Fine Arts, Boston*. Boston, 1967. Exhibition, December 1, 1967–January 14, 1968.

————. *The Flute and the Brush: Indian Paintings from the William Theo Brown and Paul Wonner Collection*. Newport Beach, 1976.

PAL, 1978

————. *The Classical Tradition in Rajput Painting*. New York, 1978. Exhibition (traveling), Pierpont Morgan Library, New York, December 3, 1978–February 8, 1979.

PAL, 1982

————. *A Buddhist Paradise: The Murals of Alchi, Western Himalayas*. Hong Kong, 1982.

PAL, 1983

————. *Court Paintings of India*. New York, 1983.

PATNAIK, N., and WELCH, STUART CARY. *A Second Paradise*. New York, 1985.

PENNSYLVANIA ACADEMY OF THE FINE ARTS, PHILADELPHIA, 1923–24

THE PENNSYLVANIA ACADEMY OF THE FINE ARTS, PHILADELPHIA. *Paintings and Drawings of Persia and India*. Philadelphia, 1923–24.

PORTLAND ART MUSEUM, 1968

PORTLAND ART MUSEUM (OREGON). *Rajput Miniatures from the Collection of Edwin Binney, 3rd*. Exhibition (traveling), September 24–October 20, 1968.

PORTLAND ART MUSEUM, 1973–74

————. *Indian Miniature Painting from the Collection of Edwin Binney, 3rd*. Exhibition, December 2, 1973–January 20, 1974.

PRINCETON UNIVERSITY, THE ART MUSEUM, 1982

PRINCETON UNIVERSITY, THE ART MUSEUM. *Indian Paintings from the Polsky Collections*. Exhibition, May 8–June 18, 1982.

RANDHAWA, 1953

RANDHAWA, MOHINDER SINGH. "Kangra Paintings Illustrating the Life of Shiva and Parvati." *Roopa-Lekhā*, vol. 24, nos. 1–2 (1953), pp. 23–39.

————. *Kangra Paintings of the Bhāgavata Purāṇa*. New Delhi, 1960.

————. *Kangra Paintings on Love*. New Delhi, 1962.

RANDHAWA, 1963

————. *Kangra Paintings of the Gīta Govinda*. New Delhi, 1963.

————. *Kangra Paintings of the Bihārī Sat Saī*. New Delhi, 1966.

RANDHAWA and GALBRAITH, 1968

RANDHAWA, MOHINDER SINGH, and GALBRAITH, JOHN KENNETH. *Indian Painting: The Scene, Themes and Legends*. Boston, 1968.

RANDHAWA, MOHINDER SINGH, and RANDHAWA, DORIS SCHREIER. *Kishangarh Painting*. Bombay, 1980.

RAY, 1978

RAY, EVA. "Documentation for Paiṭhān Paintings." *Artibus Asiae*, vol. 40, no. 4 (1978), pp. 239–82.

ROBINSON, ed., 1976

ROBINSON, B. W., ed. *Islamic Painting and the Arts of the Book*. London, 1976.

SCHIMMEL, ANNEMARIE. *Mystical Dimensions of Islam*. Chapel Hill, 1975.

SEN, 1984

SEN, GEETI. *Paintings from the Akbar Nama*. New Delhi, 1984.

SHAH and DHAKY, eds., 1975

SHAH, U. P., and DHAKY, M. A. *Aspects of Jaina Art and Architecture*. Ahmadabad, 1975.

SHARMA, 1974

SHARMA, O. P. *Indian Miniature Painting*. Brussels, 1974. Exhibition, Bibliothèque Royale Albert Iᵉʳ, Brussels, October 5–26, 1974.

SHIVESHWARKAR, LEELA. *The Pictures of the Chaurapanchasika: A Sanskrit Love Lyric*. New Delhi, 1967.

SIMSAR, MUHAMMED AHMED. *Oriental Manuscripts of the John Frederick Lewis Collection in the Free Library of Philadelphia*. Philadelphia, 1937.

SINGH, M. K. BRIJRAJ. *The Kingdom That Was Kotah*. New Delhi, 1985.

SIVARAMAMURTI, 1977

SIVARAMAMURTI, CALAMBAR. *The Art of India*. New York, 1977.

Skelton, Robert. "Documents for the Study of Painting at Bijapur in the Late 16th and Early 17th Centuries." *Arts Asiatiques*, vol. 5 (1958), pp. 97–125.

————. "The Ni'mat-nama: A Landmark of Malwa Painting." *Marg*, vol. 12, no. 3 (1959), pp. 44–50.

————. *Indian Miniatures from the XVᵗʰ to the XIXᵗʰ Centuries*. Venice, 1961.

SKELTON, 1973

————. *Rājasthāni Temple Hangings of the Kṛishṇa Cult from the Collection of Karl Mann, New York*. New York, 1973. Exhibition organized by the American Federation of Arts, New York, 1973.

————. "Facets of Indian Painting." *Apollo*, vol. 104, no. 176 (October 1976), pp. 266–73.

SKELTON, 1981

————. "Shaykh Phul and the Origins of Bundi Painting." In *Chhavi-2*, 1981, pp. 123–29.

SMART, 1973

SMART, ELLEN S. "Four Illustrated Mughal Bāburnāma Manuscripts." *Art and Archaeology Research Papers*, vol. 1 (June 1973), pp. 54–58.

————. "Six Folios from a Dispersed Manuscript of the *Babarnama*." In P. & D. Colnaghi & Co., Ltd., London, 1978, pp. 109–32.

SMART and WALKER, 1985

SMART, ELLEN S., and WALKER, DANIEL S. *Pride of the Princes: Indian Art of the Mughal Era in the Cincinnati Art Museum*. Cincinnati, 1985.

SOUSTIEL and DAVID, 1973

SOUSTIEL, JEAN, and DAVID, MARIE-CHRISTINE. *Miniatures orientales de l'Inde: Les écoles et leurs styles*. 3 vols. Paris, 1973.

SPINK, 1971

SPINK, WALTER M. *Krishnamandala: A Devotional Theme in Indian Art*. Ann Arbor, 1971.

SPINK & SON, LONDON. *Painting for the Royal Courts of India*. Exhibition, April 7–23, 1976.

————. *Two Thousand Years of Indian Art*. Exhibition, April 6–23, 1982.

STCHOUKINE, IVAN V. *La Peinture indienne à l'époque des grands Moghols*. Paris, 1929.

STRZYGOWSKI, JOSEF; GLÜCK, HEINRICH; KRAMRISCH, STELLA; and WELLESZ, EMMY. *Asiatische Miniaturenmalerei.* Klagenfurt, 1933.

TANDAN, RAJ KUMAR. *The Ragamala Paintings from Basohli.* Lalit Kalā Series, no. 20. New Delhi, 1980.

————. *Indian Miniature Painting, 16th through 19th Centuries.* Bangalore, 1982.

TOD, JAMES. *Annals and Antiquities of Rajasthan.* 2 vols. London, 1914.

TOPSFIELD, ANDREW. *Paintings from Rajasthan in the National Gallery of Victoria.* Melbourne, 1980.

————. "Painting for the Rajput Courts." In Gray, ed., 1981, pp. 159–76.

TOPSFIELD, 1981
————. "Sāhibdīn's Gīta-Govinda Illustrations." In *Chhavi-2,* 1981, pp. 231–38.

————. *An Introduction to Indian Court Painting.* Owings Mills, Md., 1985.

UNIVERSITY OF WISCONSIN, ELVEHJEM ART CENTER, 1971
UNIVERSITY OF WISCONSIN, ELVEHJEM ART CENTER. *Indian Miniature Painting.* Madison, 1971.

VICTORIA AND ALBERT MUSEUM, LONDON. *Indian Art.* London, 1969.

VICTORIA AND ALBERT MUSEUM, LONDON, 1982
————. *The Indian Heritage: Court Life and Arts under Mughal Rule.* Exhibition, April 21–August 22, 1982.

WALDSCHMIDT and WALDSCHMIDT, 1967
WALDSCHMIDT, ERNST, and WALDSCHMIDT, ROSE LEONORE. *Miniatures of Musical Inspiration in the Collection of the Berlin Museum of Indian Art.* Wiesbaden, 1967.

————. *Miniatures of Musical Inspiration in the Collection of the Berlin Museum of Indian Art.* Pt. 2, *Ragamala Miniatures from Northern India and the Deccan.* Wiesbaden, 1975.

WELCH and WELCH, 1982
WELCH, ANTHONY, and WELCH, STUART CARY. *Arts of the Islamic Book: The Collection of Prince Sadruddin Aga Khan.* Ithaca, 1982. Exhibition (traveling), Asia House Gallery, New York, October 7, 1982–January 2, 1983.

WELCH, STUART CARY. "The Paintings of Basawan." *Lalit Kalā,* no. 10 (1961), pp. 7–17.

————. "Mughal and Deccani Miniature Paintings from a Private Collection." *Ars Orientalis,* vol. 5 (1963), pp. 221–33.

————. "Book Review: *Bundi Painting.* By Pramod Chandra." *Ars Orientalis,* vol. 5 (1963), pp. 293–95.

————. *The Art of Mughal India: Painting & Precious Objects.* New York, 1964. Exhibition, Asia House Gallery, New York, Winter 1964.

————. *A King's Book of Kings: The Shah-nameh of Shah Tahmasp.* New York, 1972.

WELCH, 1973
————. *A Flower from Every Meadow: Indian Paintings from American Collections.* New York, 1973. Exhibition, Asia House Gallery, New York, Spring 1973.

WELCH, 1976
————. *Indian Drawings and Painted Sketches: 16th through 19th Centuries.* New York, 1976. Exhibition, Asia House Gallery, New York, Winter 1976.

WELCH, 1978
————. *Imperial Mughal Painting.* New York, 1978.

————. "Return to Kotah." In *Essays on Near Eastern Art and Archaeology in Honor of Charles Kyrle Wilkinson,* ed. Prudence Harper and Holly Pittman, pp. 78–93. New York, 1983.

WELCH, 1985
————. *India: Art and Culture 1300–1900.* New York, 1985. Exhibition, The Metropolitan Museum of Art, New York, September 14, 1985–January 5, 1986.

WELCH and BEACH, 1965
WELCH, STUART CAREY, and BEACH, MILO CLEVELAND. *Gods, Thrones, and Peacocks: Northern Indian Painting from Two Traditions—Fifteenth to Nineteenth Centuries.* Exhibition (traveling), Asia House Gallery, New York, September 23–December 12, 1965.

DORIS WIENER GALLERY, NEW YORK, 1970
DORIS WIENER GALLERY, NEW YORK. *Indian Miniature Paintings.* Exhibition, April 4–May 20, 1970.

WILKINSON, JAMES V. S. *Mughal Painting.* London, 1948.

ZEBROWSKI, MARK. "Decorative Arts of the Mughal Period." In Gray, ed., 1981, pp. 177–89.

————. "Transformations in Seventeenth Century Deccani Painting at Bijapur." In *Chhavi-2,* 1981, pp. 170–81.

ZEBROWSKI, 1983
————. *Deccani Painting.* London, 1983.